Expressionism in Germany and France

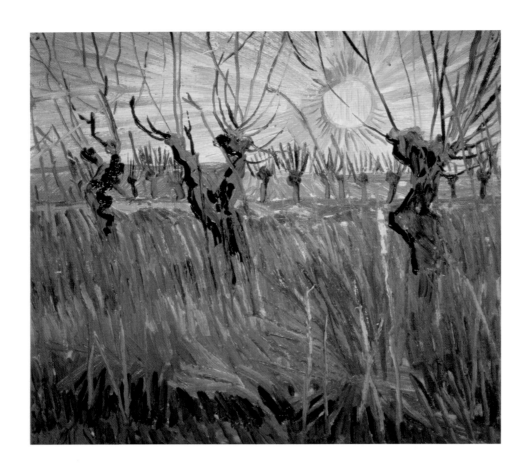

EXPRESSIONISM

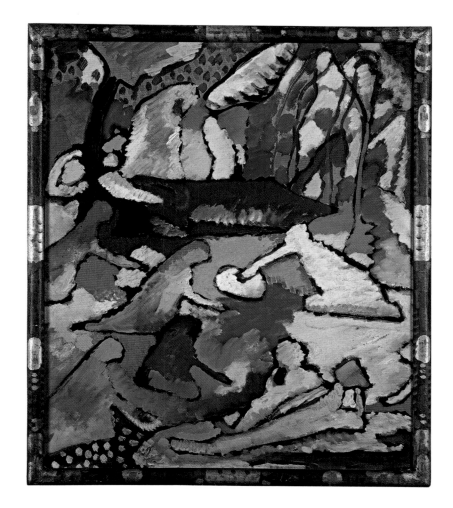

in Germany and France

From Van Gogh to Kandinsky

Timothy O. Benson

With curatorial assistance by
Frauke Josenhans

With contributions by
Laird M. Easton | Claudine Grammont | Frauke Josenhans | Peter Kropmanns |
Katherine Kuenzli | Magdalena M. Moeller | Sherwin Simmons

Los Angeles County Museum of Art
The Montreal Museum of Fine Arts

DelMonico Books • Prestel
Munich • London • New York

Published in conjunction with the exhibition *Expressionism in Germany and France: From Van Gogh to Kandinsky*.

This exhibition was organized by the Los Angeles County Museum of Art and the Kunsthaus Zürich in collaboration with the Montreal Museum of Fine Arts.

Funding for the exhibition is provided by Violet Spitzer-Lucas and the Spitzer Family Foundation and Christie's. Additional support is provided by the Wallis Annenberg Director's Endowment Fund. This exhibition is supported by an indemnity from the Federal Council on the Arts and the Humanities.

In Montreal, the exhibition benefits from the support of Air Canada, Bell, as well as *La Presse* and *The Gazette*. The Montreal Museum of Fine Arts wishes to thank the Volunteer Association of the Montreal Museum of Fine Arts, whose exemplary fundraising activities have contributed to the Museum's development since 1948. The Museum would also like to recognize the invaluable role of the Arte Musica Foundation and the Fondation de la Chenelière in its educational and cultural programming. The Museum's International Exhibition Programme receives financial support from the Exhibition Fund of the Montreal Museum of Fine Arts Foundation and the Paul G. Desmarais Fund. The Museum would like to acknowledge the ongoing support of Quebec's Ministère de la Culture et des Communications, the Conseil des arts de Montréal and the Canada Council for the Arts.

Exhibition itinerary:
Kunsthaus Zürich:
February 7–May 11, 2014

Los Angeles County Museum of Art:
June 8–September 14, 2014

The Montreal Museum of Fine Arts:
October 6, 2014–January 25, 2015

Copyright © 2014 Museum Associates /Los Angeles County Museum of Art and the Montreal Museum of Fine Arts and Prestel Verlag, Munich, London, New York

Published by Los Angeles County Museum of Art, the Montreal Museum of Fine Arts, and DelMonico Books, an imprint of Prestel Publishing

Prestel, a member of Verlagsgruppe Random House GmbH

Prestel Verlag
Neumarkter Strasse 28
81673 Munich
Germany
Tel.: +49 89 41 36 0
Fax: +49 89 41 36 23 35

Prestel Publishing Ltd.
14–17 Wells Street
London W1T 3PD
United Kingdom
Tel.: +44 20 7323 5004
Fax: +44 20 7323 0271

Prestel Publishing
900 Broadway, Suite 603
New York, NY 10003
Tel.: 212 995 2720
Fax: 212 995 2733
Email: sales@prestel-usa.com
prestel.com

Los Angeles County Museum of Art
5905 Wilshire Boulevard
Los Angeles, California 90036
(323) 857-6000
lacma.org

The Montreal Museum of Fine Arts
Jean-Noël Desmarais Pavilion
1380 Sherbrooke Street West
Montreal, Quebec H3G 1J5
(514) 285-2000
mbam.qc.ca

Library of Congress Cataloging-in-Publication Data
Expressionism in Germany and France : from Van Gogh to Kandinsky / Timothy O. Benson ; with curatorial assistance by Frauke Josenhans ; with contributions by Laird M. Easton, Claudine Grammont, Peter Kropmanns, Katherine Kuenzli, Magdalena M. Moeller, Sherwin Simmons.
 pages cm
 "Published in conjunction with the exhibition Expressionism in Germany and France: From Van Gogh to Kandinsky. This exhibition was organized by the Los Angeles County Museum of Art and the Kunsthaus Zürich in collaboration with the Montreal Museum of Fine Arts."
 Includes bibliographical references and index.
 ISBN 978-3-7913-5340-1—ISBN 978-2-89192-377-4
 1. Expressionism (Art)—Germany—Exhibitions. 2. Expressionism (Art)—France—Exhibitions. I. Benson, Timothy O., 1950- author. Expressionism in Germany and France. II. Los Angeles County Museum of Art. III. Kunsthaus Zürich. IV. Montreal Museum of Fine Arts.
 N6868.5.E9E9125 2014
 709.04'04207479493—dc23
 2013044740
ISBN:
978-3-7913-5340-1 (Trade)
978-2-89192-377-4 (Museum)

Printed and bound in China

Expressionism in Germany and France: From Van Gogh to Kandinsky
Head of Publications: Lisa Gabrielle Mark
Editor: Sara Cody, with Phil Graziadei
Designer: Stuart Smith, with David Karwan and Stefano Giustiniani
Creative Director: Lorraine Wild
Photo Editor: Piper Severance
Production Manager: Karen Farquhar

Contents

Foreword

"VAN GOGH STRUCK modern art like lightning," a German observer once said of the transformational experience that this seminal artist's work represented for artists in Germany during the first decade of the twentieth century. German artists had just discovered Georges Seurat, Paul Signac, and other Neo- and Post-Impressionists, and they would soon encounter the work of Paul Gauguin, Paul Cézanne, and Henri Matisse. The work of artists in France was being avidly collected and exhibited in Germany, and it gained an ever-increasing resonance among German artists. While modernism in Germany was indebted to many cultures across Europe, its most sustained exchange was certainly with French culture, with its cosmopolitan center in Paris. The exhibition *Expressionism in Germany and France: From Van Gogh to Kandinsky* explores the diverse and richly varied cultural milieu from which the pivotal modernist movement known as German Expressionism evolved.

The Los Angeles County Museum of Art (LACMA), Kunsthaus Zürich, and the Montreal Museum of Fine Arts are pleased to present this exploration of the fascinating artistic ambiance and interchange of exhibitions, collectors, art dealers, cultural figures, and artists as seen through masterpieces brought together from collections throughout Europe and North America. Each of these institutions has maintained a sustained and distinguished focus on French and German art through their collections as well as a broad array of groundbreaking exhibitions. LACMA has explored the cultures of Germany and France in many exhibitions, including *Expressionist Utopias: Paradise, Metropolis, Architectural Fantasy* (1993) and *Renoir to Matisse: The Eye of Duncan Phillips* (2004). Devoted to this field of interest, Kunsthaus Zürich organized, among others, *Graphik des Expressionismus* (1958), *Cuno Amiet und die Maler der Brücke* (1979), and *Max Beckmann and Paris: Matisse, Picasso, Braque,* *Léger, Rouault* (1998). The Montreal Museum of Fine Arts has presented exhibitions ranging from *Voyage into Myth: French Painting from Gauguin to Matisse from the Hermitage Museum, Russia* (2003) to *Van Dongen* (2009), *Otto Dix* (2010), and *Lyonel Feininger* (2012). It is thus fitting and immensely rewarding to engage in this productive partnership.

Artistic influence is a complex and often mysterious process. We can explore this subtle genealogy here by seeing assembled some of the spectacular works of art from France that German artists are known to have encountered in exhibitions and collections in Germany. This includes French masterpieces ranging from Fauvism to Cubism once seen, for example, in Berlin at Paul Cassirer's gallery or Herwarth Walden's gallery, in Dresden at Emil Richter's gallery, or in Cologne at the influential Sonderbund exhibition of 1912. Pioneering museum directors and collectors, such as Harry Graf Kessler, Karl Ernst Osthaus, and Bernhard Koehler in Germany and Sara and Michael Stein in Paris, all played a crucial role in gathering artists around the latest advances. Artists such as Paula Modersohn-Becker, Max Pechstein, Wassily Kandinsky, August Macke, Franz Marc, and Alexei Jawlensky (himself an avid collector of Van Gogh), among many others, all visited Paris and responded to the latest trends by producing entirely original works of their own incorporating brilliant colors in expressive vivacious brushstrokes, as seen in so many of the works on view in this exhibition.

Expressionism in Germany and France was organized by Timothy O. Benson, curator of LACMA's Robert Gore Rifkind Center for German Expressionist Studies, whose initial research was supported by the Alexander von Humboldt Foundation, and we are grateful to him for his expertise and his diligent and persistent efforts to bring this exhibition to fruition. He has brought together leading authorities on French and German modernism to contribute their perspectives in the essays in this catalogue, and we thank them for enriching our understanding of the intermingling of German and French cultures and artistic influence in general. We are indebted to Tobia Bezzola, former curator at Kunsthaus Zürich, who accompanied the project in its beginnings, Cathérine Hug, curator at the Kunsthaus Zürich, who carried it on, and Anne Grace, curator of modern art at the Montreal Museum of Fine Arts, for their essential roles in realizing this project. We also thank the project teams at the respective institutions, namely, Frauke Josenhans, Sandra Haldi, Franziska Lentzsch, Pascal Normandin, and Sandra Gagné.

This exhibition would not have been possible without the invaluable generosity of our lenders and sponsors, including Violet Spitzer-Lucas and the Spitzer Family Foundation, Christie's, and an indemnity from the Federal Council on the Arts and the Humanities (LACMA), Credit Suisse and Ernst von Siemens Stiftung (Kunsthaus Zürich), and the Canada Travelling Exhibitions Indemnification Program of Heritage Canada (Montreal Museum of Fine Arts). Cultural exchange between Germany and France continues to make vital and creative contributions to the visual arts, and we hope this historical investigation of the origins of Expressionism will further enrich this unfolding discourse.

Michael Govan
CEO and Wallis Annenberg Director
Los Angeles County Museum of Art

Christoph Becker
Director
Kunsthaus Zürich

Nathalie Bondil
Director and Chief Curator
Montreal Museum of Fine Arts

Acknowledgments

WHILE MODERNISM in Europe evolved from an interaction of many diverse cultures, the relationship between Germany and France exerts an extraordinary influence even today. I was reminded of this when I was an advisor on *The Expressionist Roots of Modernism* (2003) by Peter Lasko, whose untimely death just prior to the book's publication prevented further discussions many historians and curators would like to have had with this stimulating author. *Expressionism in Germany and France* is, in a sense, an attempt to continue that conversation with others, to examine a variety of perspectives, and above all to explore more deeply how German and French artists engaged with one another in the unprecedented cosmopolitan ambience of Europe before World War I. Its underlying concept was deepened by a residency in 2006 at the Kunsthistorisches Institut at the Freie Universität in Berlin that was supported by the Alexander von Humboldt Foundation and benefited from the advice of my host, Thomas W. Gaehtgens, who encouraged me to investigate the probing research being conducted into French–German cultural transfer at the Deutsches Forum für Kunstgeschichte in Paris.

A significant exhibition of paintings and works on paper of the highest quality is crucial to our comprehension of modernism and the essential contributions made by German and French artists of the early twentieth century. I am deeply grateful to the institutions whose shared enthusiasm made the realization of this endeavor possible, as well as for the support of their respective directors: CEO and Wallis Annenberg Director Michael Govan at the Los Angeles County Museum of Art (LACMA), Christoph Becker at Kunsthaus Zürich, and Director and Chief Curator Nathalie Bondil at the Montreal Museum of Fine Arts. Nor would an exhibition of this magnitude and complexity be accomplished without the support of Violet Spitzer-Lucas and the Spitzer Family Foundation and the Wallis Annenberg Director's Endowment Fund.

The resources of LACMA's Robert Gore Rifkind Center for German Expressionist Studies have been indispensable, and our extraordinary curatorial assistant, Frauke Josenhans, has been involved in all aspects of realizing the exhibition, ranging from useful curatorial suggestions and intensive research to complex organizational details. Her predecessor, Kathleen Chapman, initiated extensive fundamental research on this project, while curatorial administrator Karen Palmer handled a wide variety of administrative tasks, specialist librarian Erika Esau obtained often rare research materials, Christine Vigiletti was helpful in organizing the loans, and volunteer Helgard Field-Lion handled correspondence with aplomb.

Vital cooperation from our collaborating institutions came from Tobia Bezzola, former curator at the Kunsthaus Zürich, and his successor Cathérine Hug, as well as Anne Grace, curator of modern art at the Montreal Museum of Fine Arts. Sandra Haldi, Franziska Lentzsch, and Gerda Kram in Zürich and Pascal Normandin, Sandra Gagné, Magdalena Berthet, Francine Lavoie, and Sébastien Hart in Montreal also provided invaluable work in producing the exhibition as well as the German and French editions of this catalogue. Crucial administrative support at LACMA came from Zoe Kahr, Deputy Director for Exhibitions and Planning, and Nancy Thomas, Senior Deputy Director for Art Administration and Collections.

This exhibition could not have been possible without the generosity, expertise, and support of dozens of institutions and collections all over the world, and we extend our profound thanks to the following:

Canada: Alison Beckett, Lloyd DeWitt, Matthew Teitelbaum (Art Gallery of Ontario); the Freda and Irwin Browns Collection; Louise Désy, Renata Guttman (Canadian Centre for Architecture); Jonathan Deitcher, Erika Friesen (Collection Deitcher); Ash Prakash (Collection Prakash); Pierre-Laurent Boullais (Galerie Pangée); Nissa Khan, Robert Landau (Landau Fine Art); Julie Bronson, Carol Podedworny (McMaster Museum of Art); Gregory Burke, Donald Roach (Mendel Art Gallery); Marc Mayer, Alana Topham (National Gallery of Canada); H. Arnold Steinberg Collection; Anke Kausch (VKS Art).

Denmark: Dorthe Aagesen, Kasper Monrad (Statens Museum for Kunst).

France: Pierre Berend Collection; Brigitte Léal, Olga Makhroff, Alfred Pacquement, Jonas Storsve (Centre Pompidou, Paris, Musée national d'art moderne); Antoinette Le Normand-Romain (Institut national d'histoire de l'art); Virginie Delcourt, Annette Haudiquet (Musée André Malraux, Le Havre); Fabrice Hergott, Sophie Krebs (Musée d'Art moderne de la Ville de Paris); Guy Tosatto, Isabelle Varloteaux (Musée de Grenoble); Ghislaine Le Normand, Marie-Madeleine Massé, Marie-Paule Vial, (Musée de l'Orangerie); Caroline Berne, Axel Hémery (Musée des Augustins); Stéphane Bayard, Guy Cogeval, Caroline Mathieu (Musée d'Orsay); Hubert Cavaniol, Isabelle Collet, Christophe Leribault (Petit Palais).

Germany: Silvia Diekmann (Akademie der Künste, Berlin); Magdalena M. Moeller, Cathy Stoike (Brücke-Museum); Cathrin Klingsöhr-Leroy (Franz Marc Museum); Birgit Schulte (Karl Ernst Osthaus-Museum Hagen); Hubertus Gaßner, Ulrich Luckhart, Karin Schick, Meike Wenck (Hamburger Kunsthalle); Ute Kahl Collection; Volker Adolphs, Stephan Berg (Kunstmuseum Bonn); Thomas Bauer-Friedrich, Jana Bille, Ingrid Mössinger, Beate Ritter (Kunstsammlungen Chemnitz); Marion Ackermann, Anette Kruszynski, Katharina Nettekoven (Kunstsammlung Nordrhein-Westfalen); Ulrike Groos (Kunstmuseum Stuttgart); Tanja Pirsig-Marshall (Landesmuseum für Kunst und Kulturgeschichte, Münster); Tobia Bezzola,

Susanne Brüning, Mario-Andreas von Lüttichau (Museum Folkwang); Stephan Diederich, Philipp Kaiser, Kaspar König, Manuela Müller (Museum Ludwig); Manfred Reuther, Christian Ring (Stiftung Ada and Emil Nolde); Ulrich Krempel, Carina Plath (Sprengel Museum); Sigrid Müller (Staatsbibliothek zu Berlin); Christiane Lange, Sean Rainbird (Staatsgalerie Stuttgart); Birgit Dalbajewa, Hartwig Fischer, Petra Kuhlmann-Hodick, Bernhard Maaz, Barbara Rühl (Staatliche Kunstsammlungen Dresden); Anita Beloubek-Hammer, Joachim Jäger, Luise Seppeler, Dieter Scholz (Staatliche Museen zu Berlin, Nationalgalerie); Antje Birthälmer, Gerhard Finckh, Brigitte Müller (Von der Heydt-Museum); Andreas Blühm (Wallraf-Richartz Museum); Christian Fuhrmeister (Zentralinstitut für Kunstgeschichte, Munich).

Great Britain: Chris Dercon, Becky Rhodes, Nicholas Serota, Nicole Simões da Silva (Tate).

Netherlands: Lisette Pelsers, André Straatman (Kröller-Müller Museum); Jette Hoog Antink, Ann Goldstein, Ankie van den Berg (Stedelijk Museum); Leo Jansen (Van Gogh Museum).

Norway: Ben Frija (Galleri K).

Spain: Purificación Ripio (Carmen Thyssen-Bornemisza Collection); Paloma Alarcó, Beatriz Blanco, Guillermo Solana (Museo Thyssen-Bornemisza).

Switzerland: Ruth Binde; Pieter Coray; Alexandra Barcal, Konstanze Forst-Battaglia, Paul Tanner (ETH Zürich); Ursina Fasani, Mara Folini (Fondazione Marianne Werefkin, Museo Comunale d'Arte Moderna, Ascona); Eberhard Kornfeld, Christine Stauffer (Galerie Kornfeld, Bern); Thorsten Sadowsky, Astrid Heinrich (Kirchner Museum, Davos); Philippe Büttner (Kunsthaus Zürich); Charlotte Gutzwiller, Bernhard Mendes Bürgi (Kunstmuseum Basel); André Mayer (Dan Mayer Collection); Claire Häfliger, Werner Merzbacher (Merzbacher Kunststiftung); Jean-Yves Marin, Martine Struelens (Musée d'Art et d'Histoire, Geneva); Hortense Anda-Bührle, Lukas Gloor, Ruth Nagel (Stiftung Sammlung E. G. Bührle, Zürich); Peter Fischer, Edith Heinimann (Zentrum Paul Klee).

United States: Sylvain Bellenger, Stephanie D'Alessandro, Douglas Druick, Gloria Groom, Nancy Ireson, Adrienne L. Jeske, Anna Simonovic (Art Institute of Chicago); Mandy Bartram, Doreen Bolger, Jay Fisher, Rena M. Hoisington (Baltimore Museum of Art); Alina Brezhneva, Cyanne Chutkow, Vanessa Fusco, Sharon H. Kim, Rachel Rees, Samantha Shaffer (Christie's); Fred Bidwell, David Franklin, C. Griffith Mann, Gretchen Shie Miller, William Robinson (Cleveland Museum of Art); Maxwell L. Anderson, Tricia Dixon, Heather MacDonald, Olivier Meslay (Dallas Museum of Art); John B. Henry, Ashley Phifer (Flint Institute of Arts); Scott Allan, James Cuno, Thomas W. Gaehtgens, Lee Hendrix, Edouard Kopp, Timothy Potts, Scott Schaefer, Stephanie Schrader (the Getty Research Institute and the J. Paul Getty Museum); Granvil and Marcia Specks (Granvil Specks Collection); Cynthia Burlingham, Portland McCormick, Ann Philbin (Hammer Museum); Ellen W. Lee, Sherry Peglow, Charles L. Venable (Indianapolis Museum of Art); Kim Broker, Sabine Eckmann (Kemper Art Museum); Patty Decoster, Eric M. Lee (Kimbell Art Museum); Lisa Cain, Thomas P. Campbell, Caitlin Corrigan, George R. Goldner, Susan Stein (Metropolitan Museum of Art); Daniel T. Keegan, Jane O'Meara, Brady Roberts (Milwaukee Art Museum); Kaywin Feldman, Patrick Noon, Tanya Morrison (Minneapolis Institute of the Arts); Carla Caputo, Leah Dickerman, Glenn D. Lowry, Cora Rosevear, Ann Temkin (Museum of Modern Art); Scott Gutterman, Elizabeth Kujawski, Ronald S. Lauder, Renée Price, Sefa Saglam, Janis Staggs (Neue Galerie); Harry Cooper, Lisa M. MacDougall, Mary Morton, Earl A. Powell III, Andrew Robinson (National Gallery of Art); Joseph Rishel, Timothy Rub (Philadelphia Museum of Art); Susan Behrends Frank, Joseph Holbach, Dorothy Kosinski (Phillips Collection); Ann Eichelberg, Brian J. Ferriso (Portland Art Museum); Brent R. Benjamin, Simon Kelly, Diane Mallow (Saint Louis Art Museum); John Digesare, Ariel Plotek, Roxana Velásquez (San Diego Museum of Art); Neal Benezra, Kelly Parady (San Francisco Museum of Modern Art); Richard Armstrong, Susan Davidson, Vivien Greene, Jodi Myers, Nancy Spector, David Stockman (Solomon R. Guggenheim Museum); Kathleen A. Edwards, Sean O'Harrow (University of Iowa Museum of Art); Alex Nyerges, John Ravenal, Mary Sullivan (Virginia Museum of Fine Arts). We are also grateful to Gary Wolff and Sherry and Joy Glass, Robert Looker Jr. and Mary M. Looker, Arline and David Edelbaum, and Alfred and Ingrid Lenz Harrison.

Many colleagues helped tremendously in researching and mounting this exhibition, including Javier Arnaldo, Peter Chametzky, Jay Clarke, Marion Deshmukh, Rahel Feilchenfeldt, Walter Feilchenfeldt, Éva Forgács, Francoise Forster-Hahn, Reinhold Heller, Karl Johns, Barbara Kaerwer, Catherine Krahmer, Jörg Maass, John Marciari, Bruce Robertson, Aya Soika, Christoph Vitali, Rose-Carol Washton Long, and Christian Weikop.

At LACMA a number of curatorial departments provided vital help, and we thank Stephanie Barron, Carol S. Eliel, Leslie Jones, Patrice Marandel, Britt Salvesen, and Naoko Takahatake. Further thanks to Erika Franek, Meredith Rogers, Emily Saccenti, Renee Montgomery, Maia November, Delfin Magpantay, and Amy Wright for their diligence and skill in managing the innumerable details of loans, risk management, and indemnification. We also received support from the staff of the Mr. and Mrs. Allan C.

Balch Research Art Library, including Alexis Curry, Tracy Kerr, and Julia Kim. Kris Lewis, Chi-Young Kim, and Ondy Sweetman helped us obtain U.S. indemnity from the Federal Council on the Arts and the Humanities, and Matthew Thompson, Kate Virdone, and Rachel Zelaya were crucial to our fundraising efforts.

The authors who participated in this volume contributed not only exceptional texts but indispensable advice and insight, and I am very grateful to Laird M. Easton, Claudine Grammont, Frauke Josenhans, Peter Kropmanns, Katherine Kuenzli, Magdalena M. Moeller, and Sherwin Simmons. The catalogue itself was realized with the guidance and creativity of our crack publishing team, headed by Lisa Gabrielle Mark, and with the input of the museum's creative director, Lorraine Wild. Sara Cody, whose intelligence and sensitivity brought this book clarity and consistency, edited the catalogue with the deft assistance of Phil Graziadei. Stuart Smith, with the assistance of David Karwan and Stefano Giustiniani, created an outstanding book that is both elegant and dynamic. Piper Wynn Severance ably juggled the many details of researching and acquiring photography. Ben Letzler, Steven Lindberg, and Rose Vekony brought sensitivity to their translations of German and French texts for our volume. We are also indebted to Mary DelMonico, of DelMonico Books • Prestel, for her understanding and her consistent support of this volume as an international publication.

The exceptional exhibition design was magnificently created in Los Angeles by Frederick Fisher & Partners Architects, and we appreciate the work and vision of Fred Fisher, David Ross, and their team, including Nathan Prevendar and Scott Flax. Their design was masterfully implemented by Victoria Behner and accompanied by Maja Blazejewska's effective graphics. William Stahl oversaw the building of our displays, while Jeffrey Haskin and his team installed the artworks with the greatest care. Mark Gilberg and his team of conservators, notably Joe Fronek, Soko Furuhata, Elma O'Donoghue, Virginia Rasmussen, and Janice Schopfer, assured that the objects were protected at every stage. Mary Lenihan energetically oversaw our public programming and educational efforts.

Profound thanks are due to Robert Gore Rifkind and Max Rifkind, of the Rifkind Foundation, for their ongoing support of acquisitions and exhibitions. Above all, the enduring endeavor to understand the mysteries of artistic influence and exchange represented by *Expressionism in Germany and France* could not have been accomplished without the generosity of our lenders, listed on page 296, to whom all involved in this project express our deepest gratitude.

Timothy O. Benson
Curator, Robert Gore Rifkind Center for German Expressionist Studies
Los Angeles County Museum of Art

Plates

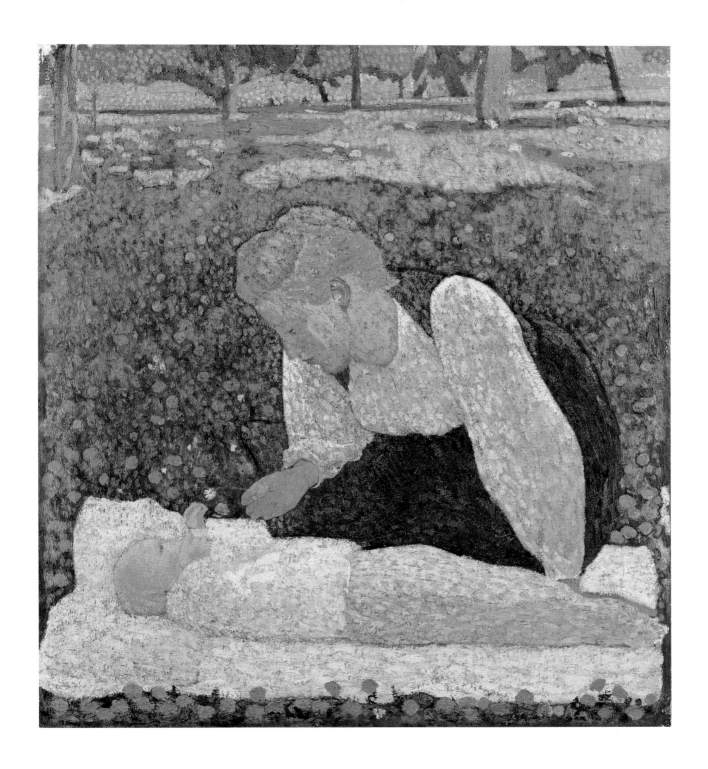

Cuno Amiet
Mother and Child in the Garden, c. 1903
plate 1 | cat. 1

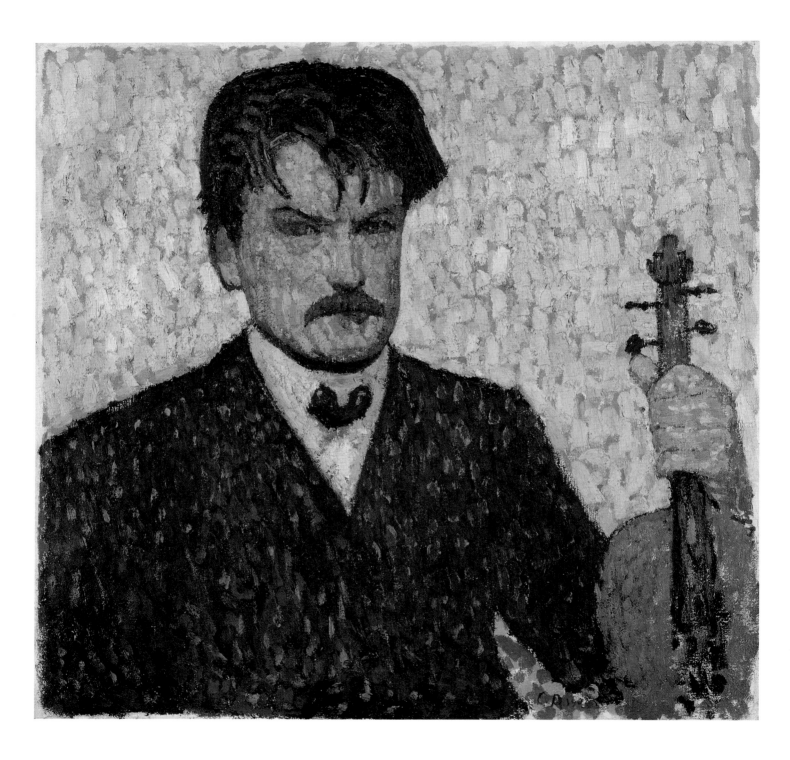

Cuno Amiet
Portrait of the Violinist Emil Wittwer-Gelpke, 1905
plate 2 | cat. 2

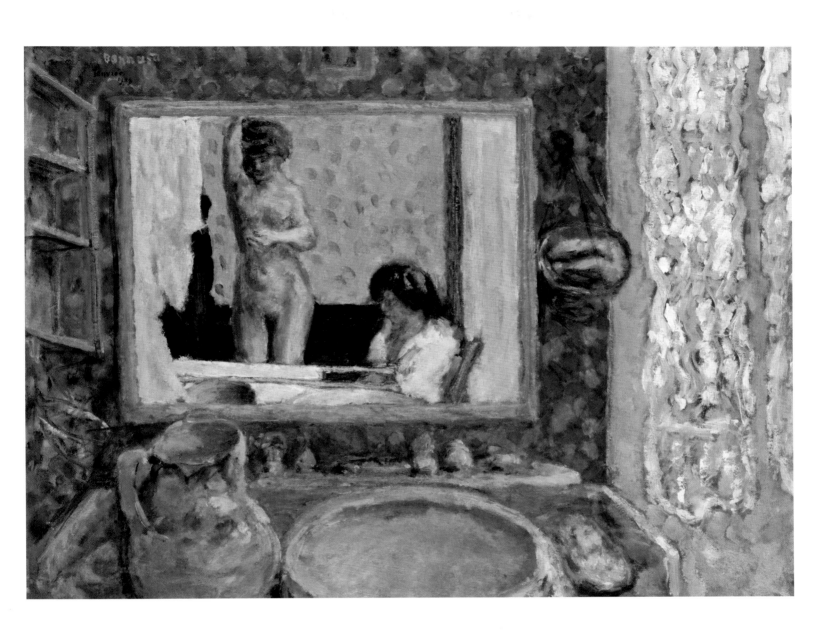

Pierre Bonnard
The Mirror in the Green Room, 1908
plate 3 | cat. 4

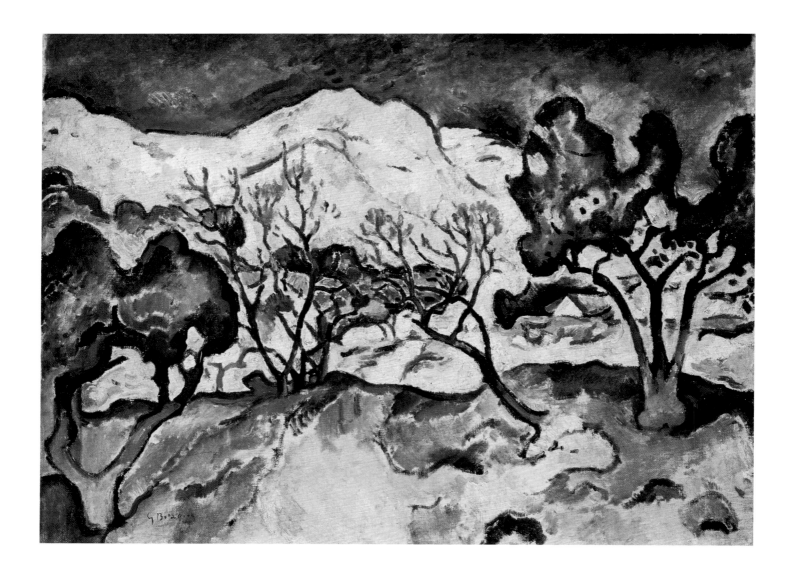

Georges Braque
Landscape at L'Estaque, 1906
plate 4 | cat. 5

Georges Braque
Landscape at La Ciotat, 1907
plate 5 | cat. 6

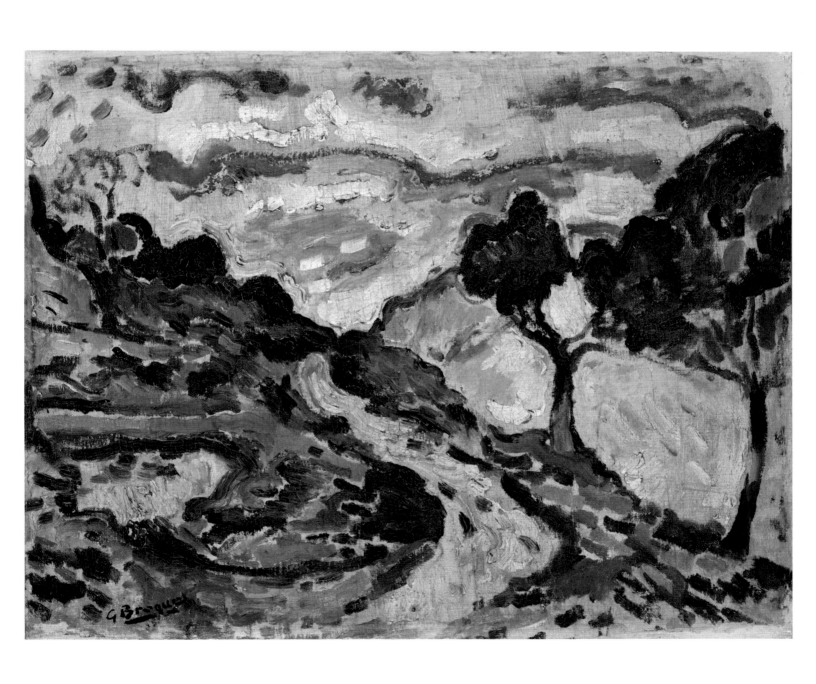

Georges Braque
Woman with Mandolin, 1910
plate 6 | cat. 8

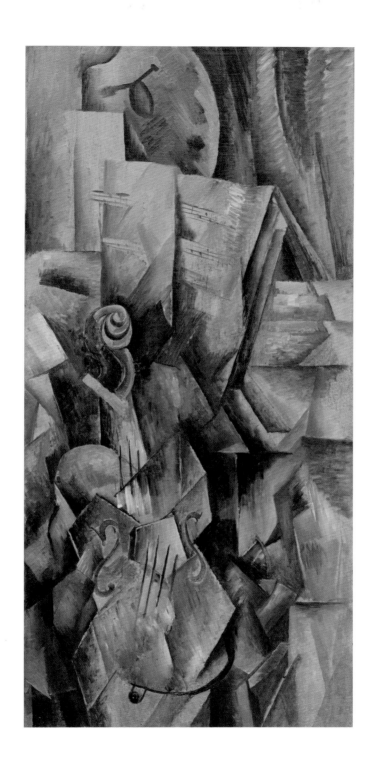

Georges Braque
Violin and Palette, 1909
plate 7 | cat. 7

Paul Cézanne
Still Life with Apples, 1893–94
plate 8 | cat. 14

19

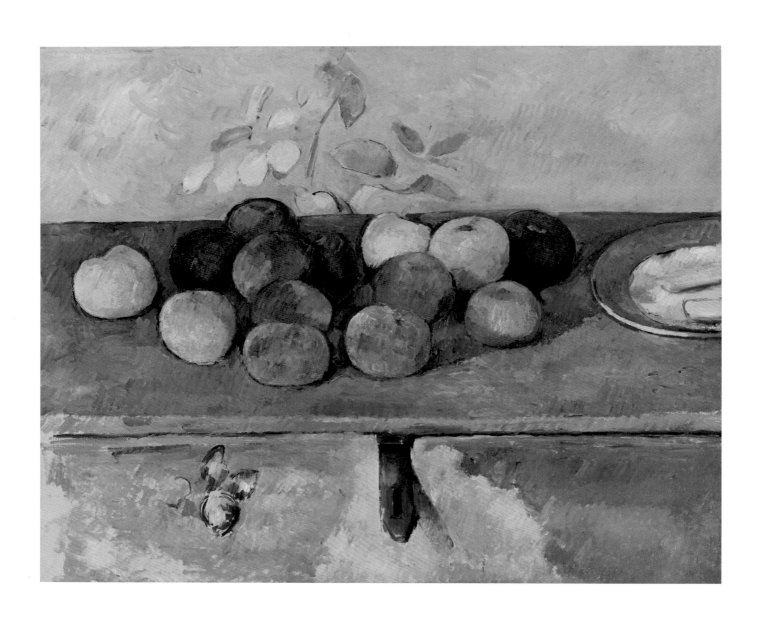

Paul Cézanne
Apples and Biscuits, 1879–80
plate 9 | cat. 10

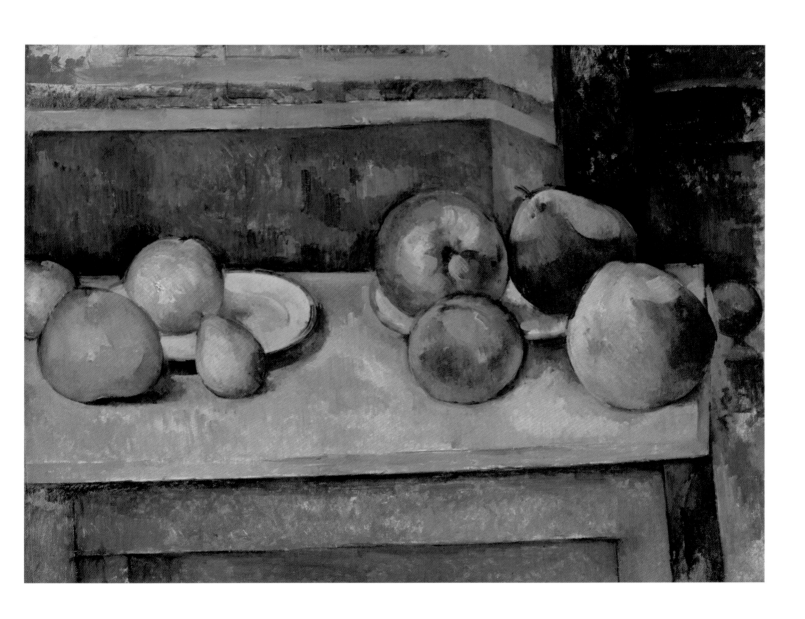

Paul Cézanne
Still Life with Apples and Pears, c. 1891–92
plate 10 | cat. 13

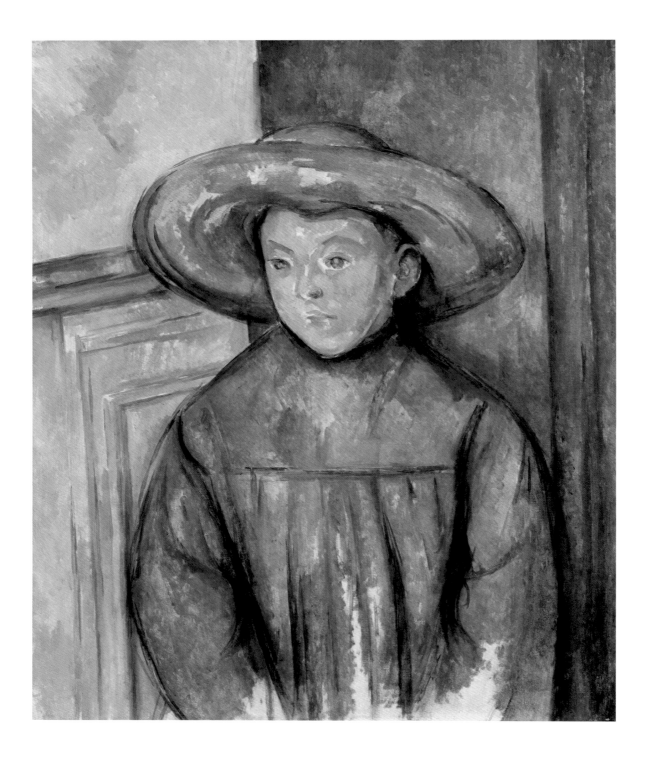

Paul Cézanne
Boy with a Straw Hat, 1896
plate 11 | cat. 15

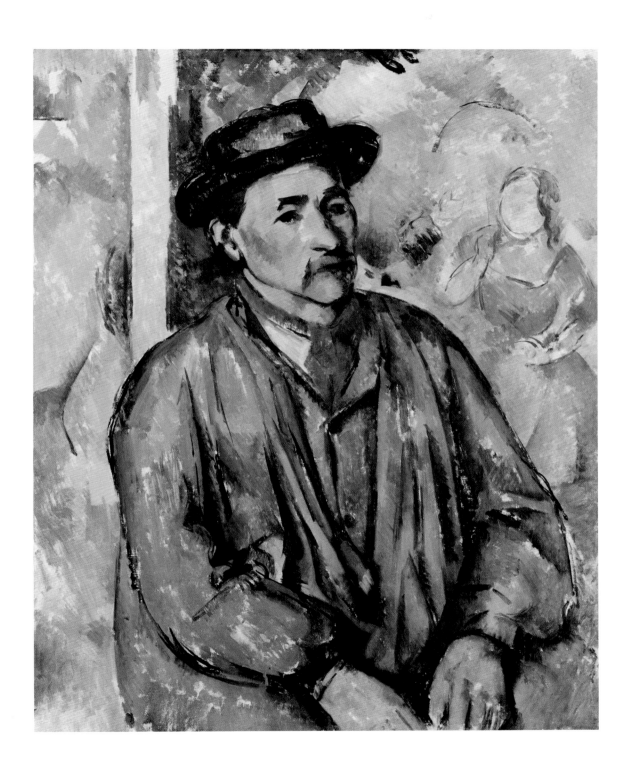

Paul Cézanne
Peasant in a Blue Smock, c. 1896–97
plate 12 | cat. 16

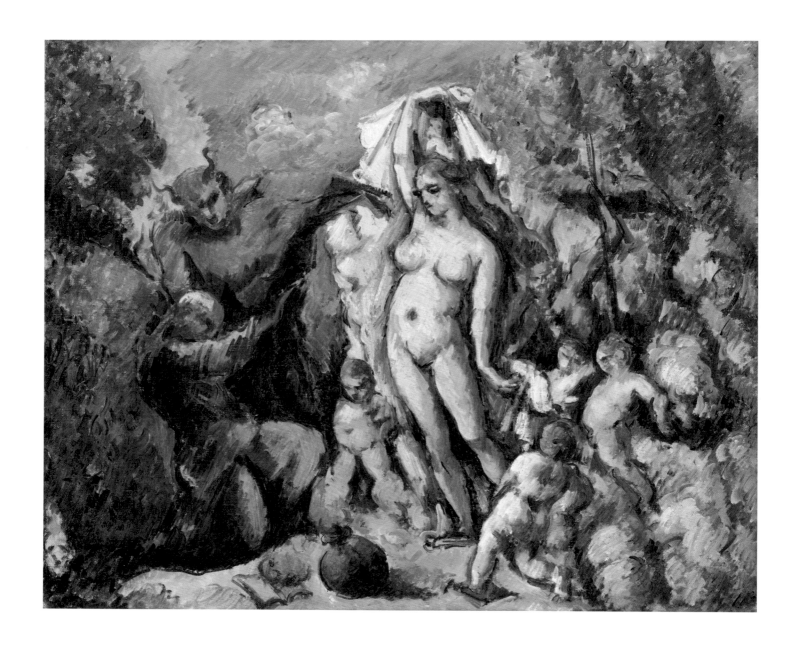

Paul Cézanne
The Temptation of St. Anthony, 1877
plate 13 | cat. 9

Paul Cézanne
Three Bathers, 1879–82
plate 14 | cat. 11

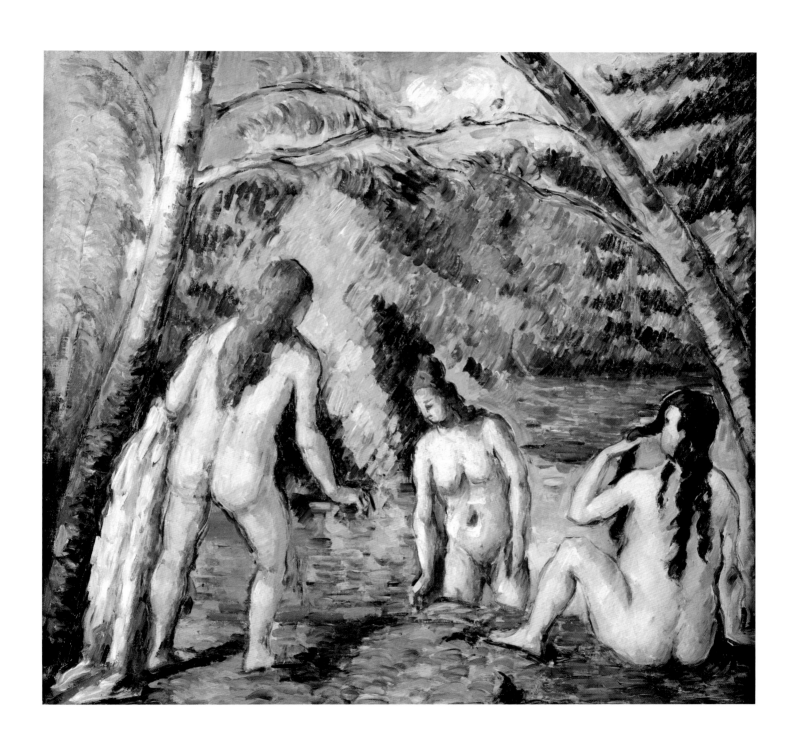

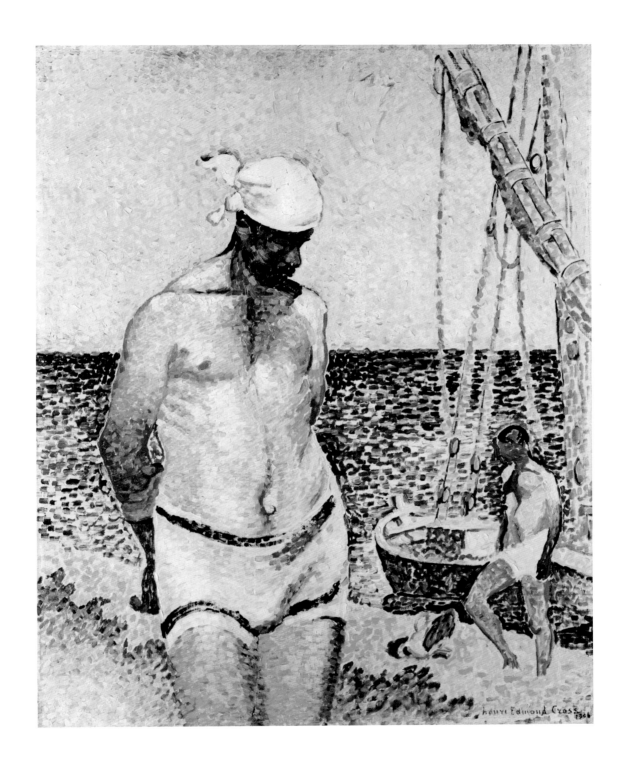

Henri-Edmond Cross
Bather, 1906
plate 15 | cat. 18

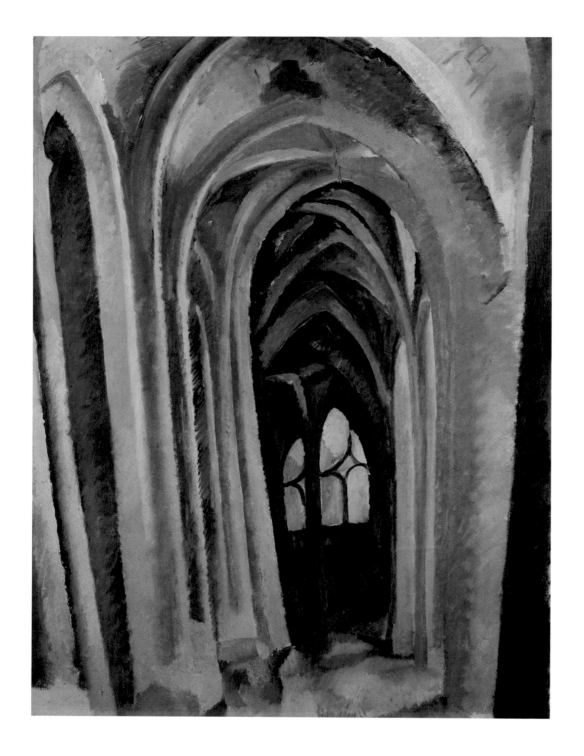

Robert Delaunay
Saint-Séverin No. 2, 1909
plate 16 | cat. 19

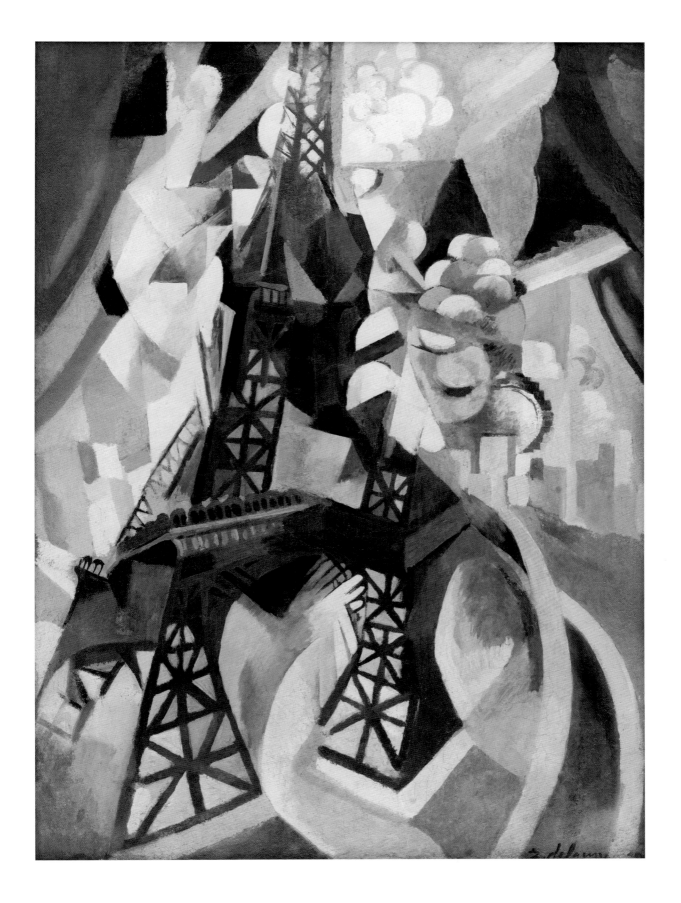

Robert Delaunay
Red Eiffel Tower, 1911–12
plate 17 | cat. 20

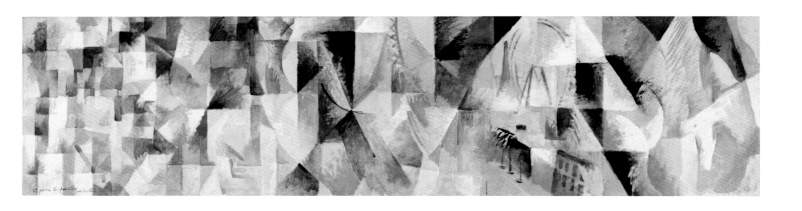

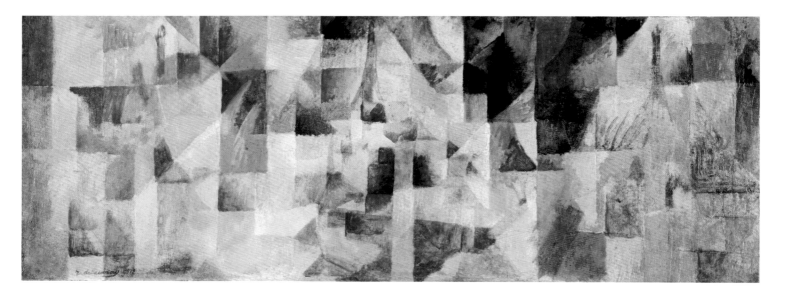

top:
Robert Delaunay
Windows on the City (First Part, First Simultaneous Contrasts), 1912
plate 18 | cat. 22

bottom:
Robert Delaunay
Three-Part Windows, 1912
plate 19 | cat. 21

André Derain
Boats in Chatou, 1904–5
plate 20 | cat. 23

André Derain
Landscape at Cassis, 1908
plate 21 | cat. 26

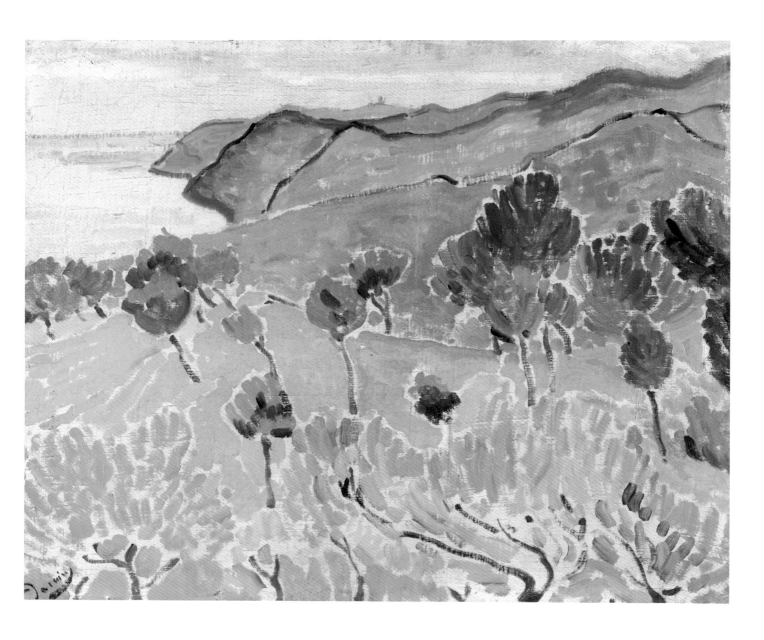

André Derain
Landscape by the Sea: The Côte d'Azur near Agay, 1905
plate 22 | cat. 25

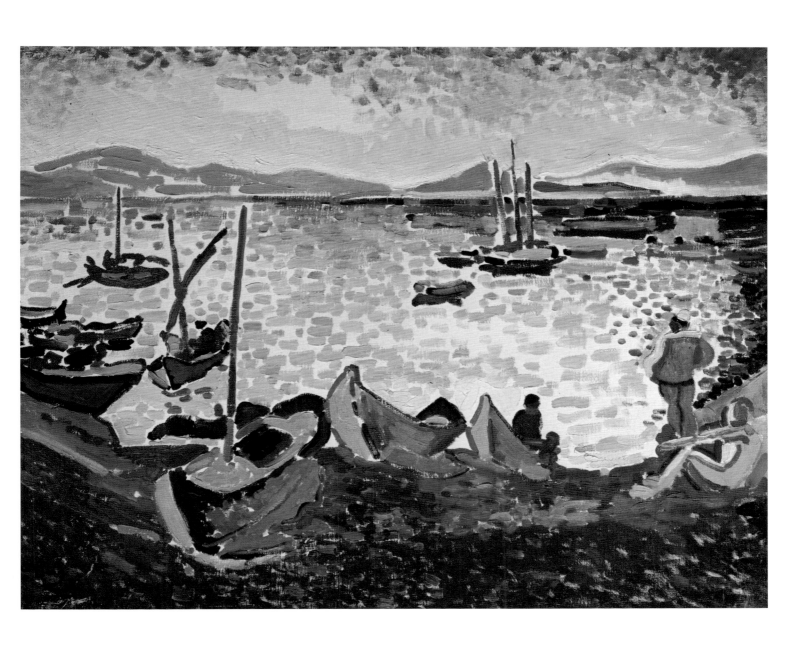

André Derain
Boats in the Port of Collioure, 1905
plate 23 | cat. 24

Kees van Dongen
The Purple Garter, c. 1910
plate 24 | cat. 31

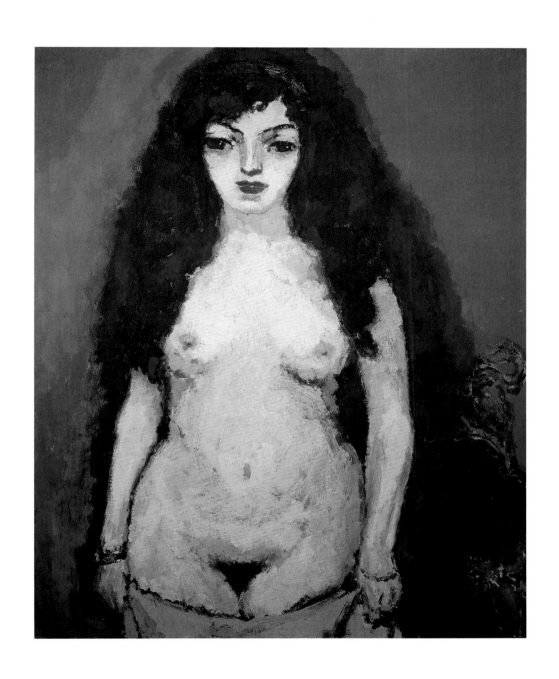

Kees van Dongen
Nude Girl, c. 1907
plate 25 | cat. 28

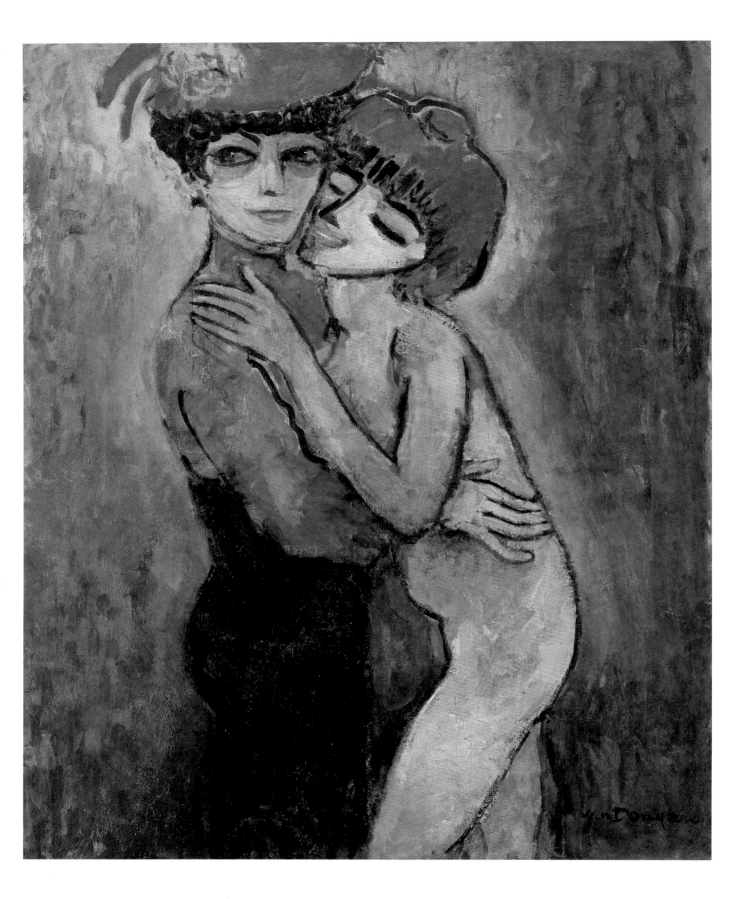

Kees van Dongen
Girlfriends, c. 1908
plate 26 | cat. 30

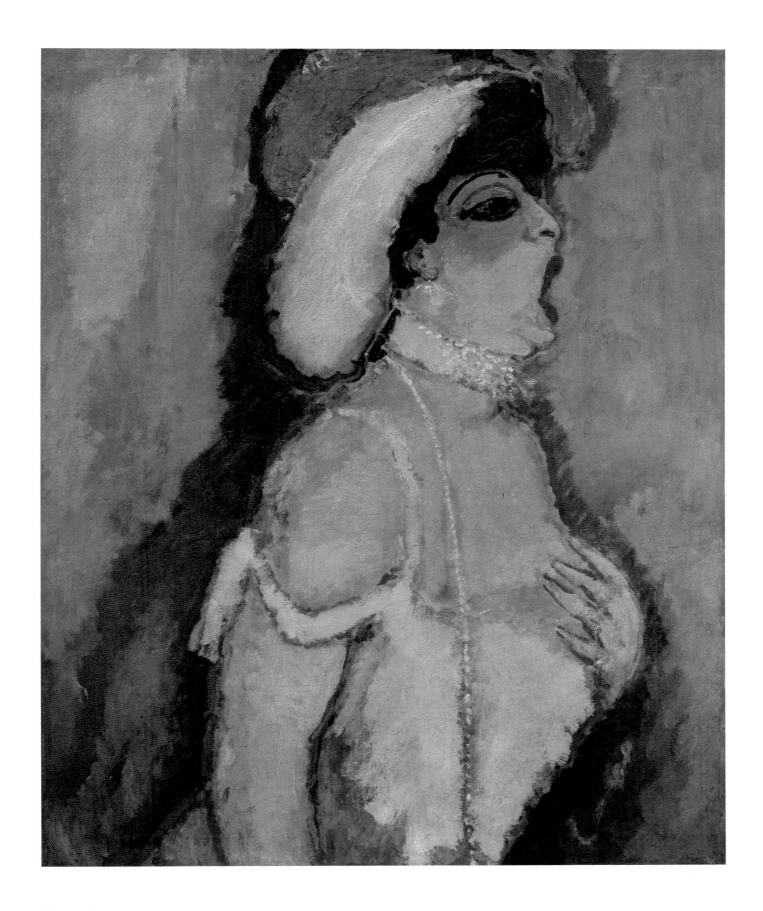

Kees van Dongen
Modjesko, Soprano Singer, 1908
plate 27 | cat. 29

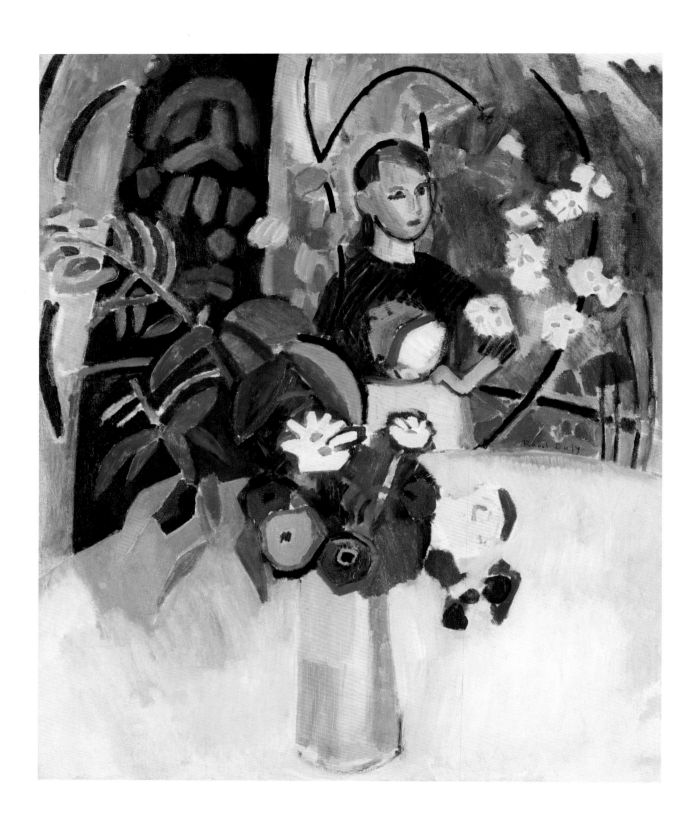

Raoul Dufy
Jeanne in the Flowers, 1907
plate 28 | cat. 33

Raoul Dufy
The Little Palm Tree, 1905
plate 29 | cat. 32

40

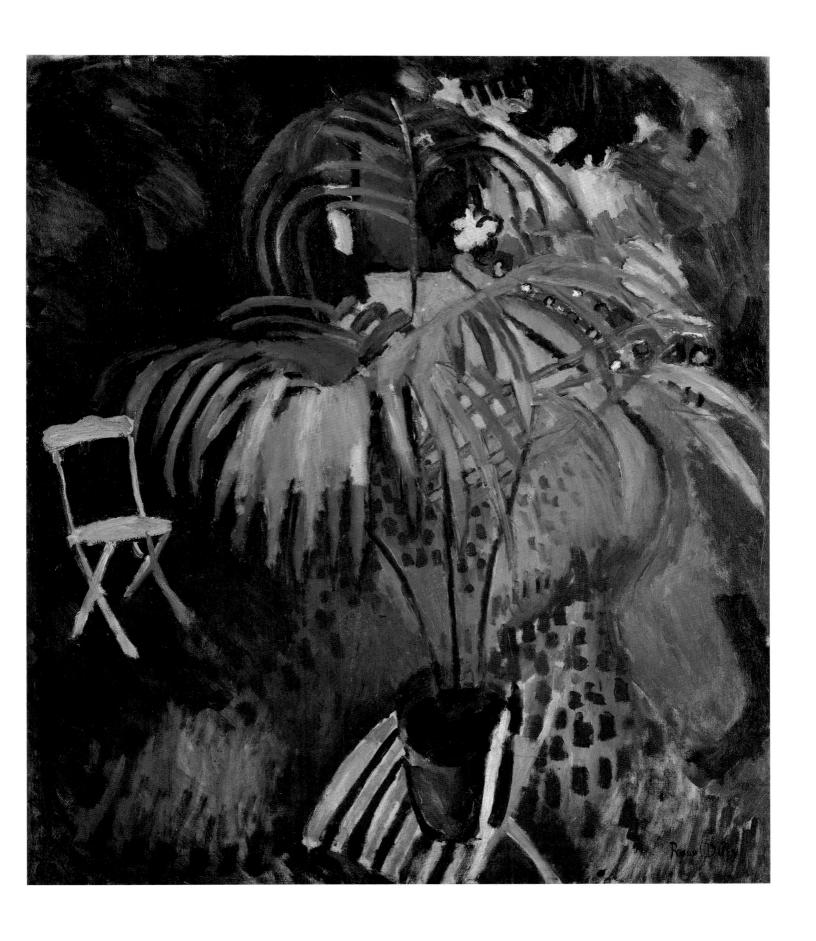

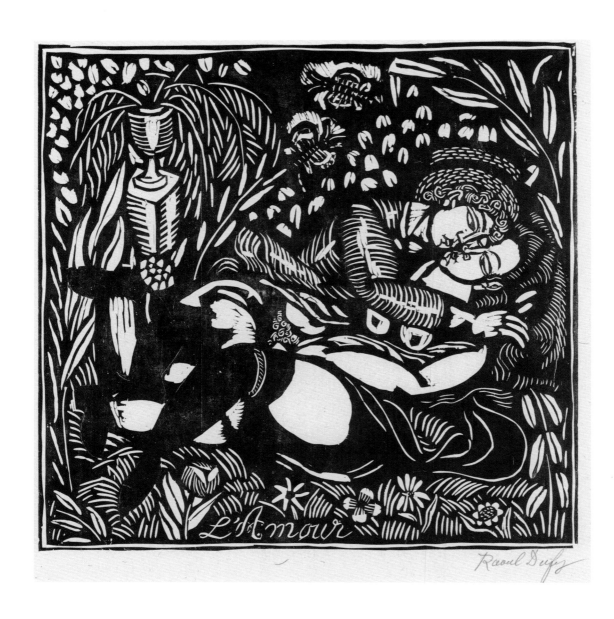

Raoul Dufy
Love, c. 1910
plate 30 | cat. 41

Raoul Dufy
Dance, c. 1910
plate 31 | cat. 36

Raoul Dufy
Green Trees at L'Estaque, 1908
plate 32 | cat. 35

Raoul Dufy
The Aperitif, 1908
plate 33 | cat. 34

TIMOTHY O. BENSON

Expressionism in Germany and France

IN ONE OF the first uses of the term, the introduction to the 1911 catalogue of the twenty-second Berlin Secession exhibition noted "a number of works of young French painters, of the Expressionists, hosted here… because the Secession always considers it their obligation to present what is interesting created outside of Germany."[1] It may seem strange to us a century later that the term *Expressionism*, now ubiquitous but scarcely used at all before 1911, should be associated with French rather than German art. Yet when the term was introduced by Roger Fry in 1910 in reference to the exhibition *Manet and the Post-Impressionists* at the Grafton Galleries in London, there was little consistency as to its national identity. Arthur Clutton-Brock, writing the next year in *The Burlington Magazine*, could suggest renaming the French "Post-Impressionists"— headed by Cézanne, Gauguin, and Van Gogh—as "the Expressionists,"[2] while in 1912 the title of the first show at Herwarth Walden's Galerie Sturm in Berlin was *Der Blaue Reiter, Franz Flaum, Oskar Kokoschka, Expressionisten*. Walden held additional exhibitions later that year on the "German Expressionists" and the "French Expressionists" alike.[3]

From its beginnings, when the Brücke group was founded in Dresden in 1905, the artistic movement known today as German Expressionism rapidly absorbed the latest tendencies from France. For the Brücke artists—Fritz Bleyl, Erich Heckel, Ernst Ludwig Kirchner, and Karl Schmidt-Rottluff, who were soon joined by Cuno Amiet, Akseli Gallen-Kallela, Emil Nolde, Max Pechstein, and others—Neo-Impressionism was already an international stylistic idiom. Kirchner, for example, had seen Neo-Impressionists and other modern artists at Galerie Arnold in Dresden in 1904 in a show that included Georges Seurat's *The Seine at Courbevoie* (1884), along with works by Paul Baum, Henri-Edmond Cross, Maurice Denis, Curt Herrmann, Maximilien Luce, Camille Pissarro, Pierre-Auguste Renoir, Théo van Rysselberghe, Alfred Sisley, and Paul Signac.[4] Neo-Impressionism—based on the application of separate colors to the painting's surface, often following chromatic theory and with the objective of allowing the viewer's eye to mix the colors—spread across Europe as the main alternative to French Impressionism,[5] the bastion of which in Germany was the Berlin Secession, founded in 1898. As Bleyl recounted, it was precisely Impressionism—with its emphasis on "the accidental, merely frugally natural impression"—that the Brücke artists were seeking to overcome.[6] Even while many of their earliest graphic works were still imbued with

Jugendstil (the widespread German equivalent to Art Nouveau), the Brücke not only absorbed Neo-Impressionism in their paintings but took it a step further as a strategy informing their first break into color; Kirchner, for example, later claimed of Neo-Impressionism that he had "quickly made its laws of color theory my own."[7]

Yet as well versed in the techniques of Neo-Impressionism as they were, the Brücke artists were so astonished by Vincent van Gogh's "Post-Impressionist" works (as they would later be known) that their teacher Fritz Schumacher recalled that they were "totally beside themselves."[8] The occasion for this response was the Van Gogh exhibition at Galerie Arnold in Dresden, which opened just months after the group was founded and included works from his late period of towering

achievement in Saint-Rémy and Auvers such as *Thatched Sandstone Cottages at Chaponval* (plate 51), *Field with Poppies* (p. 78) and *Self-Portrait with Pipe and Straw Hat* from his earlier Paris period. Van Gogh's spontaneous and vivacious brushwork and departure from local color (where leaves are green and skies are blue) in favor of a deep emotional engagement in color (where skies can become green, as in *Wheatfield with Reaper*, plate 49) offered an entirely new avenue away from what they regarded as a fatal empiricism coursing through both Impressionism and Neo-Impressionism. Ernst Blass, an Expressionist writer and habitué of Berlin's Café des

Max Pechstein
Young Girl, 1908
plate 132 | cat. 170

Vincent van Gogh
Self-Portrait with Pipe and Straw Hat, 1887
Oil on canvas on cardboard
16 ⁹⁄₁₆ × 11 ¹³⁄₁₆ in. (42 × 30 cm)
Van Gogh Museum, Amsterdam,
The Netherlands

Westens, recalled that for his generation, "Van Gogh stood for expression and experience as opposed to Impressionism and Naturalism. Flaming concentration, youthful sincerity, immediacy, depth; exhibition and hallucination.... The courage of one's own means of expression."[9]

Culture and Geography

That the work of Van Gogh—who had died in relative obscurity fifteen years earlier—was finally becoming widely available was due to a network of international cultural exchange between Germany and France in the form of exhibitions, private collections, trade on the art market, and travel by artists, dealers, and museum directors. These activities were complemented by a lively critical discussion in illustrated art periodicals and books as well as among artists through correspondence and conversation at such meeting points as the Café des Westens in Berlin and the Café du Dôme in Paris. *Expressionism in Germany and France: From Van Gogh to Kandinsky* thus proposes an inquiry not only about artistic influence but also about culture and geography. Where did Expressionism come from and how did it relate to national boundaries?

The cosmopolitan ambience of the avant-garde was scarcely immune from the undercurrents of nationalism that had accompanied the emergence of modernism in Germany from its very beginnings. A widespread perception prevailed in Germany that French art had come to dominate the contemporary German scene and art market. Many artists, critics, and officials within arts institutions feared what regional artist Carl Vinnen called "the great invasion of French art," which he denounced in his infamous tract of 1911, *Ein Protest deutscher Künstler* (A Protest of German Artists). For Vinnen, German artists had simply become too Frenchified (*Französlinge*);[10] the younger generation, in Vinnen's eyes, might even be lost to Germany because "a people [*ein Volk*] is only driven to great heights by artists of its own flesh and blood."[11] Vinnen's polemic captured the deep resentment of much current opinion. One of Vinnen's cosigners, art critic Hans Rosenhagen, cited as evidence of a destructive influence on German youth and the general gullibility of the German art world a recent exhibition of the Neue Künstlervereinigung München (New Artists Association of Munich, or NKVM) at Paul Cassirer's Berlin gallery, which included works by Picasso, Braque, and Kees van Dongen.[12] "While the French take every opportunity to laugh...

in Germany everything is immediately taken terribly seriously," Rosenhagen wrote.[13]

Vinnen's volume generated significant controversy. In response, a compilation of rejoinders by some seventy-five artists, galleries, collectors, and writers was published as *Im Kampf um die Kunst: Die Antwort auf den "Protest deutscher Künstler"* (The Struggle for Art: The Answer to the "Protest of German Artists").[14] The "answerers" to Vinnen—ranging from Gustav Pauli, the director of the Bremen Kunsthalle whose purchase of Van Gogh's *Field with Poppies* had set off the protest in the first place, to future Blaue Reiter artist Franz Marc, representative of the younger vanguard that had already rejected the Impressionism so revered by Pauli's

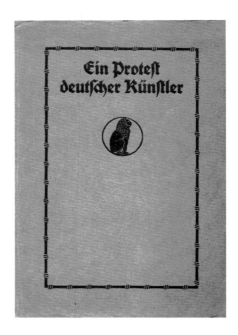

generation—generally advocated embracing French modernism as a means for German artists to evolve their own direction. This direction was clearly seen in the 1911 Neue Secession exhibition that had broached the term *Expressionists*. In his review of this exhibition, critic Paul Fechter saw the "authority of today's endeavors within both French and German artistic yearning" as progressing to "the emphasis on the picture and its laws of artistic synthesis independent from nature as the only goal of painterly activity."[15]

This episode and others like it illustrate how the history of Expressionism—and the works of

Carl Vinnen, *Ein Protest deutscher Künstler*, 1911
Los Angeles County Museum of Art,
Robert Gore Rifkind Center for German
Expressionist Studies

French and German artists presented in *Expressionism in Germany and France*—must be seen as part of a wider discourse, including exhibition reviews, proclamations, public disputes, and exhibitions staged as narratives. This terrain is too vast to be considered in its entirety, but it can be considered *episodically* through actual artistic practice—that is, as contingent upon particular situations or "sites" of artistic exchange that were not infrequently contested by participating artists, critics, collectors, and other interested parties. Such episodes might be understood as case studies within a complex web of "cultural transfer," in the terminology developed by Michael Espagne and Michael Werner, to account for intercultural exchange between France and Germany that involved reception, behavior, utilization, and processes of reification such as collective memory—in short, an understanding of national cultures as intertwined with one another, rather than substantively opposed to one another, as they evolved their respective national identities.[16] The achievement of the pictorial synthesis beyond national boundaries that Fechter dreamed of remained elusive partly due to differing collective memories, myths, belief systems, and symbols. Yet modernism and a growing bourgeois class challenged national identities and the hegemony of official cultural policies in the last years of Wilhelmine Germany. From this interaction of flourishing cosmopolitanism and lingering cultural differences evolved the German interpretation of French art and, in turn, the uniqueness of German Expressionism—what Pechstein, in his recollections of his time in Paris in 1908, called "the fight against Impressionism . . . [but] in another formal language appropriate to the French élan,"[17] and which he so forcefully realized in his masterful painting *Young Girl* (plate 132).

From its inception, modernism in Germany had been inextricably tied to French Symbolist literature and Impressionist art, which the Expressionists' predecessors had sought to integrate into German culture, with its venerable literary tradition ranging from Martin Luther and Goethe to the German Romantics. Over several centuries of German political and religious antagonism—whether to toward Catholicism or French and Italian artistic and literary classicism (and especially with the awakening of nationalism during the Napoleonic wars)—a perceived gulf had evolved between German *Kultur* and French *civilization*, between Nordic mythology and Mediterranean sensibilities. Arguably this rupture was rooted in the Germans' ready embrace of and reliance on the interiority (*Innerlichkeit*)

of language and music to attain a sense of cultural unification, which stood in opposition to the cultivation of visual perception, a more empirical quality they equated with antiquity.[18] In the early nineteenth century Madame de Staël could famously declare in *De l'Allemagne* (1813) that "the Germans would rather ponder the meaning of art than practice it."[19] In 1905 the leading German advocate of French Impressionism, art historian Julius Meier-Graefe, sought to counter such tendencies in *Der Fall Böcklin* (The Case of Böcklin), which criticized Arnold Böcklin, the Symbolist painter of mythological fantasies, as part of a wider condemnation of the latest manifestations of German Idealism. Despite his Swiss origins, Böcklin was celebrated as a Germanic genius by the official art establishment and such scholars as Richard Muther, Max Lehrs, and Fritz von Ostini, the latter considering him so fundamentally German that foreigners could not understand him.[20]

But Meier-Graefe's greatest influence with artists came through *Entwickelungsgeschichte der modernen Kunst* (Developmental History of Modern Art).[21] His 1904 book, well known to the Brücke, traced French art from Delacroix to Impressionism and Art Nouveau, and considered Paris the fountainhead of modernism. In opposition to the concept of national "schools," he presented artists as occupying an imaginary stage above nationality (for example, he argued, Spanish art was saved by El Greco, who was not a Spaniard).[22] Rather than indulging in a cult of personality to construct a history of art, he envisioned art as part of a historical process of cultural evolution with an implicit history of vision.[23] But if, at various turns, he opposed nationalism as a basis for understanding art, like Fechter and others of his era he also could not entirely free himself of a belief in a German-French polarity. He saw the French (or, more broadly, the Mediterranean) sensibility as more sensual, more synthetic than the German perspective, with its penchant for the analytic and mental.[24] Indeed, such a polarity seemed to dictate formal characteristics to such an extent that Meier-Graefe eventually had to concede to Courbet and Cézanne distinguishing roots in the Northern Gothic, writing that "this generation had bits of the north as patches in their clothing."[25]

Meier-Graefe's apt analogy shows how his prewar generation in Germany was struggling to come to grips with an ever-more internationally diverse modernism. Yet, as recent scholarship has shown, what the Germans perceived as *Stimmung*—a uniquely German attitude embodying empathy, feeling, and expression on the cusp of the distinction between the "inner" and

"outer"—clearly had parallels in the French concept of *rêverie* and its many variations.[26] This may be seen especially in the work of Seurat, Cézanne, and Gauguin, as perhaps in his *Melancholic*. Such differentiation of meaning and perception is grounded in geography, in place and time, and in social conditions, rather than in metaphysical essences.[27] The episodes of exchange of artistic influence essential to an understanding of the evolution of Expressionism occur in an infrastructure of cultural exchange, involving mediators (such as museum directors, writers, or gallerists), events (including key exhibitions), and, above all, artists and their social groupings, especially the Brücke and the Blaue Reiter.

first presented extensively in 1901 at Galerie Cassirer in Berlin with such paintings as *Wheatfield with Reaper* (plate 49) and *The Poplars at Saint-Rémy* (plate 57); he was also shown in 1901 at the third Berlin Secession exhibition and in 1904 alongside work by Gauguin in the Munich Kunstverein (possibly Van Gogh's *Vase with Rose Mallows* and *Mother Roulin with Her Baby*).[28] While studying at the time in Munich for several months, Kirchner was apparently not yet receptive to this influence, finding Van Gogh's work "too nervously riven" (*zu nervös zerrissen*).[29]

Perhaps Kirchner needed the group dynamics of the Brücke to induce his groundbreaking response, for it was certainly the November 1905 Van Gogh retrospective at Galerie Arnold in Dresden (organized

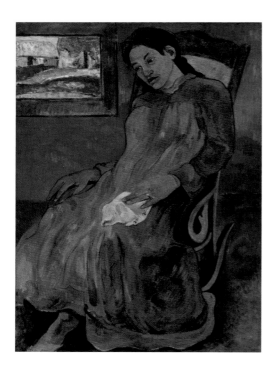

The Functioning of "Influence"

A selection of works of art linked to specific historical settings exemplifying the broader cultural exchange between France and Germany provides a basis for understanding the ways in which the more mysterious process of "influence" functions. However, this often requires an extended view of artistic practice to discern the effect of an initial encounter. Not infrequently artists respond to influences only when they are ready to. Van Gogh was

by Cassirer), with such paintings as *Thatched Sandstone Cottages at Chaponval* (plate 51), that sparked intense interest among the artists of the Brücke. Van Gogh's influence is suddenly evident in the turbulent sky of Heckel's *The Elbe at Dresden* (plate 63), which, as Magdalena Moeller has suggested, is a departure from the flickering, Impressionistic water surface at the bottom of the canvas.[30] Van Gogh is likewise unmistakable in the brushwork in Kirchner's *Park Lake, Dresden* (cat. 104) and in Schmidt-Rottluff's *Gartenstrasse Early in the*

Paul Gauguin
Melancholic, 1891
Oil on canvas
37 × 26⅞ in. (94 × 68.2 cm)
The Nelson-Atkins Museum of Art,
Kansas City, Missouri. Purchase:
William Rockhill Nelson Trust

Karl Schmidt-Rottluff
Gartenstrasse Early in the Morning, c. 1906
plate 140 | cat. 185

Morning (plate 140) where orderly arrays of strokes of complementary colors give way to more expressive passages in the foreground. According to Bleyl, prior to this exhibition, most of the original Brücke members had primarily known Van Gogh only through monotone reproductions in periodicals, Meier-Graefe's publications, and other published sources.[31] But now, after their visceral experience of being immersed in his work in person, they responded profoundly in their pursuit of a new direction they could share communally.

Rather than looking at influence as something that is simply absorbed, we find instead that influence occurs in episodes that fill selective "gaps" or "openings" in artistic practice that are created by an artist's immediate concerns and perceptions. For example, when Nolde saw the works of Van Gogh and the Impressionists in 1900 in Paris it made so little impact that he said, "Paris gave me very little."[32] When he saw Van Gogh's *Self-Portrait with Bandaged Ear and Pipe* (cat. 73) in the 1901 Secession exhibition in Berlin, he was apparently not prepared to make use of it, finding it at the time "a little crazy."[33] But by 1904 Nolde's brushwork had become gestural and his palette had exploded in luminous colors in paintings such as *Springtime in the Room* and continuing into *The White Tree Trunks* (plate 123). Such a change cannot be chalked up simply to the influence of the tonal approach of the German Impressionists of the Berlin Secession.[34] A visit in February 1906 to Karl Ernst Osthaus's remarkable collection in Hagen, rich in Van Goghs, probably encouraged this exploration of luminosity underway in *Springtime in the Room*—a direction likely reinforced by Osthaus's purchase of Nolde's painting during the artist's visit.[35] Yet even though Van Gogh had been a catalyst for their experimentation, the Brücke artists were less interested in his self-proclaimed symbolic use of color to embody such imponderables as destiny than in how he could provide an intermediary stage in the group's efforts to essentially rebuild the practice of painting from the ground up.

Consequently, on some occasions artists may allow themselves to be influenced heuristically—that is to say, to rely on a source as a means rather than an end, as described in Sherwin Simmons's account, in this volume, of the Expressionists' responses to Cubism. Even chance and accident may play a role in the process. Within Heckel's 1907 woodcut portfolio *The Ballad of Reading Gaol*, the severity of purely black-and-white Jugendstil passages, as in *The Prison Guard* (plate 65), yields to an articulation of light, shade, and atmosphere, as in the silhouette of the inmate in his somber cell in *The Prisoner*

(plate 67). Heckel's scratches and scrapes on the woodblock, resulting in accidental, indeterminate passages of light in the print, are part of a "technomorphic" procedure that eventually results in a visual vocabulary capable of the deep emotional states of fear and horror, as in *Fear* (plate 66). Very likely Heckel was using this indeterminate process of experimentation in part to achieve an equivalent to Van Gogh's vivacious brushwork.[36] Yet Heckel unintentionally attained something entirely different in form and content, approaching in an incipient way what we recognize today as Expressionism. The Brücke's subsequent evolution of a communal "Brücke style" also took place in the more isolated context of the group dynamics of the Brücke as an artists' community. As Reinhold Heller has sug-

gested, the Brücke's communal studio (initially a butcher shop rented by Heckel in 1905 in Dresden's Friedrichstadt district) in which so much of this exchange took place may be seen as a utopian site.[37] These sorts of "voluntary communities," such as the land reform communities and nudist colonies that emerged across Europe at the time, sought to build their own worlds, becoming in the process more resistant to outside influences. The Brücke's creativity thrived on an intense exchange both within and beyond

Emil Nolde
Springtime in the Room, 1904
Oil on canvas
28 ⁱ⁵⁄₁₆ × 34 ¹³⁄₁₆ in. (73.5 × 88.5 cm)
Nolde Stiftung, Seebüll

the communal settings in which they worked. Within this context the decorative arts were extremely important as the Brücke artists created their own environment with carved furniture, painted fabrics, and woven tapestries, among many applications of the applied arts.

Contested Ground: The Decorative

Influence can also be inflected by deeply rooted attitudes toward artistic practice, as exemplified in differences between Germany and France over the purpose and meaning of the decorative in art. In January 1909 Pechstein and Kirchner saw a superb selection of major works by Matisse, who was shown with Benno Berneis at Galerie Cassirer in Berlin.[38] Notable among the seventy works listed in the catalogue were thirty paintings, very likely including *Blue Nude* (*Memory of Biskra*) (p. 175) and *Harmony in Red*, as well as ten bronzes, including *Reclining Nude*, and thirty lithographs, woodcuts, and drawings. Kirchner's documented response to the Matisse exhibition is restricted to a cryptic greeting on a postcard to Heckel on which Pechstein also wrote a curious comment: "Matisse at times very wild [*wüste*]."[39] What might this mean? Given that Pechstein probably already knew Matisse's work from his 1907–8 sojourns in Paris, it is not clear that he meant this comment as praise or condemnation. The

ambiguity is telling of the reception of Matisse as an artist who so boldly crossed the standards of taste prevailing around the Berlin Secession—even Cassirer is said to have needed some convincing to mount the show.[40]

At the center of this perplexing German response was the issue of decorativeness. For German artists, "the decorative" was a complex and contradictory term with deep philosophical and historical roots that prevented them from embracing it directly.[41] It was this attitude that prompted the *Berliner Börsen Courier* to caution in its largely positive review of the Cassirer exhibition that Matisse's paintings flirted with the boundaries of "dangerous poster concocting" (*gefährlichen Plakatmacherei*), but that the "decorative dining room picture" (*decorative Speisesaalbild*), a reference to *Harmony in Red*, was "ambitious in the assertiveness of its colors."[42] Writing in *Vorwärts*, John Schikowski saw Matisse as striving for "merely an art of decoration" (*nur eine Schmuckkunst*) and, however virtuosic his execution, believed he was not destined to be among the greats of modern art.[43] For Hamburg Kunsthalle director Alfred Lichtwark, Matisse's drawings were the sole saving grace for an artist who otherwise would be seen as having "only a pronounced talent for color and decoration."[44] Max Beckmann, upon seeing the exhibition, was famously "shocked" into lamenting "one impertinent effrontery after another," and was

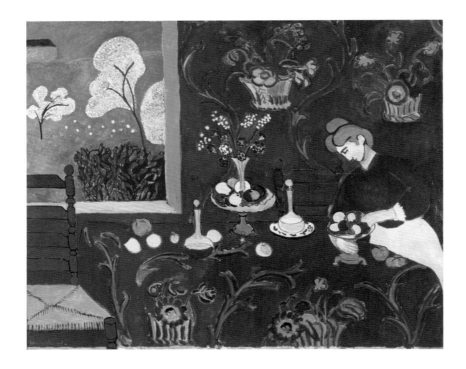

Henri Matisse
Harmony in Red, 1908
Oil on canvas
71 1/16 × 87 in. (180.5 × 221 cm)
The State Hermitage Museum,
St. Petersburg

prompted to ask, "why don't they just simply make cigarette posters?"[45]

For Beckmann, such qualities as delicacy and decorativeness were linked to France and the feminine, to which he preferred "a stronger spatial emphasis."[46] Beckmann, by his own account inspired by Cézanne (whose art he had discovered while visiting Paris in 1903–4), would later declare that his style was based "exclu-sively in terms of deep space, something that in contrast to superficially decorative art penetrates as far as possible to the very core of nature and the spirit of things."[47] Writing in 1912, the year after he painted *The Battle of the Amazons*, Beckmann insisted that art is "the conjunction of artistic sensuality with the artistic objectivity and actuality of things to be represented. Abandon this, and you inevitably fall into the domain of the applied arts."[48] For Beckmann, spatial depth would be the terrain in which modernity evolved and where French and German sources could mingle.

Given these prevailing attitudes, is it possible, as has been suggested, that Kirchner was entirely uninterested in Matisse's decorativeness?[49] Certainly it is generally assumed that Kirchner absorbed Matisse's fluid line in such drawings and lithographs as *Two Women* (plate 86), *Dodo Playing with her Fingers* (plate 85), and *The Dreaming Woman* (plate 91), while incorporating open facture in an important handful of paintings throughout that year. Any enthusiasm for Matisse, even if predictably denied later by Kirchner (who wrote in 1919 to his biographer Gustav Schiefler, "Matisse, Munch, etc. . . . whom I didn't even know by name at the time"),[50] would have found reinforcement from Pechstein, whose etching *Woman on a Sofa* (plate 127) clearly pays homage to Matisse.[51] Yet Kirchner's sketchbooks from this time already show him brilliantly capturing the motion of dancing, gesturing figures in a fluid line that is in contrast with the relative stasis of Matisse's decorative compositions.[52] However, Kirchner's evolving compositional acuity seems indebted to Matisse's harmonious compositions, as seen in a series of larger works portraying his partner, Doris "Dodo" Grosse: *Dodo at the Table* (plate 96) and *Dodo Playing with Her Fingers*, as well as *Reclining Nude in Front of Mirror* (plate 80). This suggests that what Kirchner discovered in Matisse was less fluidity of line, of which he was demonstrably already a master, and more a means of using color and line to structure composition. Moreover, Kirchner's "splotchy" paint application and the hues of his palette in his *Reclining Nude in Front of Mirror* seem indebted to paintings in the 1909 Matisse exhibition at Cassirer's gallery, constituting the origin of what art historian Donald E. Gordon called a "German Fauve Style."[53]

The other most significant moment of Matisse's influence in Germany came with the translation of his

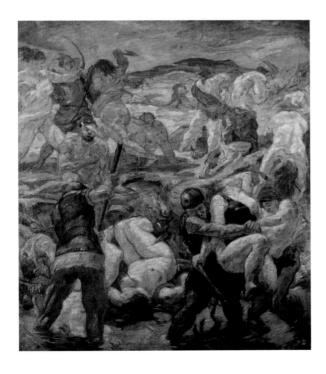

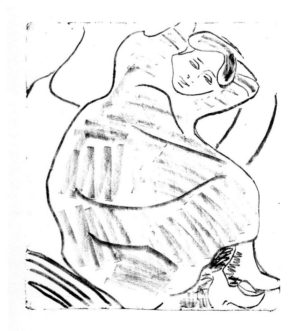

Max Beckmann
The Battle of the Amazons, 1911
Oil on canvas
98 7/16 × 86 5/8 in. (250 × 220 cm)
Robert Gore Rifkind Collection,
Beverly Hills

Ernst Ludwig Kirchner
The Dreaming Woman, 1909
plate 91 | cat. 110

seminal text, "Notes d'un peintre" (Notes of a Painter), originally published in *La Grande Revue* in late 1908 and in German in *Kunst und Künstler* in 1909. Most striking to German readers of the time was Matisse's emphasis on the subjective and how it related to overall composition: "What I'm after, above all, is expression.... Not ... the passion mirrored upon a human face [but] the place occupied by figures or objects, the empty spaces around them, the proportions, everything plays a part. Composition is the art of arranging in a decorative manner the various elements at the painter's disposal for the expression of his feelings."[54] Matisse's very tentative steps toward abstraction were followed in France by Cubism and Orphism, which reached a culmination in the works of Delaunay (such as *Red Eiffel Tower,* plate 17) nearly simultaneously with Kandinsky's prewar

In his introduction to the third Neue Secession catalogue, Max Raphael (under the pseudonym M. R. Schönlank) noted that in Impressionism "the decorative elements of the image were largely neglected," leaving it to another generation "with the greater freedom from the object to create this great decoration." This would be the task of "the young artists of all countries," whose perception of the object would replace the search for rules in the fleeting nature of the Impressionists.[56] Yet the decorative had been incorporated differently into easel painting in the French and German traditions, as has been demonstrated by Roger Harold Benjamin and others. To be sure, both Expressionists and Fauves contested what they saw as the positivist procedures of Impressionism, especially in landscapes and cityscapes that seemed to neutrally transcribe what was seen. In his

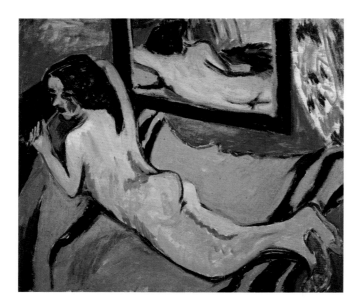

nonobjective works (*Sketch I for Painting with White Border*, plate 75, and *Section of Composition II,* plate 74). As defined by Apollinaire in his *Les peintres cubistes,* "Orphic Cubism ... [is] ... the art of painting new totalities with elements that the artist does not take from visual reality, but creates entirely by himself; he gives them a powerful reality.... This is pure art."[55] At such an early date, then, neither abstraction nor subjective expression could be assumed to be exclusively either German or French.

 Nor were French artists alone in deploying the decorative as a strategy to overcome Impressionism.

review of the 1906 Salon des Indépendants, critic François Crucy described the Fauves as "those who ask of the spectacle of nature pretexts to realize decorative composition."[57] Concurrently, critic Louis Vauxcelles sought truth in the new "landscapists" because they "see decoratively."[58]

 The idea of a decorative landscape was scarcely new, and earlier practices had been brought up to date in the writings of Matisse, André Lhote, Maurice Denis, and others. The Fauves' formal advances (flat planes of arbitrary color departing from the descriptive in favor of expressiveness) were arguably a recuperation

Ernst Ludwig Kirchner
Reclining Nude in Front of Mirror, 1909–10
plate 80 | cat. 112

of classicism.[59] Antecedents included the *paysage décoratif* derived from Greco-Roman tradition, which were extolled as "arabesques" by French academicians, imagined as fantasies by Boucher and Fragonard and in Art Nouveau, and absorbed (along with nineteenth-century mural practice) into the decorative patterns of the Symbolists and the Nabis. Examples include the patterns of Edouard Vuillard's *A Walk in the Vineyard* (plate 153), the interior of Vuillard's *Woman in a Striped Dress* (plate 152), and Bonnard's *The Mirror in the Green Room* (plate 3).

The Neo-Impressionists furthered this direction with Paul Signac, who declared in his widely read *D'Eugène Delacroix au néo-impressionnisme* (From Eugène Delacroix to Neo-Impressionism, 1899) that "even the Neo-Impressionists' canvases of small dimensions can

of color, suggestions of composition. Close your eyes and visualize the picture…consider the subject (model, landscape, etc.) in its ensemble."[62] Within this approach some Fauves attended more to portraying the local (Albert Marquet, *Le Havre, Sailboat at the Dock*, cat. 144), others more toward abstraction (André Derain, *Boats in the Port of Collioure*, plate 23), while still others fell somewhere in between (Maurice de Vlaminck, *Houses and Trees*, plate 148).

German painterly practice, by contrast, tended to see "the decorative" as a quality that belonged more exclusively to the applied arts, and therefore alien to easel painting. Whereas Matisse's brightly colored patterns of arbitrary colors function as an array of "color sensations" that seem to refer to themselves more than to nature and are "[drawn] so as to enter directly into

be presented as decorative."[60] This helps explain the affinity between the Jugendstil interiors by Henry van de Velde and the Neo-Impressionist paintings that often hung within them, for example in Cassirer's gallery and Kessler's study. Cézanne, as well, began with the decorative, and his decorative *Four Seasons* panels (1860–61) were reproduced by Marc and Kandinsky in their 1912 *Blaue Reiter Almanach* (see Katherine Kuenzli's discussion in this volume). Matisse, in turn, imbued painting with the values of "balance, purity, and tranquility."[61] To achieve this, he advised: "in painting a landscape you choose it for certain beauties—spots

the arabesque with color,"[63] Kirchner's ornate patterns are more often used to represent decorative items such as pillows and rugs, as in his *Woman in a Green Blouse* (plate 88). Blaue Reiter artist August Macke, however, made a different use of Matisse. In 1908 he visited Paris with collector Bernhard Koehler, who purchased Matisse's *Street in Arceuil* (1903–4).[64] Macke then visited the collection of Ernst Osthaus, who had just purchased Matisse's *Still Life with Asphodels* (p. 72), and over the next two years copied several other paintings by Matisse in his sketchbooks. In 1910 he traveled to Munich to see Matisse in an exhibition at Moderne

Harry Kessler's study in Weimar, designed by Henry van de Velde, with Henri-Edmond Cross's *Bather* (plate 18) on the wall to the right, c. 1910

Galerie Heinrich Thannhauser, and revisited Osthaus's collection. Over the next two years Matisse's influence on Macke is clearly seen in a tension between spatial depth and flatness and an amplification and incorporation of Matisse's flowing decorative passages into structural patterns, as in *Study for the Hat Shop* and *Still Life with Apple Peel and Japanese Fan* (1911). Such paintings provided the essential structure for his incorporation of Delaunay's luminous patterns starting around 1911. Again influence took a heuristic direction, enabling Macke to fully integrate the decorative into the compositional armature of easel painting.

The Limits of Cosmopolitanism

The cosmopolitanism underlying these advances reached a new high point with the Sonderbund exhibition in Cologne in May 1912. Osthaus was a driving force in this last in a series of four international exhibitions organized by the Sonderbund Westdeutscher Kunstfreunde und Künstler (Special Association of West German Art Lovers and Artists), a regional artists association founded in 1909.[65] With more than 630 works, the exhibition brought together contemporary artists from

across Europe in combination with modernism's "historical foundations," provided by a huge Van Gogh retrospective (120 paintings and sixteen drawings) and a substantial presentation of works by Cézanne and Gauguin (twenty-five each). Among the works shown were Van Gogh's *Pollard Willows at Sunset* (plate 50), *The Poplars at Saint-Rémy* (plate 57), *Two Women Digging in Field with Snow* (cat. 77), and *Mallows* (cat. 65). Cézanne was also spectacularly represented with *Peasant in a Blue Smock* (plate 12) and *Still Life with Apples* (plate 8). Gauguin could still be a revelation with such paintings as *Portrait of the Artist's Mother* (p. 72) and *Barbarian Tales* (p. 62). The spectacular *triumphus* of Van Gogh, Gauguin, and Cézanne was intended to bolster the case for the departure from Impressionism that the most recent trends from across Europe represented, even as they were scarcely known to the broad public in Germany. These works ranged from Matisse's *Street in Arceuil*, Georges Braque's Cubist *Violin and Palette* (plate 7), and Picasso's *Head of a Woman* (p. 58), lent by Alfred Flechtheim, to works by the Brücke and Blaue Reiter artists. Richart Reiche proclaimed in his catalogue foreword that Impressionism and naturalism had been superseded by a new movement (*Bewegung*) that "young artists of nearly every European region had joined," and which he labeled "Expressionist."[66]

The cosmopolitanism of both the Sonderbund and the extensive exhibition program evolving at Herwarth Walden's Galerie Sturm in Berlin was complemented by the gradual superseding of the north–south polarity in art historical writings. For example, Wilhelm Worringer in *Formprobleme der Gotik* (Form in Gothic, 1910) sought to render the Gothic—previously a strictly nationalized concept—as a "supranational phenomenon" where both the tendencies underlying the Gothic and those leading to its polar opposite in the classical are considered universal forces across all cultures.[67] Such a culturally universal polarity had been the subject of Worringer's *Abstraktion und Einfühlung* (Abstraction and Empathy, 1907), which strongly influenced Kandinsky's theory of an emerging polarity between "the great realism" and "the great abstraction" and the Blaue Reiter's unprecedented range of interest in European and non-Western cultures.

Yet within this cultural ambience, new directions were developing that were at once contravening and constructive—and this despite, or even because of, Walden's attempts to realize his cosmopolitan vision. Prompted by a general disappointment with the lack of space at the Sonderbund, which had restricted artists

August Macke
Study for the Hat Shop, 1913
Pastel on paper
7½ × 5½ in. (19 × 14 cm)
Virginia Museum of Fine Arts,
Richmond. The Ludwig and
Rosy Fischer Collection, gift of the
Estate of Anne R. Fischer

to only three submissions, in June–July 1912 Walden held a special exhibition of German Expressionist works left out of the Sonderbund (featuring Blaue Reiter artists), followed by "French Expressionists" in August (primarily Fauves).[68] Over the course of the next year he sought to conflate "Expressionism" with Cubism and Futurism throughout his manifold endeavors at Galerie Sturm and in his periodical *Der Sturm*. However, although Walden had included both Kirchner and Pechstein in his premiere exhibition (devoted primarily to the Blaue Reiter) in March 1912 and presented the Neue Secession in December of that same year,[69] the Brücke artists declined to participate in the apex of his boldly international enterprise, the First German Autumn Salon in 1913.[70] This project was sponsored

(*Ursprünglichkeit*) both in the German old masters and in non-Western sources.[71] Such nationalist tendencies throughout the German avant-garde would soon increase with the outbreak of World War I.

It was also during this atmosphere of growing nationalism that the first synthetic history of Expressionism was written by Paul Fechter in 1914. Despairing at the increasing materialism of the age, he sought to regain the primacy of spirit (*Geist*), one of the prime tropes of interiority, and along with it the expressive instinct.[72] He saw Van Gogh as Germanic in his ability to show the way toward an overcoming of Impressionism: "Van Gogh is a last resort of Impressionism, he is at once also the beginning of the antithesis, the beginning of the end, because the ecstasy achieves not

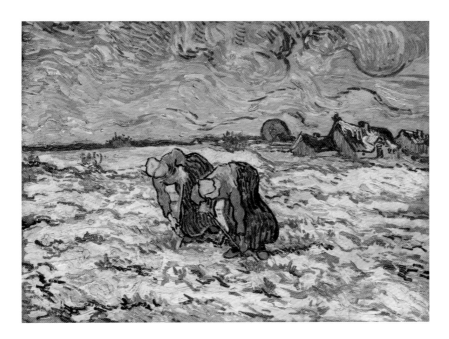

by Koehler and created in close collaboration with the Blaue Reiter. Perhaps Kirchner, who in 1912 was at work on a history of the group titled *Chronik der Brücke*, feared that the Brücke would lose its identity amid so many other "-isms" from so many nations, all considered analogous with Expressionism. If prompted to seek a national identity for the Brücke's art, it is scarcely surprising that Kirchner declared in his *Chronik* that the Brücke—immune from any contemporary foreign influences—were "uninfluenced by Cubism, Futurism, etc." Instead, the Brücke sought authenticity

only to new decorative values, but also a new level of commitment with him."[73] The Expressionists, in turn, were now set in opposition to French artists, despite Fechter's earlier hopes for a synthesis.

It is largely this nationalized concept of Expressionism that has come down to us today. Through the exploration of episodes of exchange of artistic influence in this exhibition and catalogue, we hope to regain the perspective of Expressionism as a broader movement

Vincent van Gogh
Two Women Digging in Field with Snow, 1890
cat. 77

beyond a particular nation's borders, as documented in the extensive chronology by Frauke Josenhans and in the six essays by scholars of the period. We start by looking at the case of Harry Kessler, the peripatetic collector, critic, and museum director whose extensive travels allowed him to instigate numerous important exhibitions and collaborations, including Henry van de Velde's architectural design for Cassirer's gallery in Berlin and Osthaus's museum in Hagen (not to mention Kessler's own collection and residences in Weimar and Berlin). In his essay, Laird M. Easton expands our understanding of Kessler, probing his relationships with poets of the day and his acceptance and promotion of the Expressionist generation of German artists and

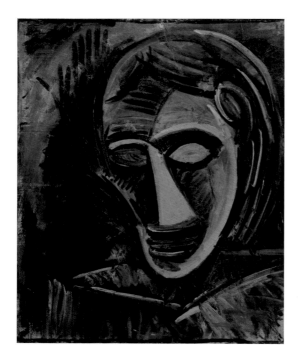

writers, testifying to a profound understanding of cultural transformation unfathomable to many who had introduced French modernism into Germany. Meanwhile, as Claudine Grammont conveys in her nuanced account, many German artists frequented Paris, gathering at the Café du Dôme, attending exhibitions at the Salon d'Automne, and visiting numerous studios, galleries, and collections. She considers the relationships between the Fauves and the Expressionists, including Kandinsky and Franz Marc, as well as the roles played in this context by Matisse's academy and his "Notes d'un peintre,"

while offering a cogent account of how Matisse's critical reception was adversely affected by his associations with aspiring German artists.

Beginning in the late nineteenth century, exhibitions in Berlin, Dresden, and Munich presented in-depth presentations of Impressionism and Neo-Impressionism; around 1904–5, simultaneous with the birth of Expressionism, exhibitions in Germany also made the works of Cézanne, Van Gogh, Gauguin, and (eventually) Matisse widely available. In an essay based on research of unprecedented depth, Peter Kropmanns not only unearths the logistics of how such exhibitions were created through the cooperation of German and French dealers, collectors, and museum directors, but also examines the role of art criticism and a discourse of "distancing and demarcation" that evolved over centuries of cultural differentiation. Magdalena M. Moeller provides an investigation of such differentiation as well as commonalities in the evolving styles of the Fauves and the Brücke. While both groups reacted against what Matisse called "the tyranny of Divisionism" (the Brücke doing so slightly later than the Fauves), the Brücke also began to respond to the Fauves around 1908, allowing them to transcend the "purity and serenity" of Matisse's concept of "expression" to arrive at a more unfettered range of emotion.

Another departure evolved among the Brücke artists in part as a response to criticism that they too closely aligned themselves with the decorative flatness of the Fauves, and in part in harmony with their independent discovery of the tribal art of Africa and Oceania. Sherwin Simmons uses works by Kirchner, Schmidt-Rottluff, Heckel, and the independent artist Lyonel Feininger (who maintained friendships with the Blaue Reiter artists) to examine the Brücke's reception of Cubism; he argues that the works of Picasso and Braque were absorbed as a means rather than an end—functioning (in the words of art critic Curt Glaser) as a "byway" leading elsewhere, especially back to German Romanticism. The Munich-based Blaue Reiter group also responded in a variety of ways to current artistic trends in Paris. August Macke remained more consistent with museum director Hugo von Tschudi's emphasis on Parisian cosmopolitanism and Impressionist painting (even if interpreting those sources with what Macke saw as a greater spiritual resonance), while Kandinsky and Marc responded with an internationalism based on folk art and constructions of the "primitive"—which, as Katherine Kuenzli demonstrates in her highly original essay, turned on their interpretation of Henri Rousseau.

Pablo Picasso
Head of a Woman, 1908
Oil on canvas
29 × 23 ⅞ in. (73.6 × 60.6 cm)
The Museum of Modern Art, New York,
Florene May Schoenborn Bequest

Their appreciation of Rousseau's direct yet formally condensed realistic style necessitated a break from the materialist perception they saw in the Impressionism championed by Tschudi and Meier-Graefe's generation, and afforded them a means toward regaining the "interiority" they found lacking in much of French modernism.

Taken together, these contributions help us understand Expressionism as a multivalent international modernist movement with profoundly meaningful social exchange before it was tragically cut short by World War I. Yet as the calamitous war progressed, and as many of the artists and intellectuals who survived it began to reassess the direction being taken by European culture under the aegis of nationalist beliefs, it was the cosmopolitan cultural exchange of the Expressionist era that presaged a new direction for the post–World War I era, where a true internationalism and cultural unity could be imagined.

ENDNOTES

1. *Katalog der XXII. Ausstellung der Berliner Secession* (Berlin: Verlag der "Ausstellungshaus am Kurfürstendamm," 1911), 11, quoted in Stephan von Wiese, *Graphik des Expressionismus* (Stuttgart: Hatje, 1976), 8.

2. Arthur Clutton-Brock, "The Post-Impressionists," *The Burlington Magazine* 18 (January 1911): 216, cited and discussed in Marit Werenskiold, *The Concept of Expressionism* (Oslo: Universitetsforlaget, 1984), 9ff.

3. For a complete list of exhibitions held at the Sturm galleries during the 1910s, see Barbara Alms and Wiebke Steinmetz, eds., *Der Sturm: Chagall, Feininger, Jawlensky, Kandinsky, Klee, Kokoschka, Macke, Marc, Schwitters und viele andere im Berlin der zehner Jahre*, exh. cat. (Delmenhorst: Städtische Galerie Delmenhorst, Haus Coburg; Bremen: Hauschild, 2000), 257–70.

4. Ruth Negendanck, *Die Galerie Ernst Arnold (1893–1951): Kunsthandel und Zeitgeschichte* (Weimar: VDG, 1998) and H. A. Lier, "Ernst Arnolds Kunstsalon," *Dresdner Journal*, March 30, 1904, no. 74, afternoon edition.

5. *Le néo-impressionisme: De Seurat à Paul Klee*, exh. cat. (Paris: Musée d'Orsay, 2005).

6. Fritz Bleyl, "Erinnerungen," in Hans Wentzel, "Fritz Bleyl, Gründungsmitglied der 'Brücke,'" *Kunst in Hessen und am Mittelrhein* 8 (1968): 99, trans. in Magdalena M. Moeller, "Van Gogh and Modern Germany," *Vincent van Gogh and the Modern Movement, 1890–1914*, ed. Georg-W. Költzsch and Ronald de Leeuw, exh. cat. (Essen: Museum Folkwang; Freren: Luca, 1990), 314.

7. Ernst Ludwig Kirchner, "Die Lehrjahre," in Eberhard W. Kornfeld, *Ernst Ludwig Kirchner: Nachzeichnung seines Lebens* (Bern: Kornfeld; Fribourg: Office du livre, 1979), 334.

8. Fritz Schumacher, *Stufen des Lebens: Erinnerungen eines Baumeisters* (Stuttgart and Berlin: Deutsche Verlags-Anstalt, 1935) 283, cited in Magdalena M. Moeller, "Van Gogh and Modern Germany," 313. Trans. in Christiane Remm, "Dresde al la luz de Van Gogh," trans. as "Dresden in the Light of Van Gogh," in Javier Arnaldo and Magdalena M. Moeller, eds., *Brücke: El nacimiento del expresionismo alemán*, exh. cat. (Madrid: Fundación Colección Thyssen-Bornemisza, 2005), 378.

9. Ernst Blass, "Das alte Café des Westens," *Die literarische Welt* 4, no. 35 (1928): 3, trans. by J. M. Ritchie in Paul Raabe, ed., *The Era of German Expressionism* (Woodstock, NY: Overlook, 1974), 29.

10. Carl Vinnen, "Quousque tandem," in *Ein Protest deutscher Künstler* (Jena: Diederich, 1911), 2 and 12, trans. in Timothy O. Benson and Éva Forgács, eds., *Between Worlds: A Sourcebook of Central European Avant-Gardes, 1910–1930* (Los Angeles: Los Angeles County Museum of Art; Cambridge, MA: MIT Press, 2002), 50–51. Among Vinnen's 140 cosigners were twenty museum directors. Cf. Peter Paret, *The Berlin Secession: Modernism and Its Enemies in Imperial Germany* (Cambridge, MA: Belknap Press of Harvard University Press, 1980), 186ff., and Költzsch and de Leeuw, *Vincent van Gogh and the Modern Movement.*

11. Vinnen, *Protest*, 12 (see also 7–10), cited and trans. in Paret, *Berlin Secession*, 185.

12. The exhibition of the Neue Künstlervereinigung München (NKVM, the Munich group cofounded by Wassily Kandinsky, Alexei Jawlensky, and Gabriele Münter in 1909) was held in January 1911. Vinnen, *Protest*, 59 and 65–69, cited in Paret, *Berlin Secession*, 187–88. For a list of works shown in the exhibition see Annegret Hoberg and Helmut Friedel, eds., *Der Blaue Reiter und das Neue Bild: Von der "Neuen Künstlervereinigung München" zum "Blauen Reiter,"* exh. cat. (Munich: Städtische Galerie im Lenbachhaus, 1999) 340–47.

13. "Die Franzosen benutzen jede Gelegenheit, um zu lachen…. In Deutschland wird alles sogleich furchtbar ernst genommen." *Protest*, 68, my translation.

14. See Wulf Herzogenrath and Dorothee Hansen, eds., *Van Gogh: Fields; The "Field with Poppies" and the Artists' Dispute*, exh. cat. (Bremen: Kunsthalle; Ostfildern-Ruit: Hatje Cantz, 2002), 148–241, for the most accessible account of the controversy in English.

15. Paul Fechter, "Zur IV. Ausstellung der 'Neuen Secession,'" *Vossische Zeitung*, November 18, 1911, quoted in Martina Ewers-Schultz, *Die französischen Grundlagen des "rheinischen Expressionismus" 1905 bis 1914: Stellenwert und Bedeutung der französischen Kunst in Deutschland und ihre Rezeption in den Werken der Bonner Ausstellungsgemeinschaft von 1913* (Münster: Lit Verlag, 1996), 20. Cf. Paul Fechter, "Fortbildungen des Impressionismus," *Deutsche Kunst und Dekoration* 29, no. 5 (1911–12): 299–304.

16. Michael Espagne and Michael Werner, eds., *Transferts: Les relations interculturelles dans l'espace franco-allemand (XVIIIe–XIXe siècle)* (Paris: Éditions Recherche sur les civilisations, 1988). Cf. Katharina Middell and Mathias Middell, "Forschungen zum Kulturtransfer: Frankreich und Deutschland," *Grenzgänge: Beiträge zu einer modernen Romanistik* 1, no. 2, (1994): 107–22. For a discussion of ethno-symbolism and its application to European culture, see Anthony D. Smith, "Nationalism and Modernity," in Timothy O. Benson, *Central European Avant-Gardes: Exchange and Transformation, 1910–1930*, exh. cat. (Los Angeles: Los Angeles County Museum of Art; Cambridge, MA: MIT Press, 2002), 68–80.

17. Max Pechstein, *Erinnerungen*, ed. Leopold Reidemeister (Stuttgart: Deutsche Verlags-Anstalt, 1993), 32.

18. For this argument see Hans Belting, *The Germans and Their Art: A Troublesome Relationship*, trans. Scott Kleager (New Haven, CT: Yale University Press, 1998).

19. Madame de Staël, chap. 32 in *De l'Allemagne* (Paris, 1813). Cf. Belting, *The Germans*, 8. See also Sébastien Allard and Danièle Cohn, eds., *De l'Allemagne: De Friedrich à Beckmann*, exh. cat. (Paris: Hazan; Musée du Louvre éditions, 2013).

20. Fritz von Ostini, *Böcklin* (Bielefeld: Velhagen & Klasing, 1907), 123, quoted in Thomas W. Gaehtgens, "Les rapports de l'histoire de l'art et de l'art contemporain en Allemagne à l'époque de Wölfflin et de Meier-Graefe," in *Revue de l'art*, no. 88 (1990): 33.

21. Julius Meier-Graefe, *Entwickelungsgeschichte der modernen Kunst* (Stuttgart: Verlag J. Hoffman, 1904). The original title reflects the common spelling of its day; subsequent editions use *Entwicklungsgeschichte.*

22. Julius Meier-Graefe, *Entwicklungsgeschichte der modernen Kunst*, ed. Hans Belting (Munich: Piper, 1987), 2:717.

23. Gaehtgens, "Les rapports de l'histoire de l'art," 32, 34.

24. Meier-Graefe, *Entwicklungsgeschichte* [1904], 1:25.

25. Meier-Graefe, *Entwicklungsgeschichte* [1987], 2:585, originally in the 3rd ed. published in 1924 by Piper. For more on Meier-Graefe's ahistorical "horizontal" approach see Kenworth Moffett, *Meier-Graefe as Art Critic* (Munich: Prestel, 1973), 41.

26. See Kerstin Thomas, ed., *Stimmung: Ästhetische Theorie und künstlerische Praxis*, Passagen/Passages 33 (Berlin and Munich: Deutscher Kunstverlag, 2010), and Kerstin Thomas, *Welt und Stimmung bei Puvis de Chavannes, Seurat und Gauguin*, Passagen/Passages 32 (Berlin and Munich: Deutscher Kunstverlag, 2010). *Rêverie* has its origins in Jean-Jacques Rousseau, *Les rêveries du promeneur solitaire* (Paris, 1782). Also see Thomas, *Stimmung*, vii.

27. As discussed by Pierre Bourdieu, understanding works of art requires taking "into account not only…artists, art critics, dealers, patrons, etc.,… but also…the field of social agents (e.g., museums, galleries, academies, etc.) which help to define and produce the value of works of art." Pierre Bourdieu, *The Field of Cultural Production: Essays on Art and Literature* (New York: Columbia University Press, 1993), 37. Interdisciplinary approaches might include those of Henri Lefebvre, *The Production of Space* (Oxford: Blackwell, 1991), Thomas DaCosta Kaufmann, *Toward a Geography of Art* (Chicago: University of Chicago Press, 2004), and Clifford Geertz, *The Interpretation of Cultures: Selected Essays* (London: Fontana, 1973).

28. *Die Schule von Pont-Aven: Im Kunstverein, München* opened on August 20, 1904. The show included forty-six paintings by Gauguin, Van Gogh, Schuffenecker, Diriks, Friesz, and Slewinski. See Peter Kropmanns, *Gauguin und die Schule von Pont-Aven: Im Deutschland nach der Jahrhundertwende* (Sigmaringen: Thorbecke Verlag, 1997), 18–22.

29. Kirchner, "Die Lehrjahre," 333.

30. Költzsch and de Leeuw, *Vincent van Gogh and the Modern Movement*, 353.

31. "Eines Tages brachte Kirchner aus irgendeiner Bücherei einen bebilderten Band von Meier-Graefe über die modernen französischen Künstler mit. Wir waren begeistert." Bleyl, "Erinnerungen," 94, cited in Moeller, "Van Gogh and Modern Germany," 313. For discussion of other publications, cf. Bleyl, "Erinnerungen," 96.

32. Tilman Osterwold, ed., *Emil Nolde*, exh. cat. (Stuttgart: Wüttermbergische Kunstverein and Nolde Stiftung, 1987), 227.

33. Moeller, "Van Gogh and Modern Germany," 315–16. See Emil Nolde, *Mein Leben* (Cologne: DuMont, 1976), 186. As Magdalena M. Moeller points out, Nolde was probably confusing his experience in Munich with time spent in Berlin in 1901 when Van Gogh's *Self-Portrait with Bandaged Ear and Pipe* (1889) was shown at the Berlin Secession. See Jacob-Baart de la Faille, *L'oeuvre de Vincent van Gogh: Catalogue Raisonné.* 4 vols. (Paris-Brussels, Les Éditions G. van Oest, 1928), no. 529. See Magdalena M. Moeller, "Van Gogh und die Rezeption in Deutschland bis 1914," in Költzsch and de Leeuw, *Vincent van Gogh and the Modern Movement*, 316n8.

34. For example, some similarities may be seen between Max Liebermann's outdoor scenes, such as *In the Tents* (1900) and Nolde's *Summer's Afternoon* (1903). See Barbara C. Gilbert, ed., *Max Liebermann: From Realism to Impressionism*, exh. cat. (Los Angeles: Skirball Cultural Center, 2005), 177, and Martin Urban, *Emil Nolde: Werkverzeichnis der Gemälde*, vol. 1 (Munich: C. H. Beck, 1987), no. 124, illus. p. 135.

35. Nolde discusses his sojourn in Emil Nolde, *Jahre der Kämpfe* (Berlin: Rembrandt-Verlag, 1934), 75ff. The date of his first visit is established as February 14 or 15, 1906, in *Emil und Ada Nolde, Karl Ernst und Gertrud Osthaus: Briefwechsel*, ed. Herta Hesse-Frielinghaus (Bonn: Bouvier, 1985), 1n1.

36. Similarly, Kirchner's weblike structure of gouging in his woodcut *Mädchenakt*, and his use of open facture in his paintings of 1908 (e.g., *Aktgruppe I and II*), sought a painterly modeling of the body inspired by Van Gogh. See Hans Ulrich Lehmann, entry for Kirchner's *Mädchenakt* in Birgit Dalbajewa and Ulrich Bischoff, eds., *Die Brücke in Dresden 1905–1911*, exh. cat. (Dresden: Galerie Neue Meister, Staatliche Kunstsammlungen Dresden; Cologne: König, 2001), 176.

37. Reinhold Heller, "Bridge to Utopia: The Brücke as Utopian Experiment," in Timothy O. Benson, ed., *Expressionist Utopias: Paradise, Metropolis, Architectural Fantasy* (Los Angeles: Los Angeles County Museum of Art, 1993), 62–83.

38. The most comprehensive analysis of this exhibition is found in Peter Kropmanns, "Matisse in Deutschland" (PhD diss., Humboldt Universität, Berlin, 2000), 102–32.

39. Ernst Ludwig Kirchner and Max Pechstein to Heckel in Dresden, postcard, January 12, 1909. At one point Kirchner wanted to invite Matisse to join the Brücke, but nothing came of it, according to Lucius Grisebach, *Ernst Ludwig Kirchner 1880–1938* (Cologne: Benedikt Taschen Verlag, 1996), 29.

40. Hans Purrmann claimed retrospectively in 1955 to have met with Cassirer first in Paris, at which time he seemed disinclined to show Matisse; Purrmann and Matisse allegedly arrived in Berlin in December 1908 uncertain of whether an exhibition would happen. Although Kropmanns ("Matisse in Deutschland," 103–4) casts considerable doubt on this account, he seems to give some credence to a 1949 account by Friedrich Ahlers-Hestermann that Matisse himself convinced Liebermann and Slevogt, who had Cassirer's confidence, that the show would be beneficial. See Friedrich Ahlers-Hestermann, *Pause vor dem dritten Akt* (Hamburg: Gebr. Mann, 1949), 176–80. In 1955 Purrmann also reported that Liebermann shook his head when seeing Matisse's *Still Life with Red Rug*. See Kropmanns, "Matisse in Deutschland," 112.

41. For a discussion of Kant, Heidegger, Riegl, and Worringer and ramifications relevant to the Expressionists, see Jenny Anger, *Paul Klee and the Decorative in Modern Art* (Cambridge: Cambridge University Press, 2004), 7–32.

42. *Berliner Börsen Courier*, no. 15, January 10, 1909, 3, cited in Kropmanns, "Matisse in Deutschland," 108.

43. John Schikowski, "Aus den Kunstsalons," *Vorwärts*, January 16, 1909, 67, cited in Kropmanns, "Matisse in Deutschland," 111–12.

44. Lichtwark, letter of January 6, 1909, in Alfred Lichtwark, *Briefe an die Kommission für die Verwaltung der Kunsthalle*, ed. Gustav Pauli (Hamburg: Westermann, 1924), 256.

45. Max Beckmann, *Leben in Berlin: Tagebuch 1908–1909*, ed. Hans Kinkel (Munich: R. Piper, 1983), 18.

46. Diary entry of January 9, 1909, translated in Max Beckmann, *Self-Portrait in Words: Selected Writings and Statements, 1903–1950*, ed. Barbara Copeland Buenger (Chicago: University of Chicago Press, 1997), 98. For extensive discussion of Beckmann's gendering of the decorative and his complex metaphorical understanding of space, see Jay A. Clarke, "Space as Metaphor: Beckmann and the Conflicts of Secessionist Style in Berlin," in *Of "Truths Impossible to Put in Words": Max Beckmann Contextualized*, ed. Rose-Carol Washton Long and Maria Makela (New York: Peter Lang, 2009), 49–80.

47. Max Beckmann, "Das neue Program," *Kunst und Künstler* 12 (March 1914): 299ff., trans. as "The New Program" in Beckmann, *Self-Portrait in Words*, 132. Cited in Karen Lang, "Max Beckmann's Inconceivable Modernism," in Long and Makela, *Beckmann Contextualized*, 84.

48. Max Beckmann, "Thoughts on Timely and Untimely Art," in Beckmann, *Self-Portrait in Words*, 116, discussed in Lang, "Beckmann's Inconceivable Modernism," 96.

49. Gabrielle Linnebach, "La Brücke et le fauvisme," in *Paris-Berlin: 1900–1933*, exh. cat. (Paris: Centre national d'art et de culture Georges Pompidou, 1978), 70–76.

50. Kirchner to Gustav Schiefler, March 31, 1919, in Ernst Ludwig Kirchner and Gustav Schiefler, *Briefwechsel: 1910–1935/1938*, ed. Wolfgang Henze (Stuttgart and Zürich: Belser Verlag, 1990), 118–19.

51. See also the lithograph *Reclining Nude* (1909) in Günter Krüger, *Das druckgraphische Werk Max Pechsteins* (Tökendorf: R.C. Pechstein-Verlag, 1988), lithograph no. 62, illus. in *Brücke und Berlin: 100 Jahre Expressionismus*, ed. Anita Beloubek-Hammer, Magdalena M. Moeller, and Dieter Scholz, exh. cat. (Berlin: Neue Nationalgalerie; Nicolaische Verlagsbuchhandlung, 2005), 44, cat. no. 396.

52. This is especially seen in the P5 and P6 sketchbooks in the Kirchner archive at Davos. For a discussion of Kirchner's rendering of movement in the sketchbooks, see Gerd Presler, *Ernst Ludwig Kirchner: Die Skizzenbücher; "Ekstase des ersten Sehens": Monographie und Werkverzeichnis* (Davos: Kirchner Verein, 1996), 79–93.

53. Donald E. Gordon, in "Kirchner in Dresden," makes this argument for Kirchner's *Girl under Japanese Umbrella* (1909), Düsseldorf, Rheinland Westfalen State Coll., illus. in Grisebach, *Ernst Ludwig Kirchner*, 37. This painting is no. 57 in Donald E. Gordon, *Ernst Ludwig Kirchner: Mit einem kritischen Katalog sämtlicher Gemälde* (Munich: Prestel, 1968).

54. Henri Matisse, "Notizen eines Malers," *Kunst und Künstler* 7, no. 8 (May 1909): 336–39. Trans. in Herschel B. Chipp, *Theories of Modern Art: A Source Book by Artists and Critics* (Berkeley: University of California Press, 1968), 131–32.

55. Guillaume Apollinaire, *Les peintres cubistes: Méditations esthétiques* (Paris: E. Figuière, 1913; repr. Geneva: Cailler, 1950), 27. Citations refer to the Cailler edition. Trans. by Hajo Düchting in "Orphism," *Grove Art Online, Oxford Art Online*, Oxford University Press, accessed September 10, 2013, http://www.oxfordartonline.com/subscriber/article/grove/art/T063959.

56. M. R. Schönlank [Max Raphael], foreword to *Katalog der Neuen Secession Berlin: 3. Ausstellung; Gemälde* (Berlin: Baron, 1911), 9–16, repr. in Anke Daemgen and Uta Kuhl, *Liebermanns Gegner: Die Neue Secession in Berlin und der Expresionismus*, exh. cat. (Berlin: Stiftung Brandeburger Tor; Schleswig: Stiftung Schleswig-Holsteinische Landesmuseen, Schloss Gottorf; Cologne: Wienand, 2011), 203.

57. F. Crucy, "Le Salon des Indépendants," *L'Aurore*, March 22, 1906, cited in Roger Harold Benjamin, "The Decorative Landscape, Fauvism, and the Arabesque of Observation," *The Art Bulletin* 75, no. 2 (June, 1993): 296. For example, combining Anselm Feuerbach with Delacroix and the Impressionists, as critic Karl Scheffler noted in his review of the Berlin Secession exhibition in which the *Battle of the Amazons* was shown, "Berlin Secession," *Kunst und Künstler* 10 (1911–12): 437–38, cited and discussed in Clarke, "Space as Metaphor," 71.

58. Louis Vauxcelles, "Le Salon des Indépendants," *Gil Blas*, March 20, 1906, cited in Benjamin, "The Decorative Landscape," 297.

59. Benjamin, "The Decorative Landscape," 296.

60. Paul Signac, *D'Eugène Delacroix au néo-impressionnisme* (Paris, [1898], repr. 1911), 89. Cited in Benjamin, "The Decorative Landscape," 301.

61. Henri Matisse, "Notes d'un peintre," in Henri Matisse, *Ecrits et propos sur l'art*, ed. Dominique Fourcade (Paris, 1972), 50, originally published in *La Grande Revue* 2, no. 24 (December 25, 1908); Benjamin, "The Decorative Landscape," 299.

62. Matisse to his students, 1908, quoted in Sarah Stein, "A Great Artist Speaks to His Students [1908]," repr. in Alfred H. Barr, *Matisse: His Art and His Public* (New York: Museum of Modern Art, 1951), 551–52.

63. Benjamin, "The Decorative Landscape," 312.

64. Later shown in the 1912 Sonderbund exhibition. Illus. in Barbara Schaefer, ed., *1912: Mission moderne*, exh. cat. (Cologne: Wienand; Wallraf-Richartz Museum & Fondation Corboud, 2012), cat. no. 261, p. 569; also discussed in Ursula Heiderich and Erich Franz, eds., *August Macke und die frühe Moderne in Europa*, exh. cat. (Münster: Westfälisches Landesmuseum für Kunst und Kulturgeschichte; Bonn: Kunstmuseum Bonn; Ostfildern-Ruit: Hatje Cantz, 2001), 140.

65. The two most substantial scholarly accounts of the exhibition are Magdalena M. Moeller, *Der Sonderbund: Seine Voraussetzungen und Anfänge in Düsseldorf* (Cologne: Rheinland Verlag, 1984), and Schaefer, *Mission moderne*.

66. Richart Reiche, foreword to *International Kunstausstellung: Städtische Ausstellungshalle, 25 Mai bis 30 Sept., 1912: Sonderbund Westdeutscher Kunstfreunde und Künstler* (Cologne: Schauberg, 1912), 3.

67. See Rose-Carol Washton Long, *National or International? Berlin Critics and the Question of Expressionism* (Berlin: Akademie Verlag, 1993), 523–24, and "Brücke, German Expressionism and the Issue of Modernism," in *New Perspectives on Brücke Expressionism: Bridging History*, ed. Christian Weikop (Burlington, VT: Ashgate, 2011), 11–30.

68. See the exhibition list in Alms and Steinmetz, *Der Sturm*, 257–270.

69. Kirchner's woodcuts were prominently featured in *Der Sturm* during 1911. See Bruce Davis, *German Expressionist Prints and Drawings: The Robert Gore Rifkind Center for German Expressionist Studies* (Los Angeles: Los Angeles County Museum of Art; Munich: Prestel, 1989), 403–4.

70. See Timothy O. Benson, "Brücke, French Art and German National Identity," in Weikop, *New Perspectives*, 31–55, and Mario-Andreas von Lüttichau, "Erster Deutscher Herbstsalon, Berlin 1913," in *Stationen der Moderne: Die bedeutenden Kunstausstellungen des 20. Jahrhunderts in Deutschland*, ed. Michael Bollé and Eva Züchner, exh. cat. (Berlin: Berlinische Galerie, Museum für Moderne Kunst, Photographie und Architektur; Berlin: Nicolai, 1988), 130–40.

71. Meike Hoffmann, *Leben und Schaffen der Künstlergruppe "Brücke" 1905–1913* (Berlin: Reimer, 2005), 196, 198–99.

72. Paul Fechter, *Der Expressionismus*, 3rd ed. (Munich: R. Piper, 1919), 3–4.

73. Ibid., 9.

FRAUKE JOSENHANS

Chronology

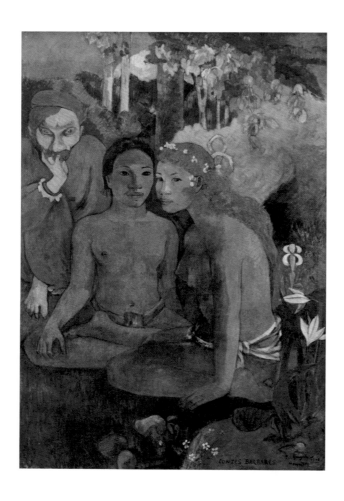

1883
□ Art dealer Fritz Gurlitt organizes the first Impressionism exhibition in Germany at his gallery in Berlin (October). The works come from the collection of Carl and Felicie Bernstein in Berlin and from art dealer Paul Durand-Ruel in Paris.

1888–89
■ Emergence of the Nabis (from the Hebrew word for "prophet"), a group of art students at the Académie Julian in Paris who embrace the decorative function of painting and reject traditional norms and linear perspective. The group includes Paul Sérusier, Maurice Denis, Pierre Bonnard, and Edouard Vuillard.

1890
■ Vincent van Gogh dies on July 29 in Auvers-sur-Oise, near Paris, of gunshot wound.

1892
□ Norwegian avant-garde painter Edvard Munch is included in an exhibition of the Association of Berlin Artists in November; his work prompts such a scandal that the exhibition is closed within a few days and is widely discussed in the national and international press.

■ American illustrator Lyonel Feininger, after spending several years in Germany, settles in Paris and studies at the Académie Colarossi.

■ Henri Matisse enrolls at the École des Arts Décoratifs in Paris, where he makes the acquaintance of fellow student Albert Marquet.

■ Raoul Dufy begins taking evening classes at the École municipale des Beaux-Arts in Le Havre, where he meets Othon Friesz. He is later joined at the school by Georges Braque.

1894
□ The arts and literary periodical *Pan* is founded in Berlin (published between 1895 and 1900), with critic Julius Meier-Graefe and writer Otto Julius Bierbaum as its art editors; it is financially supported by writer and patron Harry Kessler. One of the most important platforms for Art Nouveau in Germany, it features original graphics by artists such as Franz von Stuck, Max Klinger, Paul Signac, and Félix Vallotton.

● First exhibition of La Libre Esthétique, an artistic society founded in 1893 in Brussels to carry on the work of the Groupe des Vingt (Les XX, or the Twenty). The annual exhibition features the works of Belgian painters as well as foreign artists and becomes essential in spreading Neo-Impressionism and Post-Impressionism. Paul Gauguin shows five works at the first exhibition.

1895
■ Matisse is accepted by the École des Beaux-Arts in Paris and enrolls in the class taught by Symbolist painter Gustave Moreau. Marquet and Henri Manguin also join Moreau's class.

1896
□ Art historian Hugo von Tschudi is appointed director of the National Gallery, Berlin, and starts to acquire works by Edouard Manet and the Impressionists. He frequently visits museums, galleries, and collectors in Paris and throughout Europe.

□ Alexei Jawlensky and Marianne Werefkin move to Munich from St. Petersburg. Wassily Kandinsky moves to Munich from Moscow in December.

1897
□ German painter and collector Curt Herrmann begins his friendship with Belgian artist and designer Henry van de Velde and makes the acquaintance of Julius Meier-Graefe; Herrmann starts to collect modern French art.

July
■ Dutch painter Kees van Dongen travels to Paris, where he stays until 1898.

October
□ Tschudi purchases *Mill on the Couleuvre at Pontoise* by Paul Cézanne for the National Gallery in Berlin. This first purchase of a Cézanne by a museum is widely commented on in France. (Two paintings by Cézanne had already entered the Musée du Luxembourg

Paul Gauguin
Barbarian Tales, 1902
Oil on canvas
51¾ × 35⅝ in. (131.5 × 90.5 cm)
Museum Folkwang, Essen

Paul Cézanne
Mill on the Couleuvre at Pontoise, 1881
Oil on canvas
28¹⁵⁄₁₆ × 36 in. (73.5 × 91.5 cm)
Staatliche Museen zu Berlin,
Nationalgalerie

in Paris in 1896 through the bequest by Impressionist painter Gustave Caillebotte.)

November
■ Art dealer Ambroise Vollard organizes the first Cézanne solo exhibition at his gallery in rue Laffitte, Paris.

December
■ Kessler discovers Neo-Impressionism in Paris through Maximilien Luce and Paul Signac.

1898
□ Cousins Bruno and Paul Cassirer open the Kunstsalon Bruno & Paul Cassirer in Berlin.

□ The Berlin Secession is established with Bruno and Paul Cassirer as secretaries.

□ Neo-Impressionism exhibition at Galerie Keller & Reiner in Berlin (October–November).

1899
May □ Opening of the First Berlin Secession exhibition, mainly exhibiting works by artists from Germany and German-speaking countries, including Lovis Corinth, Max Liebermann, Käthe Kollwitz, Arnold Böcklin, and Ferdinand Hodler.

Autumn
■ Emil Nolde travels from Munich to Paris and attends the Académie Julian; he stays until 1901.

■ In Paris, Meier-Graefe opens La Maison Moderne, a gallery devoted to Art Nouveau works, in the rue des Petits-Champs; the interior is designed by Henry van de Velde.

October
■ Van Dongen settles in Paris permanently.

1900
□ Kandinsky studies with Symbolist painter Franz von Stuck in Munich. Hans Purrmann and Paul Klee are also among Stuck's students.

■ André Derain becomes acquainted with Maurice de Vlaminck, and both artists start to work in Chatou, a small town on the Seine in the suburbs of Paris.

January
■ Paula Modersohn-Becker travels to Paris, where she stays until June, studying at the Académie Colarossi and at the École des Beaux-Arts and making the acquaintance of Emil Nolde. She probably sees an exhibition of the Nabis at Galerie Bernheim-Jeune. That spring she discovers Cézanne's work at the gallery of Ambroise Vollard.

March
□ Franz Marc enrolls at the Academy of Fine Arts in Munich.

● Seventh exhibition of La Libre Esthétique in Brussels, with works by Louis Valtat and Signac (March 1–31).

Spring
□ Second Berlin Secession exhibition.

April
■ Galerie Bernheim-Jeune presents Nabis exhibition, with works by Pierre Bonnard, Maurice Denis, Aristide Maillol, Paul Sérusier, Félix Vallotton, and Edouard Vuillard.

■ The Exposition Universelle opens in Paris at the Grand Palais (April 15–October 15), including works by many German and other foreign artists, including Paul Baum, Karl Hofer, Max Liebermann, Cuno Amiet, Wilhelm Uhde, Kees van Dongen, Gustav Klimt, and others. Nolde and Pablo Picasso are among the artists who visit the exhibition.

Autumn
■ Matisse studies at the Académie Carrière in Paris, where he meets André Derain.

November
□ Group exhibition at Kunstsalon Bruno & Paul Cassirer in Berlin, including thirteen paintings by Cézanne (November–early January 1901), twelve of which are lent by French art dealer Paul Durand-Ruel. *Still Life with Apples and Pears* (plate 10) is among the Cézanne works shown.

1901
□ Bruno and Paul Cassirer end their business partnership, and the gallery is renamed Galerie Paul Cassirer.

□ Kandinsky founds the Phalanx association with other Munich-based artists, with the aim of exhibiting work by German artists as well as artists from outside Germany. The Phalanx painting school opens over the winter of 1901–2.

□ Gauguin's lithograph *Spirit of the Dead Watching*, based on a painting done in Tahiti, is acquired by the Kupferstichkabinett in Berlin; it is probably the first work by Gauguin to enter a German museum.

□ Christian Rohlfs moves to Hagen, where he is given a studio at the future Folkwang Museum and studies French art in the collection of Karl Ernst Osthaus, an important patron of avant-garde art and architecture.

■ Picasso settles permanently in Paris.

January
□ Modersohn-Becker visits Berlin, going to Galerie Cassirer as well as museums.

March
■ Galerie Bernheim-Jeune in Paris presents the first Van Gogh retrospective, organized by French poet and art critic Julien Leclercq, with

seventy-one paintings (March 15–31). André Derain introduces Matisse to Vlaminck during one of their visits. Paul Cassirer also attends.

● Eighth exhibition of La Libre Esthétique in Brussels (March 1–31).

Spring
□ Third Berlin Secession exhibition, including five Van Gogh paintings, among them *Self-Portrait with Bandaged Ear and Pipe* (cat. 73).

■ Seventeenth Salon des Indépendants in Paris presents works by Cézanne, Marquet, Matisse, Henri Rousseau, and others (April–May).

Summer
□ Ernst Ludwig Kirchner begins to study architecture at the Technical Institute of Saxony in Dresden.

December
□ Galerie Cassirer in Berlin presents first one-man exhibition of Van Gogh in Germany with nineteen works, including *The Poplars at Saint-Rémy* (plate 57) and *Wheatfield with Reaper* (plate 49) (December–January 1902).

□ Fourth Berlin Secession exhibition (graphic arts).

1902
□ Gabriele Münter becomes Kandinsky's student at the Phalanx school in Munich.

■ Georges Braque moves to Paris, where he reconnects with his friends Dufy and Friesz.

■ Curt Herrmann travels to Paris in order to prepare an exhibition on Neo-Impressionism for Paul Cassirer. He visits Signac and also meets Belgian Neo-Impressionist painter Théo van Rysselberghe.

January
□ Second Phalanx exhibition in Munich.

February
● Ninth exhibition of La Libre Esthétique in Brussels.

Spring
□ Fifth Berlin Secession exhibition.

■ Eighteenth Salon des Indépendants in Paris, with works by Bonnard, Marquet, Matisse, Manguin, Rousseau, and others (March–May).

April
□ *Farbenschau* (Color Show) exhibition at the Kaiser Wilhelm Museum in Krefeld, organized by Friedrich Deneken, displaying eight works by Signac and six by Curt Herrmann.

May
■ In Paris, Kessler visits the Salon des Indépendants, where he sees works by Signac, Henri-Edmond Cross, Denis, and Vuillard. He

buys Signac's *Samois: Morning Mist* (Prague, Národní Galerie v Praze). Tschudi and Kessler visit Van Rysselberghe and Signac in Paris and Auguste Rodin in Meudon. Tschudi acquires oil and watercolor studies from Signac.

July
□ Karl Ernst Osthaus opens the Museum Folkwang in Hagen.

August
■ German poet Rainer Maria Rilke travels to Paris to write his Rodin monograph.

October
□ Bruno Cassirer begins publishing the periodical *Kunst and Künstler*, presenting modern art (with an emphasis on French art).

Winter
□ Sixth Berlin Secession exhibition (graphic arts).

1903
□ Kessler becomes vice president of the Deutscher Künstlerbund (German Artists League), which he launches together with Alfred Lichtwark (director of the Hamburg Kunsthalle), Lovis Corinth, Max Liebermann, and others.

□ Publication of German translation (by Sophie Herrmann) of Signac's 1899 treatise *D'Eugène Delacroix au néo-impressionnisme* (From Eugène Delacroix to Neo-Impressionism).

January
□ Exhibition of French, Belgian, and German Neo-Impressionists at Galerie Cassirer (first in Hamburg and then in Berlin), conceived by Herrmann and including works by Signac, Cross, Van Rysselberghe, Luce, Paul Baum, Herrmann, and Rohlfs.

● *Die Entwicklung des Impressionismus in Malerei und Plastik* (The Evolution of Impressionism in Painting and Sculpture) exhibition at the Vienna Secession (January–February).

February
□ Munich Secession exhibition, including seven paintings by Van Gogh (February–March).

■ Modersohn-Becker returns to Paris and stays until March, visiting the Musée du Luxembourg, the Louvre, and Rodin's studio. She spends time with Rilke (then Rodin's secretary).

● Tenth exhibition of La Libre Esthétique in Brussels.

March
□ Kessler is appointed director of the Grand Ducal Museum of Arts and Crafts in Weimar.

□ Rilke's monograph on Rodin is published in Berlin.

■ Osthaus travels to Paris and probably sees paintings by Gauguin at Galerie Vollard.

Spring
□ Seventh Berlin Secession exhibition, with works by Cézanne, Gauguin, Bonnard, and Van Gogh.

■ Galerie Bernheim-Jeune in Paris presents an exhibition on Vallotton and Vuillard (April 27–May 10).

May
□ Phalanx exhibition in Munich, organized by Kandinsky and others, includes sixteen works by Claude Monet; it is the first major exhibition of his work in Germany.

□ Munich Secession exhibition, including works by Jawlensky.

■ Paul Gauguin dies on May 8 in Hiva Oa, on the Marquesas Islands, in French Polynesia.

■ Jawlensky travels to Normandy, where he rejoins Werefkin. They travel together to Paris, where they visit Galerie Vollard.

■ Marc travels to Paris with Friedrich Lauer, a fellow art student from Munich. They decide to extend their stay to several months, also traveling to the Loire Valley, Brittany, and Normandy. Returning to Munich in September, Marc abandons the academy completely.

August
□ *Deutsche und französische Impressionisten und Neo-Impressionisten* (German and French Impressionists and Neo-Impressionists) at the Grand Ducal Museum in Weimar, with works by Signac, Bonnard, Denis, Cross, Herrmann, Luce, Vuillard, and Van Rysselberghe, including the latter's *Beach at Low Tide, Ambleteuse, Evening* (plate 138) and Signac's *Samois, the Bank, Morning* (plate 144).

October
□ *Ausstellung der Holländischen Secession* (Dutch Secession Exhibition) in Wiesbaden, with fifteen paintings by Van Gogh, including his *Restaurant of the Siren at Asnières* (plate 56) and *The Poplars at Saint-Rémy* (plate 57) (October 4–30).

■ First Salon d'Automne is held in Paris at the Petit Palais, which Kessler attends (October 31–December 6). The Salon honors Gauguin with a room of five paintings and four studies.

■ Max Beckmann leaves the Grand Ducal School of Arts in Weimar and moves to Paris, where he remains until early 1904. In December he attends the Académie Julian alongside fellow students Corinth, Ernst Barlach, Modersohn-Becker, and Kollwitz.

November
□ Phalanx exhibition in Munich with *Germinal* portfolio published in 1899 by Meier-Graefe,

featuring woodcuts and lithographs by Bonnard, Denis, Van Gogh, Rodin, Van Rysselberghe, Vuillard, Gauguin, Vallotton, and others. Kirchner visits the exhibition.

■ In Paris, Galerie Vollard presents a posthumous exhibition of Gauguin (November 4–28), including his *Barbarian Tales* (p. 62), subsequently acquired by Osthaus. Kessler attends and acquires Gauguin's *Spirit of the Dead Watching*.

December
□ Osthaus organizes a small exhibition of Gauguin works drawn from his collection and from Vollard.

□ Eighth Berlin Secession exhibition (graphic arts).

Winter
□ Kirchner continues his architectural studies at the Royal College of Science and Technology in Munich and attends graphic art classes taught by Hugo Steiner-Prag at the Debschitz School, where he produces his first woodcuts. He returns to the Technical Institute in Dresden in 1904, where he meets fellow student Erich Heckel.

1904
□ Several private collectors in Germany acquire paintings by Gauguin, including Tschudi, Julius Stern (director of the National Bank of Germany), and lawyer and musician Felix von Rath.

□ Meier-Graefe publishes his *Entwickelungsgeschichte der modernen Kunst* (Developmental History of Modern Art), including one chapter on Cézanne.

Paul Gauguin
Spirit of the Dead Watching, 1892
Oil on burlap mounted on canvas
45 ¹¹⁄₁₆ × 53 in. (116.1 × 134.6 cm)
Albright-Knox Art Gallery, A. Conger Goodyear
Collection, 1965

■ German art dealer and collector Wilhelm Uhde settles in Paris.

■ In Paris, Tschudi meets painter Émile Bernard, who had been a friend of Van Gogh and an artistic colleague of Gauguin as part of the Pont-Aven school. He probably introduces Tschudi to Gauguin's work.

February

☐ The Kaiser Wilhelm Museum in Krefeld presents the exhibition on Impressionism and Neo-Impressionism that originated in Weimar in 1903, including works by Gauguin and Van Gogh, lent by Vollard and Osthaus. Münter and Kandinsky probably see the exhibition.

☐ Kessler acquires three Cézanne paintings from Vollard. (Kessler notes February in his diary, although Vollard notes the acquisition as of November.)

■ Gauguin exhibition at Galerie Vollard in Paris.

■ Twentieth Salon des Indépendants in Paris (February 21–March 24), with works by Van Dongen, Dufy, Manguin, Matisse, Munch, Vallotton, and Valtat, among others. Kessler and Beckmann visit the Salon.

● Eleventh La Libre Esthétique exhibition in Brussels, including several paintings by Cézanne and Gauguin (February 15–March 29). The show is visited by Kessler.

March

☐ Osthaus acquires further paintings by Gauguin, including *Young Girl with a Fan*.

☐ Tenth Phalanx exhibition in Munich (March 27–May 1), including works by Signac, Van Rysselberghe, Vuillard, Bonnard, Luce, and Vallotton.

☐ The Grand Ducal Museum in Weimar presents exhibition with works by Manet, Monet, Renoir, and Cézanne.

Spring

☐ Ninth Berlin Secession exhibition.

☐ Exhibition of modern French artists at Galerie Arnold in Dresden, including works by Baum, Cross, Denis, Herrmann, Luce, Pissarro, and Van Rysselberghe.

April

☐ Cézanne exhibition, featuring about thirty paintings, shown at Galerie Cassirer in Berlin (April 22–June 15).

☐ *Linie und Form* (Line and Form) exhibition at Kaiser Wilhelm Museum in Krefeld (April 19–June 5), with works by Denis, Van Gogh, and Gauguin.

■ Galerie Bernheim-Jeune in Paris presents exhibition on the Nabis.

May

■ First issue of the periodical *Les Tendances Nouvelles* (New Trends), founded by painter Alexis Mérodack-Jeanneau.

June

■ Kandinsky presents several works at the exhibition *Les Tendances Nouvelles* in Paris.

■ First solo exhibition of Matisse's works (from 1897 to 1903) at Galerie Vollard, featuring forty-five paintings and one drawing (June 1–18).

July

☐ Rodin exhibition at the Grand Ducal Museum in Weimar, showing sculpture, photographs, and drawings.

August

☐ *Die Schule von Pont-Aven* (The School of Pont-Aven) exhibition at the Munich Kunstverein, with forty-six paintings by Gauguin and works by Bernard and Van Gogh (opens August 20).

October

☐ Exhibition of Impressionist and Neo-Impressionist works at Galerie Emil Richter in Dresden, including at least one Cézanne.

■ Second Salon d'Automne at the Grand Palais, including several paintings by Matisse (opens October 15). One entire gallery dedicated to Cézanne presents thirty-one paintings and two drawings.

Paul Gauguin
Young Girl with a Fan, 1902
Oil on canvas
36 ³⁄₁₆ × 28 ¹¹⁄₁₆ in. (91.9 × 72.9 cm)
Museum Folkwang, Essen

November

☐ Exhibition at Galerie Cassirer in Berlin, showing forty-three works by Van Gogh and various German artists (November 22–mid-December).

■ Kandinsky visits Paris; he shows his work at Galerie des Tendances Nouvelles and the Salon d'Automne, where he is awarded a medal for his work.

■ Van Dongen solo exhibition at Galerie Vollard (November 15–25).

December

☐ At the Grand Ducal Museum in Weimar, Kessler presents an exhibition of French artists, including Signac, Seurat, Denis, Maillol, and Gauguin.

● Münter and Kandinsky travel to Tunisia (via Strasbourg, Basel, Lyon, and Marseille), where they stay until April 1905.

1905

February ☐ Bonnard visits Curt Herrmann and his wife in Berlin, where he paints his portrait of Sophie Herrmann. He also travels to Weimar and Kassel (through March).

■ In Paris, Kessler visits French collector Gustave Fayet, who owns an extensive Gauguin collection.

■ Modersohn-Becker's third trip to Paris. She takes classes at the Académie Julian and visits the Salon des Indépendants, where she sees works by Matisse and retrospectives of Seurat and Van Gogh. Fascinated by Denis, Vuillard, and Bonnard, she visits Denis's workshop in March. She and her husband (painter Otto Modersohn) see the Fayet collection of Gauguins.

■ *1ère Exposition des Intimistes* (First Exhibition of the Intimists) at Galerie Henry Graves in the rue de Caumartin in Paris, with works by Bonnard, Vuillard, and Matisse (February 5–25).

● Twelfth La Libre Esthétique exhibition in Brussels. Nolde exhibits several works.

March

☐ Third Impressionism and Neo-Impressionism show at the Grand Ducal Museum in Weimar, with works by Signac, Van Rysselberghe, Cross, Luce, and Denis.

■ Twenty-first Salon des Indépendants in Paris, including Seurat and Van Gogh retrospectives (March 24–April 30). Matisse, Derain, Vlaminck, Marquet, Manguin, and Rousseau also present several works, including the latter's *The Wedding* (plate 137).

April

☐ Galerie Cassirer in Berlin shows more than twenty Van Gogh paintings, including *Restaurant*

of the Siren at Asnières (plate 56) (April 29–May 25). All of them are lent by Johanna van Gogh-Bonger, widow of Van Gogh's brother Theo.

May

☐ Galerie Richter in Dresden shows forty works by Cuno Amiet in an exhibit seen by the future Brücke artists. They will invite Amiet to join the group in September 1906.

☐ Deutscher Künstlerbund exhibition at the new Berlin Secession building in the Kurfürstendamm (through October).

■ Matisse settles in Collioure in the South of France for the summer; he is joined by Derain in July.

■ Klee travels with Swiss painter Louis Moilliet to Paris.

June

☐ June 7: The Brücke (Bridge) artists group is founded in Dresden by Kirchner, Heckel, Fritz Bleyl, and Karl Schmidt-Rottluff.

☐ Group exhibition at Galerie Cassirer in Berlin, including a Cézanne still life.

■ Maillol introduces Matisse to Georges-Daniel de Monfreid, a close friend of Gauguin with a large collection of his works. Matisse abandons Neo-Impressionism and adopts a broad palette and flat areas of color, exemplified in *Open*

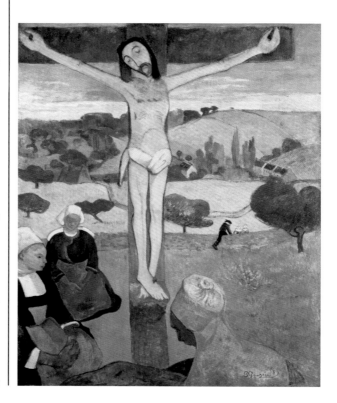

Paul Gauguin
The Yellow Christ, 1889
Oil on canvas
36¼ × 28⅞ in. (92.1 × 73.3 cm)
Albright-Knox Art Gallery, General
Purchase Funds, 1946

Window, Collioure (plate 110), shown at the Salon d'Automne the same year.

July
☐ Gauguin exhibition in Weimar, at the Grand Ducal Museum, organized by Harry Kessler (July 7–September 15). The thirty-three works (paintings, drawings, and one sculpture), including *The Yellow Christ* and *Haystacks in Brittany* (plate 45), are mainly from the collections of Gustave Fayet, Maurice Fabre, and de Monfreid. Nolde attends the exhibition.

September
☐ Galerie Cassirer in Hamburg shows fifty-four Van Gogh paintings, including *Thatched Sandstone Cottages at Chaponval* (plate 51). The exhibition travels to Galerie Arnold in Dresden (October 26–November 11), where it is seen by the Brücke members.

■ Beckmann honeymoons with wife Minna Tube in Paris.

October
■ Third Salon d'Automne at the Grand Palais, showing works by Matisse, Jawlensky, and Kandinsky, among others (October 18–November 25).

■ French art critic Louis Vauxcelles, writing the review of the Salon, uses the term *Fauves* ("wild beasts") to describe the works by Matisse, Derain, Vlaminck, and others—inadvertently coining the movement's name.

■ Group exhibition of Charles Camoin, Derain, Dufy, Manguin, Matisse, and Vlaminck at Galerie Berthe Weill in Paris (October 21–November 20).

■ Van Dongen exhibition, *Une Saison*, at Galerie Druet in Paris (October 23–November 11).

November
☐ Modersohn-Becker visits the Folkwang Museum in Hagen and meets the Osthauses.

☐ Kunsthandlung Beyer & Sohn in Leipzig presents the first Brücke group show, featuring works on paper.

■ Hans Purrmann settles in Paris.

December
☐ Exhibition of still lifes in Berlin at Galerie Keller & Reiner, including one work by Cézanne.

1906
☐ Jean de Rotonchamp publishes the first French monograph on Gauguin in Paris, but it is printed in Weimar and promoted by Kessler.

☐ Tschudi acquires a second Gauguin painting for his own collection.

☐ The first annual Brücke print folio, with works by Bleyl, Heckel, and Kirchner,

is published. Seven portfolios in total were published from 1906 to 1912.

■ Jawlensky and Werefkin spend the major part of the year in France, between Brittany, the South of France, and Paris. Jawlensky also visits Arles "in search of Van Gogh."

January
☐ Nolde exhibition at Galerie Arnold in Dresden (through March). After members of the Brücke see the show, the group invites Nolde to join them.

☐ *Jahrhundertausstellung deutscher Kunst 1775–1875* (Centennial Exhibition of German Art), organized by Tschudi and Meier-Graefe, opens at the National Gallery in Berlin (through May).

☐ Exhibition of watercolor drawings by Rodin at the Grand Ducal Museum in Weimar, including *Female Nude from Behind, Her Left Arm Raised*. This exhibition incites critics to turn against Kessler, eventually forcing him to resign from the directorship of the museum.

● Galerie Miethke in Vienna presents Van Gogh exhibition.

February
☐ International Art Exhibition at Bremer Kunstverein, with two landscapes by Cézanne and works by Van Gogh, Jawlensky, and Nolde.

☐ Group exhibition at Galerie Cassirer, including a Cézanne landscape, *Village by the Sea* (location unknown).

Auguste Rodin
Female Nude from Behind, Her Left Arm Raised,
c. 1900
Graphite on paper with pink and brown water coloring
12 ⅞ × 9 ¹³⁄₁₆ in. (32.7 × 25 cm)
Klassik Stiftung Weimar

■ Modersohn-Becker travels to Paris for the fourth time, staying until March 1907. Probably visits the collection of Sarah and Michael Stein; they live close to her in the rue Madame and their collection is open to the public every Saturday. Probably sees Cézanne paintings at Vollard's gallery in March and visits the Salon des Indépendants. Travels to Brittany in April.

● Thirteenth La Libre Esthétique exhibition in Brussels, including works by Manguin, Marquet, and Matisse (February 22–March 25).

Spring
□ Eleventh Berlin Secession exhibition, including Neo-Impressionist paintings by Bonnard, Signac, and Cross, as well as two Gauguins and works by Jawlensky and Kandinsky.

March
□ Nolde and his wife visit Osthaus in Hagen, and meet painter Christian Rohlfs in Soest.

■ Matisse solo exhibition at Galerie Druet, presenting fifty-five paintings alongside sculptures, watercolors, lithographs, and woodcuts (March 19–April 7).

■ Twenty-second Salon des Indépendants (March 20–April 30), which includes Matisse's *The Joy of Life* (The Barnes Foundation) as well as works by other Fauve artists and Rousseau.

● Derain travels to London for the first time to work on a series of city views.

● Marc travels to Greece with his brother Paul, returning to Munich via Italy at the end of April.

April
■ Osthaus visits Cézanne in Aix-en-Provence. He buys two paintings, including *Bibémus Quarry*.

May
□ 3. *Deutsche Kunstgewerbeausstellung* (Third Exhibition of German Decorative Art) opens in Dresden, presenting a major survey of art and design (through October). The exhibition includes the *Dritte Neo-Impressionisten Ausstellung* (Third Neo-Impressionist Exhibition) organized by Kessler in Weimar; the exhibition interiors are designed by Van de Velde. Max Pechstein, who contributes several mosaics and wall paintings to the exhibition, meets Heckel on this occasion and joins the Brücke shortly afterward.

□ The Kaiser Friedrich Museum in Posen (now Poznań, Poland) shows an exhibition of French Impressionist paintings as well as works by Van Gogh and Cézanne.

■ Kandinsky and Münter travel to France (via Genoa, Milan, Lucerne, and Basel), arriving in Paris on May 22. They move to Sèvres in June and stay for a year. Kandinsky shows works

on paper at the Salon des Indépendants and publishes woodcuts in *Les Tendances Nouvelles*. He also shows works at the *Musée du Peuple* exhibition in Angers.

■ Galerie Bernheim-Jeune in Paris presents Vallotton exhibition (May), followed by Vuillard exhibition (May–June).

July
□ The Brücke artists present prints at Kunsthandlung Beyer & Sohn in Leipzig (through August); the show travels to the Katharinenhof in Frankfurt am Main.

■ Feininger settles in Paris (with some interruptions) until May 1908, and studies again at the Académie Colarossi. Meets Purrmann and Oskar Moll and the Café du Dôme circle. Begins painting in oil.

August
■ Modersohn-Becker visits Rousseau's workshop in Paris.

September
□ First group exhibition of the Brücke in Dresden at the lamp factory of Karl-Max Seifert, including Amiet's *Portrait of the Violinist Emil Wittwer-Gelpke* (plate 2).

□ *Ausstellung französischer Künstler* (Exhibition of French Artists) debuts at the Munich Kunstverein, then travels to Frankfurt (October), Dresden (November), Karlsruhe (December), and Stuttgart (January). The show is organized by art historian Rudolf Adelbert Meyer and art dealer Eugène Druet, and includes works by Cézanne, Gauguin, Van Gogh, Matisse, Manguin, and Marquet, as well as Neo-Impressionists and numerous photographic reproductions of Gauguin's works.

Paul Cézanne
Bibémus Quarry, 1888–90
Oil on canvas
25⅝ × 31⅞ in. (65 × 81 cm)
Museum Folkwang, Essen

October

■ Paul Cézanne dies on October 23 in Aix-en-Provence.

■ Braque and Friesz sojourn in the South of France until February 1907. Following Cézanne's footsteps, they spend their time primarily in L'Estaque.

■ Fourth Salon d'Automne at the Grand Palais, including a Gauguin retrospective (October 6–November 15); his *Swineherd* (plate 44) is among the works presented. An exhibition of Russian art, *Deux siècles d'art russe* (Two Centuries of Russian Art), is organized as part of the Salon and includes works by Kandinsky and Jawlensky. Curt Herrmann shows at the Salon as well and acquires paintings by Matisse, including *Canal du Midi* (private collection), and Derain.

November

■ Münter returns to Paris for a month and frequents the drawing class of Théophile Steinlen at the Académie Grande Chaumière.

■ Bonnard exhibition at Galerie Bernheim-Jeune.

December

☐ Exhibition of woodcuts by Brücke artists at the Seifert lamp factory in Dresden.

☐ Twelfth Berlin Secession exhibition (graphic arts), including works by Brücke artists and Kandinsky, and thirty drawings by Van Gogh.

1907

January ■ Large Signac retrospective at Galerie Bernheim-Jeune (through February); the show may have been seen by Kandinsky and Münter.

February

☐ Heckel visits Osthaus's collection in Hagen, where he views his Gauguin paintings.

■ German art dealer Daniel Henry Kahnweiler arrives in Paris.

■ Modersohn-Becker and her husband visit Rodin in Meudon, near Paris, and also make excursions to Versailles, Fontainebleau, Barbizon, and Saint-Denis.

March

☐ Finnish artist Akseli Gallen-Kallela joins the Brücke.

■ Twenty-third Salon des Indépendants at the Grand Palais, including a retrospective of Cézanne's works (March 20–April 30). Matisse is a member of the committee and presents his *Blue Nude* (p. 175). Münter presents six paintings. Braque presents several of his works from L'Estaque, of which Uhde acquires five.

■ Marc travels to Paris at the end of March, where he visits Van Gogh and Gauguin exhibitions.

■ Modersohn-Becker sees Auguste Pellerin's Cézanne collection in Paris shortly before her departure.

● Galerie Miethke in Vienna presents several works by Cézanne, Denis, Marquet, Matisse, Signac, Valtat, and Gauguin.

● Fourteenth exhibition of La Libre Esthétique in Brussels.

Spring

☐ Thirteenth Berlin Secession exhibition, with ten Van Gogh paintings. Heckel visits the exhibition.

■ Galerie Bernheim-Jeune in Paris presents Cross exhibition (April–May).

May

☐ Kunsthalle Mannheim presents an exhibition including several works by Van Gogh (May 1–October 20).

☐ Kaiser Wilhelm Museum in Krefeld presents an exhibition of French art with works by Signac (through July).

☐ Schmidt-Rottluff spends several months in and around Dangast, on the North Sea. He is joined later by Heckel. Both artists paint several landscapes during this time.

■ Kahnweiler opens his gallery in Paris in rue Vignon.

June

☐ Museum Folkwang in Hagen presents works by Brücke artists.

■ August Macke travels to Paris for four weeks, financially supported by art patron Bernhard Koehler Sr. (the uncle of Elisabeth Gerhardt, Macke's future wife).

September

☐ Exhibition of the Brücke at Galerie Richter, Dresden.

☐ In Berlin, Paul Cassirer shows works by Matisse, including *Red Rugs* (plate 112) and *The Geranium* (Art Institute of Chicago) alongside watercolors by Cézanne and works by Munch and Curt Herrmann (September 29–October 18). Heckel and Schmidt-Rottluff may have seen this show.

☐ Kandinsky and Münter travel to Berlin, where they sojourn until April 1908.

October

☐ Osthaus acquires *Still Life with Asphodels* (p. 72) by Matisse.

☐ Folkwang Museum in Hagen shows works by Braque, Dufy, and other French artists.

☐ The Deutscher Werkbund, an association of artists, architects, and industrialists, is founded in Munich by Peter Behrens and others.

■ Cézanne retrospective at the Fifth Salon d'Automne (October 1–21). Matisse's paintings *Red Madras Headdress* (The Barnes Foundation) and *Le Luxe I* (Musée national d'art moderne, Centre Georges Pompidou) are also presented at the Salon, along with twelve works by Kandinsky, six prints by Münter, and Rousseau's *The Snake Charmer* (Musée d'Orsay).

November

☐ Paula Modersohn-Becker dies of an embolism on November 20 in Worpswede, Germany.

☐ The periodical *Kunst und Künstler* publishes German translation of Gauguin's travel journal *Noa Noa*.

■ Kahnweiler buys a group of paintings from Van Dongen to be sold at his gallery.

■ Exhibition at Galerie Berthe Weill in Paris, with works by Camoin, Derain, Manguin, Marquet, Matisse, Vlaminck, and Van Dongen (opens November 2).

December

☐ Galerie Eduard Schulte in Berlin presents its first joint exhibition of German and French artists, including six works by Gauguin, as well as the Nabis, Fauvists, Robert Delaunay, and Picasso (opens December 8). Macke, who is studying in Berlin with Corinth, visits the exhibition with Koehler Sr., who later acquires Gauguin's *Portrait of the Artist's Mother*.

☐ Fourteenth Berlin Secession exhibition (graphic arts), with works by Brücke artists, Van Gogh, and Van Rysselberghe, among others. The show (held at Galerie Cassirer due to rennovations of the Secession Building) also presents drawings by Matisse, lent mostly by Edward Steichen. Macke visits the exhibition.

☐ *Französische Kunstausstellung* (French Art Exhibition) at the Kaiser Wilhelm Museum in Krefeld.

☐ Matisse exhibition at the Museum Folkwang, with seven of his paintings, including *Still Life with Asphodels*.

☐ Late 1907: Nolde and Bleyl leave the Brücke.

■ Galerie Bernheim-Jeune in Paris shows portraits by Van Gogh, Gauguin, Cézanne, Matisse, and Van Dongen, including the latter's *Modjesko, Soprano Singer* (plate 27).

■ After visiting Italy, Pechstein travels via Switzerland to Paris, where he stays until April 1908.

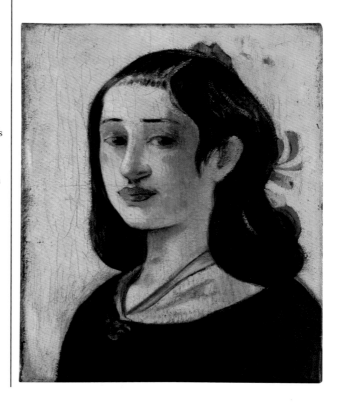

Henri Matisse
Still Life with Asphodels, 1907
Oil on canvas
45⅞ x 35 in. (116.5 x 89 cm)
Museum Folkwang, Essen

Paul Gauguin
Portrait of the Artist's Mother, c. 1890
cat. 56

■ Late 1907: Jawlensky visits Matisse's studio in Paris, where he most likely sees *Red Madras Headdress*.

■ Oskar and Margarethe Moll sojourn in Paris, where they frequent the Café du Dôme and become closely acquainted with Matisse.

1908

□ Tschudi is dismissed from his position as director by Kaiser Wilhelm II because of his numerous acquisitions of French avant-garde art for the National Gallery. He is replaced by Ludwig Justi.

□ Kunstsalon Friedrich Cohen in Bonn shows woodcuts and linocuts by Münter made after her return from Paris, demonstrating her reception of the Nabis and Fauves.

□ Van Dongen exhibition at Galerie Flechtheim in Düsseldorf.

□ Osthaus acquires *A Walk in the Vineyard* (plate 153) by Vuillard for his Villa Hohenhof in Hagen, the interior of which is designed by Henry van de Velde.

□ Matisse and Munch are invited to join the Brücke, but neither becomes a member.

■ Uhde organizes the first Rousseau solo exhibition at his gallery in Paris; however, having forgotten to include the address on the invitation, no one attends the exhibition.

January
□ Vollard sells works by Vlaminck and Maillol to the Städel Museum in Frankfurt.

□ Macke visits Osthaus's collection in Hagen for the first time.

■ Académie Matisse opens in Paris with a group of about ten students, including Hans Purrmann, Oskar and Margarethe Moll, and Max Weber.

■ Galerie Druet shows thirty-five Van Gogh paintings (January 6–18).

■ Galerie Bernheim-Jeune shows one hundred Van Gogh paintings (January 6–February 1). Pechstein visits both Van Gogh exhibitions.

February
□ Galerie Brakl & Thannhauser in Munich shows twenty-three works by young painters from France, including Van Dongen.

March
□ Galerie Cassirer shows twenty-seven paintings by Van Gogh in Berlin (March 5–22).

□ Galerie Brakl & Thannhauser in Munich presents seventy-one Van Gogh paintings, and

Jawlensky acquires *The House of Père Pilon* (private collection).

□ Kunstsalon W. Zimmermann in Munich shows thirteen works by Van Gogh and eight by Gauguin (March 23–April 15).

■ Van Dongen exhibition at Galerie Kahnweiler (March 2–28).

■ Twenty-fourth Salon des Indépendants (March 20–May 2). Kandinsky and Münter each present six prints.

● Fifteenth La Libre Esthétique exhibition in Brussels.

Spring
□ Munich Secession (March–May), including works by Cézanne and drawings by Klee, who attends the exhibition.

□ Fifteenth Berlin Secession exhibition, with works by Marquet, Van Dongen, and Van Gogh.

April
□ In Munich, Jawlensky meets Polish painter Wladyslaw Slewinski, who had been a friend of Gauguin and owned some of his works. Jawlensky turns from Neo-Impressionism and Matisse to Gauguin, and will introduce Kandinsky and Münter to Gauguin.

■ Pechstein sojourns again in Paris until July. He participates in the Salon des Indépendants, and meets Van Dongen and possibly Derain.

■ Galerie Bernheim-Jeune presents Van Rysselberghe exhibition.

May
□ The Van Gogh exhibition (shown in March at Brakl & Thannhauser) is shown in Dresden at Galerie Richter, where Kirchner sees it; he paints *Landscape with Houses and Man*, inspired

Henry van de Velde's music room at Karl Ernst Osthaus's Villa Hohenhof, with Edouard Vuillard's painting *A Walk in the Vineyard* (plate 153)

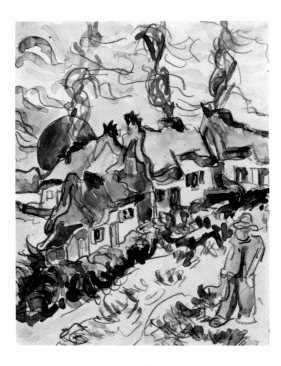

by one of Van Gogh's paintings. The exhibition then travels to the Frankfurt Kunstverein.

June
☐ Matisse is in Germany with Purrmann, visiting Speyer, Munich, Nuremberg, and Heidelberg, where they meet with Matisse's former students Oskar and Margarethe Moll.

July
☐ Exhibition by the Brücke at Galerie Richter. Also presents works by Van Dongen, Friesz, Marquet, and Vlaminck.

■ Group exhibition in Paris, with works by Camoin, Friesz, Manguin, and Marquet, at Galerie Druet.

■ Macke travels to Paris with Koehler and Elisabeth Gerhardt; they visit the Durand-Ruel, Vollard, and Bernheim-Jeune galleries in search of new works for Koehler's collection. Félix Fénéon, director of Galerie Bernheim-Jeune, offers two watercolors by Signac and one by Cross to Macke.

● Exhibition at Künstlerhaus Zürich with works by Van Gogh, Amiet, and Giovanni Giacometti.

August
☐ Jawlensky, Kandinsky, Münter, and Werefkin spend the summer in the alpine village of Murnau, where they each produce several painted works.

September
☐ Pechstein moves back to Berlin.

☐ Exhibition of Fauve and Brücke artists at Galerie Richter in Dresden, including works by Heckel, Schmidt-Rottluff, Kirchner, Pechstein, Amiet, Derain, Van Dongen, Friesz, Marquet, Picasso, Signac, and Vlaminck (September 1–13).

October
☐ Exhibition at Galerie Cassirer, including eight Van Gogh paintings (October 15–November 11).

■ Sixth Salon d'Automne at the Grand Palais (October 1–November 8). Matisse presents several paintings, drawings, and sculptures, and Münter and Kandinsky exhibit prints.

November
■ Braque exhibition at Galerie Kahnweiler in Paris (November 9–28). Art critic Louis Vauxcelles describes the paintings as being composed of "cubes," thus coining the term *Cubism*.

■ Van Dongen retrospective at Galerie Bernheim-Jeune (through December).

■ Vuillard exhibition at Galerie Bernheim-Jeune.

■ Denis exhibition at Galerie Druet.

December
☐ Sixteenth Berlin Secession exhibition (graphic arts), showing works by Brücke artists as well as by Bonnard, Matisse, Munch, and others.

☐ Matisse travels to Berlin to prepare for his exhibition opening the following month at Galerie Cassirer. On his return to Paris he visits Osthaus in Hagen with Purrmann and sees Osthaus's villa Hohenhof, conceived and decorated by Van de Velde, including Matisse's ceramic panel *Nymph and Satyr* installed in the winter garden. He spends Christmas with the Molls in Berlin.

■ Uhde organizes an exhibition at his gallery on the rue Notre-Dame-des-Champs, showing works by Braque, Derain, Dufy, and Picasso (December 21–January 15, 1909).

■ Exhibition of works by Friesz, Manguin, Marquet, and Van Dongen at Galerie Druet (December 21–January 15).

■ Matisse publishes "Notes d'un peintre" (Notes of a Painter) in *La Grande Revue* (December 25). He responds to the various critics of his works by explaining that his artistic sources range from Egyptian and Greek art to Impressionism, stating famously, "What I pursue above all is expression" ("Ce que je poursuis par-dessus tout, c'est l'expression").

Ernst Ludwig Kirchner
Landscape with Houses and Man, c. 1909
Watercolor and pencil on paper
7⅝₁₆ x 6 in. (20.2 x 15.3 cm)
Franz Marc Museumsgesellschaft

1909

☐ Wallraf Richartz Museum in Cologne acquires Gauguin's painting *Woman with a Chignon* (private collection).

☐ Tschudi is appointed general director of the Bavarian State Picture Collections in Munich.

☐ Van Dongen joins the Brücke.

■ Kandinsky's portfolio of five xylographs, *Xylographies*, is published in an edition of 1,000 by Tendances Nouvelles in Paris.

January
☐ Founding of the Neue Künstlervereinigung München, or NKVM (New Artists Association Munich), including Kandinsky (president), Jawlensky (vice president), Münter, and Werefkin.

☐ Matisse show at Galerie Cassirer in Berlin, largely installed by the artist himself (January 1–20). The exhibition presents about seventy works—including *Blue Nude* (p. 175) and *Harmony in Red* (p. 52). Kirchner, Schmidt-Rottluff, and Pechstein see the show.

February
■ The French periodical *Le Figaro* publishes Filippo Tommaso Marinetti's "Futurist Manifesto."

■ Bonnard exhibition at Galerie Bernheim-Jeune.

● Heckel travels to Italy. He stays until May and visits Rome, Verona, Padua, Venice, and Florence.

March
☐ Munich Secession exhibition, with works by Cézanne.

☐ Following his first trip to Germany in December 1908, Marquet travels to Hamburg, where he stays until May.

■ Twenty-fifth Salon des Indépendants at the Orangerie in the Tuileries gardens, with works by Braque, Delaunay, Vlaminck, Dufy, Friesz, Matisse, Van Dongen, and others (March 25–May 5). Kandinsky exhibits two paintings at the Salon.

● Sixteenth La Libre Esthétique exhibition in Brussels, with works by Bonnard, Cross, Denis, Manguin, Signac, and others (March 7–April 12).

Spring
☐ *Leihausstellung von Gemälden, Zeichnungen und Bildwerken aus bremischem Privatbesitz* (Exhibition of Paintings, Drawings, and Sculptures from Private Collections in Bremen) at Kunsthalle Bremen shows two paintings by Gauguin and three by Van Gogh, as well as paintings by Modersohn-Becker.

☐ Eighteenth Berlin Secession exhibition shows works by Bonnard, Vlaminck, Van Gogh, Friesz, Jawlensky, Vuillard, Pechstein, and

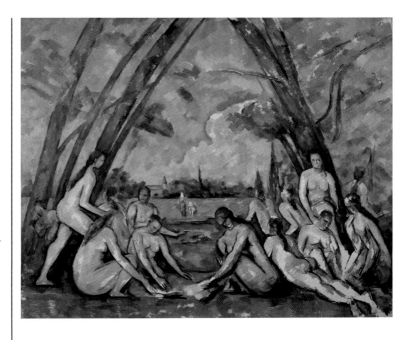

Georg Tappert, as well as Cézanne's *The Large Bathers*.

May
☐ Matisse's "Notes d'un peintre," translated into German by Margarethe Moll, is published in *Kunst und Künstler*.

☐ The Sonderbund, a special union of artists and patrons founded in Düsseldorf, holds its first exhibition at Kunsthalle Düsseldorf, presenting works by local artists and the French avant-garde. The show also includes graphics by Van Gogh, Cézanne, Gauguin, and Munch, all from the collection of Alfred Flechtheim.

☐ Exhibition at Galerie Brakl in Munich with forty-nine Van Gogh paintings.

June
☐ Brücke exhibition at Galerie Richter in Dresden (June 15–29). The show travels on to the Lindenau Museum in Altenburg, then on to Brunswick.

☐ Kandinsky, Werefkin, and Jawlensky spend their second summer in Murnau.

☐ Pechstein spends the summer in Nidden, a fishing village on the Baltic coast.

August
☐ Graphic arts exhibition at the Folkwang Museum in Hagen, with works by Van Gogh, Gauguin, Matisse, and others.

Paul Cézanne
The Large Bathers, 1900–1906
Oil on canvas
82 7/8 × 98 3/4 in. (210.5 × 250.8 cm)
Philadelphia Museum of Art, purchased
with the W. P. Wilstach Fund, 1937

□ Heckel, Kirchner, and Pechstein work at the Moritzburg Lakes, near Dresden.

September
■ Matisse settles permanently in Issy-les-Moulineaux, outside Paris.

October
□ Galerie Brakl in Munich shows about fifty Van Gogh paintings, presented in the catalogue by periods (Paris, Arles, Saint-Rémy-de-Provence, and Auvers-sur-Oise).

■ Macke and his wife travel to Bern; there they meet up with painter Louis Moilliet, with whom they return to Paris. Macke visits the Paul Bureau and Henri Rouart collections (with works by Honoré Daumier) and meets German painter Karl Hofer in Paris.

■ Seventh Salon d'Automne (October 1–November 8). Macke visits the Salon, which includes works by Vlaminck, Manguin, Marquet, Jean Puy, Van Dongen, Matisse, Kandinsky, Münter, and the Italian Futurists.

November
□ In Berlin, Cassirer presents a large-scale Cézanne exhibition (November 27–December 10), with forty-two works, lent by Vollard and private German collectors. Pechstein, Schmidt-Rottluff, and Kirchner visit the show.

□ Nineteenth Berlin Secession (graphic arts) includes twenty-three drawings by Van Gogh and two drawings by Gauguin (November 27–January 9).

■ Galerie Druet in Paris shows fifty-two paintings by Van Gogh (November 8–20).

■ *Nature morte et fleurs* (Still Lifes and Flowers) exhibition in Paris at Galerie Blot, with works by Cézanne, Manguin, Marquet, Matisse, Vallotton, Van Gogh, and Vuillard.

December
□ First NKVM exhibition, at Moderne Galerie Thannhauser in Munich (December 1–15). Baum, Jawlensky, Girieud, Kandinsky, Münter, and Werefkin are among the artists presented. The show travels to other German cities as well as to Brünn (now Brno, Czech Republic).

□ Exhibition of works by Amiet at Moderne Galerie Thannhauser (December 15–January 15).

□ Purrmann invites Raoul Dufy and Othon Friesz to Munich. There, Dufy sees Kandinsky's woodcuts at Galerie Thannhauser. In early 1910, after his return to Paris, Dufy works on several woodcuts, including *Love* and *Dance* (plates 30 and 31).

□ Van Gogh exhibition at Galerie Brakl in Munich. Franz Marc assists gallery owner Josef Brakl in hanging the exhibition.

1910
□ Meier-Graefe publishes his monograph on Cézanne.

January
□ The Cologne Kunstverein shows thirty-five drawings by Van Gogh.

□ Macke, his cousin Helmuth Macke, and Bernhard Koehler Jr. see Franz Marc's works exhibited at Galerie Brakl and decide to visit Marc in his workshop in Munich. Koehler Jr. and his father, Berlin manufacturer Bernhard Koehler Sr., start to support Marc.

□ Kandinsky publishes a report in the periodical *Apollo* of the first NKVM exhibition.

□ Van Gogh exhibition organized by Galerie Brakl in Munich travels to Kunstverein Frankfurt, then to Galerie Arnold in Dresden (February) and Gerstenberger in Chemnitz (April).

■ Cézanne exhibition at Galerie Bernheim-Jeune. Matisse lends his own Cézanne painting, *Three Bathers* (plate 14).

February
□ Macke sees works by French landscape painters, including Matisse, at Moderne Galerie Thannhauser in Munich. Inspired by Paul Sérusier's experiments with color, Macke begins to concentrate on color theory.

□ Marc's first solo exhibition at Galerie Brakl in Munich. Macke sees the show and contacts Marc, which initiates a close artistic friendship.

■ Matisse exhibition at Galerie Bernheim-Jeune (February 14–March 5) shows several works lent by the Stein family (Gertrude Stein, her brothers Leo and Michael, and Michael's wife, Sarah).

March
□ Städtisches Museum in Elberfeld (today Von der Heydt Museum in Wuppertal) holds the exhibition *Gustave Courbet und die Entwicklung der französischen Malerei* (Gustave Courbet and the Development of French Painting), including works by Matisse, Marquet, and Van Dongen.

□ The first issue of the avant-garde periodical *Der Sturm* is published in Berlin by Herwarth Walden. The journal showcases illustrations and texts by Expressionist artists and writers.

■ Twenty-sixth Salon des Indépendants, which includes Rousseau's jungle painting *The Dream* (Museum of Modern Art, New York) (March 18–May 1).

● Seventeenth exhibition of La Libre Esthétique in Brussels, with works by Cross, Manguin, Gauguin, Matisse, Signac, Vuillard, and others (March 12–April 17).

Spring
☐ Twentieth Berlin Secession exhibition.

April
☐ Pechstein founds the Neue Secession, together with Georg Tappert, Arthur Segal, and others, following the rejection of his submitted works by the Berlin Secession. Other Brücke members join as well. Pechstein is elected its first president in May.

■ Friesz exhibition at Galerie Druet in Paris, with several works inspired by his trip to Munich.

May
☐ First exhibition of the Neue Secession at Galerie Macht in Berlin, with works by Brücke artists as well as Segal and Tappert. Otto Mueller participates and meets Kirchner; he joins the Brücke later that year.

■ Marquet exhibition at Galerie Druet, followed by Manguin exhibition at the end of the month.

■ *Nus* (Nudes) exhibition at Galerie Bernheim-Jeune, with works by Cross, Gauguin, Manguin, Matisse, Van Dongen, and others.

■ NKVM member Adolf Erbslöh visits Pierre Girieud in Paris, and together they visit the

studios of Rousseau, Braque, Derain, Van Dongen, Vlaminck, and Picasso.

July
☐ Second Sonderbund exhibition in Düsseldorf at the Städtischer Kunstpalast, including works by Bonnard, Braque, Cross, Denis, Derain, Vlaminck, Friesz, Jawlensky, Kirchner, Manguin, Matisse, Nolde, Pechstein, Picasso, Purrmann, Schmidt-Rottluff, Signac, Van Dongen, and Vuillard (July 16–October 9).

☐ French painters Pierre Girieud and Henri Le Fauconnier join the NKVM.

☐ Jawlensky and Kandinsky spend the summer in Murnau.

August
☐ Gauguin retrospective shown at Moderne Galerie Thannhauser in Munich, which travels to Galerie Arnold in Dresden in September. Kirchner creates the poster for the Dresden show, inspired by Gauguin's *Portrait of the Artist's Mother* (p. 72).

☐ Klee, who had settled in Munich in 1906, meets Macke and later Kandinsky.

September
☐ Brücke exhibition at Galerie Arnold in Dresden with works by Amiet, Heckel, Kirchner, Münter, Pechstein, Schmidt-Rottluff, and others.

☐ Second NKVM exhibition at Galerie Thannhauser (September 1–14). The show presents Fauvist works, including woodcuts, and early Cubist works, notably by Picasso (*Head of a Woman*, p. 263); other artists include Kandinsky, Jawlensky, Münter, and Erbslöh (*The Red Skirt*, plate 34). The exhibition receives negative reviews and critical response, but Marc writes a supportive review of the exhibition, and meets Erbslöh, Jawlensky, Werefkin, and Alexander Kanoldt in October. The show travels to Karlsruhe, Mannheim, Hagen, Berlin (Galerie Cassirer), Dresden (Galerie Arnold), and Weimar.

☐ Moderne Galerie Thannhauser shows works by the French avant-garde, including Braque, Derain, Picasso, Le Fauconnier, and Van Dongen, as well as works by the Brücke.

■ Henri Rousseau dies in Paris on September 2.

● Kandinsky spends two months in Russia.

October
☐ Matisse and Marquet travel to Munich, where they visit the exhibition of Islamic art *Meisterwerke Muhammedanischer Kunst* (Masterpieces of Muhammadan Art) with Purrmann. Marc and Macke also see the show. Matisse visits Tschudi's private collection. Tschudi commissions Matisse's *Still Life with Geranium* (Munich, Pinakothek der Moderne).

Ernst Ludwig Kirchner
Poster for Gauguin Exhibition at Galerie Arnold, Dresden, 1910
cat. 114

□ Seco nd Neue Secession exhibition at Galerie Macht in Berlin.

□ Van Gogh exhibition at Galerie Cassirer, with fifty-two paintings and several drawings (October 25–November 20).

□ Kunstverein Leipzig presents *Ausstellung französischer Kunst des 18., 19. und 20. Jahrhunderts* (Exhibition of French Art from the 18th, 19th, and 20th Centuries), with works by Cézanne, Gauguin, Monet, Pissarro, and Signac.

■ Eighth Salon d'Automne at the Grand Palais in Paris, including works by Münter and Kandinsky.

■ Cross exhibition at Galerie Bernheim-Jeune, including the painting *Bather* (plate 15), commissioned and owned by Harry Kessler.

November
□ Twenty-first Berlin Secession exhibition (graphic arts).

■ Robert Delaunay marries Sonia Uhde-Terk, who was previously married to Wilhelm Uhde (from 1908 until August 1910).

● Grafton Galleries in London presents the exhibition *Manet and the Post-Impressionists*.

December
□ Macke visits the Osthaus collection in Hagen, where he sees works by Matisse, notably *Still Life with Asphodels* (p. 72).

1911 ■ In Paris, Wilhelm Uhde publishes the first monograph on Henri Rousseau.

January
□ Gustav Pauli, director of the Kunsthalle Bremen, acquires the Van Gogh painting *Field with Poppies* for his museum, prompting German painter Carl Vinnen to publish *Ein Protest deutscher Künstler* (Protest of German Artists), inveighing against what was seen as favorable treatment of French art by German museums and directors. Kandinsky and Marc begin working on a joint response.

□ Group exhibition at Galerie Cassirer in Berlin, with works by Braque, Derain, Vlaminck, Picasso, and future Blaue Reiter artists.

□ Marc meets Kandinsky, initiating a close friendship, as well as Münter and Jawlensky at Werefkin's home in Munich.

□ Exhibition in Cologne sponsored by the Gereonsklub, a recently formed association of avant-garde artists. The show includes works by Amiet, Derain, Van Gogh, Hodler, Picasso, and Sérusier.

□ Kunstverein Frankfurt presents Van Gogh exhibition from Cassirer.

■ Signac exhibition at Galerie Bernheim-Jeune.

● Arthur Clutton-Brock, in an article in *The Burlington Magazine*, proposes renaming the "Post-Impressionists"—principally Cézanne, Gauguin, and Van Gogh—as "Expressionists."

February
□ Third Neue Secession exhibition at Galerie Macht in Berlin, with works by many Brücke artists.

□ Marc joins the NKVM.

□ Galerie Commeter in Hamburg shows Impressionism exhibition, with works by Cézanne, Monet, and Pissarro. Schmidt-Rottluff visits the exhibition.

□ The first issue of the periodical *Die Aktion* is published by Franz Pfemfert in Berlin. It promotes Expressionism and frequently publishes the work of emerging young artists.

■ Vuillard exhibition at Galerie Bernheim-Jeune.

March
□ Group exhibition at Galerie Cassirer in Berlin, including works by Cézanne.

● Eighteenth La Libre Esthétique exhibition in Brussels.

Spring
□ Twenty-second Berlin Secession exhibition, with works by Beckmann, Braque, Derain, Van Dongen, Dufy, Feininger, Manguin, Picasso, and Van Rysselberghe.

Vincent van Gogh
Field with Poppies, 1889–90
Oil on canvas
27 15/16 × 35 13/16 in. (71 × 91 cm)
Kunsthalle Bremen

April

■ Twenty-seventh Salon des Indépendants exhibition includes a room devoted to Cubism, presenting works by Fernand Léger, Piet Mondrian, and Delaunay, including his *Eiffel Tower* (Solomon R. Guggenheim Museum), among others. This major presentation of Cubist art initiates controversy and a broad public debate. Several works by Rousseau are also shown, including *The Wedding* (plate 137). Feininger visits the Salon and also shows some works. Münter and Kandinsky also exhibit at the Salon.

May

□ Major exhibition of Marc's works at Moderne Galerie Thannhauser in Munich, including *Monkey Frieze* (p. 259). The exhibition, which will travel to Mannheim, also features works by Girieud.

□ Munich Secession exhibition includes several works by the Nabis.

June

■ Matisse closes his academy in Paris.

■ *L'Eau* (Water) exhibition at Galerie Bernheim-Jeune, followed by *Montagne* (Mountain) exhibition in July.

■ Kessler visits Matisse's studio in Issy-les-Moulineaux.

■ Van Dongen exhibition at Galerie Bernheim-Jeune (June 6–24).

August

□ *Im Kampf um die Kunst* (The Struggle for Art), the response to Vinnen's *Protest*, is published in Munich and contains numerous contributions by artists, gallerists, collectors, and writers. Among the signatories defending innovative museum directors and arguing for the acceptance of French art are Karl Ernst Osthaus, Curt Herrmann, Christian Rohlfs, Wilhelm Uhde, Cuno Amiet, Harry Kessler, Paul Cassirer, Alfred Flechtheim, Wassily Kandinsky, August Macke, and Franz Marc.

● Kirchner travels to Prague, where he sees Cubist paintings.

October

□ Exhibition *Kunst unserer Zeit in Kölner Privatbesitz* (Art of Our Time in Private Collections in Cologne) at the Wallraf Richartz Museum in Cologne, with works by Amiet, Derain, Vlaminck, Friesz, Kandinsky, Marc, and Manguin, among others.

□ Kirchner moves from Dresden to Berlin and takes a studio near Pechstein. He is soon followed by Schmidt-Rottluff and Heckel. Pechstein and Kirchner briefly open an art school in Berlin-Wilmersdorf, but it closes in September 1912 due to lack of students.

□ Gallery Commeter in Hamburg shows fifty-one Van Gogh paintings.

□ Galerie Cassirer in Berlin presents group exhibition with Manet, Monet, Cézanne, and Van Gogh paintings (October–November).

□ Kandinsky begins corresponding with Delaunay after receiving photographs of Delaunay's works from his former student Elisabeth Epstein, a friend of Sonia Delaunay's.

■ Ninth Salon d'Automne at the Grand Palais in Paris. Jawlensky travels from Munich to Paris for the Salon and meets with Matisse, Girieud, and Van Dongen.

November

□ Twenty-third Berlin Secession exhibition.

□ Fourth Neue Secession exhibition becomes the first exhibition to present work by members of the Brücke and the future Blaue Reiter together (November 18–January 31).

□ Exhibition with works by Marc at Museum Folkwang in Hagen.

□ Hugo von Tschudi dies in Munich on November 23 of a heart ailment.

December

□ Pechstein leaves the Neue Secession.

□ Third NKVM exhibition in Munich at Moderne Galerie Thannhauser. After the jury rejects one of his paintings (the highly abstract *Composition V*), Kandinsky quits the NKVM. Marc and Münter follow him, and together they found the Blaue Reiter group.

□ First Blaue Reiter exhibition is held at the Moderne Galerie Thannhauser (December 18–January 1). The exhibition presents works by Delaunay and Rousseau, including the latter's *Malakoff, the Telegraph Poles* (plate 136), alongside works of Blaue Reiter artists, including Marc's

Franz Marc
The Large Blue Horses, 1911
Oil on canvas
41⅝ x 71⁵⁄₁₆ in. (105.7 x 181.1 cm)
Walker Art Center, Minneapolis, gift of T. B. Walker Foundation, Gilbert M. Walker Fund, 1942

Stony Path (plate 105) and *The Large Blue Horses* (p. 79). The show travels on to eleven other venues through the summer of 1914, including the Gereonsklub in Cologne, where Macke sees it in January 1912, and Bremen.

☐ Publication of Kandinsky's *Über das Geistige in der Kunst* (Concerning the Spiritual in Art).

■ Wilhelm Niemeyer, director of Hamburg School of Applied Arts and one of the organizers of the Sonderbund exhibitions, visits Picasso's studio in Paris.

■ Van Dongen exhibition at Galerie Bernheim-Jeune (December 4–16).

1912

☐ The Neue Pinakothek in Munich receives a major collection of Impressionist and Post-Impressionist works, left to the museum by Tschudi upon his death. Important paintings by Gauguin, Van Gogh, including *Sunflowers*, Cézanne, and Manet are among those bequested.

● The Balkan Wars of 1912 and 1913 fan the tensions among Austria-Hungary, France, Germany, Great Britain, and Russia.

January
☐ Jawlensky quits the NKVM. He meets Paul Klee and Nolde in Munich.

■ Galerie Barbazanges in Paris presents Delaunay's first solo exhibition.

■ Galerie Bernheim-Jeune presents *Les peintres futuristes italiens* (Italian Futurist Painters).

February
☐ Second Blaue Reiter exhibition, *The Blaue Reiter: Black and White,* at Galerie Hans Goltz in Munich (February 12–April). The show includes more than three hundred graphic works by Blaue Reiter artists, Brücke artists, the Swiss Moderner Bund, and the Russian and French avant-garde.

☐ Galerie Arnold in Dresden shows forty-one Van Gogh paintings.

March
☐ Fifth Neue Secession exhibition in Berlin.

☐ Herwarth Walden's Galerie Sturm opens in Berlin with *Der Blaue Reiter, Franz Flaum, Oskar Kokoschka, Expressionisten,* the touring exhibition of the Blaue Reiter artists and others (March 12 through early April).

■ Twenty-eighth Salon des Indépendants in Paris, where Kandinsky shows his *Improvisation* (*nos. 24, 25, 26*). Münter and Feininger exhibit at the Salon as well.

● Nineteenth exhibition of La Libre Esthétique in Brussels.

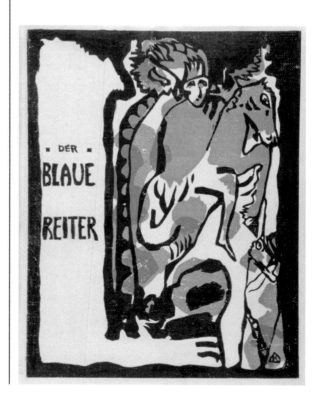

Vincent van Gogh
Sunflowers, 1888
Oil on canvas
36¼ × 28¾ in. (92 × 73 cm)
Neue Pinakothek, Bayerische
Staatsgemäldesammlungen, Munich

Cover of *Der Blaue Reiter Almanach,*
2nd ed., 1914
Los Angeles County Museum of Art,
Robert Gore Rifkind Center for German
Expressionist Studies

Spring
☐ Twenty-fourth Berlin Secession exhibition, with works by Picasso, Rousseau, and Van Gogh also on view. Pechstein joins the Berlin Secession at the invitation of Paul Cassirer, who is in charge of its organization; he does not appear to have informed his colleagues in the Brücke of his decision. Pechstein's participation in the exhibition comes as a shock to the rest of the Brücke, who consider it a breach of trust, and he is expelled from the Brücke in May.

April
☐ Galerie Cassirer in Berlin shows several Cézanne paintings.

☐ First group exhibition of the Brücke in Berlin at Galerie Fritz Gurlitt, with works by Amiet, Heckel, Kirchner, Mueller, Pechstein and Schmidt-Rottluff.

☐ Leipzig Annual Exhibition, with works by Beckmann, Friesz, Gauguin, Klee, Manguin, Marquet, Matisse, Pechstein, Picasso, Van Gogh, Werefkin, and others (April 7–late June).

☐ Second exhibition at Galerie Sturm in Berlin, with works by Braque, Delaunay, Derain, Vlaminck, Dufy, Friesz, Kandinsky, Marc, and Italian Futurists.

☐ Macke has his first solo show, at Moderne Galerie Thannhauser in Munich.

■ Klee visits Delaunay in Paris. He translates essay, "La Lumière," into German for *Der Sturm* (January 1913).

May
☐ The almanac *Der Blaue Reiter* is published in Munich, with the financial support of Bernhard Koehler Sr. One of the *Eiffel Tower* paintings by Delaunay, owned by Koehler, is illustrated.

☐ Opening the third Sonderbund exhibition in Cologne at the Municipal Exhibition Hall (May 24). Presenting a broad panorama of the European avant-garde, the exhibition includes Cézanne (26 works, including *Peasant in the Blue Smock* and *Still Life with Apples*, plates 12 and 8), Van Gogh (125 works, including *Two Women Digging in Field with Snow*, p. 57, and *Pollard Willows at Sunset* and *The Poplars at Saint-Rémy*, plates 50 and 57), Gauguin (25 works, including *Portrait of the Artist's Mother*, p. 72), and Braque (7 works, including *Violin and Palette*, plate 7).

☐ Pechstein travels to Cologne to see the Sonderbund exhibition and also visits the Museum Folkwang in Hagen.

☐ Galerie Sturm presents a graphic arts exhibition, with several works by Gauguin, Kandinsky, and Picasso.

☐ Great Art Exhibition at the Municipal Exhibition Hall in Dresden, including Cézanne paintings.

June
☐ *Moderne Kunst: Plastik, Malerei, Graphik* (Modern Art: Sculpture, Painting, Graphics) in Hagen at the Museum Folkwang, with works by Cézanne (including *Bibémus Quarry*, p. 70), Gauguin, Cross, Jawlensky, Kandinsky, Matisse, Nolde, Pechstein, Rohlfs, and Van Gogh (June–July).

☐ At Galerie Sturm in Berlin, Marc and Kandinsky organize an independent Blaue Reiter exhibition of pictures rejected by the Sonderbund.

July
☐ Exhibition *Französische Expressionisten* (French Expressionists) at Galerie Sturm, including works by Braque, Derain, Friesz, and Vlaminck.

☐ Moderner Bund Exhibition at Kunsthaus Zürich, with works by Delaunay, Klee, Marc, Matisse, and Münter.

☐ Frankfurter Kunstverein presents *Die klassische Malerei Frankreichs im 19. Jahrhundert* (Classic French Painting from the 19th Century), with works by Manet, Monet, Gauguin, Van Gogh, and Vuillard.

August
☐ Brücke exhibition at Galerie Commeter in Hamburg.

September
☐ Second Blaue Reiter exhibition in Munich. Nolde participates in the show.

■ August and Elisabeth Macke travel with Franz and Maria Marc to Paris. They visit the private collections of Vollard, Madame Bernheim, Durand-Ruel, and the Steins, as well as the studios of Henri Le Fauconnier and of Robert Delaunay.

October
☐ After returning to Bonn, Marc and Macke work with Walden on the Futurist exhibition at the Gereonsklub in Cologne (previously shown at Galerie Sturm in Berlin).

☐ Group exhibition at Galerie Cassirer in Berlin, including Cézanne and Van Gogh.

☐ *Erste Gesamt-Ausstellung* (First Collective Exhibition) at Neue Kunst Hans Goltz in Munich, showing works by Braque, Cézanne, Delaunay, Derain, Matisse, Picasso, Van Dongen, and Van Gogh, as well as by Brücke and Blaue Reiter members.

☐ Kandinsky's first one-man exhibition, at Galerie Sturm, Berlin.

□ Futurist exhibition at Otto Feldmann's Rheinischer Kunstsalon in Cologne. The show was previously shown in Paris, London, and Berlin.

■ Tenth Salon d'Automne at Grand Palais, attended by Marc and Macke.

■ Galerie Bernheim-Jeune presents Rousseau exhibition, including *The Walk in the Forest* (cat. 180).

■ Salon de la Section d'Or at Galerie la Boétie in Paris presents a large exhibition of Cubist works by Marcel Duchamp, including his *Nude Descending a Staircase* (Philadelphia Museum of Art), Fernand Léger, and Francis Picabia, among others. The exhibition is organized by the Puteaux Group. Poet and critic Guillaume Apollinaire invents the term *Orphism* to describe the analogy between music, form, and color.

● Second Post-Impressionist exhibition opens at the Grafton Galleries in London (October 5–December 31).

November
□ Futurist exhibition at Moderne Galerie Thannhauser in Munich (previously shown in Cologne).

□ Nolde exhibition at Max Dietzel and Paul Ferdinand Schmidt's Neuer Kunstsalon in Munich.

□ Twenty-fifth Berlin Secession exhibition (graphic arts).

□ Third *Juryfreie Kunstschau* (Non-Juried Art Show) at Kunsthaus Lepke in Berlin, including Braque and Picasso.

1913
□ Emil vom Rath gives his Gauguin painting *Riders on the Beach* to the Wallraf Richartz Museum, Cologne.

□ Final Brücke group exhibition shown at Kunsthalle Basel and at Der Neue Kunstsalon in Munich.

January
□ Galerie Sturm presents Delaunay exhibition, including works from the *Fenêtres* series (January 12–February 20). Delaunay, accompanied by Guillaume Apollinaire, travels to Berlin for the exhibition and then visits Macke in Bonn. The show travels to the Gereonsklub in Cologne.

□ Marc solo exhibition at Moderne Galerie Thannhauser in Munich; it is subsequently shown in Jena and Berlin (at Galerie Sturm).

□ Museum Folkwang in Hagen shows works by Cross, Signac, Van Rysselberghe, and Luce.

□ Galerie Cassirer in Berlin presents the Reber Collection, including five Van Gogh paintings as well as Cézanne, with his *Peasant in a Blue Smock* (plate 12), and Gauguin.

■ Van Dongen exhibition at Galerie Bernheim-Jeune (January 27–February 8).

February
□ Picasso exhibition at the Moderne Galerie Thannhauser in Munich, including *Head of a Woman* (p. 263). The show travels on to Cologne, where it is shown as a smaller version at Rheinischer Kunstsalon.

□ Galerie Sturm shows Delaunay paintings.

□ Pechstein solo exhibition at Kunstsalon Fritz Gurlitt in Berlin.

● The International Exhibition of Modern Art, also called the Armory Show, opens in New York and introduces the American public to European avant-garde art, including Fauvism, Cubism, and Futurism. Artists include Kandinsky, Kirchner, Gauguin, Van Gogh, Braque, Delaunay, Duchamp, Matisse, and Munch (February 17–March 15).

March
□ Galerie Cassirer in Berlin shows group exhibition with seven Van Gogh paintings.

■ Twenty-ninth Salon des Indépendants.

■ Herwarth and Nell Walden travel to Paris and meet with Delaunay.

● La Libre Esthétique exhibition *Interprétations du Midi* (Interpretations of the South) in Brussels (March 8–April 13).

April
□ Preparations begin for the *Erster Deutscher Herbstsalon* (First German Autumn Salon) at Galerie Sturm; Macke and Marc are closely involved.

□ Twenty-sixth Berlin Secession exhibition, with works by Kirchner, Pechstein, Van Gogh, and Matisse.

May
□ Matisse exhibition at the Kunstsalon Fritz Gurlitt in Berlin (May 1–10).

□ After several internal conflicts about the group's leadership, the Brücke is dissolved on May 27.

□ Van Dongen exhibition at the Moderne Galerie Thannhauser in Munich (May–June).

□ Great Art Exhibition at Royal Fine Arts Building in Stuttgart, with works by Cézanne, Gauguin, and Van Gogh (May–October).

☐ Great Art Exhibition at Municipal Exhibition Hall in Düsseldorf, including works by Beckmann, Moll, Pechstein, and Vuillard (May–October).

July

☐ *Ausstellung Rheinischer Expressionisten* (Exhibition of Rhenish Expressionists) at the Kunstsalon in Bonn, with works by Heinrich Campendonk, Max Ernst, and Macke (July 10–August 10).

Summer

☐ Group exhibition at Galerie Cassirer, including Cézanne and Van Gogh.

August

☐ Galerie Goltz in Munich presents *II. Gesamtausstellung: Neue Kunst* (Second Great Exhibition of New Art), with works by Bonnard, Braque, Cézanne, Derain, Van Dongen, Delaunay, Picasso, Matisse, and others.

September

☐ First German Autumn Salon at Walden's Galerie Sturm (September 19–December 1). The exhibition presents more than 350 works by seventy-five artists from twelve countries, including Delaunay, Feininger, Jawlensky, Kandinsky, Klee, Macke, Marc, and Münter, and also includes a Rousseau retrospective. It presents a survey of all contemporary avant-garde movements, including Expressionism, Cubism, Futurism, and Orphism.

☐ The former Brücke artists do not participate in Walden's Autumn Salon. Instead they present their works at the *Herbstausstellung* (Autumn Exhibition) organized at Cassirer galerie, alongside Picasso, Beckmann, and Munch.

October

☐ First exhibition at Neue Galerie in Berlin, with works by Braque, Picasso, Van Dongen, and Van Gogh.

☐ Exhibition at Kunstverein Cologne, with works by Cézanne and Van Gogh.

● Nolde and his wife, Ada, leave Germany as part of an official expedition to New Guinea, traveling via Russia, Japan, and China.

November

☐ *Expressionisten. Kubisten. Futuristen* (Expressionists, Cubists, Futurists) exhibition at Galerie Sturm, including works by Hans Arp, Campendonk, Dufy, Jawlensky, Léger, Macke, and more.

☐ *Degas/Cézanne* exhibition at Galerie Cassirer, Berlin.

☐ Galerie Flechtheim in Düsseldorf presents Paul Signac exhibition (through December).

■ Eleventh Salon d'Automne at Grand Palais.

December

☐ Picasso exhibition at Neue Galerie in Berlin.

☐ Sixth Neue Secession exhibition in Berlin, with Dufy, Friesz, Schmidt-Rottluff, and Tappert.

☐ Bonnard and Vuillard visit Hamburg at the invitation of Alfred Lichtwark, director of the Hamburger Kunsthalle.

1914

☐ Paul Fechter publishes *Der Expressionismus*, the first book on Expressionism. Fechter stresses the movement's roots in the German metaphysical tradition, but also explains its birth as a continental reaction to Impressionism.

January

☐ *Die Neue Malerei* (The New Painting) exhibition at Galerie Arnold, Dresden, showing Expressionist works by the Blaue Reiter, NKVM, former Brücke artists such as Kirchner (including his *Seated Woman with Wood Sculpture*, plate 82), and Oskar Kokoschka.

August Macke
Merchant with Jars, 1914
Watercolor
10½ × 8½ in. (26.6 × 20.7 cm)
LWL-Landesmuseum für Kunst und Kulturgeschichte

□ Galerie Richter shows works by Picasso alongside African sculpture. The exhibition, organized by Kahnweiler, was previously shown at Neue Galerie in Berlin (November 1913).

■ Cézanne exhibition at Galerie Bernheim-Jeune.

February
□ International Exhibition at Kunsthalle Bremen, including Braque, Bonnard, Cézanne, Vlaminck, Gauguin, Picasso, and Van Gogh.

March
■ Thirtieth Salon des Indépendants.

April
□ First exhibition of the Freie Secession, a newly created association of artists who split off from the Berlin Secession. The former Brücke artists participate.

□ *Ausstellung französischer Malerei* (Exhibition of French Painting) at Galerie Arnold in Dresden (April–May).

● Macke travels via Thun and Bern to Marseille, where he meets with Paul Klee and Louis Moilliet; together they travel to Tunisia. This trip gives rise to a major series of watercolors by both Klee and Macke, using geometrical, almost abstract forms (p. 83). In the months after his return, Macke frequently uses motifs inspired by this visit in his paintings, as seen in his *Landscape with Cows and Camel* (plate 102).

● Pechstein and his wife leave Germany to travel to Palau (in the Pacific) via Italy, the Suez Canal, Malaysia, Singapore, and Hong Kong.

May
□ Galerie Cassirer exhibition in Berlin of 120 Van Gogh paintings (through June).

□ *Rheinische Expressionisten* (Rhenish Expressionism) exhibition at Galerie Flechtheim, Düsseldorf.

□ Deutsche Werkbund exhibition in Cologne, to which Heckel, Kirchner, and Schmidt-Rottluff contribute (May–October).

Summer
● June 28: Assassination of Archduke Franz Ferdinand, heir to the Austro-Hungarian throne, in Sarajevo, Bosnia. The event leads to a crisis among the major European powers that leads to Austria's declaration of war on Serbia on July 28.

● August 3: Germany declares war on France; Great Britain declares war on Germany on August 4.

□ Matisse exhibition at the Kunstsalon Fritz Gurlitt in Berlin, with works from the Sarah and Michael Stein collection in Paris, including his *Self-Portrait*; the nineteen paintings on

loan are confiscated (and later sold) following the declaration of war.

□ Futurist exhibition at Galerie Sturm.

□ Marc enlists in military service as a volunteer in August; Kirchner, Macke, Max Beckmann, George Grosz, Heckel, Klee, Kokoschka, Mueller, Schmidt-Rottluff, and Otto Dix enlist or volunteer as well.

□ Cassirer launches the periodical *Kriegszeit* (Wartime), featuring illustrations by many leading German artists.

● Marc Chagall and Kandinsky return to Russia via Switzerland, and Münter goes to Sweden via Switzerland. Jawlensky and Werefkin are also forced to leave Germany for Switzerland.

September
■ August Macke dies on the battlefield in Perthes-les-Hurlus, France, on September 26.

1915
□ Pechstein returns to Germany via the United States and enlists in the army in September.

□ Kirchner, after having served as artillery driver, suffers a nervous breakdown and is exempted from army service.

Henri Matisse
Self-Portrait, 1906
Oil on canvas
21⅝ × 18⅛ in. (55 × 46 cm)
Statens Museum for Kunst/National
Gallery of Denmark, Copenhagen

□ Beckmann suffers a mental breakdown and is dismissed from military service. Grosz is dismissed as unfit for service.

1916 ● Kandinsky and Münter end their relationship.

February
● The Cabaret Voltaire is founded in Zurich by Hugo Ball and Emmy Hennings, and becomes the birthplace of Dada.

March
□ Albert Bloch (an American Expressionist and Blaue Reiter member) and Paul Klee exhibition at Galerie Sturm in Berlin.

■ Franz Marc dies on March 4 near Verdun, France.

July
□ *Expressionisten. Kubisten. Futuristen* (Expressionists, Cubists, Futurists) exhibition at Galerie Sturm, with works by Chagall, Ernst, Feininger, Kandinsky, Klee, Kokoschka, Fernand Léger, Marc, Münter, Francis Picabia, Gino Severini, and others.

September
□ Kandinsky exhibition at Galerie Sturm.

□ Galerie Richter presents *Deutsche Expressionisten* (German Expressionists) exhibition.

□ *Franz Marc: Gedächtnis-Ausstellung* (Franz Marc Memorial Exhibition) at the Neue Secession in Munich, presenting 164 works.

November
□ A Franz Marc memorial exhibition is held at Galerie Sturm in Berlin presenting 53 works.

1917 ● Dutch painters Piet Mondrian and Theo van Doesburg and Dutch architect J. J. P. Oud found De Stijl, an abstract movement stressing the social and spiritual value of art.

January
● First Dada exhibition at Galerie Corray in Zürich.

● After spending time in sanatoriums, Kirchner travels to Davos in the Swiss Alps, where he will settle in 1918.

February
● Russian Revolution begins, leading to dissolution of the Russian Empire.

March
□ *Franz Marc: Gedächtnis-Ausstellung* (Franz Marc Memorial Exhibition) at Neues Museum, Wiesbaden.

April
● The United States declares war on Germany.

Spring
□ Pechstein is released from military duty and returns to Berlin.

September
□ Feininger exhibition at Galerie Sturm in Berlin.

October
🔥 *Französische Kunst des XIX. und XX. Jahrhunderts* (French Art of the 19th and 20th Centuries) at the Kunsthaus Zürich (October 5–November 14).

Winter
□ By the end of the year, Dresden-based artists Conrad Felixmüller, Constantin von Mitschke-Collande, and others found the Expressionistische Arbeitsgemeinschaft Dresden (Expressionist Working Group Dresden).

1918 World War I ends on November 11 with the defeat of Germany and the collapse of the German and Austro-Hungarian empires.

Plates

Adolf Erbslöh
The Red Skirt, 1910
plate 34 | cat. 44

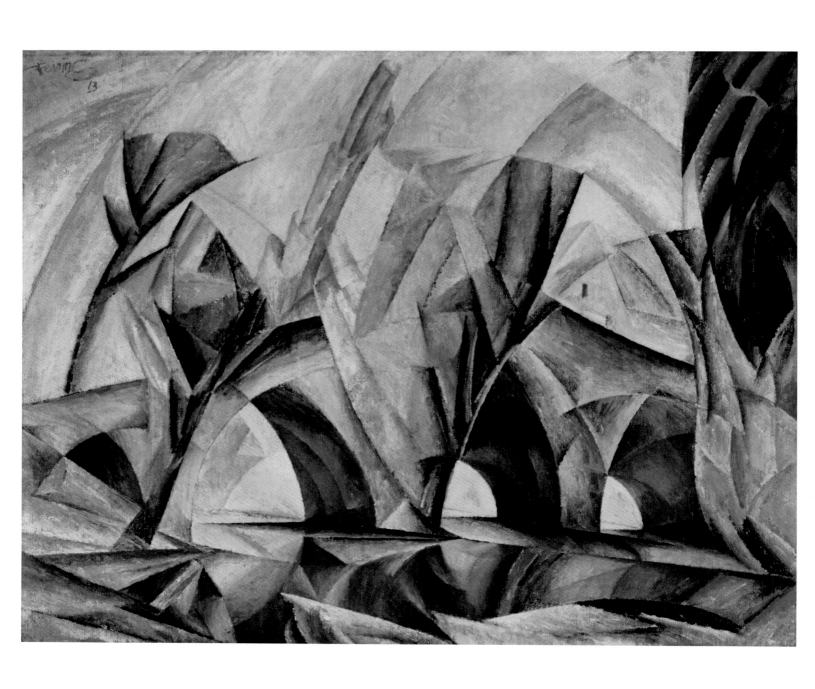

Lyonel Feininger
Bridge I, 1913
plate 35 | cat. 47

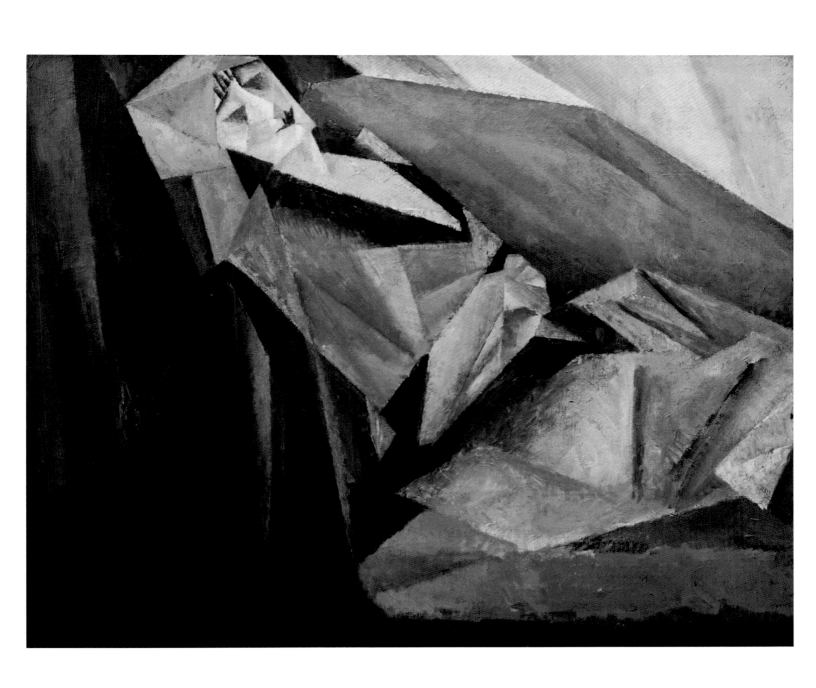

Lyonel Feininger
Sleeping Woman—Julia, 1913
plate 36 | cat. 48

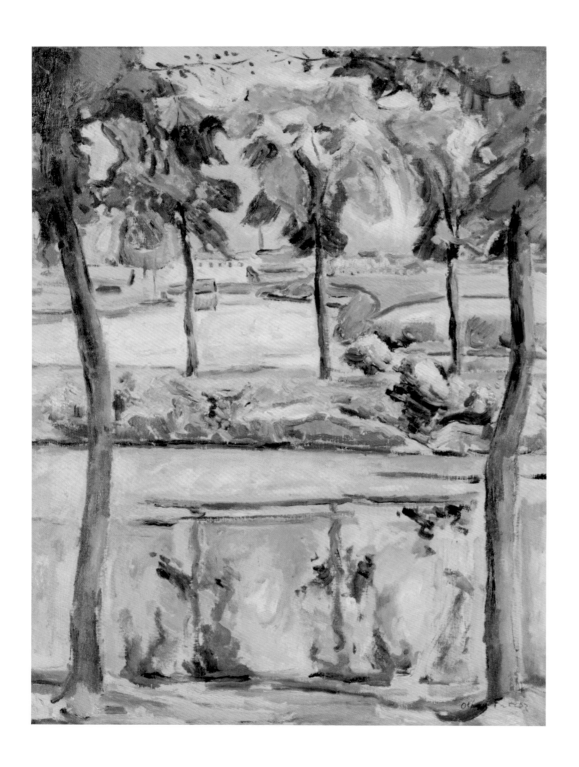

Othon Friesz
The Canal at Anvers, 1906
plate 37 | cat. 49

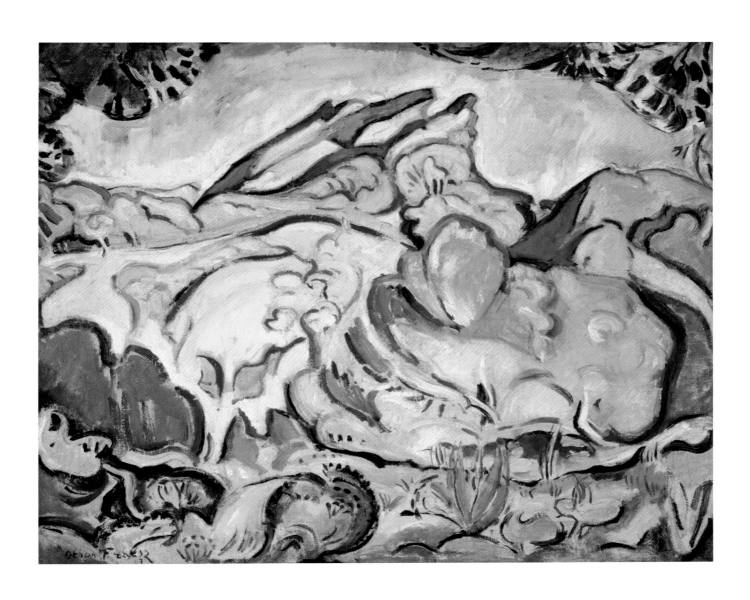

Othon Friesz

Landscape (The Eagle's Beak, La Ciotat), 1907
plate 38 | cat. 51

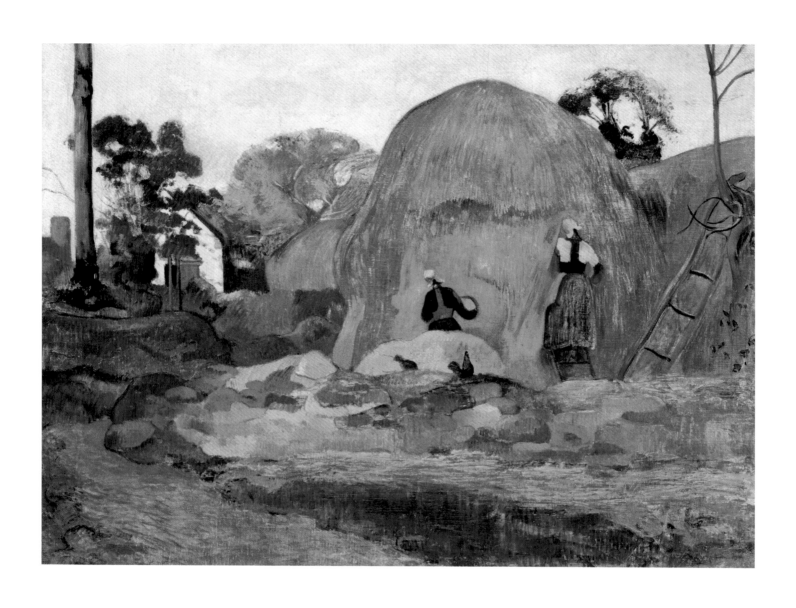

Paul Gauguin
The Yellow Haystacks, 1889
plate 39 | cat. 53

Paul Gauguin
The House of Pan-Du, 1890
plate 40 | cat. 55

top:
Paul Gauguin
At Play in Fresh Water, 1893–94
plate 41 | cat. 59

bottom:
Paul Gauguin
Human Misery, 1898–1900
plate 42 | cat. 63

94

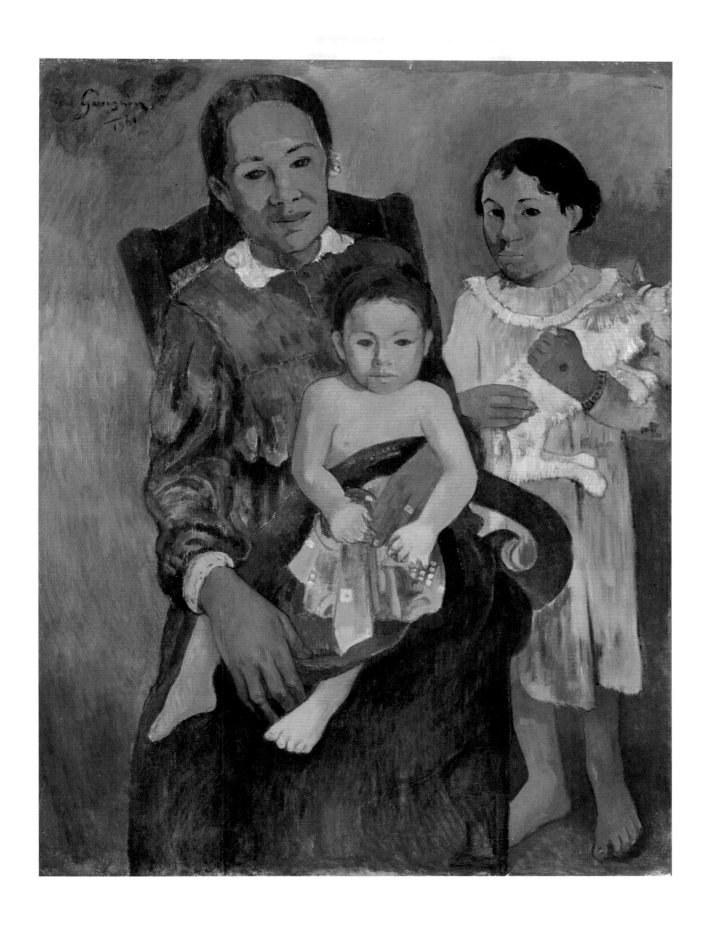

95

Paul Gauguin
Polynesian Woman with Children, 1901
plate 43 | cat. 64

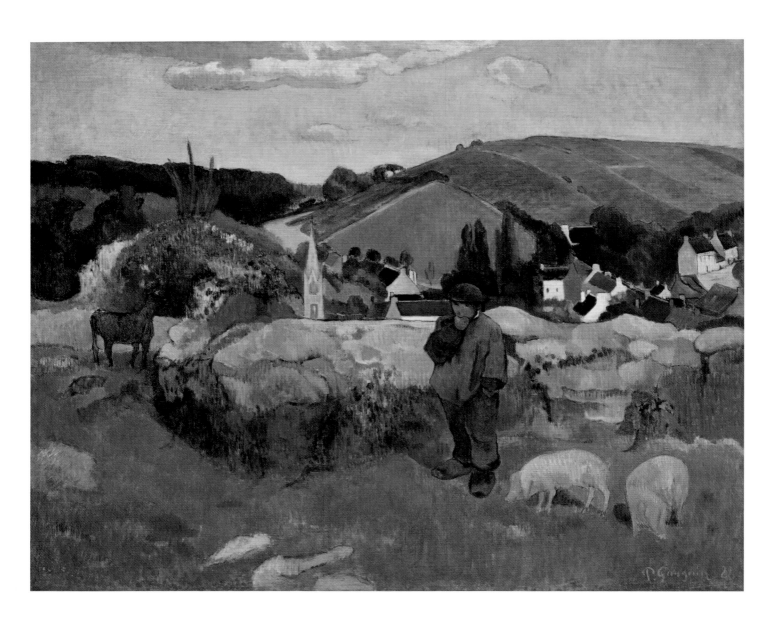

Paul Gauguin
Swineherd, 1888
plate 44 | cat. 52

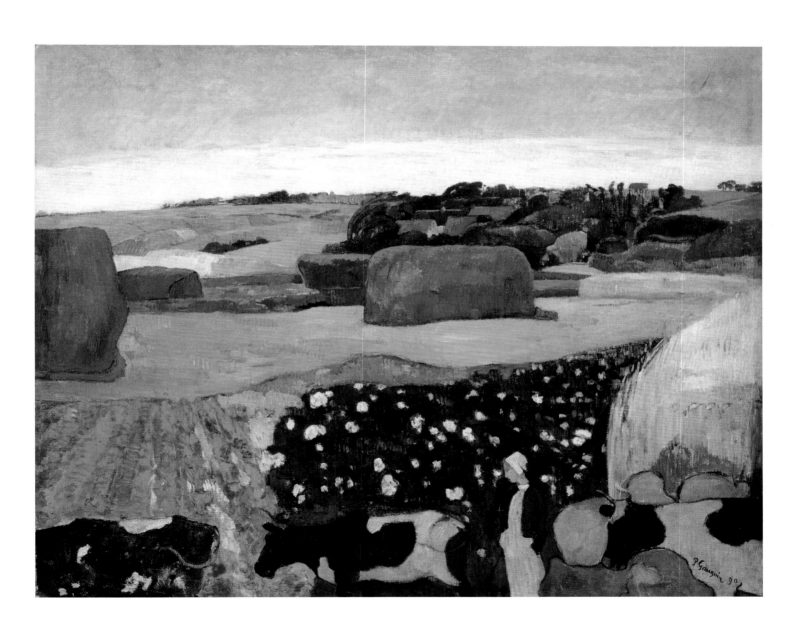

Paul Gauguin
Haystacks in Brittany, 1890
plate 45 | cat. 54

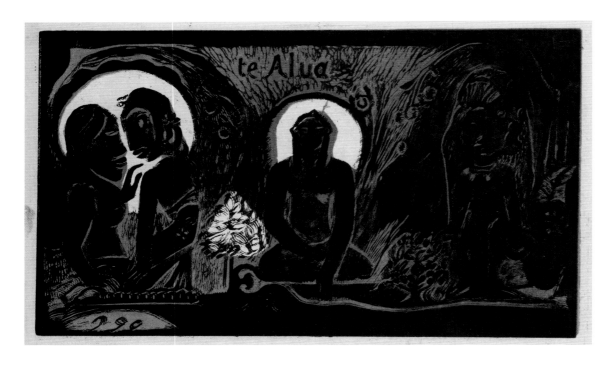

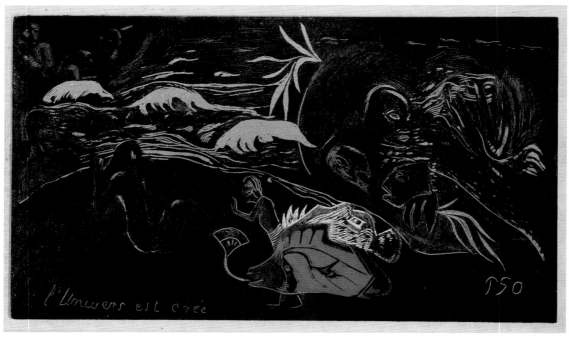

top:
Paul Gauguin
The Gods, 1893–94
plate 46 | cat. 62

bottom:
Paul Gauguin
The Creation of the Universe, 1893–94
plate 47 | cat. 60

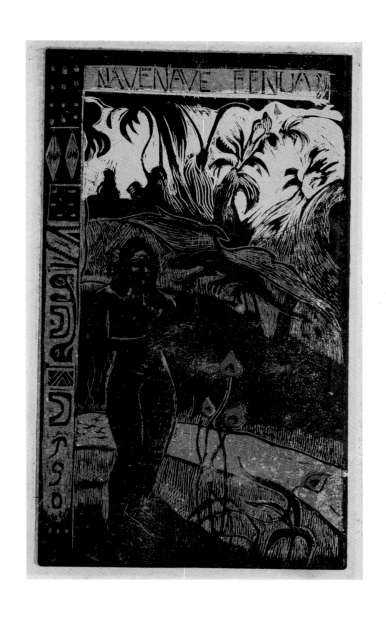

Paul Gauguin
Magnificent Land, 1893–94
plate 48 | cat. 61

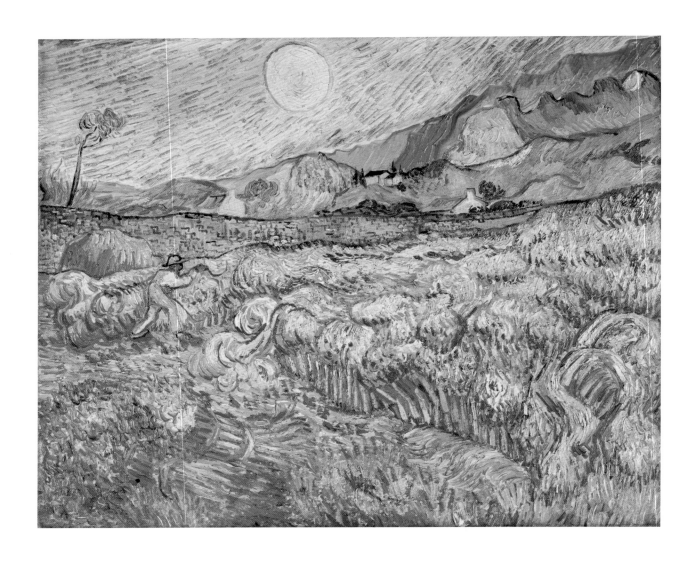

Vincent van Gogh
Wheatfield with Reaper, 1889
plate 49 | cat. 74

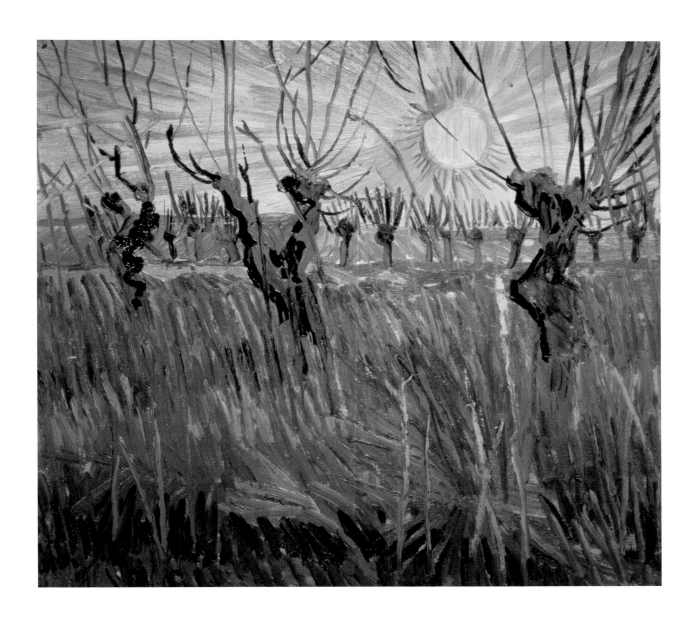

Vincent van Gogh
Pollard Willows at Sunset, 1888
plate 50 | cat. 69

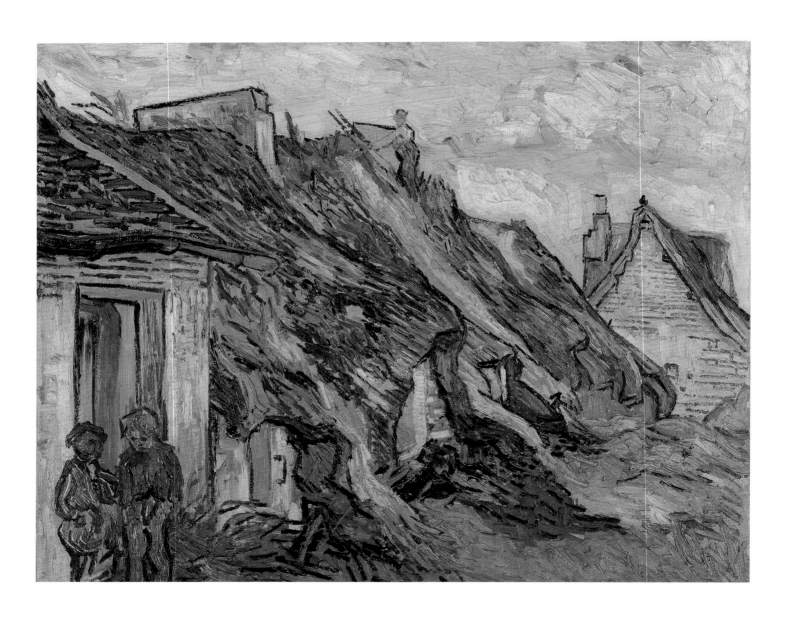

Vincent van Gogh
Thatched Sandstone Cottages at Chaponval, 1890
plate 51 | cat. 76

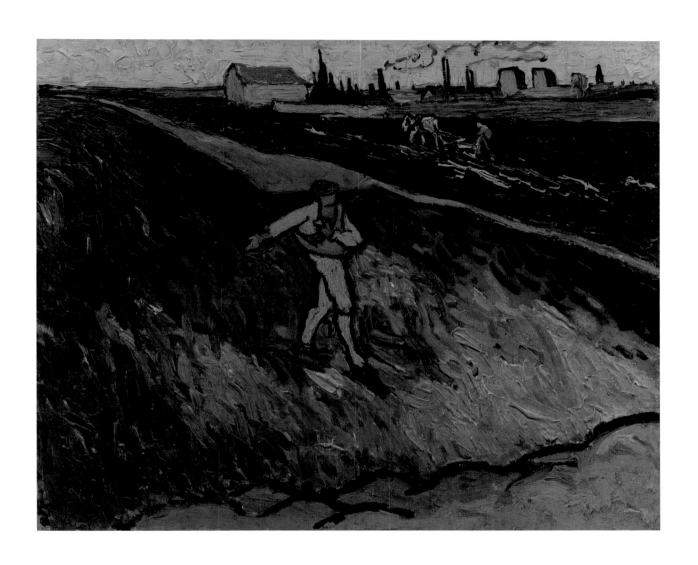

Vincent van Gogh
The Sower: Outskirts of Arles in Background, 1888
plate 52 | cat. 71

top:
Vincent van Gogh
The Road to Tarascon, 1888
plate 53 | cat. 70

bottom:
Vincent van Gogh
The Bridge at Langlois, 1888
plate 54 | cat. 68

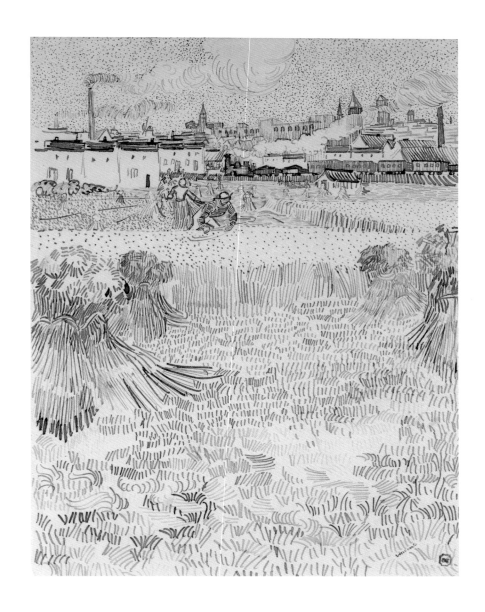

Vincent van Gogh
Arles: View from the Wheat Fields, 1888
plate 55 | cat. 67

Vincent van Gogh
Restaurant of the Siren at Asnières, 1887
plate 56 | cat. 66

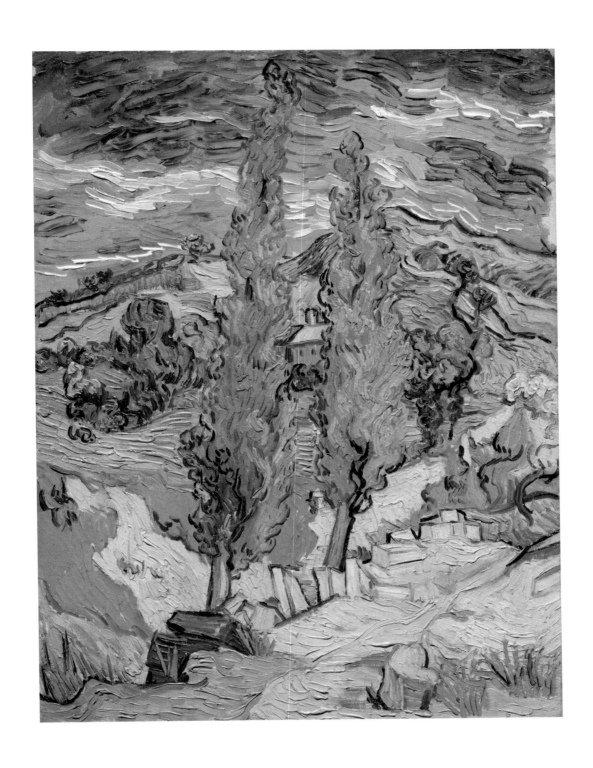

Vincent van Gogh
The Poplars at Saint-Rémy, 1889
plate 57 | cat. 72

Erich Heckel
Group on Holiday / Group Outdoors, c. 1909
plate 58 | cat. 85

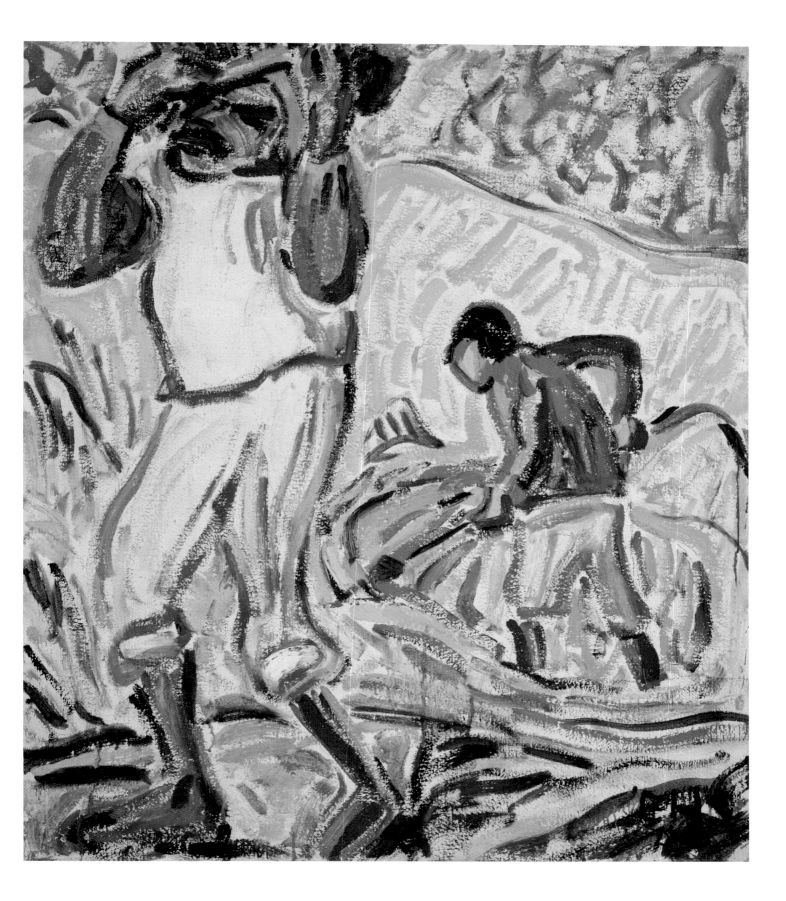

Erich Heckel
Sand Diggers on the Tiber, 1909
plate 59 | cat. 84

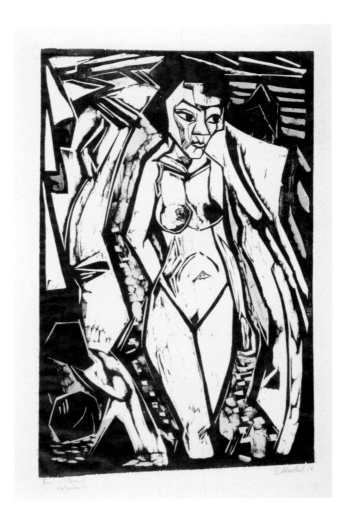

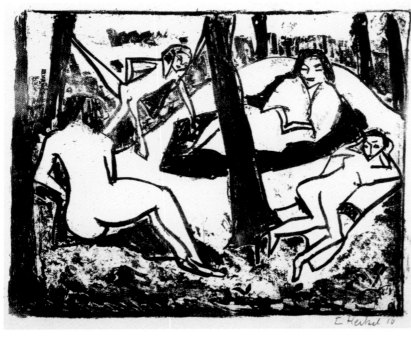

top:
Erich Heckel
Female Nude on the Beach, 1913
plate 60 | cat. 89

bottom:
Erich Heckel
Scene in the Woods, 1910
plate 61 | cat. 87

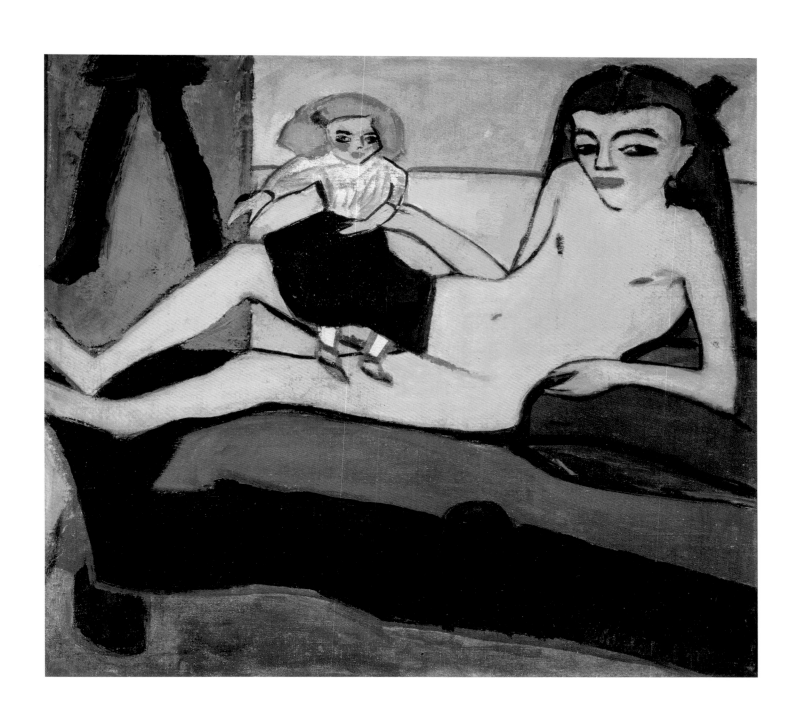

Erich Heckel
Girl with Doll, 1910
plate 62 | cat. 86

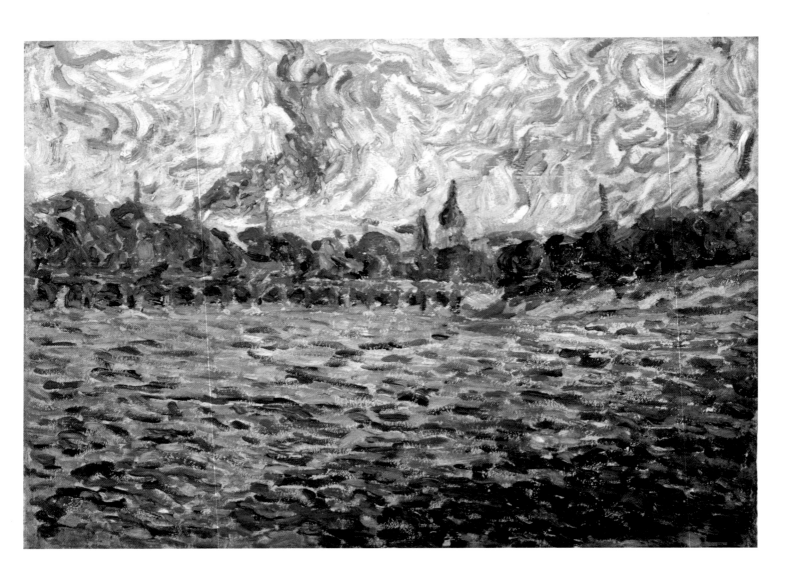

Erich Heckel
The Elbe at Dresden, 1905
plate 63 | cat. 78

Erich Heckel
Landscape at Dangast, 1907
plate 64 | cat. 82

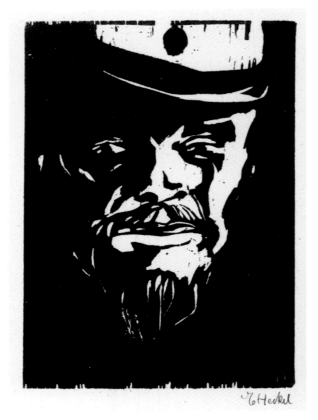

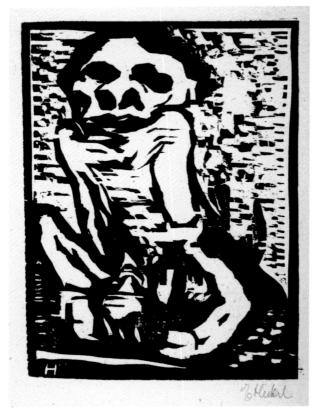

top:
Erich Heckel
The Prison Guard, 1907
plate 65 | cat. 81

bottom left:
Erich Heckel
Fear, 1907
plate 66 | cat. 79

114

opposite bottom right:
Erich Heckel
The Prisoner, 1907
plate 67 | cat. 80

Erich Heckel
Woman on the Bed, 1908
plate 68 | cat. 83

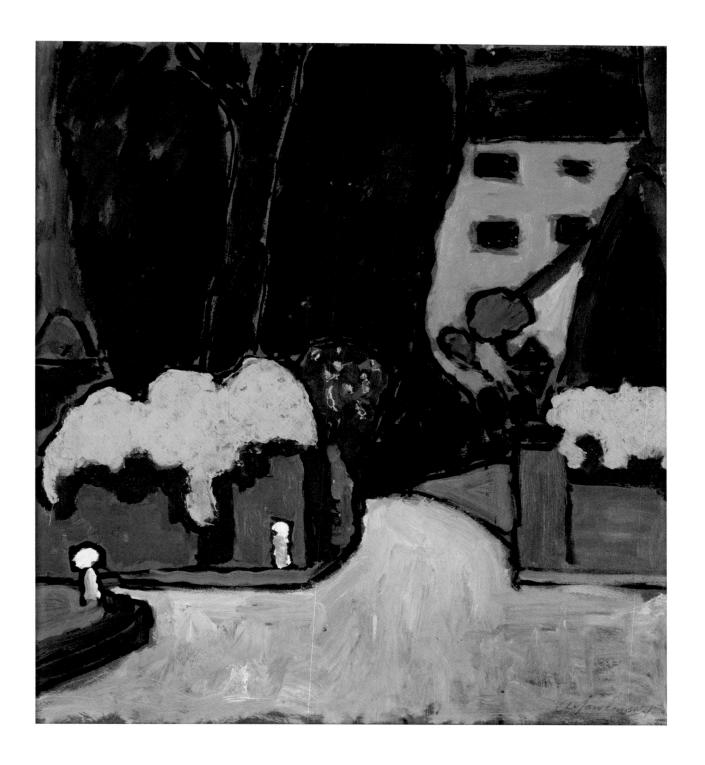

Alexei Jawlensky
Landscape, c. 1911
plate 69 | cat. 94

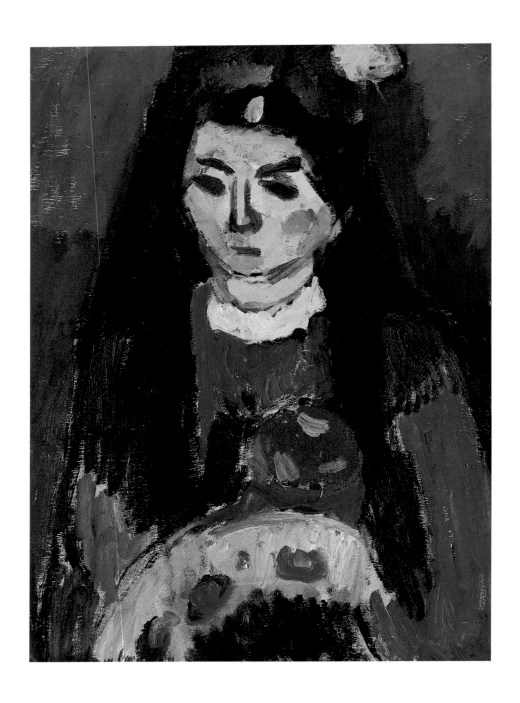

Alexei Jawlensky
Red Blossom, 1910
plate 70 | cat. 92

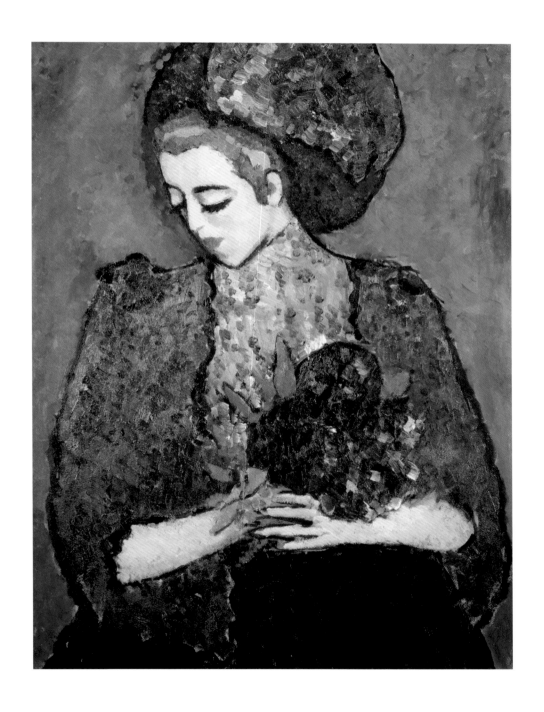

Alexei Jawlensky
Girl with Peonies, 1909
plate 71 | cat. 91

Alexei Jawlensky
Fairy Princess with a Fan, 1912
plate 72 | cat. 95

Alexei Jawlensky
Girl with Purple Blouse, 1912
plate 73 | cat. 96

Wassily Kandinsky
Section of Composition II, 1910
plate 74 | cat. 102

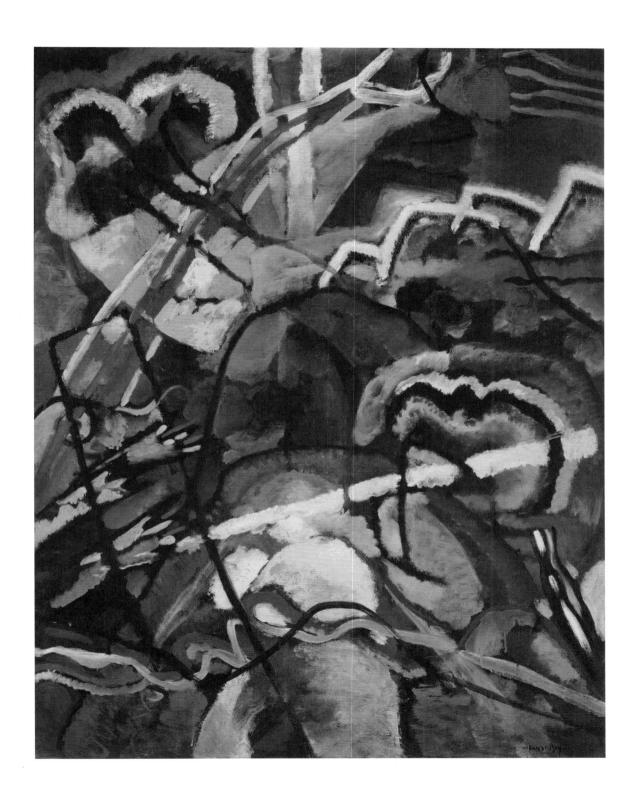

Wassily Kandinsky
Sketch I for Painting with White Border, 1913
plate 75 | cat. 103

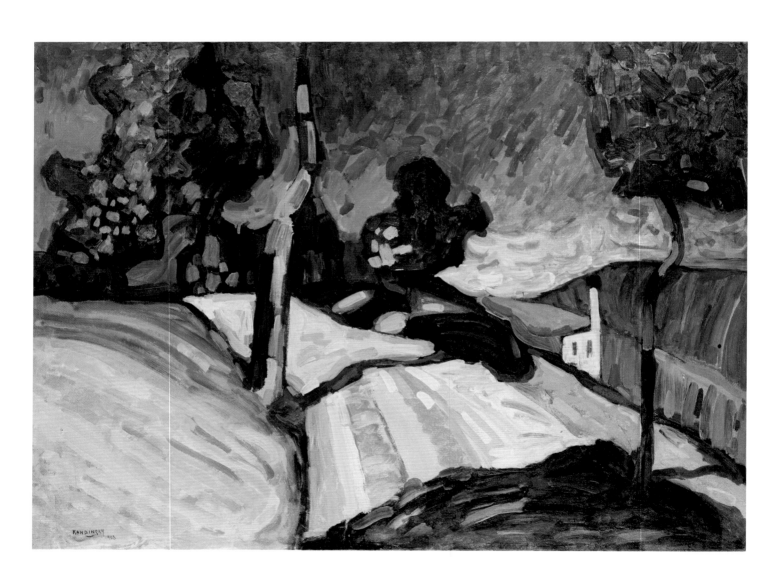

Wassily Kandinsky
Murnau, Kohlgruberstrasse, 1908
plate 76 | cat. 100

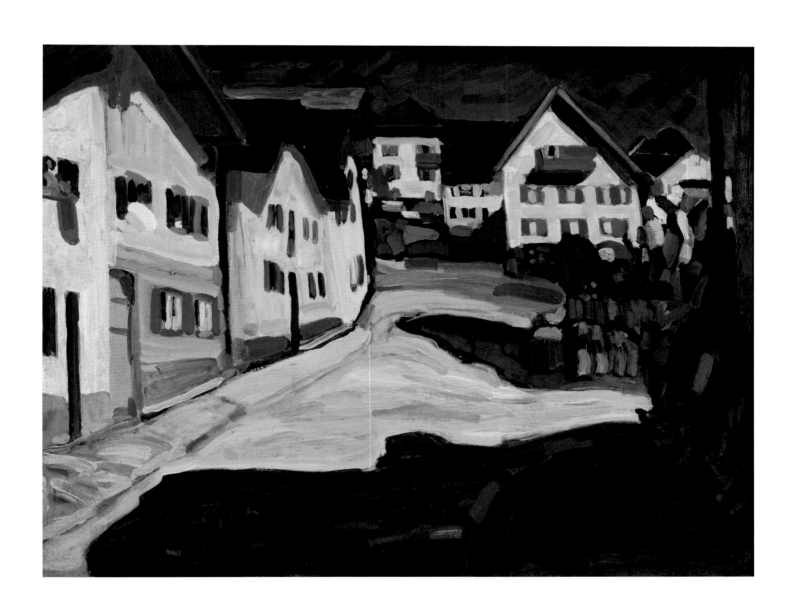

Wassily Kandinsky
Murnau, Burggrabenstrasse 1, 1908
plate 77 | cat. 99

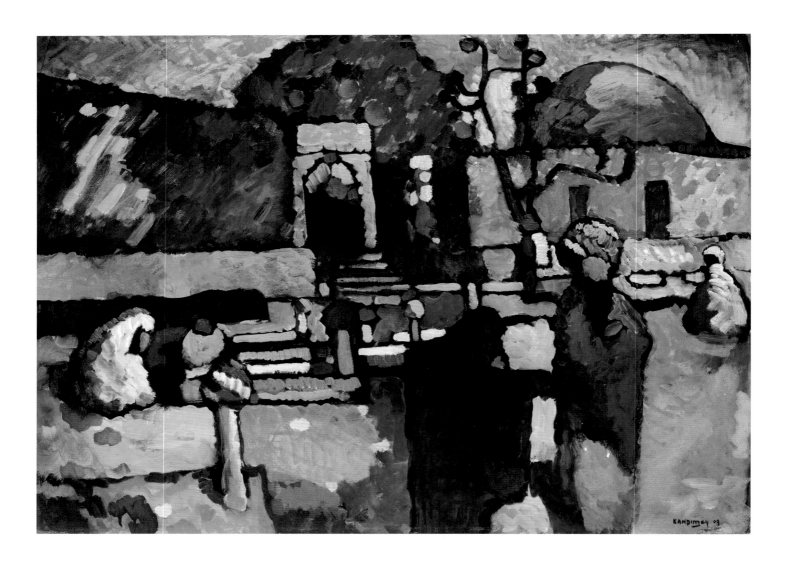

Wassily Kandinsky
Arabian Cemetery, 1909
plate 78 | cat. 101

Ernst Ludwig Kirchner
Dance Hall Bellevue, 1909–10
plate 79 | cat. 111

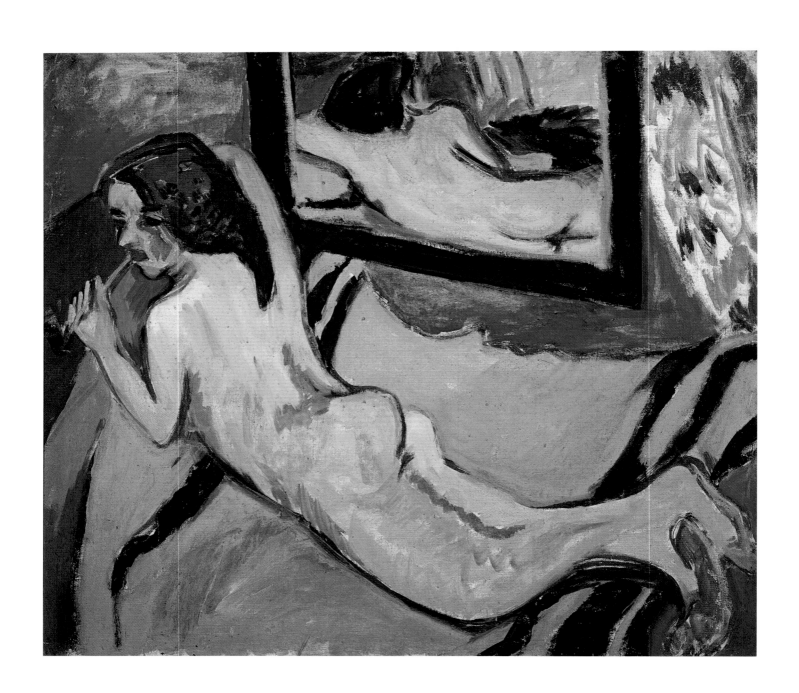

Ernst Ludwig Kirchner
Reclining Nude in Front of Mirror, 1909–10
plate 80 | cat. 112

Ernst Ludwig Kirchner
Artist—Marcella, 1910
plate 81 | cat. 113

Ernst Ludwig Kirchner
Seated Woman with Wood Sculpture, 1912
plate 82 | cat. 120

Ernst Ludwig Kirchner
Street, Berlin, 1913
plate 83 | cat. 124

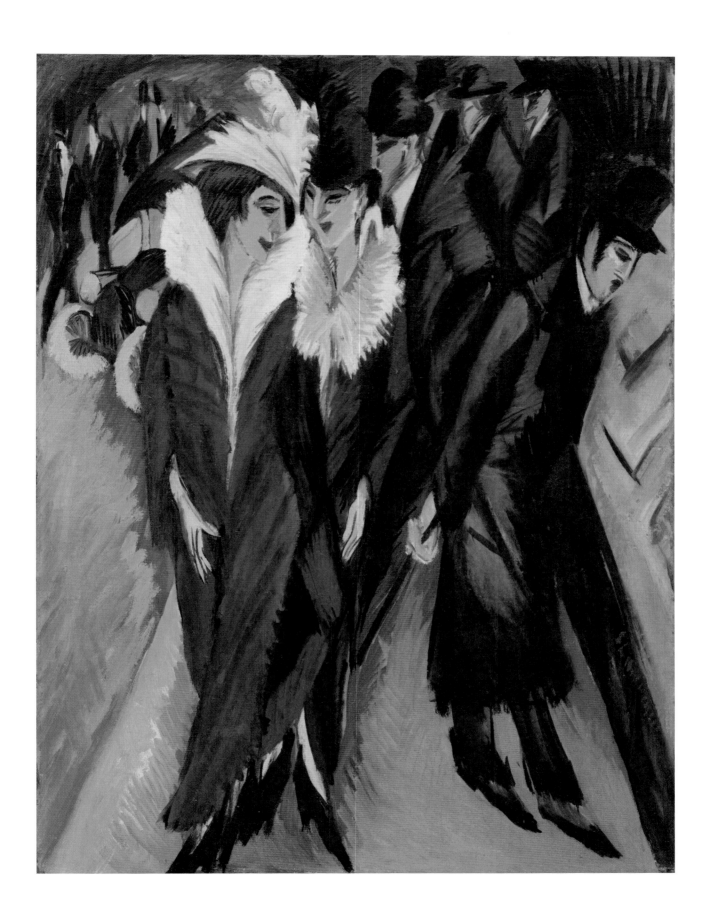

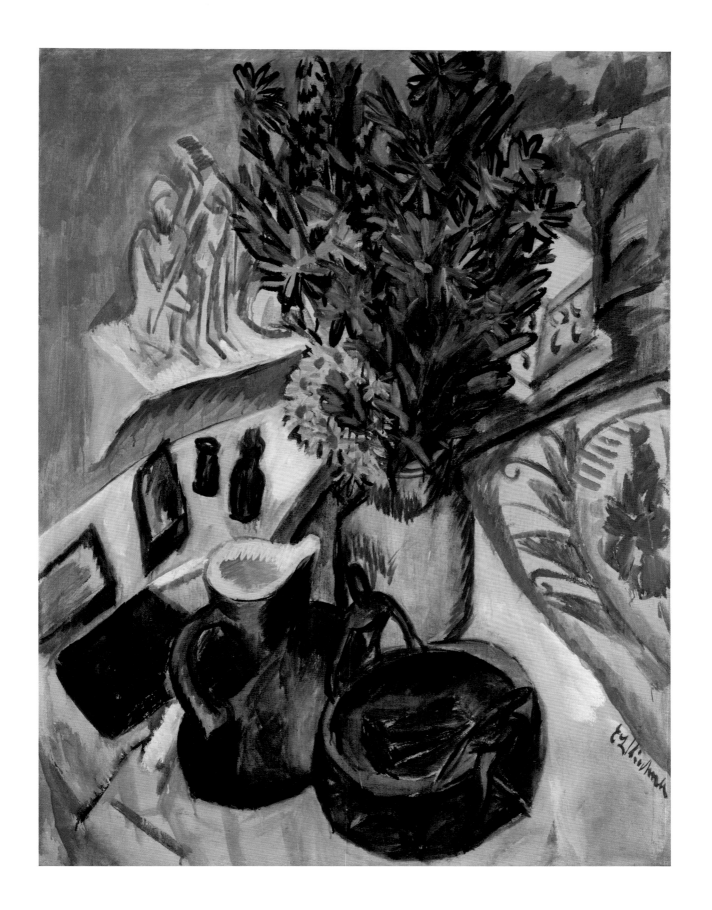

Ernst Ludwig Kirchner
Still Life with Jug and African Bowl, 1912
plate 84 | cat. 121

133

Ernst Ludwig Kirchner
Dodo Playing with Her Fingers, 1909
plate 85 | cat. 108

Ernst Ludwig Kirchner
Two Women, c. 1910
plate 86 | cat. 117

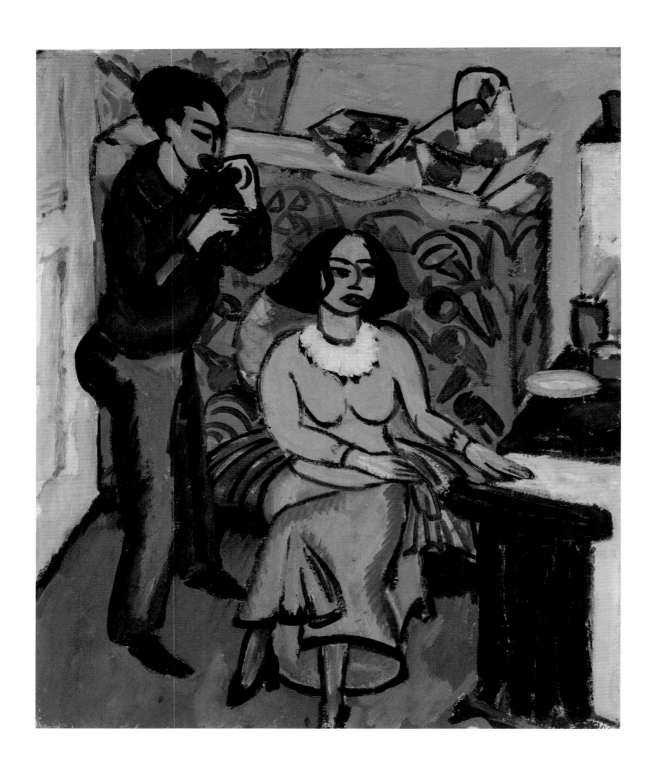

Ernst Ludwig Kirchner
Otto and Maschka Mueller in the Studio, 1911
plate 87 | cat. 119

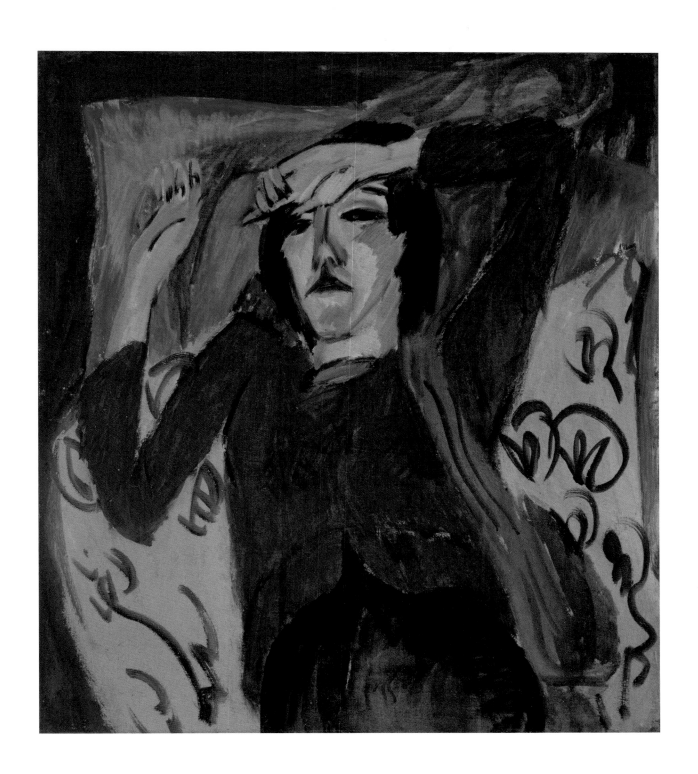

Ernst Ludwig Kirchner
Woman in a Green Blouse, 1910
plate 88 | cat. 116

top:
Ernst Ludwig Kirchner
Still Life with Pitcher and Flowers, 1907
plate 89 | cat. 105

bottom:
Ernst Ludwig Kirchner
Love Scene, 1908
plate 90 | cat. 106

139

top:
Ernst Ludwig Kirchner
The Dreaming Woman, 1909
plate 91 | cat. 110

bottom:
Ernst Ludwig Kirchner
Three Bathers at the Moritzburg Lakes, 1910
plate 92 | cat. 115

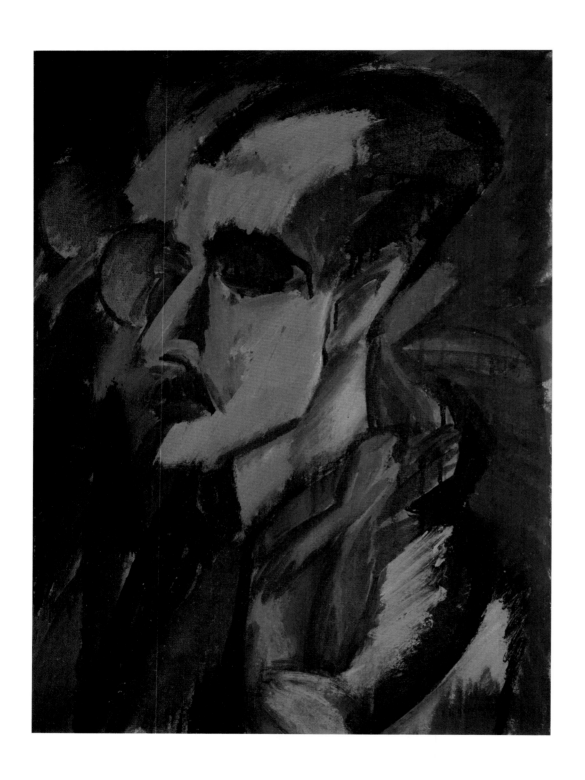

Ernst Ludwig Kirchner
Portrait of Gewecke, 1914
plate 93 | cat. 125

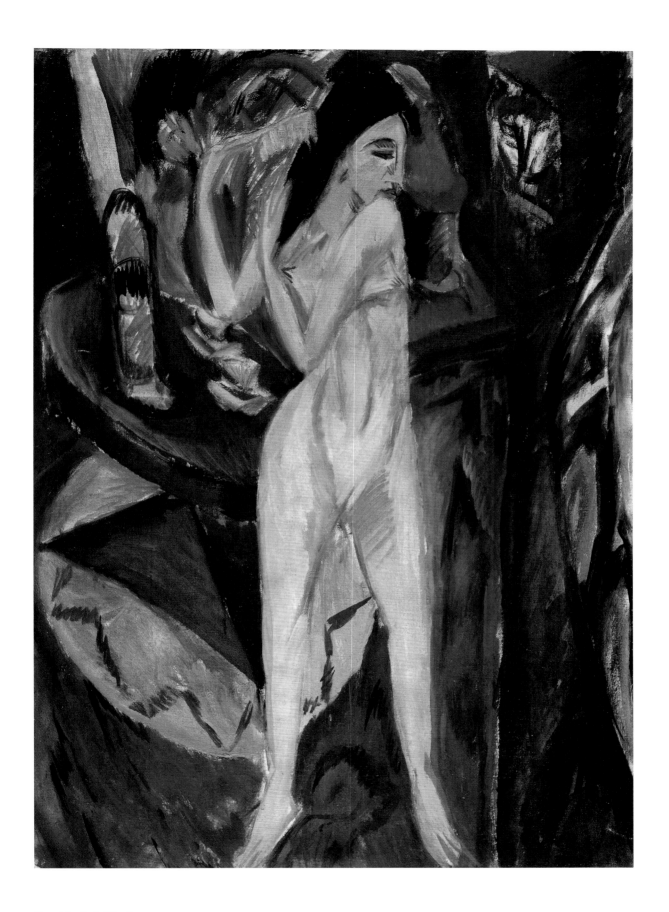

Ernst Ludwig Kirchner
Nude Combing Her Hair, 1913
plate 94 | cat. 123

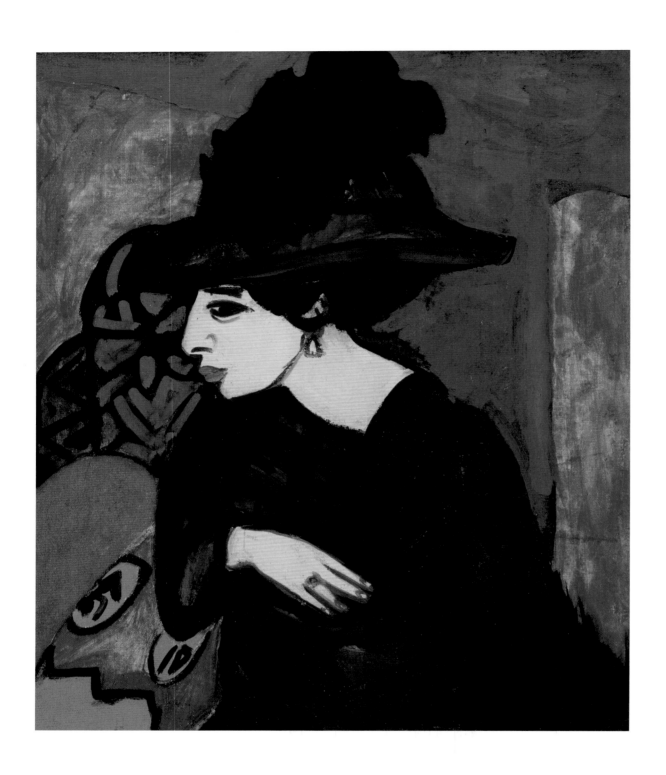

Ernst Ludwig Kirchner
Dodo with a Feather Hat, 1911
plate 95 | cat. 118

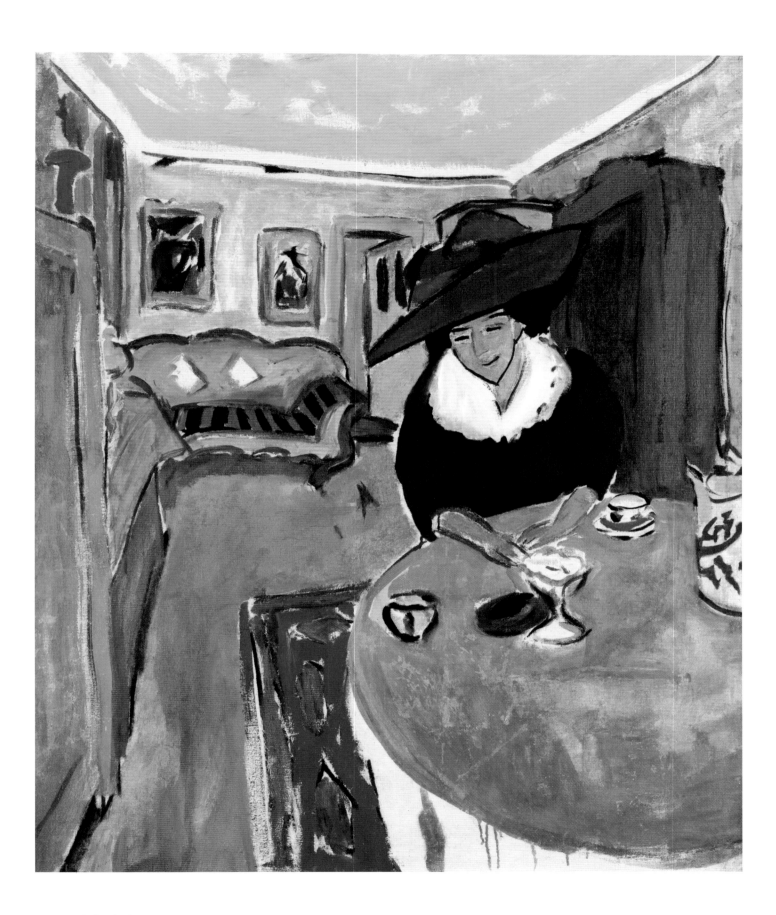

Ernst Ludwig Kirchner
Dodo at the Table (*Interior with Dodo*), 1909
plate 96 | cat. 107

LAIRD M. EASTON

Harry Graf Kessler's Path to Expressionism

IN APRIL 1916, in the midst of World War I, Eberhard von Bodenhausen, a leading figure in the Krupp armaments firm, wrote to Hugo von Hofmannsthal about his recent disturbing encounter with their mutual friend Harry Graf Kessler. Twenty years earlier Bodenhausen and Kessler—fraternity brothers at university—had been comrades-in-arms in the struggle to introduce aesthetic modernism to Germany. Both men had served on the board of the seminal journal *Pan* in the 1890s, where they made the acquaintance of the leading modernist German writers and artists. They also acted as liaisons between *Pan* and the international Art Nouveau movement, traveling to Paris, Brussels, and London to seek contributions to the journal. Bodenhausen and Kessler

collaborated in bringing the Belgian designer and architect Henry van de Velde to Germany and conspired successfully to have him appointed head of the school of design in Weimar. When Kessler was appointed director of the Grand Ducal Museum of Arts and Crafts there as well, Bodenhausen supported his friend's efforts to turn Weimar into a center for the promulgation of aesthetic modernism. They took part in the founding of the Deutscher Künstlerbund (German Artists League), an umbrella organization of secessionist groups seeking to protect modern art from the vehemently antimodern *Kunstpolitik* (art policy) of the Kaiser.

Yet by 1916 their paths had parted, at least when it came to art and literature. Describing his old friend to Hofmannsthal, Bodenhausen wrote:

> He is very fresh; for my feelings however a little too impetuous in relation to modern literature etc. He seems restlessly to experience what all but the fewest people can experience, and what I had always wished for myself: not to lose contact, even in old age, with the latest examples of artistic production. That he at the same time, as corresponds to his character, exaggerates all of this is probably the necessary pendant to such a talent.

Kessler tells Bodenhausen of young poets and writers of whom he has never heard: Johannes Robert Becher, Franz Werfel, Theodor Däubler. Excitedly he tries to introduce Bodenhausen to the young poet, war dodger, and morphine addict Johannes Becher—"something which I quite emphatically rejected," Bodenhausen assured Hofmannsthal. Out of friendship Bodenhausen reads some Becher:

> [S]ome poems...appear strong. But exactly these appear, in the eyes of connoisseurs, to be more or less outdated and full of clichés. Everything else fills me with the most honest disgust, both regarding the content and the form.... [Kessler] concluded, in a worried manner, that my strenuous activity in the last 10 years had damaged my receptivity, especially regarding vital life.[1]

After a recent long conversation with Kessler in this vein, Bodenhausen reported being deeply disturbed and unable to sleep afterward.

While Bodenhausen's letter expresses, amid the bewilderment and scorn, some wistful envy of Kessler's ability to stay in contact with the latest artists and writers, Hofmannsthal's response lacked all such nuances. Instead he mocked scornfully Kessler's openness to new art. "I don't know, perhaps I am unjust, but he bets on *every* horse that's in the running—I find that deadly boring."[2] This spleen can be attributed, in part, to long-festering personal resentments Hofmannsthal nourished against Kessler. But this exchange also illustrates perfectly the incomprehension and scorn with which the first generation of German modernists—those marked by the battles

Harry Graf Kessler in 1898
Klassik Stiftung Weimar/Fotothek

over Impressionist art—greeted the new and upcoming generation of Expressionist writers and artists.[3] The greatest symbol of this changing of the avant-garde was the rejection by the Berlin Secession of the Expressionist artists in 1910 even though earlier it had displayed works by Max Beckmann, Emil Nolde, and Wassily Kandinsky.[4] Mocking their elders, the rejected artists formed the Neue Secession and mounted one of the first major exhibitions of their art.

Bodenhausen's letter suggests that Kessler was one of the few members of his generation to remain open to the new art and literature. But what was Kessler's real relation to Expressionism? Was it only Expressionist literature he embraced or did he feel the same way about Expressionist art? If so, why does his diary—usually the site of extensive reflections on art that interested him—appear to be so reticent on Expressionism? To the extent that he was receptive to Expressionism, was this simply a matter of a personality that, as Hofmannsthal's sneer suggests, was predisposed to welcome whatever was fashionable at the moment? Or was there a deeper affinity at work? And how did this "traveler between worlds," as Hofmannsthal in a more generous moment called him, situate the new German art against the French modernists whom he knew so intimately? Did his encounter with the Nabis or with Henri Matisse give him a vocabulary to understand Expressionism? Kessler was an inveterate composer of flowcharts tracing the roots and evolution of modern art: how did Expressionism fit into these schemas? This essay will argue that Kessler came around to thinking of Expressionism as a specifically Nordic, or German form. His deepest personal taste was more attracted to its opposite, the classical, Mediterranean modernism represented by the work of Aristide Maillol, but over time he came to see in Expressionism a revival of the northern, Gothic style within the general European aesthetic.

In a number of articles published around the turn of the century, Kessler elaborated an aesthetic theory that had much in common with the goals of Expressionism. In particular he stressed the importance of three phenomena—the role of feeling, the religious roots of art, and the uses of ornament—that played paramount roles in Expressionist aesthetics. The chief accusation Kessler leveled against academic art was its lack of feeling. His description of the art of Anton von Werner, the paragon of German academic art—"Usually twelve to sixty uniformed, expressionless

gentlemen stand around, utterly dry and stiff"—seethes with contempt.[5] In contrast to this lifeless masquerade, he argued that genuine art was characterized by the expression of real feeling.

His most extensive theoretical discussion of aesthetics, the essay "Art and Religion: The Religious Crowd," published in *Pan* (April 1899), argued that the most inexhaustible source of genuine art had always been religion. The artist emulates the priest in that he employs rhythm, harmony, and poetry to evoke emotions in his public. Over time the "feeling-tones" unleashed by art become unmoored from their religious roots, become overcomplicated, desiccated and etiolated, a matter for pale aesthetes and decadents. Only a resurgence of religious feeling could rescue art from the cul-de-sac of "art for art's sake." Kessler believed he was witnessing the beginning of such a religious revival in the spread of a Nietzschean celebration of life.[6]

Of particular interest for Kessler was ornamental art. It was the visual analogue of rhythm, a key word for him. His journal is full of detailed commentary on the ornamentation he found on Greek vases and Mayan tombs. Ornament was an expression of the *Kunstwollen* (artistic will) of a people, to use Alois Riegl's term; it was a record of their most fundamental attitude toward life. Abstract or primitive ornament was not a way station on the path to realism but a perfectly legitimate art in its own terms. In some ways Kessler's observations on ornament adumbrated the views that Wilhelm Worringer would present in 1907 in his *Abstraction and Empathy*.[7]

By the time "Art and Religion" was published, Kessler was in the midst of a decisive aesthetic experience: the encounter with French modernism. This was certainly a foreordained rendezvous. Born in Paris in 1868, his father a German banker, his mother a member of the Anglo-Irish gentry, Kessler was first educated in a lycée. His mother, a strikingly beautiful woman, kept a salon frequented by artists, actors, and writers, among them Sarah Bernhardt, Eleonora Duse, Tommaso Salvini, Guy de Maupassant, Auguste Rodin, and Henrik Ibsen. The Kesslers performed musical duets together and their house included a private theater where Alice von Kessler once danced a memorable tarantella as Nora in Ibsen's *A Doll's House*.[8] Harry's lifelong habit of making the acquaintance of artists and writers therefore had deep roots in his childhood. Although he was sent to England at age twelve to attend boarding school

in Ascot, he always considered France to be one of his three homelands, along with Germany and Great Britain. His observations on French culture and politics, often contrasted with English or German counter-examples, fill his extraordinary diary.[9] Described by Auden as "perhaps the most cosmopolitan man who ever lived," Kessler eventually chose to identify himself as a German first and foremost, a choice symbolized by his switching from English to German in his journal during his last year at university. But he kept permanent suites at hotels in Paris and London, and spent his life in a nearly continual rotation between France, England, and Germany, so much so that the doorman at the Grand Hotel called him "*l'homme à vapeur.*"

While waiting for an opening in the Foreign Service that never materialized, Kessler became interested in the emerging modern art and literature that he encountered in Berlin in the 1890s. Joining the board of the modernist journal *Pan*, he undertook a number of trips to Paris to make contact with French artists and writers. Under the impact of his discovery of first the Impressionists and then Post-Impressionists, especially the Pointillists, his earlier enthusiasm for artists such as Arnold Böcklin and Max Klinger, but also for the German Impressionists, withered. He came to believe that Germany simply lacked the culture of the eye, the painterly traditions of France. After visiting an exhibition of Gustav Klimt in Dresden, he noted sadly: "Everywhere one looks, German art of the nineteenth century hardly advanced beyond the beginnings. Just compare Overbeck with Ingres, Feuerbach with Puvis de Chavannes, Böcklin with Delacroix, Leibl with Manet, all second best."[10]

This attitude of scorn/concern only deepened when he met the Nabis, the artists with whom he formed his most intimate relationships as both a patron and a friend. The work of Maurice Denis, Edouard Vuillard, Pierre Bonnard, and especially Maillol seemed to him to be a *summum bonum* of painting, the very culmination of a distinguished tradition. Their flattened perspective and broad swatches of complementary colors, their exploration of the formal harmonies and rhythms of colors and textures seemed to Kessler to point to an art completely devoid of *Ideengeschichte* (history of ideas), the curse of the German artists he had once admired. Compared to the work of the French, their colors seemed muddied, their technique deficient. Shortly

after a visit to Paris, he viewed the recent work of his Weimar friend Ludwig von Hofmann. Privately appalled, Kessler advised him to go to Paris to learn from the masters, advice he repeated to other German artists. He came to see it as his mission, when he became director of the museum of arts and crafts in Weimar, to educate the German eye. This meant moving away from the biographical and historical approach to art history prevalent in Germany toward one that saw the discipline as the history of aesthetic problems, how to capture light on canvas, for example.

In a prospectus outlining how the museum's collection would be reorganized to emphasize formal aesthetic qualities, rather than along historical lines as before, he exclaimed: "We do not want to create historians."[11]

Admittedly there is no clear line leading from the Nabis to the Expressionists. Certainly some Expressionists were influenced by the work of the Nabis and there was some personal contact,[12] but the influence was a matter of formal techniques—the emotional tone is quite different. Expressionism oscillates dramatically between moods of darkest despair and of chiliastic ecstasy. By contrast, the work

Vincent van Gogh
Portrait of Doctor Gachet, 1890
cat. 75

of the Nabis seems on the surface at least serene, tranquil, self-assured, whatever darker currents may also run through it.[13] This is how Kessler interpreted it at any rate. He tended to appropriate the French art he most admired to the classical tradition. Certainly this was the case with the artist to whom he was closest as a patron, Maillol. Seeing in the sculptor a living remnant of classical antiquity, the culture that meant so much to him, Kessler was fond of drawing a contrast between Maillol's calm, timelessly serene nudes and Auguste Rodin's restless, tormented figures. In an article written after the war but relying on his earlier conversations with Maillol on the theme, Kessler described the two sculptors as antipodes:

> Rodin, the continuation of the French late Gothic, of the "dix-huitième," the master of details, of realistic observation, of the soft or stormy fluctuating surfaces, the dramatic silhouette; Maillol, the Greek, the master of masses, of the round fullness of physical health, which strives for the light, and for whom the detail has only as much worth as the white veil of blossoms for the fruit tree, serving to illuminate momentarily its structure and the powerful thirst of its sap.[14]

As much as he admired Rodin, a longtime friend, there was no doubt which style Kessler preferred. A "higher *Griechentum* [Hellenism]" was the goal that inspired Kessler his whole life.[15]

The polarity evident in his contrast of Rodin and Maillol began to pervade Kessler's thinking across the arts. He amplified it and deployed it in a number of fields. It also began to acquire a national-cultural coloration. He noted the difference between the lyrical-tragic point of view, the subjective point of view of each individual, and the comedic point of view, the view of God, distanced and objective:

> To place the accent on titles, position, relations: that is the comedic view of life. The tragic sees "the inner value." The Englishman is, despite Shakespeare, narrowly constrained in that comic worldview, "snobbism." We Germans are endlessly far removed from it. We have no comedy and instead of snobs, only careerists, no half aesthetic admiration for position, but rather only naked greed and calculation.[16]

In all of this there is, of course, a sharp criticism of German culture. It suffered, in Kessler's eyes, from an excess of inwardness, of lyrical subjectivity. It needed a dose of the comedic and occasionally, as when he attended the premiere of Carl Sternheim's *Die Hose* (The Underpants) in 1911, he thought it might be moving in that direction. But even if he was more strongly drawn to the classical side of the polarity, Kessler was also attracted at times to the lyrical-subjective side. Indeed the very establishment of the antithesis permitted him to be open to an art emphasizing these qualities. He always conceived of the Gothic, especially the thirteenth century, as being the necessary pendant to the Greek: both

contributed equally to the formation of modern European culture. For someone drawn to the idea of the gentleman/dandy, as well as to Mediterranean classicism, he was surprisingly susceptible to the prophetic, mystical, lyrical strain represented by poets such as Ludwig Derleth and Richard Dehmel. This was the side of him that would later welcome Expressionism.

He admired many of the artists whom the Expressionist generation considered their predecessors. It is true that Kessler wrote in the 1890s how strange his patronage of Edvard Munch was, given how little

Harry Graf Kessler, Paul Hildesheim, Ludwig von Hofmann, Edward Gordon Craig, and Henry van de Velde discussing the plan for a new theater in Weimar, c. 1904
Schiller-Nationalmuseum/Deutsches Literaturarchiv, Marbach

he cared for his art. But later he sat for the series of portraits Munch did of him, culminating in the great, full-length painting now in the National Gallery in Berlin.[17] He was a great admirer of Matthias Grünewald's Isenheim altarpiece, which he took Dehmel to see.[18] He owned several works by Van Gogh, including *Portrait of Doctor Gachet* (p. 147), and saw in him a representative of a specifically Germanic "energetic interpretation of nature."[19] Once, he defended Van Gogh's *Flowering Garden with Path* against Paul Signac, who, while admiring the colors, claimed not to see any subject in the painting. The "*feeling*" was the important thing, Kessler replied: "And the feeling that this painting conveys had been not

sculpture, there are several ways in which Kessler can be seen as groping toward an Expressionist aesthetic. From a very early age he had been fascinated by dance, dreaming of an art form that would transcend the conventional ballet of his day. Although he found Isadora Duncan to be affected and sentimental, he was deeply impressed with her compatriot Ruth St. Denis. Certainly St. Denis's orientalist dances were a far cry from, say, Mary Wigman's *Ausdruckstanz* (expressive dance), but it was their expressive power that struck both him and Hofmannsthal, to whom he introduced her.[22] In the elaborate ceremonies Kessler imagined transpiring in his elaborate proposal for a memorial in

simply joy in a certain juxtaposition of tones, but also a joy in spring and flowers mixed in."[20] About Matisse he was more cautious, sounding out the—at first— rather negative opinions of other artists before eventually meeting him and forming his own opinion. After a visit to the artist's studio in Issy-les-Moulineaux, he registered this mixed impression: "Individual color harmonies, individual lines of Matisse are of great intensity and expressive power but everywhere a mixture of the childlike."[21]

Once one thinks of Expressionism more broadly, however, moving beyond painting and

Weimar, St. Denis would be invited to dance in the temple, the inner sanctum sanctorum devoted to the Dionysian principle.[23] Later this enthusiasm would reach a crescendo with his ecstatic reception of the Ballets Russes, which led to his coauthoring with Hofmannsthal of the ballet-pantomime *Josephslegende* (The Legend of Joseph), premiered by Sergei Diaghilev's company in Paris in May 1914 and in London in June. Kessler's musings on dance were shaped by his desire to find forms of movement that would express the rhythms of modern life. He was deeply interested in the efforts by Émile Jaques-Dalcroze and others

Edward Gordon Craig's illustration for the Cranach-Presse *Hamlet*, 1928

to teach children a new way of moving. As Peter Jelavich has shown, Expressionist painters shared these interests, although they tended to draw inspiration from the popular dances they saw at the varietés and cabarets.[24]

Another proto-Expressionist project that absorbed Kessler's attention was the new theater envisioned by Edward Gordon Craig. He first encountered Craig's work in an exhibition of ex libris designs in London in April 1903. Impressed, the very next day he attended a production of Ibsen's *The Vikings at Helgeland* that Craig had directed. He was struck by the austere design, the almost total lack of any

single element is more important on stage than all the others then it is not the word, but rather movement, the gesture."[25] All of these ideas were to be enormously influential on Expressionist theater in its efforts to go beyond naturalism and to uncover a deeper reality. Craig's specific ideas for sets—the use of screens, great flights of steps, sharply etched shadows, and so forth—would also be adopted by many Expressionist directors, both stage and film.[26] Certainly the woodcuts illustrating Shakespeare that so impressed Kessler and led, decades later, to the 1928 Cranach edition of *Hamlet*, are Expressionist in their spirit.

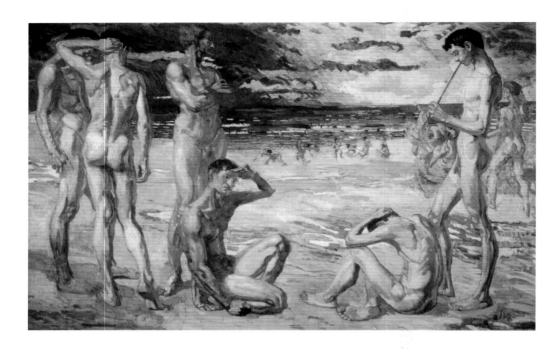

stage decoration, and the suggestive use of lighting to create the illusion of infinite space. The following September he met Craig and very soon took upon himself the task of introducing Craig and his ideas to Germany. Although few of his planned works ever saw production, at least not in the form in which he desired, Craig found a ready audience for many of his ideas in Germany. Craig, like Kessler, was fascinated by modern dance and movement, and in his preface to the German edition of Craig's *The Art of Theatre*, Kessler emphasized this: "Craig believes that a work for the stage doesn't always have to be composed of three parts literature and one part painting and music, according to the old recipe. Quite the contrary: if any

Turning to architecture, the story of Kessler's hopes for the grandiose Nietzsche monument can be seen as a misbegotten effort to create an Expressionist architecture. Reacting to a modest proposal by Elisabeth Förster-Nietzsche that a memorial be erected in Weimar in honor of her brother, Kessler seized upon the idea with his customary brio and soon had concocted an elaborate plan involving a memorial to be designed by Van de Velde, with a statue representing the Apollonian principle, for which Vaslav Nijinsky would serve as a model for Maillol. Behind the memorial there would be a stadium for sports, a pool, and—when Kessler's imagination reached its zenith—a discreet institute for eugenics, designed to

Max Beckmann
Young Men by the Sea, 1905
Oil on canvas
58¼ × 92½ in. (148 × 235 cm)
Klassik Stiftung Weimar

help beautify the race.[27] A tenacious, albeit intermittent, resistance waged by Nietzsche's sister stymied the project, and then the war put a final, merciful end to it.

Quite apart from the misgivings of the sister, Kessler had to deal with the recalcitrance of the architect. Van de Velde approached his task with a palpable hesitation, grumbling and raising objections to both the stadium and the monument. The stadium design was satisfactory, but his sketches for the monument filled Kessler with despair. "I fear he is 'out of his depth' with this commission," he confided to his journal.[28] The next month he wrote to the architect, seeking to explain to him what he had in mind. The temple must be, he explained, "a transposition of the personality of Nietzsche into a grand architectural formula.... An *expressive* rather than a constructive architecture, a grand formula inspired by Nietzsche's personality alone, like a grand musical motif would try to express *Zarathustra*. Thus an architecture purely abstract, purely rhythmic, like all musical architecture."[29] Still, Van de Velde could not deliver, and soon Kessler requested that he design simply a hall with four walls and a roof. "The truth is that our age lacks any tradition of and handle on decorative architecture. This complete failure of Van de Velde, after repeated efforts, to find an architectural expression for a pure and aimless joy in life and lightness, proves it."[30] What Kessler was calling for was an Expressionist architecture, something similar to what Erich Mendelsohn would try to achieve after the war with his Einstein Tower.[31]

If these incidents may be read as evidence for Kessler's openness to Expressionism, then the question can be asked: how is it that nothing in his journal or correspondence suggests a deep engagement with Expressionism before the war? It is true that he is listed as a "passive member" of the Brücke from at least 1907, something that required an annual fee of twelve marks (later twenty-five) and earned one the right to a modest portfolio of prints.[32] He also was instrumental in securing, at the third annual exhibition of the German Artists League held in Weimar in 1906, a year-and-a-half fellowship at the Villa Romana in Florence for the young Max Beckmann. He also purchased Beckmann's *Young Men by the Sea* for the museum in Weimar. But this was before Beckmann had developed a truly Expressionist style. When Kessler met him again five years later he reconfirmed Beckmann's talent but complained about his "muddy colors" that lacked "the beautiful clarity of a Vuillard or Matisse."[33] About the

controversy over the formation of the Neue Secession or the various other Expressionist exhibitions there is nothing, except on the occasion of a sitting of the German Artists League in Bremen in January 1912. The accompanying exhibition, which Kessler toured with Max Liebermann and Max Slevogt, had a room displaying the "students of Henri Matisse," among them Alexei Jawlensky, a key figure in the Blaue Reiter. Liebermann rejected them entirely, calling their art a "slurring," not a "language." "I pointed out to Liebermann that that which Jawlensky and friends are slurring is perhaps *exactly that which* others *before them had expressed clearly*. One cannot exclude the

possibility that this slurring was the beginning of a *new* language."[34] This comment to his old ally suggests an open-mindedness toward Expressionism.

The simplest explanation for the lack of any concrete *prise de position* on the matter is that Kessler was too preoccupied with other matters in the last four years before the war. In 1906 he was forced to resign his post as director of the Grand Ducal Museum of Arts and Crafts in Weimar due to a manufactured scandal over an exhibition of Rodin's watercolors that had offended local sensibilities.[35] In the following years he concentrated on his own production. For several years he labored mightily on a history of modern art up to Impressionism, hoping to correct what

George Grosz
Metropolis, 1916–17
Oil on canvas
39 3/8 × 40 3/16 in. (100 × 102 cm)
Museo Thyssen-Bornemisza, Madrid

he saw as the deficiencies of Julius Meier-Graefe's *Entwickelungsgeschichte der modernen Kunst*.[36] He also became involved in collaborating with Hofmannsthal on the libretto for *Der Rosenkavalier* (The Knight of the Rose), with the plans for the Nietzsche monument, and then finally again, in the all-absorbing effort to produce his ballet *Josephslegende* shortly before the war. Under the pressure of this last event, his journal almost literally disintegrates into a series of hastily scribbled notes.

It was only in the spring of 1916, after seeing fighting in Belgium and then on the eastern front, that he found time to devote to art and literature again. On a mission back to Berlin, he met the young poet Johannes Becher at the home of Princess Mechtilde Lichnowsky. He found in Becher's poetry, which belonged to the exclamatory, vatic strain in Expressionist literature, an echo of the mood of *Aufbruch* (setting out) that he associated with the August 1914 spirit. This susceptibility to the prophetic tone had deep roots in his character. Not long before the war he had discovered Walt Whitman, and his appreciation of Becher owes something to that experience.[37] Through Becher he learned of and read the leading figures of literary Expressionism. He later met some of them in person when he became the cultural attaché in Bern. There is no doubt that his response to literary Expressionism was genuinely enthusiastic, perhaps because he thought it was especially equipped to expressing the experiences of the war.[38]

About painting there is again less, but what there is suggests that Kessler understood what the Expressionists were attempting to do. In Munich in 1916 he was strongly impressed by the memorial exhibition honoring Franz Marc, who had died in the war.[39] Perhaps this played a role in his decision to sponsor an exhibition on modern German art at the Kunsthaus Zürich in 1917, featuring, in part, German Expressionists.[40] The French shortly afterward put on an exhibition of French Impressionist and Post-Impressionist art in the same venue.[41] The Swiss press declared a net victory for the French, something that Kessler noted with sad irony—the very French art for which he had had to fight to introduce to imperial Germany was seen as self-evidently classic.[42] An exhibition of Max Pechstein's work at Galerie Fritz Gurlitt in Berlin in June 1918 elicited this response: "Pechstein uses colors like building stones to construct surfaces and forms, color patterns and at the same time cubic masses. Brutal, not very inventive, limited in its harmonies, but forceful and purposeful."[43]

Of decisive importance was his meeting with George Grosz the previous November. Confronted by the painter's urban scenes, Kessler stressed their continuity within a German tradition that included the German Impressionist painters, but precluded the French: "a continuation of the northern German, Berlin tradition of Schadow, Menzel, Liebermann—in their ruthless ugliness completely un-French." Summing up his wartime engagement with Expressionism, he wrote:

I think Grosz has something demonic in him. This new Berlin art in general, Grosz, Becher, Benn, Wieland Herzfelde, is most curious. Big-city art, with a tense density of impressions that appears simultaneous, brutally realistic, and at the same time fairy-tale–like, just like the big city itself, illuminating things harshly and distortedly as with search lights and then disappearing in the glow. A highly nervous, cerebral, illusionist art, and in this respect reminiscent of the music hall and also of film, or at least of a still possible, still unrealized film.[44]

Shortly thereafter he would commission the Herzfelde brothers and Grosz, on behalf of the German high command, to make an animated propaganda film—in the Expressionist style—mocking the arrival of American troops in France.[45] A few months later, after visiting the Ernst Ludwig Kirchner show at the Kunsthaus Zürich, he had an extraordinary personal epiphany. Immediately after recording his impressions of Kirchner, without indicating a shift to another topic, he wrote: "A monstrous gap exists between this order and the political/military order. I stand on both sides of the abyss into which one peers vertiginously."[46] To see in the paradigmatic Expressionist Kirchner a hieroglyph for all the youthful German art and literature with which he had become familiar, to further see it as the logical continuation of the same impulses that animated his engagement on behalf of French and German Impressionism twenty years earlier, and finally to understand the looming conflict between the new, youthful, antiwar Expressionist culture and the resentful Wilhelmine establishment—here Kessler was truly both a historian and a prophet. By the last year of the war, then, it seems that Kessler identified German Expressionist art and literature as the worthy modern representative of the Gothic side of the European aesthetic. Germany had, at last, caught up to France—at least in this respect.

ENDNOTES

1. Bodenhausen to Hofmannsthal, April 14, 1916, cited in Laird M. Easton, *The Red Count: The Life and Times of Harry Kessler* (Berkeley: University of California Press, 2002), 245. All translations by the author.

2. Ibid., 246.

3. As Hermann Bahr, a member of Kessler and Bodenhausen's generation, wrote: "People who have trusted my judgment about painting for over twenty years are now suddenly angry at me because I also wish to understand Expressionism—I must not do that! It's very comic, even if a somewhat bitter joke, to see them deploy the very same arguments that, twenty years earlier, the older generation had used against them. They do not realize that now they are the old ones." Hermann Bahr, *Expressionismus* (Munich: Delphin-Verlag, 1916), 27.

4. Peter Selz, *German Expressionist Painting* (Berkeley: University of California Press, 1974), 113-14. On the debates unleashed within the Berlin Secession by this decision, see Peter Paret, *The Berlin Secession: Modernism and Its Enemies in Imperial Germany* (Cambridge, MA: Harvard University Press, 1980), 200-234. In Bodenhausen's defense, however, it must be mentioned that, at the time of controversy over the Neue Secession, he wrote to Kessler expressing admiration for Ernst Ludwig Kirchner's work; see the letter of July 10, 1910, in Eberhard von Bodenhausen and Harry Graf Kessler, *Ein Briefwechsel: 1894–1918*, ed. Hans Ulrich Simon (Stuttgart: Klett, 1978), 91.

5. Kessler, "Herr von Werner," in *Gesammelte Schriften*, ed. Cornelia Blasberg and Gerhard Schuster, vol. 2, *Künstler und Nationen* (Frankfurt am Main: Fischer Verlag, 1988), 79.

6. Kessler, "Kunst und Religion: Die Kunst und die religiöse Menge," in *Gesammelte Schriften*, 2:9-47. See also Easton, *Red Count*, 82-87, and Alexandre Kostka, "Harry Graf Kesslers Überlegungen zum modernen Kunstwerk im Spiegel des Dialogs mit Henry van de Velde," in *Harry Graf Kessler: Ein Wegbereiter der Moderne*, ed. Gerhard Neumann and Günter Schnitzler (Freiburg im Breisgau: Rombach, 1997), 161-80.

7. For the parallels with Expressionism, see Roger Cardinal, *Expressionism* (London: Paladin, 1984), 15-67, as well as David Morgan, "The Enchantment of Art: Abstraction and Empathy from German Romanticism to Expressionism," *Journal of the History of Ideas* 57, no. 2 (1996): 317-41. Besides Selz, other useful narratives include Wolf-Dieter Dube, *Expressionism*, trans. Mary Whittall (New York: Praeger, 1973), and John Willett, *Expressionism* (New York: McGraw-Hill, 1970).

8. Easton, *Red Count*, 19.

9. He began it in 1880 when he was twelve and kept it, with only a few interruptions, for fifty-seven years,

until his death in exile from Nazi Germany in 1937. An abridged version of the post–World War I diaries were published in German in 1961, with an English translation in 1971. The prewar diaries were rediscovered only accidentally in Majorca, Spain, in 1983. Eight volumes of a projected nine-volume edition of the complete journal have been published (as of July 2013) by Klett-Cotta under the supervision of the German Literary Archives.

10. June 15, 1904, in Kessler, *Das Tagebuch*, ed. Roland S. Kamzelak and Ulrich Ott, 9 vols. (Stuttgart: Cotta, 2004), 3:683 (hereafter cited as *TB*).

11. April 22, 1902; cited in *Journey to the Abyss: The Diaries of Count Harry Kessler, 1880–1918*, ed. and trans. Laird M. Easton (New York: Knopf, 2011), 278.

12. See Shulamith Behr, *Expressionism* (Cambridge: Cambridge University Press, 1999), 37.

13. Claire Frèches-Thory and Antoine Terrasse, *The Nabis: Bonnard, Vuillard, and Their Circle* (New York: Abrams, 1990) is a standard work; see also Elizabeth Prelinger, "The Art of the Nabis: From Symbolism to Modernism," in *The Nabis and the Parisian Avant-Garde*, ed. Patricia Eckert Boyer (New Brunswick: Rutgers University Press, 1988).

14. Cited in Easton, *Red Count*, 123-24.

15. See Kostka, "Kesslers Überlegungen"; see also Laird Easton, "The Rise and Fall of the 'Third Weimar': Harry Graf Kessler and the Aesthetic State in Wilhelmian Germany, 1902–1906," *Central European History* 29, no. 4 (1997): 495-532.

16. October 4, 1903, Easton, *Journey*, 304.

17. He also admired Munch's stage decorations for Max Reinhardt's production of Ibsen's *Ghosts*; November 9, 1906, *TB*, 4:200.

18. September 3, 5, 1901, *TB*, 3:431-32.

19. June 30, 1904, *TB*, 3:687; January 18, 1908, *TB*, 4:399.

20. January 19, 1908, *TB*, 4:538.

21. June 1, 1911, Easton, *Journey*, 539.

22. October 29, November 16, 18, December 10, 1906, ibid., 381, 385-88, 390-91. Hofmannsthal was also enchanted by her, calling her "the Lydian dancer come down from the relief"; see Hugo von Hofmannsthal, "Die unvergleichliche Tänzerin," in *Gesammelte Werke: Reden und Aufsätze I, 1891–1913* (Frankfurt am Main: Fischer Verlag, 1979), 496-501.

23. See the description in Easton, *Red Count*, 187-88.

24. Peter Jelavich, "Dance of Life, Dance of Death," in *German Expressionism: The Graphic Impulse*, ed. Starr Figura, exh. cat. (New York: Museum of Modern Art, 2011), 36-51. Kessler's fascination with Josephine Baker after the war indicates that he too found much to admire in modern popular dance.

25. Kessler, "Die Kunst des Theaters," *Gesammelte Schriften*, 2:94-95.

26. Willett, 54; for Craig's influence on Expressionist theater in general,

see David F. Kuhns, *German Expressionist Theatre: The Actor and the Stage* (Cambridge: Cambridge University Press, 1997), 66-68.

27. About this project one can only agree with Alex Ross: "When Nietzsche howled in the middle of the night, he may have been experiencing premonitions of it." Ross, "Diary of an Aesthete," *The New Yorker* (April 23, 2012), 76.

28. November 29, 1911, Easton, *Journey*, 571.

29. December 12, 1911, ibid., 573-74.

30. March 23 and 24, 1912, ibid., 588.

31. On Expressionist architecture see Wolfgang Pehnt, *Expressionist Architecture* (New York: Praeger, 1973). On Mendelsohn, see Kathleen James, *Erich Mendelsohn and the Architecture of German Modernism* (Cambridge: Cambridge University Press, 1997).

32. Selz, *German Expressionist Painting*, 94-95; for an illustration of the portfolio with Kessler's name on it, see Figura, *German Expressionism*, 15.

33. April 17, 1911, Easton, *Journey*, 526. This was the year before Beckmann got into a polemic with Franz Marc over the value of French art and especially of Impressionism. Beckmann would later abjure his position and in 1913 his style would shift decisively to Expressionism; Selz, *German Expressionist Painting*, 238-40.

34. January 22, 1912, *TB*, 4:783-84. Emphasis in the original.

35. The watercolors were very free sketches of nudes that violated academic conventions. Kessler's enemies at the Weimar court made much of Rodin's dedication to the grand duke, exploiting as well the Kaiser's well-known antipathy to French modernism. See Easton, "Rise and Fall."

36. Intended to be a history of European color since Giotto, all that emerged was a twenty-three-page introduction to a catalogue, *Impressionisten: Die Begründer der modernen Malerei in ihren Hauptwerken* (Munich: Bruckmann, 1908).

37. Easton, *Red Count*, 242-43. On the distinction between the exclamatory, vatic and the sardonic, ironic strains in Expressionism, see Walter H. Sokel, *The Writer in Extremis: Expressionism in Twentieth-Century German Literature* (Stanford, CA: Stanford University Press, 1957).

38. See the comments on Heym and Kafka, February 29, 1916, Easton, *Journey*, 709, as well as on hearing of the death of Ernst Wilhelm Lotz, June 28, 1918, *TB*, 4:430.

39. October 10, 1916, Easton, *Journey*, 755.

40. *Deutsche Malerei XIX. & XX. Jahrhundert* (German Painting of the 19th and 20th Centuries).

41. *Französische Kunst des XIX. und XX. Jahrhunderts* (French Art of the 19th and 20th Centuries).

42. Easton, *Red Count*, 256.

43. June 28, 1918, *TB*, 4:429.

44. November 18, 1917, Easton, *Journey*, 792-93.

45. Unfortunately all copies have been apparently lost; Easton, *Red Count*, 257.

46. March 27, 1918, Easton, *Journey*, 825-26.

CLAUDINE GRAMMONT

Henri Matisse as *Herr Professor*:

The Académie Matisse and the Internationalization of the Avant-Garde, 1905–1914

ONLY QUITE RECENTLY—over the past decade—have art historians sought to shed new light on Franco-German artistic relations between 1870 and 1945. Numerous documents attesting to these exchanges have been uncovered, leading in particular to the revision of art historical approaches that have long remained nationalistic, on both the French and the German side.

Looking specifically at the period immediately before World War I, we find that apart from Cubism, the two main artistic movements that marked these years—namely, Fauvism and Expressionism—are set in a context of surging nationalisms, making them all the more difficult to comprehend. As historical categories, they have long been seen to embody the bipolar division between French (Fauvism) and German (Expressionism), even though this division was a construct made after the fact. These impoverishing taxonomies are out of date, and the study of their relations has replaced the far too basic study of the influences of one pole on another. As a result, we now see an interplay of particularly complex relations, often fluctuating and ambivalent, making it more imperative than ever to stop framing the discussion of these idioms in nationalistic categories.

The fact that Fauvism and Expressionism, both concepts with fluid outlines, were elaborated simultaneously adds further complexity to the sphere of real or symbolic exchanges. In 1912, the terms *Wilden* (wild animal—another term for the Fauves) and *Expressionisten* were essentially interchangeable, signifying the international avant-garde, irrespective of geography. Indeed, various studies have shown that the concept of Expressionism originally designated a large-scale international anti-Impressionist movement. Only around 1912 would it become an ethnogeographic notion inscribed in the racial problematics opposing Germanic and Mediterranean cultures.[1] Here we focus on that period before World War I when artistic internationalism could still be conceived not as a utopia but as a collective project. In France, the Académie Matisse—operated by the artist from 1908 to 1911—was no doubt one of the main sites of mediation for Franco-German artistic relations during the first fifteen years of the twentieth century.[2] Thus it is not so much the Académie Matisse as a teaching institution per se that interests us here, but rather its function as a social framework for culturally mixed education.

As Thomas Gaehtgens has shown, French culture in the second half of the nineteenth century stood, paradoxically, as both a model for and an adversary of German culture.[3] The spread of Impressionism and Neo-Impressionism in Germany further deepened their differences, associating the very idea of modernity, and its possible rejection, with the French sphere. The most recent French art was thus held up as a model of emancipation for anything that claimed to be anti-academic. This growing interest on the part of Germans for French culture, reflected in collections as well as in the press and in art publications, was echoed on the French side, contrary to what the nationalist model has long had us believe.[4] Germany in fact played an important role in French intellectual life, in particular among the Symbolist generation that arose in the late nineteenth century following the wave of resentment in the wake of the Franco-Prussian War (1870–71); Symbolist proponents countered naturalism with the German philosophical idealism of Kant, Hegel, or Schopenhauer[5] and took interest in Eduard von Hartmann's philosophy of the unconscious. The Wagnerian trend of the 1880s was followed, in 1900, by that of Nietzsche, whose work had a well-known impact on the painting of that period. The literary and artistic milieus at the turn of the century were closely linked, and the Fauves shared in this passion. Nietzschean thought pervades the letters that André Derain wrote to Henri Matisse between 1905 and 1907, and we know that Matisse read Kant as well as Nietzsche.[6] Fauvist aesthetics developed on a Neo-Symbolist foundation. Indeed, at the end of the 1890s a Symbolist revival arose from the literary post-Mallarmé milieu. Periodicals such as *Vers et prose* or *La Phalange* by Jean Royère revived the ideals of Symbolism, renewed through the writings of Bergson and Nietzsche. A great deal of anti-Fauve criticism, beginning in 1905, derived from the nationalistic regression to which the main figures of the first generation of Symbolists had succumbed. The Fauves gained access to German intellectualism through literary Symbolism and Post-Symbolism and the spread of these ideas in magazines that they read or collaborated on.

Another rather significant avenue was the Neo-Impressionist circle around Paul Signac, which Matisse began to frequent in 1904, a movement enthusiastically received in Belgium and Germany. The knowledge that Matisse might have had of German culture—since he did not understand the language—very likely also came through Gertrude, Leo, Michael, and Sarah Stein, his principal patrons from 1905 on.[7] Beginning that year, Matisse regularly attended the cosmopolitan salon of these Americans of German-Jewish origin, who could easily have initiated him in the most advanced German

thought, notably that on the psychology of the unconscious or perhaps the formalist theories of Alois Riegl. Moreover, the Steins played a major role in the founding of the Académie Matisse, and it was through them that Hans Purrmann, who was to become Matisse's greatest ambassador in Germany, met the artist. Significantly, it was in Germany, at the exhibition of masterworks of Islamic art in Munich in 1910—the first great international exhibition on the arts of Islam—that Matisse realized and understood the importance of Asian and Middle Eastern art for his own aesthetics. Most of the Fauves visited Germany at least once between 1905 and 1914, not merely to support the exportation of their works across the Rhine but also in a spirit of attention to German culture, to which they were attuned thanks to their Neo-Symbolist sympathy.[8]

the Académie Matisse. What a German artist discovered in the French capital depended both on the network of relations he entered into there, if any, and furthermore on the extent of his knowledge of French modern art, which would determine his affinities. Certain German mediators who lived in Paris played an essential role—notably art critic Julius Meier-Graefe, although his network was rooted more in the Impressionist or Post-Impressionist milieu than in the following generation. From 1904 until World War I, the Café du Dôme in Montparnasse served as the gathering place for the German artistic community. It was mainly thanks to the Dôme that access could be had in Paris to the most advanced developments in art and ideas. It was there, wrote Guillaume Apollinaire, "that the admiration one would profess in Germany for this or that French painter would be determined."[9]

In the other direction, most German artists of the generation of 1880 visited Paris before World War I. These visits, however, are generally not well documented and are of varying significance in their artistic careers and in the establishment of possible exchanges between Fauvism and Expressionism. Paris, known for its training dispensed at the École des Beaux-Arts and in private studios and schools, attracted numerous German artists. Emil Nolde attended the Académie Julian in 1899, as did Max Beckmann in 1903; George Grosz and Lyonel Feininger studied at the Académie Colarossi. But the most revealing example in this regard remains the German artists at the Café du Dôme and

As Annette Gautherie-Kampka's well-documented thesis has shown, the Dôme network evolved from an aggregation of groups with different origins.[10] Joining the initial nucleus of Rudolf Levy, Walter Bondy, and Emil Cardinaux (a Swiss artist) was a group from Breslau, Wilhelm Uhde and Erich Klossowski (the father of Balthus), as well as a large group from Munich art circles, including Emil Orlik, Jules Pascin, Albert Weisgerber, George Kars, and Hans Purrmann, some of them former students of German Symbolist painter Franz von Stuck (as Kandinsky had been). The Dôme was thus, as poet and critic André Salmon called it, an "exchange of new artistic stock,"[11] one of the nerve centers of the art

Académie Matisse, c. 1909, Henri Matisse
at center
Archives Matisse, Issy-les-Moulineaux

156

market between France and Germany and frequented by art gallerists and dealers such as Uhde, Paul and Bruno Cassirer (Bondy's cousins), and Alfred Flechtheim. Between 1905 and 1910, the Dôme was one of the access points to the Fauvist avant-garde for German artists. The presence of the Steins, who frequented the café and were known as the principal collectors of Matisse during this period, was crucial in this respect. The Académie Matisse was equally crucial, welcoming German students such as Friedrich Ahlers-Hestermann, Rudolf Levy, Franz Nölken, Oskar and Margarethe Moll, Hans Purrmann, Walter Alfred Rosam, and Mathilde Vollmoeller, along with Scandinavian students who also frequented the Dôme, such as Carl Palme.

Paradoxically, apart from the Russian-born artists Alexei Jawlensky and Wassily Kandinsky, the Germans who came to Paris and were later considered the most innovative artists, as members of the Brücke and the Blaue Reiter, gave little indication of having had any direct access to Fauvism as of 1905—that is, before it spread to Germany. Although Fauvism began to reach Germany in 1907, its spread did not solidify until 1910, in particular with the exhibitions organized by the Sonderbund in Düsseldorf in 1910 and Cologne in 1912.[12] Prior to that, exhibitions including Fauvists were relatively rare, since the art of Van Gogh, Gauguin, and Cézanne was at its peak of popularity in Germany at that time.[13] Consider the case of Franz Marc. During his two stays in Paris, in 1903 and 1907, he was interested in the Impressionists, in Gauguin and Van Gogh, but we don't know whether he visited the Salon des Indépendants upon his arrival at the end of March 1907, where he could have seen the Cézanne retrospective and Matisse's *Blue Nude* (*Memory of Biskra*, p. 175), which Leo Stein would later lend for Paul Cassirer's 1909 Matisse exhibition.[14] If indeed he did, his art bears no trace of Fauvism until 1910. The same is true of his friend August Macke, whose knowledge of modern French art owed primarily to the collector Bernhard Koehler, his wife's uncle. During Macke's first stay in Paris, in June 1907, he too showed interest in the Impressionists at the Galerie Durand-Ruel, but during his second stay, in 1908, he also visited the Bernheim-Jeune and Vollard galleries—the two main art dealers, in addition to Eugène Druet, for Matisse and the Fauves. However, it was not until his third stay in Paris, in October 1909, that he was struck by the Fauves at the Salon d'Automne. Matisse was his favorite: "On a purely instinctual level, I liked him the most of the whole

group. An extremely fervid painter, imbued with incredible zeal."[15]

Another example is Max Beckmann, who lived in Paris from 1903 to 1905. While his letters and journal express admiration for Manet and Cézanne, there is not a word about Matisse or the Fauves.[16] Other cases have little documentation, such as Max Pechstein's Parisian stay in 1908 (from January to early April and from April to the end of July), during which he met Kees van Dongen and exhibited at the Salon des Indépendants.[17] Still other examples have turned out to be erroneous, such as that of the antedated paintings by Ernst Ludwig Kirchner, which Gabrielle Linnebach considers part of an "arsenal of lies put out by certain painters in the Brücke to downplay their relationship with the Fauves."[18] Among the Expressionists, those of Russian

origin—Jawlensky and Kandinsky, founding members of the Blaue Reiter—established the strongest relations with the French milieu. Both exhibited at the Salon des Indépendants and the Salon d'Automne beginning in 1905.[19] Moreover, the various prizes that Kandinsky won prove that he had acquaintances and support in these institutions.[20] These connections probably resulted from his relationship with artist and writer Alexis Mérodack-Jeanneau, who in 1904 founded the Tendances Nouvelles artists' group, to which both Kandinsky and Jawlensky belonged.[21]

More is known about Kandinsky's relations with Robert Delaunay, in a general sense, than any that he might have had, even indirectly, with Matisse.

Leo Stein and friends, Café du Dôme, Paris, 1910
Yale Collection of American Literature, Beinecke Rare Book and Manuscript Library, Yale University

Those relations are numerous, however, and have yet to be explored in depth. Kandinsky and his partner Gabriele Münter spent just over a year in Paris, between May 1906 and June 1907. At the end of 1906, Münter stayed for one month at 28 rue Madame, the building where Sarah and Michael Stein lived. According to Swedish artist Carl Palme, a former student of Kandinsky's and a member of Phalanx (the Munich art association), Kandinsky then attended the gatherings hosted by the Steins.[22] From his Munich years Kandinsky knew several of Matisse's German or Russian students, not only Purrmann but also Olga Meerson and Marie Vassilieff. Furthermore, Kandinsky's correspondence with Matisse from 1910 onward shows that he knew and appreciated Matisse's work at that time. As he confided in a letter to André Dézarrois, "I was truly in love with Matisse's painting, especially in 1905 or 1906. I still vividly remember a deconstructed carafe with its stopper which was painted quite far from its 'normal' place, that is, the neck of the carafe. Natural relations were upended in that canvas."[23]

Very few German artists who came to Paris had direct access to Fauvism, then, and even fewer were able at that time to consider its aesthetic contribution. For its protagonists, in particular Matisse and Derain, Fauvism was in fact a movement of synthesis, focusing on the amalgam and hybridization of the most disparate plastic sources, and chiefly, at its outset, one of the first attempts to interpret Gauguin and Cézanne. It was therefore particularly difficult—especially for a foreigner—to penetrate the meaning of a formal language that was seemingly trivial in style but ultrasophisticated in the multiple cultural references that it conjured, whether Western, non-Western, or "primitive." Without a clearly established program and a theoretical underpinning, as Futurism and Cubism would have, Fauvism quickly ran out of steam. Born in 1905, it was seen as practically moribund by 1908, when Cubism began to emerge and Derain joined Picasso's clan. Matisse, considered the leader of the movement, chose this moment to open his academy in January 1908 and also to publish, at the end of the same year, what can be regarded as the founding text of his artistic thought, "Notes d'un peintre."[24] Thus Matisse established his theoretical ideas while also reviving interest in Fauvism. His Fauvist colleagues, who had been with him from the movement's inception, reproached him for "monopolizing" their struggle and proclaiming himself "king of the Fauves."[25] Henceforth his name alone sufficed to designate the Fauvist avant-garde.

But at that point Matisse made the intelligent move of integrating internationalism in his approach.[26] The swiftness with which "Notes d'un peintre" was translated attests to this: appearing in December 1908 in *La Grande Revue*, the article was published in German and Russian in 1909 and in English in 1910.[27] However, it is hard to tell whether that move resulted from a personal choice or from the dynamics of his network of acquaintances, in particular the Steins and some of his students who were also friends, such as Purrmann, the Molls, or Meerson. According to Margarethe Moll, Matisse opened his academy to disseminate his pictorial ideas since he could not otherwise come to be understood—not by his compatriots but rather by foreign artists.[28] The notion of achieving a sort of pictorial Esperanto is perhaps not alien to Matisse's ambition; during those years he simplified his pictorial vocabulary to an extreme, returning to the very roots of the language of forms. In this respect his educational project, addressed to students of many nationalities, fit in with his aesthetic aspirations. However, the experiment ended in failure: a misunderstanding persisted between the teacher and those of his students who came solely to paint like Matisse, imagining that he might even reveal certain miraculous recipes. As of spring 1910, Matisse had stopped giving critiques at the academy, but it is likely, as certain student accounts imply, that the school itself remained in operation until 1911.[29]

Matisse may well have been overwhelmed by the success of his academy and the reputation that it generated. For in some sense it was, paradoxically, a great success: no fewer than 120 students came to the Académie Matisse, chiefly Scandinavians, Germans, and Hungarians, though only two French students.[30] The school had a great impact on the international dissemination of the artist's work and thought. But starting in 1910, Matisse had to endure a growing number of violent xenophobic attacks in the French press on account of his academy. The sarcastic remarks began during his exhibition at Galerie Bernheim-Jeune in February. In an article titled "Whose Crown?" writer Charles Morice focused on the crowds of German and Russian foreigners at Matisse's show and commented that his German admirers sent him "a golden crown."[31] Soon thereafter, in his review of the Salon des Indépendants, he repeated the barb ("while snobs from Germany send M. Matisse a golden crown"), which Salmon took up again in 1912: "Henri Matisse is alone. This famous man, made rich by art, a crowned painter, has only students from the suburbs—those of Paris (especially in the Russian-

American alleys of Montparnasse) and those of Munich, Berlin, Moscow."[32] On his return to Berlin in January 1909, disheartened by the reception of his exhibition at the Cassirer gallery, Matisse had in fact received a laurel wreath from the American Byzantine scholar Thomas Whittemore; the wreath bore the inscription "To Henri Matisse, Triumphant on the Battlefield of Berlin."

This story about the crown seems to have made the rounds in Paris, where it was seized upon by some critics who twisted it in order to imply that the Germans had crowned Matisse "king of the Fauves."[33] But these types of attacks were hardly new; already in 1907 Louis Rouart had berated Matisse by alluding to his relationship with the Steins, saying that he was "taken seriously only by two or three Jews from San Francisco and a few art dealers."[34] The success of his academy further fueled the resentment of those who accused Matisse of exporting his talent. Apollinaire, one of Matisse's few supporters, wrote, "Haven't we recently seen the entire press (including this newspaper) attack him with uncommon violence? No man is a prophet in his own country, and while the foreigner who acclaims him acclaims France, the latter gears up to stone one of the most appealing artists on the contemporary scene."[35] The most virulent and most openly xenophobic article was by novelist Roland Dorgelès, who wrote in December 1910:

> M. Matisse has the grave visage of a *Herr Professor*, M. Matisse is a beloved teacher. M. Matisse has disciples, M. Matisse is the head of a school where those from Württemberg, Moravia, Lithuania, and Slavonia converge in admiration of him. . . . M. Matisse's products sell at ridiculous prices; German museums buy his paintings, and the hotels he has decorated are now beyond number. . . . A stern mask is his everyday countenance, and the amblers who glimpse him on horseback each morning as he rides along the paths of the park are convinced that this young man with his sober beard and solemn spectacles is a German military attaché.[36]

This *Herr Professor* image—which Matisse exploited by having both Edward Steichen and Alvin Langdon Coburn photograph him in a white artist's smock, reminiscent of a doctor's white coat—would remain with him. Matisse would later lament Marcel Sembat's reuse of this photo in the monograph he published following World War I, given the postwar ideological climate.[37]

Added to the sarcastic germanization of Matisse's function as teacher was a recurrent criticism that was often associated with the German "character" at that time: his art was deemed too theoretical and abstract.[38] Thus the attack by Dorgelès, who frequented the artistic milieu of Montmartre, should be seen in the context of the growing rivalry between "Picassoites and Matisseites." After Derain rallied to their side in 1908, the pro-Cubism partisans of Picasso sought to "dethrone," through various attacks that more or less betrayed their loyalties, "the king of the Fauves."[39] For instance, posters in Montmartre bore a slogan subtly modified from a campaign warning against the misdeeds of white lead paint (ceruse), with Matisse's name having been substituted: "Workers, painters, do not use the Matisse! Matisse has caused more harm in a year than an epidemic! Matisse drives you crazy!"[40] According to another anecdote, Salmon and Max Jacob played on the slogan

Roland Dorgelès, "Le Prince des Fauves," *Fantasio*, December 1, 1910

"Absinthe drives you mad," found on posters at the Butte Montmartre, by asserting that "Matisse drives you mad. His colors are those of an epileptic." But in 1912, during the controversy around the Salon d'Automne, the rivalries between Fauves and Cubists took a clearly political turn, and Matisse, even though his academy was by then closed, was once again the preferred target of the numerous detractors who equated modernity with *art boche* ("kraut" art).

Several times since 1905, within the context of contemporary political turmoil, Matisse and his Fauvist colleagues had been among the targets of reactionary criticism that advocated a renewal of classicism and relayed the ideals of the nationalistic Action Française movement to the sphere of the arts.[41] In response to Germany's economic and demographic progress and the tensions in Morocco and the Balkans, thoughts of war began to take hold in France by 1905, as well as the notion of a Germanic "peril." These factors reinforced nationalist sentiments that differed greatly from the patriotism of the late nineteenth century. The nationalism of Charles Maurras, a leader of Action Française, was based on an ideology of Mediterranean genius that developed, in its classical model, to counter Teutonic barbarism. In Maurras's doctrine, everything that might corrupt the classical French spirit was deemed Germanic. Until 1914, fears of the German peril continued to grow in tandem with the Balkan crises, simultaneously renewing the patriotic spirit surrounding the Franco-Prussian War as well as promoting both pacifism and the move to French internationalism, led by Jean Jaurès.[42]

Matisse and his school, filled with German and Nordic students, could attract only criticism on the part of those who professed a deep hatred for the Germanic race, as well as for this "king of the Fauves" who persisted in endangering Greco-Latin beauty. That Matisse's biggest French collector at the time was none other than the socialist deputy Marcel Sembat, a close friend of Jaurès's and an activist for internationalism, only augmented their hatred. The rise of xenophobia pervading the art world could already be felt at the 1910 Salon d'Automne, where one section, organized by Otto Grautoff, was devoted to Bavarian decorative arts.[43] It crystallized at the 1912 Salon d'Automne, where a controversy erupted accusing the Salon of giving too great a place to foreign artists, who were suspected of a conspiracy against French art. It became urgent to block "the invasion of *métèques* [wops] with no talent."[44] Siding with Frantz Jourdain, the president of the Salon,

critic Louis Vauxcelles spoke out against the foreigners, complaining in his review in *Gil Blas* that there were "a few too many Germans and Spaniards in the Fauvist and Cubist affair," and that "Matisse has had himself naturalized a Berliner."[45] The Salon d'Automne debate grew to such proportions that it was taken up at the Assemblée Nationale in December, pitting nationalists against internationalists.

At the same time, under the aegis of Albert Gleizes and Jean Metzinger, French Cubists—notably Fernand Léger, Henri Le Fauconnier, Roger de La Fresnay, and Jacques Villon—began to theorize the national significance of their painting, based on the model of the Futurists in Italy. In *Du cubisme*, published in November 1912, Gleizes and Metzinger emphasized Cubism's roots in French tradition. The presentation of the *Maison Cubiste* (Cubist House), a collective work, at the 1912 Salon d'Automne took the same direction while also seeking to embody the new classicism.[46] This attempt to position Cubism as a *juste milieu* failed, however, amid the increasingly violent attacks branding modernity as a whole, whether Fauvist or Cubist, as infected by *art boche*.[47]

Matisse took refuge from this storm in Tangier, where he spent much of 1912, and continued painting for his Russian sponsors. But he must have also felt he'd made a poor choice in opening his academy, which by then had become the target not only of the opponents of internationalism but also of the Cubists, who hoped to dethrone Matisse as the leader of the avant-garde. In 1912 André Salmon, openly pro-Cubist, delivered a lukewarm assessment of Fauvism, with particularly harsh words for Matisse: "This teacher who ran an academy was no leader, if truth be told; he was merely a headmaster. Henri Matisse's teaching would have been sought out only because foreign countries send second-rate artists to Paris, and while some young painters imitate Matisse in Germany, just as Berlin vaudevillians translate our playwrights, the French Salons are less and less cluttered with Muscovite or Scandinavian Matisseries."[48]

Across the Rhine positions likewise rigidified, and in 1912 the avant-garde took on a nationalist orientation that promoted the germanization of Expressionism.[49] Here, too, "Matisseites" were frowned upon. The fate that befell the Germans of the Café du Dôme in this context, and later in the history of art, is symptomatic of this shift. Often classified as "students of Matisse," these unfortunate denizens lost their artistic identity. Too frenchified to be appreciated in Germany, despite

Flechtheim's efforts to promote them, and confirming, in Apollinaire's words, "the artistic poverty of Germany," they had no place in French histories of German contemporary painting either.[50] Their painting, considered a variant of the Fauve style, was inevitably seen as opposed to that of the Expressionists.[51]

Finally, amid this retreat into nationalism, it is difficult to assess the real impact of Matisse's "Notes d'un peintre," although it was a major text to the extent that it proposed a theory of pictorial expression.[52] Its European reception remains to be studied in depth, but we present a few observations to conclude this essay. According to Margarethe Moll, the text had already been circulating in Berlin before its publication in *Kunst und Künstler* in May 1909.[53] Curiously, the published text was illustrated by only four Matisse paintings—*View of the Pont Saint-Michel* (c. 1900, private collection), *The Dinner Table* (1897, private collection), *Woman with a Hat* (1905, San Francisco Museum of Modern Art), and *Self-Portrait* (p. 84)—none of them new, along with reproductions of works by Cézanne and Manet. The choice of illustrations betrayed a certain caution on the part of the magazine, which thereby sought to position Matisse in the lineage of French Impressionist painting, as the introductory text also showed. The introduction furthermore highlighted the theoretical ambitions of a text written by "the representative of the young French school" who seeks to "prove the mathematics of space" and to "approach Lessing's *Laocoön* through modern means." The unnamed author, who signs only as "D. Red." (*die Redaktion,* or "the editors"), thereby integrates Matisse's formalist conception of the theory of expression, although he also dreads the danger of the "decorative trend."[54] In his preface to the third exhibition of the Neue Secession, which included numerous artists from the Brücke, Max Raphael takes up the main ideas of "Notes d'un peintre," in particular the notions of "condensation" and "expression," which he relates to the decorative mission of painting:

> The young artists of all countries…no longer take their rules from the object, whose impression Impressionists tried to reach with the means of pure painting. Instead they think of the wall and for the wall, purely in colors. They no longer want to reproduce nature in each of its transient manifestations. Rather they condense their personal sensations of an object, they compress them into a characteristic expression, in such a way that the expression

of personal sensations is strong enough to produce a wall painting. A colored decoration.[55]

The relation to Matisse's theory is even clearer in the review of the exhibition that Raphael published in *Der Sturm* in April 1911, in which he gives several excerpts from Matisse's essay.[56]

"Notes d'un peintre" also attracted attention among the artists of the NKVM (Neue Künstlervereinigung München) artists group. A letter from Franz Marc to Maria Franck on January 31, 1911, demonstrates that shortly after meeting with Jawlensky and Kandinsky, Marc had carefully read Matisse's text and approved of it.[57] Following the publication of "Notes" in *Kunst und Künstler*, Kandinsky repeatedly asked Matisse, between 1910 and 1911, to contribute an essay to *Der Blaue Reiter*, arguing that "such articles are of great importance in general and especially now."[58] Matisse

German translation of Matisse's
"Notes d'un peintre," in *Kunst und Künstler*,
May 1909
Los Angeles County Museum of Art,
Robert Gore Rifkind Center for German
Expressionist Studies

refused, and the almanac came out with two reproductions of his paintings: *Dance* and *Music*, which Kandinsky had seen some months earlier at Sergei Shchukin's home in Moscow (both 1910, today in the State Hermitage Museum, St. Petersburg).[59] Kandinsky did not hide his interest in Matisse's work and theory in his own 1912 publication, *Über das Geistige in der Kunst* (Concerning the Spiritual in Art).[60] He relates, with an insight that clearly transcends the mere reading of Matisse's article in *Kunst und Künstler* (which he cites in a note), Matisse's reflection on the iconic status of the painting as well as on its spiritual dimension. His understanding of Matisse may also have come from Russian art circles, which commented rather extensively on the artist's visit to Moscow in October–November 1911.[61]

Between 1908 and 1911, the Académie Matisse was thus one of the bastions of an internationalist conception of the avant-garde. Its strength lay in its doctrine, Matisse's "Notes d'un peintre," a text whose dissemination formed the basis of a theory of expression that united Fauvism and Expressionism before they were reclaimed in the service of nationalism and national identity. An unpublished note by Apollinaire from 1913 returns to this original overlap of Fauvism and Expressionism: "This movement of the Fauves quickly spread through the world of painting. It strove above all for expression, and thus the name Expressionism, which it was given in Germany, suits this movement well. Expressionism and Expressionist— these designations coming from the *tête d'expression* exhibited by Matisse at the 1907 Salon d'Automne."[62]

Translated by Rose Vekony

ENDNOTES

1. In this regard see especially Marit Werenskiold, *The Concept of Expressionism: Origin and Metamorphoses,* trans. Ronald Walford (New York: Columbia University Press, 1984), and Jean-Claude Lebensztejn, "Douane-Zoll," in *Figures du moderne: L'expressionnisme en Allemagne, 1905–1914,* exh. cat. (Paris: Musée d'art moderne de la ville de Paris, 1992), 50–56.

2. "Mediation" is used here in accordance with the approach in Alexandre Kostka and Françoise Lucbert, "Pour une théorie de la médiation: Réflexions sur les médiateurs artistiques entre la France et l'Allemagne," in *Distanz und Aneignung: Kunstbeziehungen zwischen Deutschland und Frankreich 1870–1945,* ed. Alexandre Kostka and Françoise Lucbert (Berlin: Akademie Verlag, 2004), 13–28.

3. Thomas Gaehtgens, "Introduction de la réception de l'art moderne français en Allemagne entre 1870 et 1945," in *Perspectives croisées: La critique d'art franco-allemande, 1870–1945* (Paris: Éditions de la Maison de l'homme, 2009), 3–25.

4. On the reception of German art in France at the end of the nineteenth century, see Françoise Lucbert, "Artiste par le cerveau et l'oreille': La réception de l'art allemand dans les milieux de l'avant-garde parisien de la fin du XIXe siècle," in Kostka and Lucbert, *Distanz und Aneignung,* 31–60, and for the interwar period, Marie Gispert, "'L'Allemagne n'a pas de peintre': Diffusion et réception de l'art allemand moderne en France durant l'entre-deux guerre, 1918–1939," PhD diss., Université de Panthéon-Sorbonne, 2008.

5. See Claude Digeon, *La crise allemande de la pensée française, 1870–1914* (Paris: Presses Universitaires de France, 1959), in particular chapter 8, "La génération de 1890," 384–450; and Frederike Kitschen, "La réception française des expositions d'art allemand contemporain," in *Perspectives croisées,* 255–72.

6. Derain's letters are published in Rémi Labrusse and Jacqueline Munck, *Matisse, Derain: La vérité du fauvisme* (Paris: Hazan, 2005), 332–51. Carrà reports that in 1914 Matisse readily cited Kant, Spinoza, and Nietzsche: Carlo Carrà, *L'éclat des choses ordinaires* (Paris: Éditions images modernes, 2006), 129.

7. On Matisse's relations with the Steins, their collection, and their role in founding the Académie Matisse, see Claudine Grammont, "Matisse as Religion: The 'Mike Steins' and Matisse, 1908–1918," in *The Steins Collect: Matisse, Picasso, and the Parisian Avant-Garde,* exh. cat. (New Haven and London: Yale University Press; San Francisco: San Francisco Museum of Art, 2011), 151–65.

8. Matisse went to Germany in June and December 1908; Albert Marquet, in 1909, and again in 1910 with Matisse; Charles Camoin, in November 1910; Raoul Dufy and Othon Friesz, in December 1909.

9. Quoted in Michel Décaudin, "Une relation conflictuelle: Apollinaire |et le monde germanique," in Kostka and Lucbert, *Distanz und Aneignung,* 201.

10. Annette Gautherie-Kampka, *Les Allemands du Dôme: La colonie allemande de Montparnasse dans les années 1903–1914* (Paris: Peter Lang, 1995).

11. André Salmon, *La jeune peinture française* (Paris: Société des Trente. Albert Messein, 1912), 129.

12. On Paul Cassirer's personal exhibition of Matisse in Berlin in January 1909, see Peter Kropmanns, *Matisse en Allemagne: Présence et réceptions méconnues, 1906–1910* (Quimperlé: Éditions Mona Kerloff, 2009), and more generally on the reception of Matisse in Germany, Peter Kropmanns, "Matisse in Deutschland," PhD diss., Humboldt Universität, Berlin, 2000.

13. On this point see Gabrielle Linnebach, *La peinture française en Allemagne: Recherches sur les rapports artistiques France–Allemagne à la veille de la seconde guerre mondiale* (Paris: Mémoire de l'École du Louvre, 1977), 49.

14. Marc left for Paris on March 27, 1907, and stayed for one week. The Salon des Indépendants opened on March 21. On Franz Marc and August Macke's relation to France see Jill Lloyd, "Macke und Marc: Ihre Blick nach Frankreich," in *Im Farbenrausch: Munch, Matisse und die Expressionisten,* exh. cat. (Göttingen: ed. Folkwang / Steidl, 2012), 99–107.

15. Quoted in Ursula Heiderich and Erich Franz, eds., *August Macke und die frühe Moderne in Europa,* exh. cat. (Ostfildern-Ruit: Hatje Cantz; Münster: Westfälisches Landesmuseum für Kunst und Kulturgeschichte, 2001), 140.

16. On Beckmann's stay in Paris, see Karin von Maur, "Paris: Une maîtrise élégante de métaphysique," in *Beckmann,* exh. cat. (Paris: Centre Georges Pompidou, 2002), and Max Beckmann, *Écrits,* trans. Thomas Kayser (Paris: Ensba, 2002).

17. On the dates of his Paris stay, see Aya Soika, *Max Pechstein: Das Werkverzeichnis der Ölgemälde,* 2 vols. (Munich: Hirmer, 2011), 1:13, and on the fact that he met with Van Dongen and exhibited at the Salon des Indépendants, see Donald E. Gordon, *Expressionism: Art and Idea* (New Haven and London: Yale University Press, 1987), 73. His name does not appear in the catalogue, but not all works on display were included.

18. Gabrielle Linnebach, "La Brücke et le fauvisme: Une querelle dépassée," in *Paris-Berlin 1900–1933,* exh. cat. (Paris: Centre Georges Pompidou, 1992), 103.

19. Jawlensky exhibited at the Salon d'Automne in 1905 and in 1906 in the Russian art section organized by Sergei Diaghilev. He likely met Matisse during the 1905 Salon d'Automne, per Peter Kropmanns, "Matisse und die Künstler des Blaue Reiter," in *Der Blaue Reiter und seine Künstler,* exh. cat. (Berlin: Brücke Museum; Tübingen: Kunsthalle Tübingen, 1998), 194. In his memoirs of 1937 he reports having had a long and exciting discussion on art with Matisse in the fall of 1911, cited in Maria Jawlensky, Lucia Pieroni-Jawlensky, and Angelica Jawlensky, *Alexej Von Jawlensky, Catalogue Raisonné of the Oil Paintings,* vol. 1, *1890–1914* (London: Sotheby's Publications, 1991), 31. Kandinsky exhibited at the Salon d'Automne almost every year from 1903 onward and at the Salon des Indépendants between 1905 and 1912.

20. Kandinsky received a medal at the end of his exhibition at the 1905 Salon d'Automne. On Kandinsky's Parisian years, see Jonathan David Fineberg, *Kandinsky in Paris, 1906–1907* (Ann Arbor, MI: UMI Research Press, 1984).

21. On Kandinsky and the Tendances Nouvelles group, see Fineberg, *Kandinsky in Paris,* and Christian Derouet, "Basile Kandinsky et Les Tendances Nouvelles à Anger en 1907," in *Kandinsky, collections du Centre Georges Pompidou, musée national d'art moderne,* exh. cat. (Paris: RMN, 1998), 139–47.

22. Johannes Eichner, *Kandinsky und Gabriele Münter: Von Ursprüngen moderner Kunst* (Munich: Bruckmann, 1957), 206; Carl Palme, *Konstens karyatider* (Stockholm: Rabén och Sjörgrenn, 1950), 66.

23. Letter from Kandinsky to André Dézarrois, July 31, 1937, quoted in Derouet, "Basile Kandinsky," 140. Kandinsky was most likely referring to *The Dinner Table* (*La desserte,* 1897), formerly in the Niarchos collection, which entered the German collection of Julius Freudenberg in 1904. See Kropmanns, *Matisse en Allemagne,* 24; the painting was reproduced in the German publication of Matisse's "Notes d'un peintre" in 1909.

24. Henri Matisse, "Notes d'un peintre," *La Grande Revue* 2, no. 24 (December 25, 1908), 731–45, repr. in Jack Flam, *Matisse on Art* (Berkeley: University of California Press, 1995), 37–43.

25. Francis Jourdain wrote Henri Manguin on April 9, 1908, about the "conflict between Matisse and the Fauves, who have risen up against their master.

They began to feel that Matisse was pontificating excessively and they told him so, refusing to be taken for his students" (Archives Jean-Pierre Manguin, Avignon).

26. There is little doubt of Matisse's internationalist convictions, as he was on the organizing committee for the exhibition *Origines et Développement de l'Art International Indépendant*, held at the Jeu de Paume from July 30 to October 31, 1937.

27. For the German version, see Henri Matisse, "Notizen eines Malers," *Kunst und Künstler* 7 (May 1909): 335–47; for the Russian, *Zolote Runo* [*Toison d'or*], no. 6 (1909): iv–x. Charles Lewis Hind published excerpts in English in "The New Impressionism," *English Review* (December 7, 1910). The same period also saw translations into Japanese and Czech.

28. Moll, in Siegfried Salzmann and Dorothea Salzmann, *Oskar Moll: Leben und Werk* (Munich: Bruckman, 1975), 46.

29. In a letter that can be dated to the beginning of 1910, Matisse tells his painter friend Jean Biette that he is going to stop his critiques (Archives Matisse, Issy-les-Moulineaux); on the continued existence of the academy in 1911, see the letter from Carl Palme to Alfred Barr on March 28, 1951 (Barr Papers, Museum of Modern Art, New York).

30. According to Isaac Grünewald's account in Alfred H. Barr Jr., *Matisse: His Art and His Public*, exh. cat. (New York: Museum of Modern Art, 1951), 117.

31. Charles Morice, "À qui la couronne," *Paris-Journal*, 51, no. 505 (February 22, 1910): 1. In addition to referring to the wreath given to Matisse by Thomas Whittemore in 1909, Morice (who had been a Dreyfusard but later contributed to *L'Occident*, a nationalist, pro–Action Francaise journal) may have intended the "golden crown" to carry a political meaning as well, perhaps alluding to the antinomy between France as a republic and Germany as an empire. The author thanks Frauke Josenhans for this suggestion.

32. Charles Morice, "Le Salon des indépendants," *Mercure de France* 84, no. 308 (April 16, 1910): 724; Salmon, *La jeune peinture française*, 60.

33. Gertrude Stein also recounts this; see Gertrude Stein, *The Autobiography of Alice B. Toklas* (New York: The Literary Guild, 1933), 115.

34. Louis Rouart, "Réflexions sur le Salon d'automne," *L'Occident*, (November 1907): 236–37.

35. Guillaume Apollinaire, "Prenez garde à la peinture," *L'Intransigeant*, March 18, 1910, quoted in Guillaume Apollinaire, *Oeuvres en prose complète*, vol. 2 (Paris: Bibliothèque de la Pléiade, 1991), 141.

36. Roland Dorgelès, "Le prince des Fauves," *Fantasio* (Paris), no. 105 (December 1, 1910): 299–300.

37. Marcel Sembat, *Henri Matisse*, 1st ed. (Paris: Éditions de la Nouvelle Revue Française, 1920). On December 31, 1919, Matisse wrote to his wife Amélie: "Is this the right time to say that I look like a German teacher and to allude to Nietzsche?" (Archives Matisse, Issy-les-Moulineaux).

38. Maurice Denis was one of the critics who complained of this, particularly in his review of the 1908 Salon des Indépendants, in which, discussing Matisse's academy, he wrote that Matisse "wants to ignore all aspects of material practice and expect everything from reasoning and theories"; quoted in Denis, "Sur l'exposition du Salon des Indépendants," *La Grande Revue* (April 10, 1908), reprinted in Maurice Denis, *Théories, 1890–1910: Du symbolisme et de Gauguin vers un nouvel ordre classique* (Paris: L. Rouart and J. Watelin, 1920), 232. Purrmann's account is quite significant in this respect. He writes, "*As a German* I was astounded that it was possible to express so many of the problems of painting in words without falling into a sterile aestheticizing"; Hans Purrmann, "From the Workshop of Henri Matisse," *The Dial* 73, (July 1922): 35 (italics mine).

39. Gertrude Stein: "Derain and Braque became followers of Picasso.... The feeling between the Picassoites and the Matisseites became bitter." Stein, *Autobiography of Alice B. Toklas*, 77, 79.

40. Dorgelès, "Le prince des Fauves," 299.

41. See Claudine Grammont, "Fauvism and the Debate around Classicism," in *Matisse and the Fauves*, exh. cat. (Vienna: Albertina, 2013), 234–49.

42. On this prewar context in France, see Digeon, *La crise allemande*.

43. Sabine Beneke, "Otto Grautoff, Frantz Jourdain und die Ausstellung Bayerisches Kunstgewerbe im Salon d'Automne von 1910," in Kostka and Lucbert, *Distanz und Aneignung*, 119–35.

44. Jean-José Frappa, "Il faut défrendre l'art français," *Le Monde illustré* (Paris), October 12, 1912; on the crisis of the 1912 Salon d'Automne, see Béatrice Joyeux-Prunel, "La Salon d'Automne 1903–1914: L'avant-garde, ses étrangers et la nation française," *Histoire & mesure* 22, no. 1 (2007), 145–82, and Christian Phéline, "Marcel Sembat et la crise du Salon d'automne (1912–1913)," in *Entre Jaurès et Matisse: Marcel Sembat et Georgette Agutte à la croisée des avant-gardes*, exh. cat (Paris: Somogy Éditions d'art, 2008).

45. Louis Vauxcelles, "Les Arts: La 'jeune peinture française,'" *Gil Blas* (Paris), October 21, 1912.

46. See Nancy Troy, *Modernism and the Decorative Arts in France: Art Nouveau to Le Corbusier* (New Haven and London: Yale University Press, 1991).

47. See David Cottington, *Cubism in the Shadow of War: The Avant-Garde and Politics in Paris, 1905–1914* (New Haven: Yale University Press, 1998), and Kenneth Silver, *Esprit de Corps: The Art of the Parisian Avant-Garde and the First World War, 1914–1925* (Princeton, NJ: Princeton University Press, 1989), chapter 1.

48. André Salmon, *La jeune peinture française*, 20.

49. See Timothy O. Benson, "Brücke, French Art and German National Identity," in *New Perspectives on Brücke Expressionism: Bridging History*, ed. Christian Weikop (Burlington, VT: Ashgate, 2011), 31–55.

50. Apollinaire, "Le Dôme et les dômiers," *Paris-Journal*, July 2, 1914, reprinted in Apollinaire, *Oeuvres*, 1:802. On the reception of the 1914 exhibition organized by Flechtheim in Düsseldorf and the place of the Café Dôme artists in the history of German art, see Gispert, "Diffusion et réception," 137–44.

51. Gautherie-Kampka, *Les Allemands du Dôme*, 217.

52. Werenskiold presents an interesting analysis of the role of "Notes d'un peintre" in the genesis of the concept of Expressionism, and particularly the impact "Notes" had on the writings of Kandinsky; see Werenskiold, *The Concept of Expressionism*.

53. On Moll's recollection of this detail, see Barr, *Matisse*, 108.

54. Matisse, "Notizen eines Malers," 335. I thank Peter Kropmanns for his help in translating this passage into French.

55. M. R. Schönlank [Max Raphael], introduction to *Katalog der Neuen Secession Berlin III* (Berlin: Baron, 1911) n.p.; quoted in Gordon, *Expressionism*, 93.

56. M. R. Schönlank [Max Raphael], "Die neue Malerei: Neue Sezession," *Der Sturm* 2, no. 58 (April 1911): 463–64.

57. Cited in Franz Marc, *Écrits et correspondances*, trans. Thomas de Kayser, ed. Maria Stravinaki (Paris: École nationale supérieure des Beaux-Arts, 2006), 286–87.

58. Letters from Kandinsky to Matisse, June 1910 and July 23, 1910 (Archives Matisse, Issy-les-Moulineaux).

59. See letter from Kandinsky to Gabriele Münter, Moscow, November 21, 1910, where he refers to "a lot of Matisses, even recent ones," cited in Annegret Hoberg, ed., *Wassily Kandinsky, Gabriele Münter: Letters and Reminiscences, 1902–1914* (Munich: Prestel, 2005), 87.

60. Wassily Kandinsky, *Concerning the Spiritual in Art*, ed. Andrew Glew, trans. Michael T. H. Sadler (London: Tate Publishing, 2006), 37–38. Originally published in English in 1914 as *The Art of Spiritual Harmony*, 1914.

61. See Albert Kostenevich and Natalia Semyonova, *Collecting Matisse*, trans. Andrew Bromfield (Paris: Flammarion, 1993).

62. Apollinaire, unpublished text from 1913; reprinted in Apollinaire, *Oeuvres*, 2:508. A *tête d'expression* refers to a study of the face made to evoke a particular mood or emotion. Apollinaire here refers to Matisse's *Red Madras Headdress* (1907, The Barnes Foundation, Philadelphia).

PETER KROPMANNS

Cézanne, Gauguin, Van Gogh, Matisse, and the Fauves:

Exhibitions of French Modernism in Berlin, Dresden, and Munich, 1904–1909

IN THE SUMMER OF 1905, an announcement appeared in the *Kunstchronik* supplement to the Leipzig *Zeitschrift für Kunstgeschichte*: "On July 15, the museum of the city of Amsterdam opened a very interesting exhibition of works by the painter Vincent van Gogh, containing no fewer than 240 paintings and 200 drawings by the artist."[1]

What seems routine today, at a time when we are used to looking across borders and even traveling to other countries for outstanding exhibitions, must have been unusual in 1905: a reference to a major exhibition in another country—and moreover concerning an artist who was still controversial fifteen years after his death—published in a journal that generally wrote only on ancient and established art. Many readers must have been startled by this notice and the same publication's subsequent highly positive review of the exhibition, since for many of them Van Gogh was a symbol of decaying values and an exponent of an absurdly raw art.[2] The name of Van Gogh, the Dutchman who had worked in France and died there in 1890, had also been familiar for some time, however, to readers who were open to new art, due in part to exhibitions that had been mounted in Germany presenting modern art from Paris and which not infrequently prompted incomprehension among critics and audiences alike. From 1883 on, German exhibitions had shown first the French Impressionists and then the French Neo-Impressionists. The number of German exhibitions to have shown multiple works by Van Gogh in the years up through 1905, however, can be counted on one hand. The same applies to Gauguin and Cézanne; Matisse and the Fauves remained unknown in this period.

Paris was, of course, the best place for Germans and other foreigners to inform themselves about new developments in French art.[3] Many came to the city in the spring, when the Paris Salon opened. Friends of innovative art were likewise interested in the Salon des Indépendants (also held in the spring) and, beginning in 1903, the Salon d'Automne as well. Knowledge of the new tendencies in art spread to Germany in a gradual, fragmentary way through solo and group shows, with exhibitions by art societies (*Kunstvereine*) and art dealers initiating conversations not only in Berlin but also in Munich, Dresden, and elsewhere. There were opportunities to make an early acquaintance with modernism in the Rhineland and Westphalia in Krefeld, Düsseldorf, Elberfeld, Barmen,[4] Hagen (where the Folkwang Museum was located), and Cologne.

The young German artists of the Brücke, Rhineland Expressionism, the Neue Künstlervereinigung München (NKVM), and the Blaue Reiter could not have seen all of these exhibitions, in particular because the artists were elsewhere for some or all of the runs of the shows. It is just as unlikely, however, that they would have missed all of them.

What follows is an outline of German exhibitions of French modernism—in particular those taking place in Berlin, Dresden, and Munich—that introduced Cézanne, Gauguin, Van Gogh, Matisse, and the Fauves between 1904 and 1909: that is, from the year preceding the founding of the Brücke in Dresden on June 7, 1905, until the year in which the NKVM was formed on January 22, 1909.[5]

Not all of the relevant exhibitions were documented with catalogues. Some catalogues were published as booklets in small print runs and are no longer extant or are summarized but not inventoried in collections of flyleaves. The search for catalogues often proves challenging, with findings naturally most prevalent at the original exhibition site. The bombings of World War II and other war losses affecting German libraries and archives have made it such that many exhibitions can be reconstructed only partially and with painstaking effort, if at all. Important clues on individual presentations can often be found in journals and newspapers, in particular local publications—not only in their reviews but also in their announcements and advertisements. Certain modern art exhibitions fell into obscurity and returned to scholarly awareness only recently, including a traveling exhibition that went to Munich and Dresden among other German cities in 1906 and 1907, and an exhibition that was shown in Berlin in 1907.

1904

A small exhibition of French "Impressionists" at the beginning of the year made the Kaiser Wilhelm Museum in Krefeld the first public museum in Germany to show three paintings by Gauguin and a painting by Van Gogh. Exhibiting these four works was made possible thanks to the collaboration between the Kaiser Wilhelm Museum's director Friedrich Deneken, Karl Ernst Osthaus, director of the private Folkwang Museum in Hagen, and the Parisian art dealer Ambroise Vollard.[6] Although this small set of works may have received little notice outside Krefeld, the circumstances behind this early opportunity to see works by Gauguin in Germany were typical. Less so was the fact that the exhibition took place at a museum; the majority of the presentations of French modernism under consideration were arranged

by art dealers, art societies, and artists' associations. Many works were not only for sale but also in fact sold—to numerous German collectors.[7]

The year's zenith in art was a Cézanne exhibition (April 22–June 15) at Galerie Paul Cassirer in Berlin. The gallery emerged in 1901 out of the Kunstsalon Bruno & Paul Cassirer, founded in 1898. It was among the most progressive art dealers in the German capital, having shown fourteen paintings by Cézanne as early as November and December of 1900, when Paul Cassirer was still running the gallery together with his cousin Bruno.[8] About thirty paintings were shown in the 1904 exhibition. The journal *Kunst und Künstler* drew the public's attention and curiosity to the show by writing

with illustrations that do not correspond with the text (including a Franz von Lenbach portrait of the former imperial chancellor, Otto von Bismarck), as though it were necessary to give an impression of social acceptability to readers simply paging through. But the attentive reader would be led, between the illustrations, to the threshold of modernism.[11]

In retrospect, a similarly important exhibition took place shortly thereafter in Munich. In August 1904, the Munich Kunstverein showed forty-six paintings by Paul Gauguin, including *Breton Boy* (1889), as well as works by Vincent van Gogh, Émile Bernard, and other artists summarized in the exhibition as belonging to the "Pont-Aven school."[12]

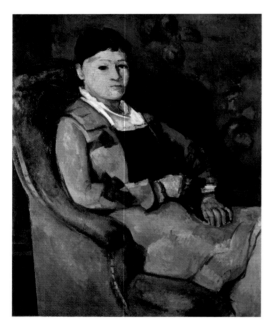

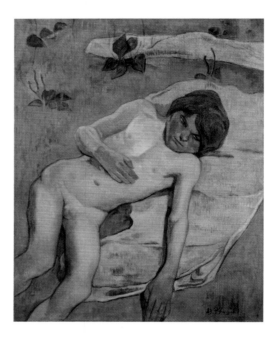

that Cassirer was presenting an "exhibition of the artist Cézanne, difficult to understand and magnificently powerful."[9] Although no catalogue is extant, an examination of the gallery's business records, archival materials from Galerie Ambroise Vollard in Paris, and contemporary newspaper and journal reviews yields a picture of an exceptionally impressive show that included still lifes, landscapes, and card players, among other subjects.[10] There was Cézanne's famous painting of the bridge in the forest of Maincy, as well as landscapes painted near L'Estaque, and the portrait *The Artist's Wife with a Fan* (c. 1878–88). In the journal *Die Kunst für alle*, critic Hans Rosenhagen published a lengthy review interspersed

At the end of the year, Paul Cassirer again presented a show in Berlin from November 22 to December 17, exhibiting works by various German artists as well as Van Gogh. Galerie Cassirer had already presented Van Gogh extensively in Berlin in 1901 and 1902.[13] Now he was represented with more than forty paintings, as evidenced by the catalogue.[14] The event is documented in press reports from no fewer than sixteen authors in newspapers and journals, all familiar to those who know the era, among them Oscar Bie, Fritz Stahl, Curt Glaser, Hans Rosenhagen, Max Osborn, and Emil Heilbut. More surprising in this context is that the architect August Endell published an assessment as

Paul Cézanne
The Artist's Wife with a Fan, 1878–88
Oil on canvas
36¼ × 28¾ in. (92 × 73 cm)
Foundation E.G. Bührle Collection, Zürich

Paul Gauguin
Breton Boy, 1889
Oil on canvas
36⅝ × 29⅛ in. (93 × 74 cm)
Wallraf-Richartz-Museum/Fondation Corboud, Cologne

well.[15] As with the Cézanne exhibition mounted the previous summer, the opinions varied from horror to delight, outrage to enthusiasm.

The Role of Art Criticism

Given the difficulty in locating catalogues for every exhibition—and in some best-case scenarios, finding only booklets that are sparsely illustrated, if at all—reviews from journals and newspapers are indispensable for our investigation.

Art criticism in Germany had already had a lengthy gestation at the turn of the twentieth century.[16] Berlin had been the imperial capital (*Reichshauptstadt*) only since 1871 and did not immediately become a capital of artistic life; as it grew in importance, the major daily newspapers began to retain arts editors for their literary sections. In addition, a large number of journals began to appear that did not merely observe and present art but also actively participated in the era's debates.[17] Commenting on the events of artistic life grew in value, and judgment and interpretation became essential components to the mission of this type of commentary. The art critic was able to

> support or weaken an artistic impression through his interpretation; his reading, which was also understood as an articulation of the understanding of the general public, was also the basis for the value judgment on which depended the public success and ultimately the existence of the work of art. If the critic believed himself obliged to conclude that a work lacked impact, in other words, lacked points of contact with the interests of the time, then he could in a way 'neutralize' such a work by denying it journalistic support or even not mentioning it at all.[18]

The critic, it was believed, must have an a priori responsibility to both the present and the past by virtue of his function as a mediator and of his professional ethics. This ideal, however, was at times forgotten. And it seems that this forgetfulness always occurred with regard to French and German art that went against academic ideas.

From the late 1880s onward, new movements in literature, music, and painting not only prompted controversies in Germany over artistic content and truth, on "traditionalism" and "modernism," but also triggered "discussions on the chances for, and the direction of, a 'German,' national art that could contend on an equal plane with the artistic high culture of the older neighboring nation states."[19] The standard was the primacy of France.[20] Among the central themes of art criticism were the dominant role of Germany's western neighbor and the dominance of French naturalism, in particular Impressionism—specifically its essence, its exponents, and its significance, including its significance for German artists and German painting. Conservative art criticism—namely that outside of Prussia—did its best to stay autonomous. All the same, on the question of the assessment of the contemporary art of France and Germany, it tended, through "its initial rejection, lengthy reserve, and then only hesitant recognition," to concur, though with motivations of its own, with courtly and academic art politics.[21]

The Franco-Prussian War of 1870–71 politicized art criticism. Fin-de-siècle newspapers and journals reflected many facets of opposing views, including the defense of academic traditions and demagoguery catering to the "disquiet of the broad public" unsettled by new, unconventional artistic expressions.[22] At times the critique of cosmopolitanism in art did not shy away from anti-Semitism as well. Other publications were hostile to art promoted by the imperial court but did not necessarily support modern movements in general or French modernism in particular.[23]

On the other side were the progressive editors who took a constructive, even benevolent (but not blindly obedient) approach to the French avant-garde; consequently, they did not enjoy universal popularity. These authors consciously or unconsciously continued the positions set forth in the writings of Franz von Reber, Richard Muther, Woldemar von Seidlitz, and Emil Heilbut, who were the forerunners of Julius Meier-Graefe and Meier-Graefe's own epochal three-volume *Entwickelungsgeschichte der modernen Kunst* (Developmental History of Modern Art, published in Stuttgart in 1904). The concept of a national art history was alien to them.

For their part, both confused patriots and inveterate nationalists took up pens. Their enemies were less the artists of other countries than Germans who, as the Heidelberg professor of art history Henry Thode wrote in 1905, propounded "that one-sided concept of art proclaiming the foreign, predominantly coming out of Berlin, that is to be forced on Germany." The journal *Grenzboten* asserted in 1904 that the art of a country could "only be lasting…if it grew up out of its native soil," whereas behind the cosmopolitan thinking of the (Berlin)

Secessionists there was "no German feeling and long-ing," and their aesthetic was "imported."[24]

Thode's attacks, received with resounding acclaim throughout Germany, were regarded by the anti-French and generally xenophobic nationalists and nativists as a call to arms.[25] In August 1905, Arthur Moeller van den Bruck (who later authored the book *Das dritte Reich* in 1923, issued in English in 1934 as *Germany's Third Empire*), published his essay "Die Ueberschätzung französischer Kunst in Deutschland" (The Overestimation of French Art in Germany), which was likely closely connected to the discussions initiated by Thode. Moeller van den Bruck's remarks show that he regarded the sympathies of critics and audiences for French art as dangerous, particularly "in an age in which the national preconditions for a German art [had] finally been created." He was likewise clear in his opposition to "cosmopolitanly characterless" art, which in his view came about all too easily from an excessive conformity to French modernism. He believed that the impulses coming out of France lacked spiritual content and were merely manual and technical in nature. Moreover, Moeller van den Bruck went on, there could be no commonalities, since art was the most visible realization of opposing, hostile ways of life.[26]

At the same time, the German public had ever more frequent opportunities to see and read about contemporary French art. *Kunst und Künstler*, edited by Bruno Cassirer from 1902 onward, was one journal that set the direction in the debate on modern art that would have foundational importance for the emancipation of progressive German art in the early years of the twentieth century.[27] Today *Kunst und Künstler* seems straitlaced and bound to Manet and Impressionism, particularly when compared to later periodicals that defended Expressionism and other movements. Yet its pedagogical role in the reception of later French art is undeniable. It brought about, among other things, the publication of letters by Van Gogh, a preprint of Gauguin's *Noa Noa*, and the translation of Matisse's theoretical work, "Notes d'un peintre" (1908).[28]

1905

The major Van Gogh retrospective in Amsterdam mentioned at the outset of this essay opened in July 1905. Paul Cassirer beat it by a few weeks when he showed more than twenty of Van Gogh's paintings from April 29 until sometime in June. He was able to arrange for the loans through an agreement with the Van Gogh family, in particular Johanna van Gogh-Bonger, whom he promised "a pecuniary success as well."[29] Later that summer—impressed by what was now his third experience with a group of paintings by Van Gogh, his contact with "some gentlemen...who are interested in Van Gogh," and the Amsterdam retrospective—Cassirer planned an eight-month traveling exhibition that would open in his Hamburg gallery before proceeding to Dresden, Berlin, and Vienna.[30]

Let us look first, however, to a significant art event in Weimar. A Paul Gauguin retrospective took place there from July 7 to September 15, encompassing thirty-three works made in Brittany and the South Seas, including paintings, drawings, and a wood sculpture. The works were made available by French collectors Gustave Fayet, Georges-Daniel de Monfreid, and Maurice Fabre, and included *The Yellow Christ* (1889; p. 68) and *The Ancestors of Tehamana* (1893). The journal *Die Kunst-Halle* saw the exhibition as an invasion: "Warning! A collection of paintings by the...obscure painter Paul Gauguin...is advancing slowly towards—Berlin. The Meier-Graefeian publicity and manufacturing of great men is taking on ever more tangible forms. Following on the idiot Van Gogh comes now—Gauguin."[31]

On September 16, at his Kunstsalon Cassirer in Hamburg, Paul Cassirer realized his plans, opening his Van Gogh exhibition with fifty-four works, including forty-seven paintings owned by Johanna van Gogh-Bonger.[32] As planned, the show traveled to Dresden, where the Galerie Ernst Arnold showed fifty Van Goghs alongside works by Constantin Guys from October 26 to November 11.[33] Founded in 1818 by Ernst Sigismund Arnold and led at the turn of the twentieth century by Ludwig W. Gutbier, the gallery had already made a name for itself with important exhibitions, having shown Impressionism in 1899 and Neo-Impressionism in 1904. The catalogue for the Van Gogh show begins with an essay on the artist by Hans Rosenhagen, followed by the list of works. Along with general titles such as "Portrait" and "Self-Portrait," many titles do offer a modicum of precision, such as "Sunset on the Rhône" and "Portrait of a Zouave." Yet none of the works is reproduced, so it will require further research to identify each of them definitively. It has been demonstrated, however, that *Still Life with Quinces* (1887–88) and *Field with Poppies* (1889–90; p. 78) were on display both at the Dresden exhibition and before it in Hamburg.[34] The Kunsthalle Bremen acquired the latter work in 1910, prompting an outcry by nationalist voices that

culminated in the well-known protest by Carl Vinnen and other artists in 1911.[35]

In January 1906, *Kunstchronik* reported on an exhibition with "certain major works" by Van Gogh at Galerie Paul Cassirer in Berlin. The journal wrote: "With Van Gogh one always has the desire at first to free oneself with a laugh—but behind his paintings is something other than childish barbarism. Now and then his combinations of colors are indeed able to fascinate."[36] Cassirer's tour continued. After Dresden came an appearance in Berlin over the winter of 1905–6, after which Cassirer sent a slightly reduced exhibition to Galerie Miethke in Vienna.[37]

1906

The new year brought a major event, though it began innocuously enough. In February Cassirer showed a painting by Cézanne,[38] while two of the artist's paintings were shown in Bremen, including a loan from the National Gallery in Berlin. At the same International Art Exhibition of the Bremen Kunstverein, nine works by Van Gogh were presented, of which seven were loans from Paul Cassirer that he had held back from Vienna.[39] In May, the museum in Posen (today Poznań) showed Impressionism, as well as works by Van Gogh (three were from Cassirer) and Cézanne.[40] The Berlin Secession presented two paintings by Gauguin in its spring

exhibition at about the same time: *The Bith* (1896) and *The Pool* (1887; today both at the Neue Pinakothek, Munich).[41] It is worth noting that colorist Louis Valtat was represented with five landscapes at this show.

In retrospect, one of the most important exhibitions of 1906 was organized by Rudolf Adelbert Meyer (who later lived in the United States and called himself Meyer-Riefstahl) with the aid of Parisian gallerist Eugène Druet. Druet had drawn attention earlier that year with a highly regarded Matisse exhibition; he dealt in high-quality reproductions as well.[42] Meyer, the German in Paris, assembled a traveling exhibition that did not focus primarily on the Fauves but brought

together the latest tendencies from Cézanne, Gauguin, and Van Gogh to the present. It was shown from September to the following February in Munich, Frankfurt, Dresden, Karlsruhe, and Stuttgart. On display were 130 works: 105 paintings, twelve watercolors, eight drawings, four pastels, and one gouache.[43]

The catalogue of this "exhibition of French artists" (only recently rediscovered) and the exhibition's reconstruction[44] make it clear that certain Fauves were seen quite early in Germany.[45] The works in the traveling exhibition included no fewer than four paintings by Charles Camoin, four paintings and four to six drawings by Henri Matisse, four paintings by Henri Manguin, four paintings by Albert Marquet, and three paintings by

Paul Gauguin
The Ancestors of Tehamana, 1893
Oil on canvas
30 1/16 × 21 3/8 in. (76.3 × 54.3 cm)
Art Institute of Chicago, gift of Mr. and
Mrs. Charles Deering McCormick

Vincent van Gogh
Still Life with Quinces, 1887–88
Oil on canvas
18 1/8 × 23 7/16 in. (46 × 59.5 cm)
Galerie Neue Meister (Gal. No. 2593),
Staatliche Kunstsammlungen Dresden

Jean Puy. Another page set forth what exactly was on display and whether Fauvist works were shown.

Matisse was not reproduced in the exceptionally rare catalogue, which was prepared in Paris and apparently printed in Munich;[46] the catalogue and a review in the *Münchner Neueste Nachrichten* nonetheless document what works of his were shown. The paintings included an unspecified still life, an unspecified landscape of Belle-Île-en-Mer, the painting *Place des Lices, Saint-Tropez* (1904), and a painting showing a boy with toys, most likely *Pierre Matisse with Bidouille* (1904), showing Matisse's son Pierre with his hobbyhorse, Bidouille. Manguin was represented with four paintings: *Maternity* (1903), *The Valley, Villa Demière* (1905), *Olive Trees at Cavalière* (1906), and the very Fauvist *Jeanne with Umbrella, Cavalière* (1906).[47]

crimes against art.... And here one must... energetically reject Vincent van Gogh above all, who may have been seen among the French as the leader of the new movements.... Paul Gauguin is similarly pathological....[48]

After being shown in Munich in September and in Frankfurt in October, the exhibition traveled to Dresden, where the same works were shown from November 3 to November 23,[49] and from there it progressed to Karlsruhe and Stuttgart. The year wrapped up with the presentation of thirty drawings by Van Gogh in Berlin, shown by the Secession at its annual winter graphic arts exhibition.[50]

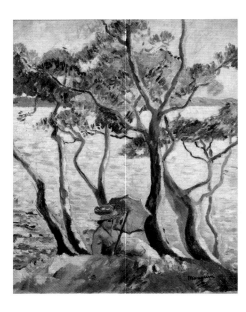

It is difficult to say how much resonance this exhibition had in Frankfurt and Dresden. The reactions in Karlsruhe and Stuttgart are even less clear, but at least in Munich, the first venue, there is documentation that the exhibition made a major impact. A review in the journal *Die christliche Kunst*, for example, chronicled the general reaction:

> For three weeks the exhibition of new French painting, occupying almost the entirety of the Kunstverein, has caused strong feelings. Resounding protests against such 'disgusting scrawls' were on the agenda. One viewer even urged me quite strongly to denounce such

1907

This year was no less rich in opportunities for encounters with contemporary French art in Germany. From May until October, the Kunsthalle Mannheim mounted a major exhibition for the city jubilee that included fourteen works by Van Gogh, which "invited the amazement of the public."[51] The Berlin Secession exhibition showed two paintings by Jean Puy alongside ten paintings by Van Gogh in the early summer.

Though Paul Cassirer continued to seek to handle "sales for all Germany" for Van Gogh to the extent that Johanna van Gogh-Bonger was amenable,[52] he now turned his attentions to an artist whom he had never

Henri Manguin
Jeanne with Umbrella, Cavalière, 1906
Oil on canvas
36¼ x 28¾ in. (92 x 73.2 cm)
Kunsthalle Bielefeld

Advertisement for *Exhibition of French Artists* at the Kunst-Salon Ernst Arnold, Dresden, 1906 (from the journal *Dresdner Anzeiger*, no. 314, November 14, 1906)

shown before. From September 29 to October 18 his gallery presented an exhibition at which works by Matisse were on display for the first time in Berlin. These paintings were incorporated into an exhibition that for the most part showed watercolors by Paul Cézanne and works by Edvard Munch, Curt Herrmann, and Heinrich Wirsing.[53] The works by Matisse, like the watercolors by Cézanne, were made available by Galerie Bernheim-Jeune in Paris.

Cassirer's catalogue lists the works by Matisse—two landscapes and four still lifes—but the imprecise titles listed (of the sort also found in Parisian catalogues of the time), such as "Still Life" and "Landscape," render it impossible to identify all of the works unambiguously. The reactions of the Berlin critics make it reasonable

before saying of Matisse: "We have encountered for the first time a young Frenchman from Cézanne's circle, Henri Matisse. He enters this avant-garde as a full-fledged comrade. His still lifes are of an intensity and blooming wealth of colored life matched by few others."[54]

The same day, the *Vossische Zeitung* printed a review of the same exhibition by Ludwig Pietsch, which began with the words, "The Kunstsalon Cassirer, Viktoriastr. 35, has once again become a true chamber of horrors," and went on to express crushing opinions of Cézanne, Munch, and Herrmann. The article is an anthology of the most contemptuous epithets from the art criticism of the era: "heap of colorful atrocities, ridiculous and mad messes," "shoddy efforts," "smudgings," "daubings." Pietsch took mercy only on the sculptural

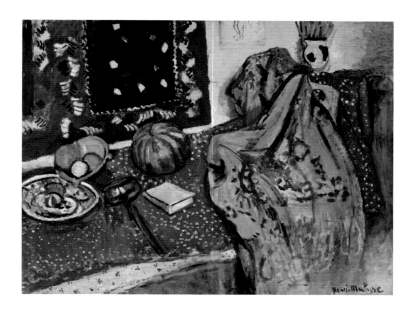

to assume, however, that primarily works from the preceding two or three years were shown. We may also infer that the famous Fauvist painting *Red Rugs* (1906) was shown as "Carpets," and *The Geranium* (1906; today at the Art Institute of Chicago) was shown as "Geranium."

The 1892 "Munch Affair" (which arose from the Norwegian painter's controversial one-man show in Berlin) was still in recent memory, and there was great general interest in Cézanne. The coherence and quantitative dominance of the sixty-nine watercolors by Cézanne may have prevented the six paintings by Matisse from receiving more attention. In a newspaper article, Max Osborn discussed Cézanne and Munch

works by Heinrich Wirsing ("the only bright spots"), whom Osborn did not mention at all and who is largely forgotten today. Pietsch did not so much as waste his breath on Matisse.[55]

In October, the Folkwang Museum in Hagen showed an ensemble of works by Georges Braque, Raoul Dufy, Auguste Herbin, and Jean Metzinger.[56] It then presented a Matisse exhibition with a mere seven paintings at the end of December. Karl Ernst Osthaus had purchased Matisse's *Still Life with Asphodels* (1907, p. 72) for his museum that autumn, and he had now obtained six more works—the paintings shown by Cassirer in September. Hagen, where Osthaus lived, was conveniently situated on the Paris-Berlin-Moscow rail

Henri Matisse
Red Rugs (*Still Life with a Red Rug*), 1906
plate 112 | cat. 153

line, a major railway for both travelers and commercial transportation.

A review in the *Hagener Zeitung* mentions two "Still Lifes," one "Landscape," a "Carpets" (*Red Rugs*) that was "painted wholly in the spirit of Cézanne, but [characterized] by stronger, more radiant colors," and a "statue." The lattermost must be the *Still Life with Plaster Figure* (1906; today at the Yale University Art Gallery, New Haven).[57] The "Landscape" was most likely the painting *The Riverbank* (1907; today in the Kunstmuseum Basel), which Osthaus went on to acquire for his museum on February 6, 1908.[58]

While the small Matisse exhibition was on display in Hagen, a presentation of other works of French modernism had been under way since early December in Berlin at an exhibition at Galerie Eduard Schulte that remains little researched even today. August Macke, the young artist from the Rhineland, was determined to see this show during a stay in Berlin. This information comes from collector Bernhard Koehler, who was also the uncle of Macke's future wife, Elisabeth: "We are now drinking our well-earned afternoon coffee at [Café] Josty," Koehler wrote to his niece, "after having seen a black-and-white exhibition at Cassirer's that opened yesterday.... Next we are going to Schulte. Modern French masters are to be seen there about whom A. is immensely excited. Naturally I have to go along!"[59]

The show at Galerie Schulte that Koehler referred to was a joint exhibition by a group of German and French artists, arranged by the painter Ida Gerhardi. Gerhardi was in contact with German art collector and art dealer Wilhelm Uhde in Paris, who would later describe himself as the show's organizer.[60] The exhibition, showing works by over thirty artists, was purportedly bound for Galerie Emil Richter in Dresden in January 1908. What is certain is that it more or less failed in Berlin, where it stayed during the Christmas season; presumably many art lovers were drawn instead to the Secession's fourteenth exhibition, the graphic arts show known as the "Black-and-White Exhibition," which was on view at the same time. Because construction work was being done on the Secession building, this important exhibition of graphic art was held at Cassirer's gallery.

The German-French show at Galerie Schulte received less praise and much less attention in the press. It included works by Maurice Denis, Ker-Xavier Roussel, Pierre Bonnard, Odilon Redon, Félix Vallotton, and Edouard Vuillard, as well as by such Fauvists as Charles Camoin, Raoul Dufy, Albert Marquet, and Jean Puy.[61] Although Aristide Maillol, Auguste Rodin, and Henri de Toulouse-Lautrec were represented only with graphic art, there were multiple paintings by Paul Gauguin to marvel at, including *Bonjour, Monsieur Gauguin* (1889; today at the Národní Galerie, Prague) and paintings of Tahitian women. Auguste Herbin, a practicing Fauvist at the time, was represented with a similar quantity of works to Vallotton. Herbin had accompanied Wilhelm Uhde to Corsica that summer and had now sent to Berlin multiple scenes from the port city of Bastia and the mountain village of Évisa.[62] It is astonishing to see that Robert Delaunay was included with a portrait of Uhde; until now it was believed that the first appearance of this French artist in Germany had been much later than 1907. A last source of astonishment may

have been Pablo Picasso, who was on display with "Portrait of a Goldsmith," "Young Man with Bouquet," and "Head of Harlequin," which were probably works from his Blue and Rose Periods, and an etching.[63]

The Secession's "Black-and-White Exhibition" that Bernhard Koehler also mentioned took place at Cassirer's from December 6 to January 6. The journal *Die Kunst für alle* emphasized the presence of Van Gogh with "some excellently drawn landscapes and pathologically interesting portraits."[64] The exhibition catalogue lists twelve drawings.[65] It is interesting that Matisse was represented as well, with eight drawings.[66]

Auguste Herbin
Port of Bastia, Corsica, 1907
Oil on canvas
25⅝ x 31⅞ in. (65 x 81 cm)
Hamburger Kunsthalle, Hamburg

The graphic works by Matisse came either in part or in whole from the collection of photographer Edward Steichen. Steichen wrote to his colleague Alfred Stieglitz, who was also the co-owner of the Little Galleries of the Photo-Secession in New York:

> I have another cracker-jack exhibition for you....Drawings by Henri Matisse the most modern of the moderns....Well they are to the figure what the Cézannes are to the landscape. Simply great. Some are more finished than Rodin's, more of a study of form than movement—abstract to the limit. I'll bring them with me, and we can show them right

> after mine, if you can so arrange it. They were just show [*sic*] in Berlin at Cassirer's.[67]

The photographer's keen eye, his enthusiasm, and his just assessment of the works' radiant power remind us not to underestimate the impact of the works shown in Berlin. Fauvism, like the Expressionism of the Brücke, cannot come across solely or predominantly through paintings, but must express itself in black and white as well. A look at Matisse's early graphic art reveals an immensely innovative potential hardly

matched by any of his contemporaries; art historian Alfred H. Barr Jr. went so far as to write that Matisse had developed a mastery of drawing at the turn of the new century that was "unequaled by any artist of his generation."[68] The drawing *Nude in a Folding Chair*, from 1906, conveys an idea of what was shown at the Berlin Secession exhibition in Cassirer's space in 1907, and has been called by Barr "thoroughly fauve in its technical variety and informality."[69]

The "Black-and-White Exhibition" was likely one of the first opportunities for Brücke artists to become aware of Matisse. Only a few days after the show closed, Karl Schmidt-Rottluff wrote (on January 8, 1908) to Cuno Amiet, the Swiss member of the group: "Dear Amiet, Do you know Van Dongen in Paris? We intend to name him a member, and we are speculating as to H. Matisse and E. Munch as well."[70]

Arranging and Cooperating

Both the Germans and the French contributed to arranging exhibitions. The first German exhibition of Impressionism, shown in Berlin in 1883, came about only through the concerted efforts of Berlin collectors Carl and Felicie Bernstein, their relative Charles Ephrussi in Paris, Galerie Durand-Ruel in Paris, and Galerie Fritz Gurlitt in Berlin, which carried out the exhibition. It is also known from Max Liebermann's correspondence with physician Max Linde that Paul Durand-Ruel traveled to Berlin and Hamburg in 1897 specifically to offer paintings by Degas and Manet for sale. Another example is Julien Leclercq, who traveled to Berlin in 1898 seeking to sell works by Van Gogh and Gauguin.[71] Rudolf Meyer appears to have acted in 1906 with similar independence, although, as discussed, with the support of Galerie Druet. Finally, the aforementioned Cézanne exhibition at Cassirer's in 1901 was brought about through the cooperation between Emil Heilbut, who acted as agent, and Durand-Ruel.

The economic ties between German and French galleries appear to have developed strongly in the years around 1900. On the French side, the partners were Durand-Ruel, Vollard, and Bernheim-Jeune, though they did not always realize the hoped-for profits. Thus Félix Fenéon, the artistic director of the Galerie Bernheim-Jeune, wrote on October 5, 1907: "We often sell paintings to Germans passing through Paris, as we had the pleasure to establish once again with you, Monsieur. But we never sell anything at our exhibitions in Germany."[72] There were also collaborations between

Henri Matisse
Nude in a Folding Chair, 1906
Brush and black ink with pen
and black ink on ivory laid paper
25 9/16 x 18 3/8 in. (65 × 46.7 cm)
Art Institute of Chicago,
gift of Mrs. Potter Palmer

German art dealers, who shared transportation costs. As a result, certain ensembles of works were shown in multiple cities (for example, both in Munich and in Dresden); the gallerists of each city would enrich their local showing with works selected from their own gallery's stock as well as from local collections, other suppliers, or other traveling ensembles of works by the same or related artists. The content of exhibitions might also change if works had been sold in the preceding city. These collaborations were seldom called such to outsiders, making it no trivial matter to trace them today.

1908

At the beginning of the year, Franz Josef Brakl in Munich showed "23 works by young Frenchmen," including Kees van Dongen.[73] By this time, Cassirer had made new plans for Van Gogh, made possible by a monographic exhibition at the Galerie Bernheim-Jeune in Paris, but his intent to realize a tour with venues in Berlin, Munich, Dresden, and Frankfurt was obstructed by difficulties in logistics and scheduling. From March 5 to March 22 he showed "only" twenty-seven paintings by Van Gogh

in Berlin. By contrast, the Munich art dealers Brakl & Thannhauser were "only" able to show about seventy-one paintings by Van Gogh at the same time. The painting "Street in Auvers" was sold at this exhibition to Alexei Jawlensky, later a member of the NKVM. Brakl's Moderne Kunsthandlung had announced no fewer than ninety-eight works by Van Gogh to the editor of the *Münchner Neueste Nachrichten*, "that is to say, a collection of a scope never before shown" (at least, never before shown in Munich, it must be added). Yet Cassirer, who had suggested the prospect of twenty-seven paintings, held these back at the last minute for his own gallery in Berlin.[74]

In the same period, from March 23 to April 15, the Kunstsalon W. Zimmermann in Munich showed thirteen works by Van Gogh. According to the catalogue, eight paintings by Gauguin were on display as well.[75] The reviews of the two Munich exhibitions at Brakl & Thannhauser and at Zimmermann mentioned early works from Holland as well as works from the Paris period and later works, including a *"Storm Landscape*, an undulant field of corn, cut through by a path, heavily beset by deep hanging clouds and fluttering black ravens," thus a work from Auvers-sur-Oise.[76]

The Brakl exhibition then went to Dresden in modified form. The catalogue from Galerie Emil Richter, where it was shown in April and May, contains an introductory text on Vincent van Gogh by art critic Paul Fechter as well as a list of seventy-five paintings—landscapes, still lifes, and portraits. Fechter's foreword focuses on the artist's development, with his late years viewed as his culmination: "There is so much that is beautiful and fine from the Paris period—but everything pales against the revelations of the last phase." Here the author draws openly on Meier-Graefe, whose assessment he shares. No works are reproduced or described in detail; not even dimensions are recorded. Among the titles of the works, however, there are references to motifs on which Van Gogh made few variations, such as "Bank of the Seine in Asnières," "Boulevard de Clichy," and "Yellow Books," whereas other titles, such as "Head of a Woman" and "Still Life," help a great deal less in the identification of the works on exhibit.[77] The catalogue reflects the show only in part: sixty-nine paintings were sent to Dresden from Munich, supplemented by seventeen works sent by Cassirer from Berlin and not listed in the catalogue.[78] The exhibition also contained fifty watercolors by Cézanne; they were likewise made available by Galerie Cassirer, which had shown them in autumn 1907.[79] The last stop for the

Frontispiece of the catalogue *Vincent van Gogh / Paul Cézanne*, published by Galerie Emil Richter, 1908
Sächsische Landesbibliothek, Staats- und Universitätsbibliothek Dresden

174

exhibition was Frankfurt, where the Kunstverein showed eighty-two paintings and sixteen drawings by Van Gogh.[80]

Cézanne, Gauguin, and Van Gogh had now been shown often in Germany, while the Fauves were still relatively unknown. Not forming a homogeneous group, they were difficult to grasp even as a loose association and were still presented only in intermittent samplings. The 1908 spring exhibition of the Berlin Secession did not change much, but it did present Albert Marquet and Kees van Dongen for the first time. Coming after the traveling exhibitions of French artists in 1906 and 1907, this was the third time that Marquet was shown in Germany—here with two paintings, one of which was a scene on the Quai des Grands-Augustins. Van Dongen was also represented with two paintings at what was apparently his Berlin premiere, having already shown in Munich in February.[81] In addition, the Secession showed two paintings by Cézanne and two by Van Gogh.

More Fauvist works were shown in Dresden in September, together with works by Brücke artists and others. Galerie Emil Richter, led by Herrmann Holst (who, like Ludwig Gutbier, was an art dealer by appointment to the royal house of Saxony), presented Erich Heckel, Karl Schmidt-Rottluff, Ernst Ludwig Kirchner, Max Pechstein, Cuno Amiet, Giovanni Giacometti, and Franz Nölken on the German side, and Charles Camoin, Maurice Denis, André Derain, Edvard Diriks, Kees van Dongen, Othon Friesz, Pierre Girieud, Charles-François-Prosper Guérin, Francis Jourdain, Edmond Lempereur, Albert Marquet, Jean Metzinger, Pablo Picasso, Jean Puy, Ker-Xavier Roussel, Paul Signac, and Maurice de Vlaminck on the French.[82] It is striking that Manguin and Matisse were apparently *not* involved.

Richard Stiller, critic of the *Dresdner Anzeiger*, wrote: "The comparison with the French...reveals almost at first glance that they, although otherwise without particular depth, have more artistic culture under their belt. All of them limit themselves extremely in their means of expression."[83] Paul Fechter, the reviewer of the *Dresdner Neueste Nachrichten,* also called for comparisons but warned the local group of artists:

The encounter may be coincidental; it is in any event valuable, in particular for the "Brücke." Not that they should make role models out of these questing people, but a comparison between the problems here and there could aid contemplation in some respects. On the German side,

above all power [underlined three times], color, and freedom [the same]. Personalities running riot. On the opposing side, a careful searching for new laws—a clear turning away from the paths of analysis of light and air to all manner of experiments with new syntheses.... That every human being as an artist...can paint what he wants to and as colorfully and energetically as he wants to—that has gradually become a precondition and is a bit lacking as a unifying goal. This is a danger for the Brücke—namely to lag,

to squander its strength on things that are ultimately already done.[84]

At roughly the same time, in Berlin Paul Cassirer presented for discussion a number of modern still lifes, including works by Cézanne, Gauguin, Van Gogh, Manguin, and Matisse.[85]

1909

More than three years after the scandal of the 1905 Salon d'Automne in Paris, at which the artists around Matisse were labeled Fauves, Galerie Cassirer in Berlin mounted

Henri Matisse
Blue Nude (*Memory of Biskra*), 1907
Oil on canvas
36 ¼ × 55 ¼ in. (92.1 × 140.3 cm)
Baltimore Museum of Art, the Cone Collection, formed by Dr. Claribel Cone and Miss Etta Cone of Baltimore, Maryland

an extensive Matisse exhibition. Between New Year's Day and January 20, 1909, an exhibition was shown encompassing a good seventy works by the artist, both older and newer and largely hung by the artist himself—including paintings, drawings, engravings, and sculpture.

The retrospective contained almost thirty paintings, including the important works *Blue Nude* (*Memory of Biskra*) (1907, p. 175), *The Coiffure* (1907, Staatsgalerie Stuttgart), and *Harmony in Red* (1908; p. 52). There were also thirty drawings, lithographs, and woodcuts, as well as ten bronzes, including the sculptures *Woman Leaning on Her Hands* (1905), *Decorative Figure* (1908), *Two Negresses* (1907–8), and *Reclining Nude I* (1907). One can hardly imagine a more important collection of premier works by Matisse, and none had been shown even in Paris at that time.[86]

The press reacted to the sensational show with at times harsh criticism. Among the visitors were illustrious and influential personalities, including important artists of several generations. Max Beckmann bristled, "The paintings by Matisse displease me immensely. One shameless effrontery after another."[87] Max Liebermann and August Gaul were more conciliatory. It seems that only two artists were unreservedly delighted. On a postcard to Erich Heckel postmarked in Berlin on January 12, 1909, Ernst Ludwig Kirchner and Max Pechstein wrote to Dresden: "Best regards, yours, Ernst—Matisse at times very wild—Regards, yours, Max."[88] Some months later, on April 27, 1909, Heckel inquired of Amiet: "Do you know Matisse personally? Then it would be best if you would invite him, in particular since his language is more familiar to you."[89] Here the Brücke artists' interest in an association with Matisse is expressed again.

That spring the Berlin Secession presented a painting by Maurice de Vlaminck alongside a painting by Van Gogh and two paintings by Othon Friesz; Vlaminck, like Friesz, was possibly appearing in Berlin for the first time. A high point of the exhibition was undoubtedly Cézanne's monumental painting *The Large Bathers* (1900–1906; p. 75), which was reproduced in the catalogue.

Also in the spring, Cassirer again showed Van Gogh in Berlin, though this appears to be documented only by press accounts. The Berlin Secession displayed one painting each by Cézanne and Van Gogh, and a Bremen exhibition drawn from local private collections (*Leihausstellung von Gemälden, Zeichnungen und Bildwerken aus brehmischem Privatbesitz*) displayed two paintings by Gauguin.[90] In April the Städtisches Museum Elberfeld showed art by Marquet.[91]

While a graphic arts exhibition at the Folkwang Museum in Hagen exhibited works by Van Gogh, Gauguin, Matisse, and others in August,[92] Paul Cassirer was preparing the large-scale Cézanne exhibition that he would mount from November 27 to December 10. Of the forty-two paintings, eighteen came from Vollard in Paris and sixteen from German private collections.[93]

In October, Brakl opened a Van Gogh exhibition in Munich with almost fifty paintings—subdivided in the catalogue into the creative periods of Paris, Arles, Saint-Rémy-en-Provence, and Auvers-sur-Oise—as well as a number of drawings.[94] Berlin, too, saw Van Gogh again at the end of 1909; the Secession presented twenty-three drawings by Van Gogh in its graphic arts show, which ran from November 27 until January 9, along with two drawings by Gauguin.[95]

Distancing and Demarcation

It is always important to consider the broader context when taking a closer look at exhibitions of French modernism in Germany between 1904 and 1909. These events were not only part of a moment in European history and art history on the eve of World War I but also part of a continuum of German-French relations spanning many centuries and having experienced many fluctuations, characterized by some peaks and many depths—by exchange, inspiration, and osmosis at some points and by rejection, distancing, and demarcation at others. In the nineteenth century, artists, patrons, and collectors became increasingly involved with intermediaries and their institutions, as well as with the art market and art criticism. At the same time, artistic matters also underwent a politicization shaped by military decisions and ideological differences within Germany.

The long-standing dispute as to the extent to which the German Expressionists could claim independence or were indebted to the French Fauves was ended after it was established that the two groups drew on similar sources and, more or less simultaneously, created something new synthetically from what was already there. A major source (though not the only one) was the art of the great colorists Cézanne, Gauguin, and Van Gogh; somewhat later the influence of Matisse and the Fauves would become apparent.

This examination of German exhibitions of the later French avant-garde begins in 1904—an important year in two respects. First, Meier-Graefe published his *Entwickelungsgeschichte*, which found a large and grateful readership. Today it is considered a milestone

in modern art history, in particular in its assessment of modern French art. But at the time it met with considerable resistance. While in 1905 the Fauves attracted attention in Paris and the Brücke formed in Dresden, Meier-Graefe's method of analyzing art from a European perspective (rather than a national one) was judged severely.[96] On the occasion of preparations for the 1904 World's Fair in Saint Louis, the question of which artists would be sent to represent Germany for the national pavilion became a political issue. When Wilhelm II intervened personally, the reactions in the press and the passionate debates in the Reichstag made clear that many were no longer disposed to let the kaiser dictate what was to be understood as art. During the Reichstag debates in February 1904, even moderate speakers found the government's position intolerable and expressed their protest.[97]

Looking at important German exhibitions of French art between 1904 and 1909 reveals that artistic life was not restricted to the capital city of Berlin. Through the Secession and its exhibitions as well as Cassirer's initiatives, Berlin had made significant gains on Munich, the German art capital of the nineteenth century; nonetheless, the Munich Kunstverein and a number of galleries in Munich brought together some remarkable exhibitions. Noteworthy events also took place from time to time in other cities throughout the German empire as well. What was for many years the most important single exhibition of Gauguin was presented in Weimar, even as he was neglected in Berlin and Dresden; Cassirer does not seem to have cared for him, and Gutbier did not devote an extensive show to him until 1910. In turn, neither Dresden nor Munich could compete with Cassirer in Berlin for the clarity and completeness of his presentations of Cézanne. The same is true of Van Gogh, although he was also shown repeatedly in Dresden and Munich and was represented prominently in Hamburg and Mannheim as well. The frequency with which Van Gogh was shown in Germany even set a record: no fewer than thirty-three exhibitions and exhibition participations are documented between 1901 and 1909, not counting notable events in nearby cities outside of Germany (e.g., Amsterdam, Vienna, and Zürich).[98] Furthermore, we have seen how Matisse, in the years after 1906 and 1907, was presented in fragmentary fashion, including in Hagen in Westphalia, before Cassirer gave him the use of his space in Berlin for a major retrospective in 1909. It also became clear that efforts to show Fauvism more broadly, like those of Herrmann

Holst (of the Galerie Emil Richter) in 1908, would not be repeated. They were crucially flawed by the omission of Matisse, Fauvism's most important representative. Some of these insights have become possible only in recent years.[99]

It is now possible to ask what all of this meant for the artists of the Brücke or the later NKVM, or for those who edited the almanac *Der Blaue Reiter*. To avoid rushing to conclusions, the extent to which artists living in Germany (but with international mobility) were able to see a given exhibition must be investigated on a case-by-case basis. It would not have helped much for artists to obtain catalogues for exhibitions they had missed, since for the most part these were illustrated minimally, if at all, and then only with low-quality black-and-white photographs. Those who were able to marvel at outstanding "reproductions of paintings by Van Gogh and Gauguin and others,"[100] by contrast, or even to attend an exhibition with art by Cézanne, Gauguin, Van Gogh, or Matisse can hardly have returned to daily life unaffected. On "the actual extent" of enthusiasm and critical appraisal, however, "only speculative statements can be made."[101] This is true for us as well—in particular when it has not been established what exactly was on display: an early painting, a painting that was atypical, a middling painting, or a mature work? Or a key work—even, as the Parisians would say, *un chef d'oeuvre*?

Translated by Ben Letzler

ENDNOTES

1. *Kunstchronik: Wochenschrift für Kunst und Kunstgewerbe,* n.s., 16 (1904–5), no. 30 (July 21, 1905): col. 491.

2. Review by J. C. G., *Kunstchronik: Wochenschrift für Kunst und Kunstgewerbe,* n.s., 16 (1904–5), no. 32 (September 1, 1905): cols. 525–26.

3. The Salon de la Libre Esthétique in Brussels must have played a role in the dissemination of French art in Germany, as is attested by the early mention in a German journal of the Fauves Camoin, Manguin, Marquet, and Matisse, who were exhibited there: *Kunstchronik: Wochenschrift für Kunst und Kunstgewerbe,* n.s., 17 (1905–6), no. 16 (February 23, 1906): col. 256. Another question is whether readers would have known anything about the names.

4. Elberfeld and Barmen, among other neighboring towns, were joined together with Wuppertal in 1929.

5. This essay builds on both my own research—see, most recently, Peter Kropmanns, "Die Fauves in Deutschland—eine Skizze," *Im Farbenrausch: Munch, Matisse und die Expressionisten,* exh. cat. Museum Folkwang, Essen (Göttingen: Steidl, 2012), 32–43—and a list of exhibitions contained in the essay by Timothy O. Benson, "Brücke, French Art and German National Identity," *New Perspectives on Brücke Expressionism: Bridging History* (Burlington, VT: Ashgate, 2011), 37–43.

6. Peter Kropmanns, "Gauguin in Deutschland: Rezeption mit Mut und Weitsicht," *Paul Gauguin: Das verlorene Paradies,* exh. cat. Museum Folkwang Essen and Nationalgalerie Berlin (Cologne: DuMont, 1998), 255.

7. The *Kunstvereine* played an increasingly important role in the dissemination of art throughout Germany. For an overview, see Ulrike Becks-Malorny, "Die Kunstvereine im 19. Jahrhundert," *Der Kunstverein in Barmen 1866–1946: Bürgerliches Mäzenatentum zwischen Kaiserreich und Nationalsozialismus* (Wuppertal: Born, 1992).

8. Walter Feilchenfeldt speaks of thirteen paintings in "Zur Rezeptionsgeschichte Cézannes in Deutschland," in Feilchenfeldt, *"By Appointment Only": Schriften zu Kunst und Kunsthandel; Cézanne und Van Gogh* (Wädenswil: Nimbus, 2005), 129. By contrast, fourteen paintings are listed in Walter Feilchenfeldt, "Les collectionneurs de Cézanne de Zola à Annenberg," *Cézanne,* exh. cat. (Paris: Réunion des musées nationaux, 1995), 575. Bernhard Echte and Walter Feilchenfeldt ultimately clarified that a fourteenth painting was shown at the exhibition but was not included in the catalogue; see *Kunstsalon Bruno & Paul Cassirer: Die Ausstellungen 1898–1901 "Das Beste aus aller Welt zeigen"* (Wädenswil: Nimbus, 2011), 363.

9. H[eilbut], *Kunst und Künstler* 2, no. 9 (June 1909): 378.

10. Bernhard Echte and Walter Feilchenfeldt, *Kunstsalon Paul Cassirer: Die Ausstellungen, 1901–1905 "Man steht da und staunt"* (Wädenswil: Nimbus 2011), 493–520.

11. Hans Rosenhagen, under the heading "Von Ausstellungen und Sammlungen" / "Berlin," *Die Kunst für alle* 19 (May 19, 1904): 401–3.

12. See A. H., "Schule von Pont-Aven," *Die Kunst* 11 (*Freie Kunst*), *Kunst für alle* 20 (September 6, 1904): 46. See also Peter Kropmanns, *Gauguin und die Schule von Pont-Aven in Deutschland nach der Jahrhundertwende* (Sigmaringen: Thorbecke, 1997), 18–24. Among the other artists were Emile Schuffenecker, Edvard Diriks, Antoine Guillaume (Tony) Minartz, and Władysław Ludwig Ślewiński.

13. Echte and Feilchenfeldt, "*Man steht da und staunt,*" 71–88.

14. Ibid., 573–98. The reference recently made by Timothy Benson ("Brücke, French Art and German National Identity," 38) to the tenth exhibition of the Phalanx group of artists in Munich, at which Van Gogh is thought to have been on display in 1904, must also be investigated.

15. Echte and Feilchenfeldt, "*Man steht da und staunt,*" 598.

16. Michael Bringmann, "Die Kunstkritik als Faktor der Ideen- und Geistesgeschichte: Ein Beitrag zum Thema 'Kunst und Öffentlichkeit' im 19. Jahrhundert," in *Kunst, Kultur und Politik im deutschen Kaiserreich,* vol. 3 (Berlin: Mann, 1983), 260.

17. Sigrun Paas, "*Kunst und Künstler,* 1902–1933: Eine Zeitschrift in der Auseinandersetzung um den Impressionismus in Deutschland" (PhD diss., Universität Heidelberg, 1976), 10, 14.

18. Bringmann, "Die Kunstkritik als Faktor der Ideen- und Geistesgeschichte," 266–67.

19. Rüdiger vom Bruch, "Kunst und Kulturkritik in führenden bildungsbürgerlichen Zeitschriften des Kaiserreichs," in *Kunst, Kultur und Politik im deutschen Kaiserreich,* vol. 3 (Berlin: Mann, 1983), 334.

20. Bringmann, "Die Kunstkritik als Faktor der Ideen- und Geistesgeschichte," 255.

21. Paas, "*Kunst und Künstler,*" 19.

22. Nicolaas Teeuwisse, *Vom Salon zur Secession: Berliner Kunstleben zwischen Tradition und Aufbruch zur Moderne, 1871–1900* (Berlin: Deutscher Verlag für Kunstwissenschaft, 1986), 54. See also vom Bruch, "Kunst und Kulturkritik," 344n 90, and Barbara Paul, *Hugo von Tschudi und die moderne französische Kunst im Deutschen Kaiserreich* (Mainz: von Zabern, 1993), esp. 27–33.

23. Paas, "*Kunst und Künstler,*" 38–40.

24. Peter Paret, *Die Berliner Secession: Moderne Kunst und ihre Feinde im Kaiserlichen Deutschland* (Berlin: Severin und Siedler, 1981), 245–47, 253; see also Paas, "*Kunst und Künstler,*" 157–59; Friedrich Eckart, "Die Kunstdebatte im Reichstag," *Grenzboten* 64, no. 1 (1904): 524, quoted in vom Bruch, "Kunst und Kulturkritik," 333.

25. Paret, *Die Berliner Secession,* 255, 257.

26. Arthur Moeller van den Bruck, "Die Ueberschätzung französischer Kunst in Deutschland," *Der Kunstwart* 18, no. 22 (August 1905): 501–8.

27. Paret, *Die Berliner Secession,* 229.

28. On Matisse and his "Notes d'un peintre," see the essay by Claudine Grammont in the present volume.

29. Feilchenfeldt, "*By Appointment Only,*" 56. See also Echte and Feilchenfeldt, "*Man steht da und staunt,*" 687–706.

30. Feilchenfeldt, "*By Appointment Only,*" 56.

31. *Die Kunst-Halle* 10, no. 21 (August 1, 1905), under the heading "Ausstellungen," 331. On the exhibition, see Peter Kropmanns, "The Gauguin Exhibition in Weimar 1905," *The Burlington Magazine* 141, no. 1150 (January 1999), 24–31.

32. Feilchenfeldt, "*By Appointment Only,*" 59. See also Carsten Meyer-Tönnesmann, "Paul Cassirers Hamburger Kunstsalon," in *Berlin SW Victoriastrasse 35: Ernst Barlach und die Klassische Moderne im Kunstsalon und Verlag Paul Cassirer* (Güstrow: Ernst Barlach Stiftung, 2003), 34–46. The Hamburg branch existed, according to Meyer-Tönnesmann, from November 10, 1901, until September 1, 1907.

33. See Ruth Negendanck, *Die Galerie Ernst Arnold (1893–1951): Kunsthandel und Zeitgeschichte* (Weimar: VDG, 1998), 407; *Kunst-Salon Ernst Arnold: Herbst 1905: II. Ausstellung.,* exh. cat. (Dresden: Arnold, 1905) (catalogue numbers 1–50 are listed with no apparent ordering, provide no dimensions, years, or other details, and only sometimes provide a place name, such as Arles, Auvers, Paris, or simply "Provence"); and Walter Stephan Laux, "Die Van Gogh-Ausstellung der Galerie Arnold, Dresden 1905," *Oud Holland* 106, no. 1 (1992): 33–34.

34. Laux, "Die Van Gogh-Ausstellung," 33; Dorothee Hansen and Henrike Holsing, *Vom Klassizismus zum Kubismus: Bestandskatalog der französischen Malerei in der Kunsthalle Bremen* (Munich: Hirmer, 2011), 328–33; and Walter Feilchenfeldt, *Vincent van Gogh & Paul Cassirer, Berlin: The Reception of Van Gogh in Germany from 1901 to 1914,* Cahier Vincent 2 (Amsterdam: Rijksmuseum and Zwolle: Waanders, 1988), 36.

35. Hansen and Holsing, *Vom Klassizismus zum Kubismus,* 311–32. For more on Vinnen's protest, see Timothy O. Benson's essay in this volume.

36. *Kunstchronik: Wochenschrift für Kunst und Kunstgewerbe,* n.s., 17 (1905–6), no. 13 (January 26, 1906): col. 200.

37. Detailed information on this and all of Cassirer's other exhibitions will be contained in Bernhard Echte and Walter Feilchenfeldt, *Kunstsalon Cassirer; Die Ausstellungen, 1905–1910; "Den Sinnen ein magischer Rausch"* (forthcoming).

38. Donald E. Gordon, *Modern Art Exhibitions, 1900–1916* (Munich: Prestel, 1974), under the heading "1906: February 20."

39. Ibid., under the heading "1906: mid-February–mid-April," and Feilchenfeldt, "*By Appointment Only,*" 61.

40. *Kunstchronik: Wochenschrift für Kunst und Kunstgewerbe,* n.s., 17 (1905–6), no. 26 (May 25, 1906): col. 411, and Feilchenfeldt, "*By Appointment Only,*" 61.

41. Kropmanns, *Gauguin und die Schule von Pont-Aven,* 27.

42. Peter Kropmanns, "Rudolf A. Meyer-Riefstahl (1880–1936): Ein vergessener Kunstvermittler," *Sediment: Mitteilungen zur Geschichte des Kunsthandels,* no. 3 (1998): 62–87. On Druet, see the commentary in Kropmanns, *Gauguin und die Schule von Pont-Aven,* 30–31.

43. Shown, according to the catalogue, were: Bernard, Bonnard, Camoin, Cousturier, Cross, Denis, Diriks, Gauguin, Van Gogh, Guérin, Matisse, Laprade, Lebeau, Luce, Manguin, Marquet, Puy, Roussel, Van Rysselberghe, Seurat, Schuffenecker, Signac, Vallotton, Valtat, and Vuillard. According to a review, the paintings came "in part from private owners (Fénéon, Luce, Verhaeren, Schuffenecker, J. Bernheim, and Vollard), in part from the large inventories of the Galerie Druet" (Wilhelm Michel, "Eine Ausstellung französischer Künstler im Münchener Kunstverein," *Zeitschrift für bildende Kunst,* n.s., 18, no. 1 [1906–7], 26). At least in Munich, according to the press, three paintings and a watercolor (?) by Cézanne were added. (*Münchner Neueste Nachrichten,* no. 415 [September 6, 1906], evening edition, 1, stated that the show, which had not previously included Cézanne, was subsequently supplemented with works privately owned in Munich: one *Fruit Still Life,* two large *Portraits of a Woman* and a *Curtain Study.*) Consequently, Wilhelm Michel (see above) has included Cézanne in his list, although Meyer expressly apologizes for the absence of Cézanne in the foreword to the catalogue. An expansion of the exhibition from the 130 works mentioned in the catalogue to 132 works is attested by multiple journalists' articles in different newspapers in the relevant cities.

44. Peter Kropmanns, "Die deutsche Matisse-Premiere: Vor 90 Jahren—München 1906," *Weltkunst* 66, no. 13 (July 1, 1996): 1519–1521. In 1966, Donald E. Gordon sought to characterize this exhibition with the aid of a review; the review, however, is no replacement for the catalogue that Gordon apparently sought in vain. See Donald E. Gordon, "Kirchner in Dresden," *The Art Bulletin* 48, nos. 3–4 (September–December 1966): 341, Paul Fechter, "Die Impressionisten bei Arnold," *Dresdner Neueste Nachrichten,* November 10, 1906, and Wilhelm Michel, "Eine Ausstellung französischer Künstler," 26. In addition, see R.[ichard] S.[tiller], "Die Ausstellung der französischen Maler bei Arnold," *Dresdner Anzeiger,* no. 323 (November 23, 1906), and the unsigned article on the opening at Galerie Arnold, under the headings "Von Ausstellungen und Sammlungen" / "Dresden" / "Galerie Ernst Arnold in Dresden," *Die Kunst* [*Die Kunst für alle* 22], no. 8 (January 3, 1907): 196–97, the latter half of which provided a review of the exhibition.

45. Weimar was originally planned as an additional venue. See Peter Kropmanns, "Matisse in Deutschland" (PhD diss., Humboldt-Universität zu Berlin, 2000).

46. *Katalog der Ausstellung Französischer Kuenstler*, exh. cat. (Paris: Galerie E. Druet, n.d. [1906]).

47. Lucile Manguin and Claude Manguin, eds., *Henri Manguin: Catalogue raisonné de l'oeuvre peint* (Neuchâtel: Ides et Calendes, 1980), cat. nos. 97, 155, 208, 211.

48. Franz Wolter, "Aus dem Münchner Kunstverein," insert to *Die christliche Kunst* 3, no. 4 (January 1, 1907): vi.

49. Duration according to advertisements by the Kunst-Salon Ernst Arnold: *Dresdner Anzeiger*, November 14, 1906, no. 314, and *Dresdner Journal*, November 10, 1906, no. 262. See also the announcement of the exhibition in the *Dresdner Journal*, first insert to no. 256, November 3, 1906.

50. Gordon, *Modern Art Exhibitions, 1900–1916*, under the heading "1906: December."

51. *Kunstchronik: Wochenschrift für Kunst und Kunstgewerbe*, n.s., 18 (1906–7), no. 26 (May 17, 1906): col. 422. The exhibition catalogue, by contrast, mentions only seven works: Gordon, *Modern Art Exhibitions, 1900–1916*, under the heading "1907: 1 May–20 October," cat. nos. 366a–g. Catalogues sometimes appeared in two or more editions; extra works could then be added.

52. Feilchenfeldt, *"By Appointment Only,"* 62.

53. Titia Hoffmeister, "Der Berliner Kunsthändler Paul Cassirer. Seine Verdienste um die Förderung der Künste und um wichtige Erwerbungen der Museen," vol. 2 (PhD diss., Universität Halle, 1991), 24. Walter Feilchenfeldt of the Cassirer Archive in Zürich kindly made available to me a copy of the catalogue.

54. Max Osborn, "'Zukunfts-Kunst' (Zur Ausstellung bei Cassirer)," *National-Zeitung*, no. 489, October 18, 1907, morning edition.

55. Ludwig Pietsch, under the heading "Kunst, Wissenschaft und Literatur," *Vossische Zeitung*, October 18, 1907, third insert.

56. Herta Hesse-Frielinghaus et al., *Karl Ernst Osthaus: Leben und Werk* (Recklinghausen: Bongers, 1971), 512.

57. Anonymous, "Folkwang," *Hagener Zeitung*, no. 301, December 24, 1907: title page.

58. Regarding the loan of six paintings from the exhibition at Cassirer's, see Paul Vogt, *Das Museum Folkwang Essen: Die Geschichte einer Sammlung junger Kunst im Ruhrgebiet* (Cologne: DuMont, 1965), 22. Vogt appears to be drawing on correspondence that is not held by the Osthaus Archive in Hagen and which may have been lost after 1965. See letter from Félix Fénéon, Galerie Bernheim-Jeune & Cie, Paris, to Karl Ernst Osthaus, Hagen, dated October 5, 1907 (copy made by Walter Feilchenfeldt of a document in the Adalbert Colsman Archive, when it was still at the Museum Folkwang, Essen).

59. Postcard from Bernhard Koehler in Berlin to his niece Elisabeth Gerhardt, Macke's future wife, in Bonn, December 6, 1907, quoted in August Macke, *Briefe an Elisabeth und die Freunde*, ed. Werner Frese and Ernst-

Gerhard Güse (Munich: Bruckmann, 1987), 157.

60. Wilhelm Uhde, *Von Bismarck bis Picasso: Erinnerungen und Bekenntnisse* (Zürich: Römerhof, 2010), 165.

61. Camoin was represented by two works: *Au parc* and *Bords du lac*; Dufy by five: *Plage du Havre, Port du Havre, Les ombrelles, Au quai* and *Au port*; Marquet by three: *Port du Havre, Un quai de Paris* and *Côte provençale*; and Puy by five: *La femme à l'ombrelle*, *"Le hamac,"* *La couseuse, La femme allongé*, and *La forêt*.

62. Herbin was represented by eleven works: three *Still Lifes, Evisa, Route d'Evisa, Châtaigniers d'Evisa, Quai vert à Bruges, Barques sur le vieux port de Bastia, Evisa le matin, Plage en Belgique*, and *Corté le matin*.

63. *Die Galerie Eduard Schulte beehrt sich zum Besuch der Dezember-Ausstellung vom 8. Dezbr. 1907 ab ergebenst einzuladen / Berlin NW, Unter d. Linden 75/76*, exh. cat. (Berlin: Galerie Eduard Schulte, 1907).

64. *Die Kunst für alle* 23 (January 2, 1908): 181.

65. Gordon, *Modern Art Exhibitions, 1900–1916*, under the heading "December."

66. At least two copies of the catalogue exist. The copy held by the Paul Cassirer Archive in Zürich lists: "Cat. no. 254–259: 6 drawings, each 80,—marks; cat. no. 260–261: 2 drawings, each 120,—marks." The copy held by the library of the Nationalgalerie, Berlin, refers in addition to: "Cat. no. 262–266: 5 lithographs, each 20,—marks." The lengthy review in *Berliner Börsen-Courier* no. 587 (December 15, 1907, morning edition, 3) does not mention Matisse.

67. Undated letter from Edward Steichen, Paris, to Alfred Stieglitz, New York [January 1908], quoted in Alfred H. Barr Jr., *Matisse: His Art and His Public* (New York: Museum of Modern Art, 1951), 112 and 113.

68. Ibid., 97.

69. Ibid., 98.

70. Marit Werenskiold, "Die Brücke und Edvard Munch," *Zeitschrift des deutschen Vereins für Kunstwissenschaft* 28 (1974): 151n11; see also Marit Werenskiold, *The Concept of Expressionism: Origin and Metamorphoses* (Oslo: Universitetsforlaget, 1984), esp. 40.

71. Kropmanns, "Gauguin in Deutschland" (see note 6), 253; Feilchenfeldt, *"By Appointment Only"* (reprint of his publication from 1988), 50.

72. Feilchenfeldt, *"By Appointment Only,"* 63.

73. *Kunstchronik: Wochenschrift für Kunst und Kunstgewerbe* 19 (1907–8), no. 16 (February 21, 1908): col. 315.

74. See Kropmanns, *Gauguin und die Schule von Pont-Aven*, 40, and Feilchenfeldt, *"By Appointment Only,"* 64.

75. Kropmanns, *Gauguin und die Schule von Pont-Aven*, 40.

76. Wilhelm Michel, "Münchener Bilderfrühling," *Kunstchronik: Wochenschrift für Kunst und Kunstgewerbe*, no. 25 (May 8, 1908): col. 420.

77. *Vincent van Gogh / Paul Cézanne: Kunstausstellung Emil Richter / Dresden, April–Mai 1908*, exh. cat. (Dresden: Emil Richter, 1908). The Nuenen period of 1883–85 was represented with cat. nos. 1–2; cat. nos. 3–27 covered Paris 1886–88; cat. nos. 28–44 Arles; cat. nos. 45–60

Saint-Rémy-en-Provence; and cat. nos. 61–75 Auvers-sur-Oise. All of the works were paintings, as can be inferred from the list of drawings that followed.

78. Feilchenfeldt, *"By Appointment Only,"* 65.

79. Ibid., 143.

80. Ibid., 65.

81. Gordon, *Modern Art Exhibitions, 1900–1916*, under the heading "1908: Spring."

82. No catalogue has been located to date; the list of persons exhibiting is derived from information in the *Dresdner Journal*, first insert to no. 213, September 12, 1908, as well as the first insert to no. 219, September 19, 1908, and appears to be complete.

83. Richard Stiller, "Emil Richters Kunstsalon," *Dresdner Anzeiger*, September 19, 1908.

84. Paul Fechter, "Kunstsalon Richter," *Dresdner Neueste Nachrichten*, September 17, 1908. See Gordon, "Kirchner in Dresden," 335–36, 345n63, 346; Donald E. Gordon (see note 44), *Ernst Ludwig Kirchner* (Cambridge, MA: Harvard University Press, 1968), 56 and 461–62nn34, 38.

85. *Kunstchronik: Wochenschrift für Kunst und Kunstgewerbe* 20, no. 4 (October 30, 1908): col. 59. Cassirer showed "Oranges and Lemons" by Matisse, a painting that has not been identified. In their winter graphic arts show, the Secession presented a "Landscape Drawing" by Matisse.

86. The exhibition, of which it was long said that it was taken down after a few days, is documented at length in Kropmanns, "Matisse in Deutschland," 101–34.

87. Max Beckmann, *Leben in Berlin: Tagebuch, 1908–1909*, ed. Hans Kinkel (Munich: Piper, 1983), 18.

88. Lucius Grisebach, *Ernst Ludwig Kirchner, 1880–1938* (Cologne: Taschen, 1995), 29. In addition to this card, a series of additional postcards are extant in which Kirchner expressed his views on Matisse by "copying" works by the Frenchman. See Gordon, "Kirchner in Dresden," (see note 44), 348n82, and Annemarie Dube-Heynig, *E. L. Kirchner: Postkarten und Briefe an Erich Heckel im Altonaer Museum in Hamburg*, ed. Roman Ketterer with Wolfgang Henze (Cologne: DuMont, 1984), 10 (January 12, 1909), 42 (November 16, 1909), 107 (May 20, 1910) and 111 (March 31, 1910).

89. Werenskiold, *The Concept of Expressionism*, 174n24.

90. Gordon, *Modern Art Exhibitions, 1900–1916*, under the heading "1909: 11 April."

91. Günter Aust, "Sammlungen und Ausstellungen in Elberfeld und Barmen" / "Städtisches Museum Elberfeld," *Der westdeutsche Impuls, 1900–1914: Kunst und Umweltgestaltung im Industriegebiet; Stadtentwicklung. Sammlungen. Ausstellungen*, exh. cat. (Wuppertal: Von-der-Heydt-Museum, 1984), 102.

92. Gordon, *Modern Art Exhibitions, 1900–1916*, under the heading "1909, 4 August."

93. Feilchenfeldt, *"By Appointment Only,"* 144.

94. Gordon, *Modern Art Exhibitions, 1900–1916*, under the heading "1909,

?October"; *Kunstchronik: Wochenschrift für Kunst und Kunstgewerbe* 21 (1909–10), nos. 10 and 11 (December 24, 1909): col. 158–59.

95. Gordon, *Modern Art Exhibitions, 1900–1916*, under the heading "27 November."

96. Paret, *Die Berliner Secession* (see note 24), 249.

97. Ibid., 167, 190–91, 221; Teeuwisse, *Vom Salon zur Secession* (see note 22), 152–53.

98. Feilchenfeldt, *Vincent van Gogh & Paul Cassirer* (see note 34), under the heading "Exhibitions," 144–48.

99. Feilchenfeldt, *"By Appointment Only,"* 47 (reprint of his publication from 1988).

100. Fritz Bleyl, "Erinnerungen" (1948), *Fritz Bleyl 1880–1966, Brücke-Archiv* 18/1993, ed. Magdalena M. Moeller (Berlin: Brücke-Museum, 1993), 214. Bleyl was referring to the Third German Arts and Crafts Exhibition that took place in Dresden in the summer of 1906. Galerie Druet also advertised in Dresden in November of 1906 by showing reproductions of works by the artists of the gallery. See Kropmanns, *Gauguin und die Schule von Pont-Aven*, 30–31.

101. Laux, "Die Van Gogh-Ausstellung," 33. For their valuable assistance in references to the literature, my grateful thanks to Marie El Caïdi, Musée départemental Maurice Denis, Saint-Germain-en-Laye; Britta Matthies, Hohen Viecheln; Carsten Meyer-Tönnesmann, Hamburg; Katia Poletti, Fondation Félix Vallotton, Lausanne; Heike Sütterlin and Janine Klemm, Sächsische Landesbibliothek, Staats- und Universitätsbibliothek Dresden.

Plates

Paul Klee
Untitled (*Spatial Architecture, Tunisia*), 1915
plate 97 | cat. 129

Paul Klee
Landscape in a Rainy Mood, 1913
plate 98 | cat. 127

Paul Klee
Soaring Vision of a Town, 1915
plate 99 | cat. 128

Maximilien Luce
The Pile Drivers / The Pavers, 1902–3
plate 100 | cat. 131

August Macke
Nude, c. 1910
plate 101 | cat. 132

August Macke
Landscape with Cows and Camel, 1914
plate 102 | cat. 134

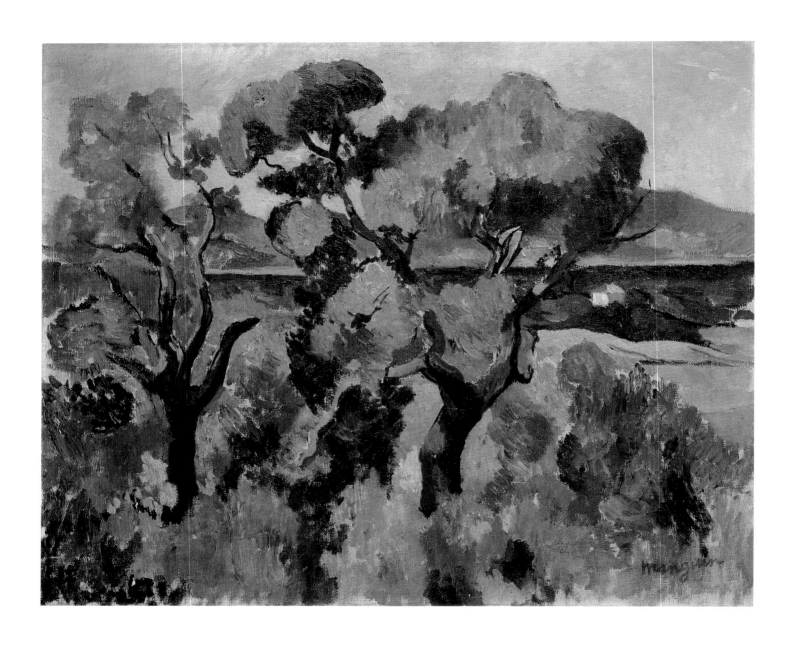

Henri Manguin
The Mistral, 1905
plate 103 | cat. 136

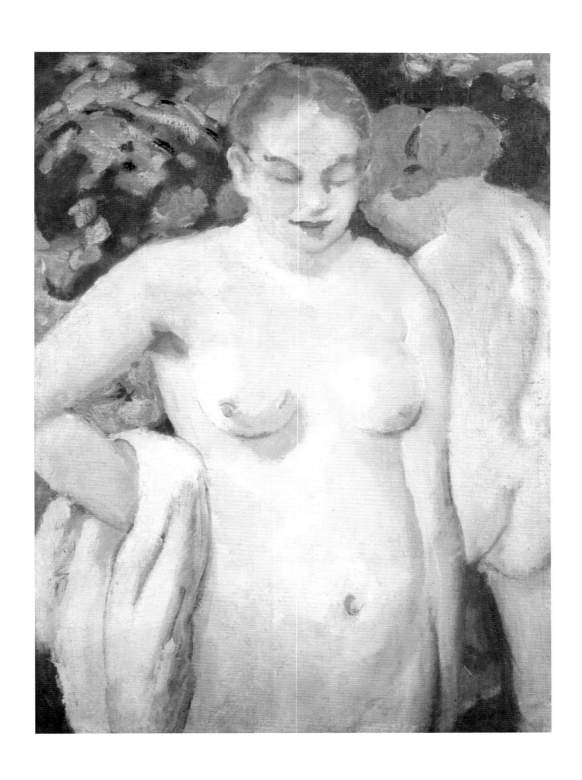

Franz Marc
Sketch, Nude on Vermilion, 1909–10
plate 104 | cat. 138

Franz Marc
Stables, 1913
plate 105 | cat. 141

Franz Marc
Stony Path (*Mountains/Landscape*), 1911
(repainted 1912)
plate 106 | cat. 139

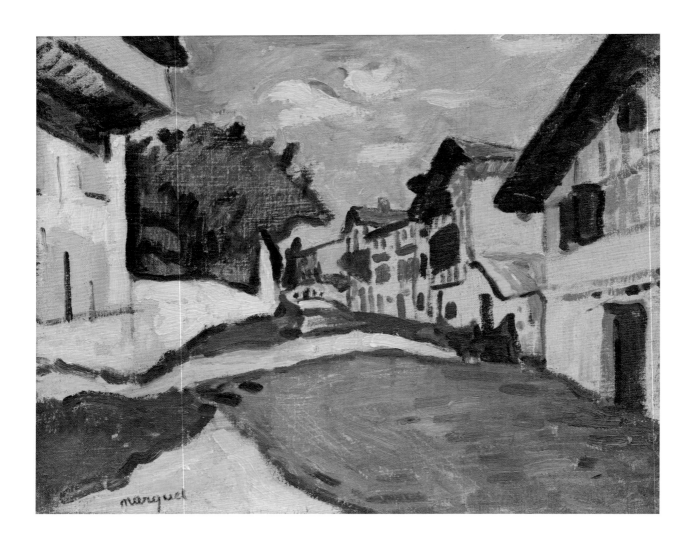

Albert Marquet
Sunny Street in Ciboure, near Saint-Jean-de-Luz, 1907
plate 107 | cat. 145

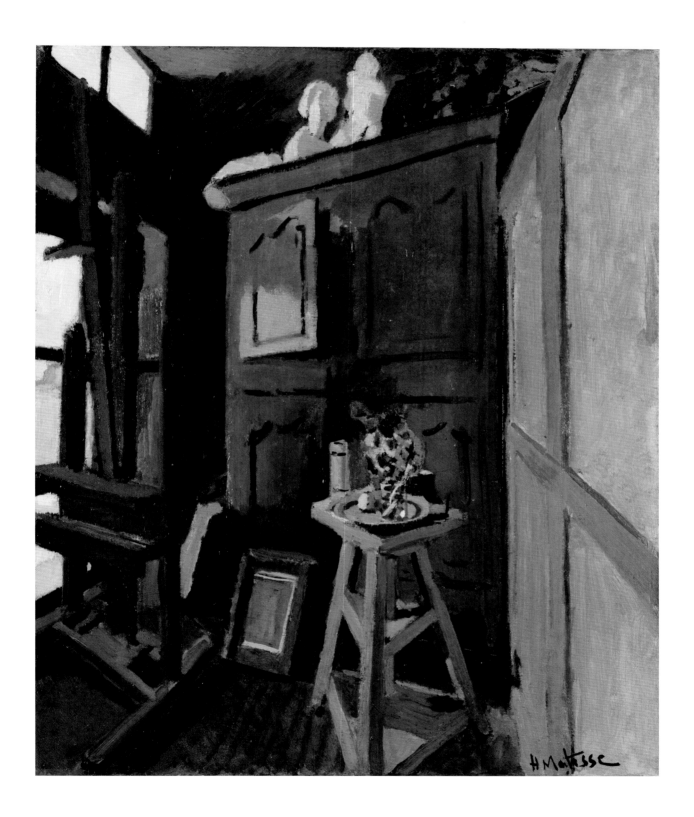

Henri Matisse
Studio Interior, c. 1903–4
plate 108 | cat. 148

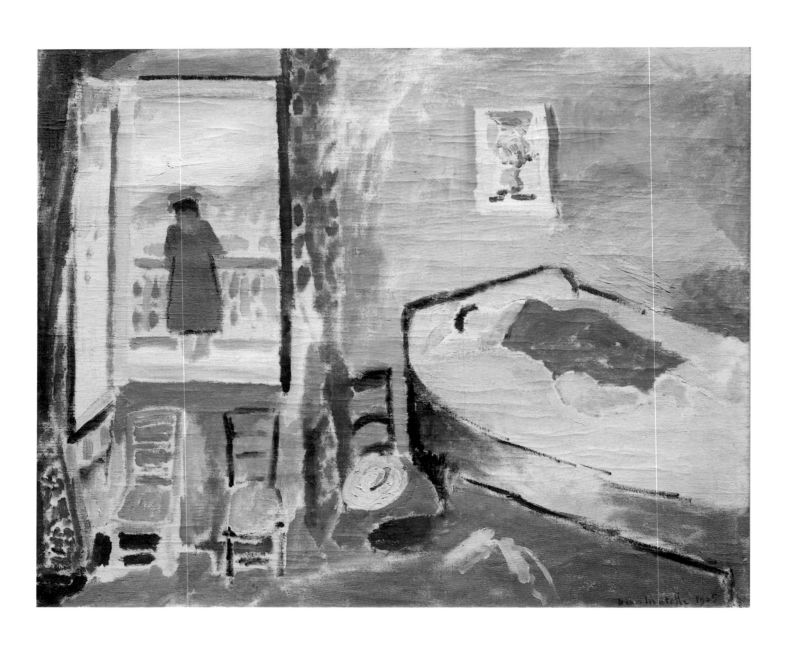

Henri Matisse
Interior at Collioure (*The Siesta*), 1905
plate 109 | cat. 149

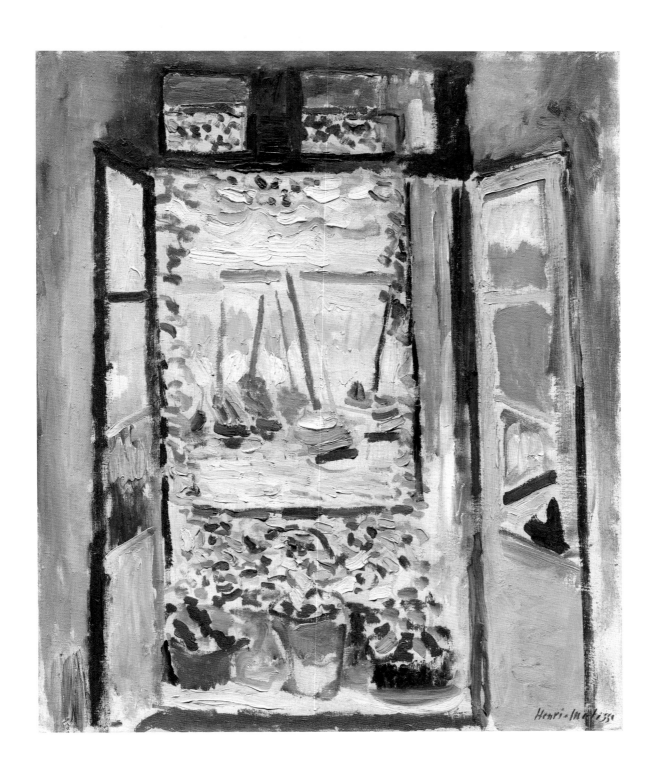

Henri Matisse
Open Window, Collioure, 1905
plate 110 | cat. 150

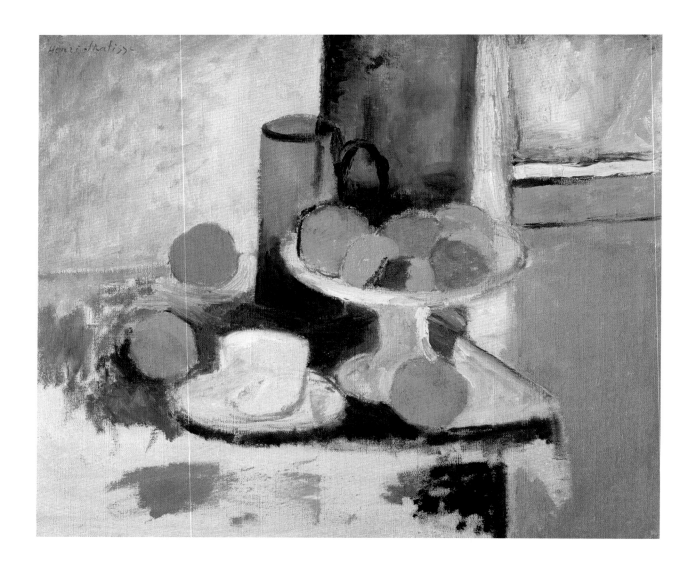

Henri Matisse
Still Life with Oranges II, c. 1899
plate 111 | cat. 146

Henri Matisse
Red Rugs (Still Life with a Red Rug), 1906
plate 112 | cat. 153

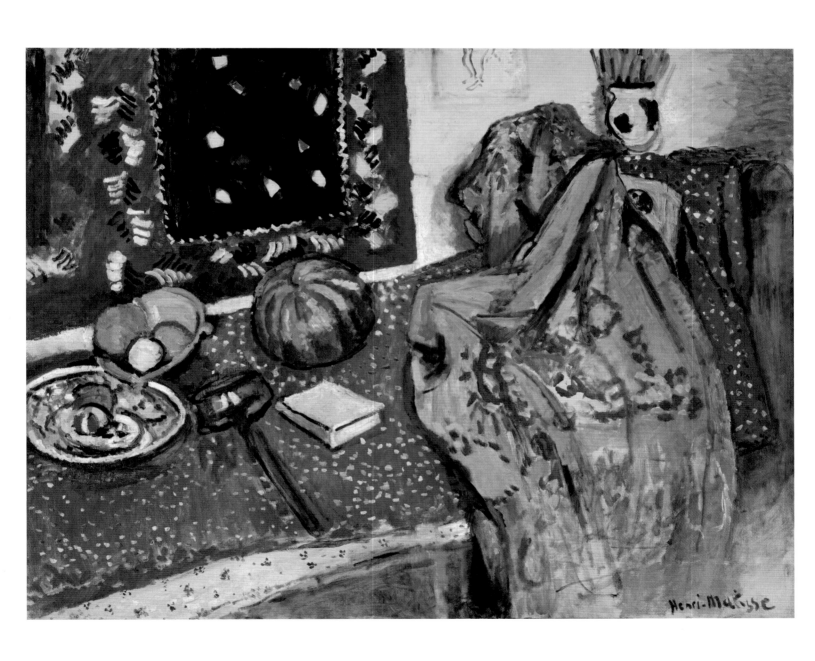

Henri Matisse
Nude with Black Hair in Profile, 1906
plate 113 | cat. 152

opposite, top:
Henri Matisse
Seated Nude Asleep, 1906
plate 114 | cat. 159

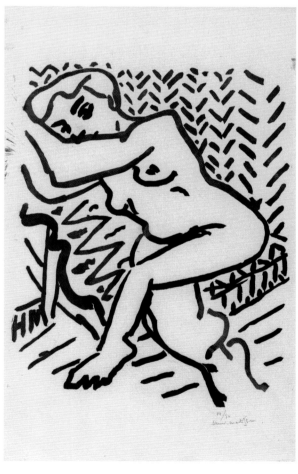

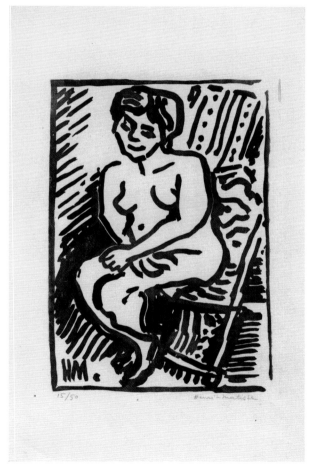

Henri Matisse
Seated Nude, 1906
plate 115 | cat. 157

Henri Matisse
Seated Nude, 1906
plate 116 | cat. 154

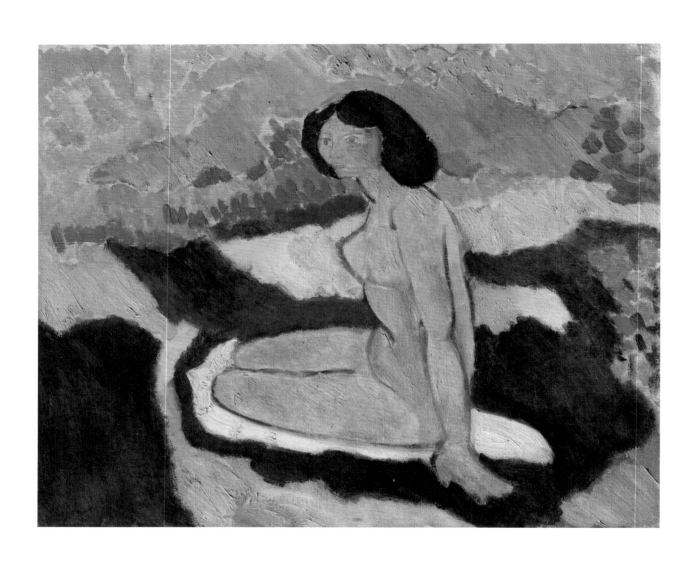

Henri Matisse
Pink Nude (*Seated Nude*), 1909
plate 117 | cat. 161

Henri Matisse
Nude Study in Blue, c. 1899–1900
plate 118 | cat. 147

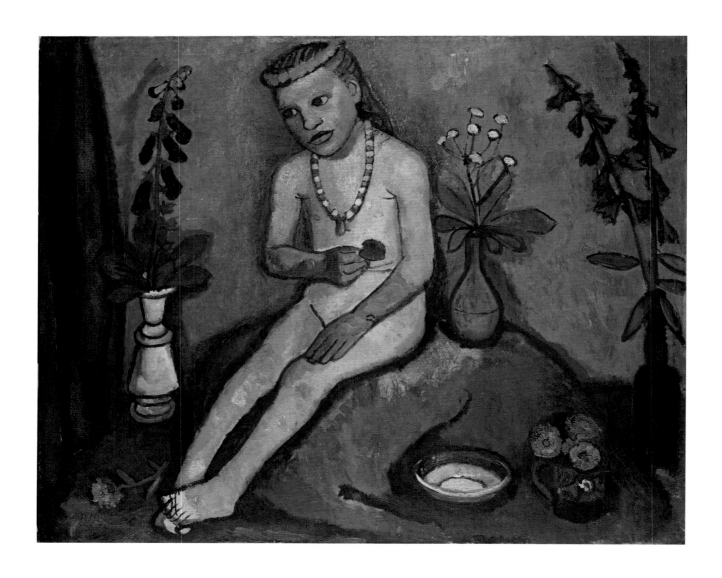

Paula Modersohn-Becker
Girl with Flower Vases, c. 1907
plate 119 | cat. 162

Gabriele Münter
Wooden Doll, 1909
plate 120 | cat. 164

Emil Nolde
Blue Sea, c. 1914
plate 121 | cat. 167

Emil Nolde
Ship in Dock, 1910
plate 122 | cat. 166

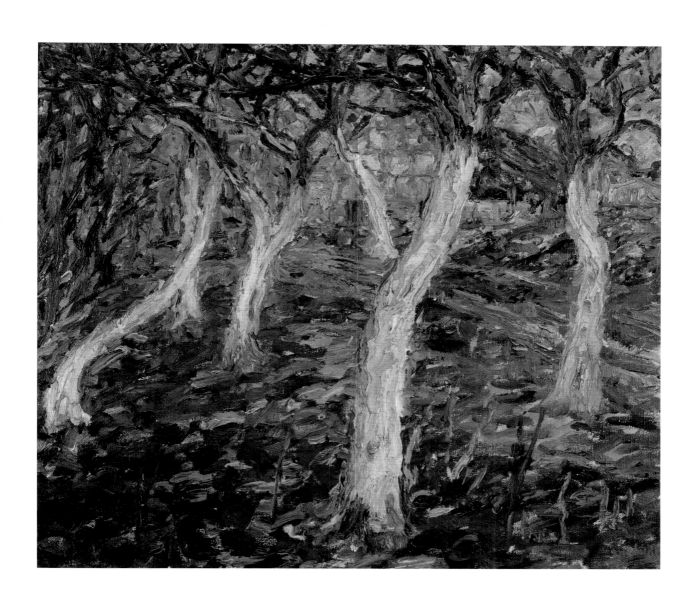

Emil Nolde
The White Tree Trunks, 1908
plate 123 | cat. 165

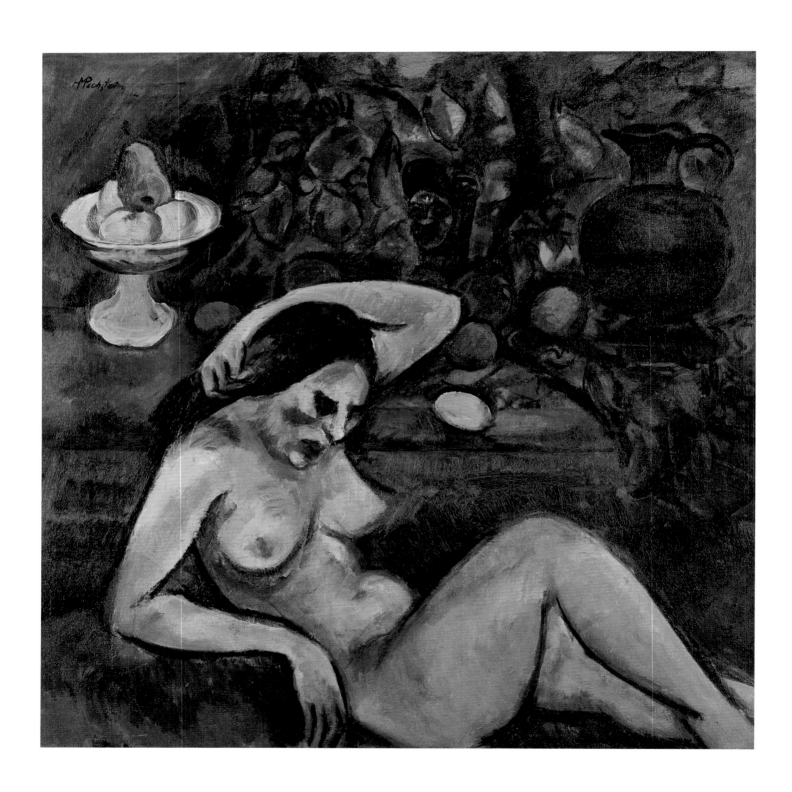

Max Pechstein
Magdalena: Still Life with Nude, 1912
plate 124 | cat. 175

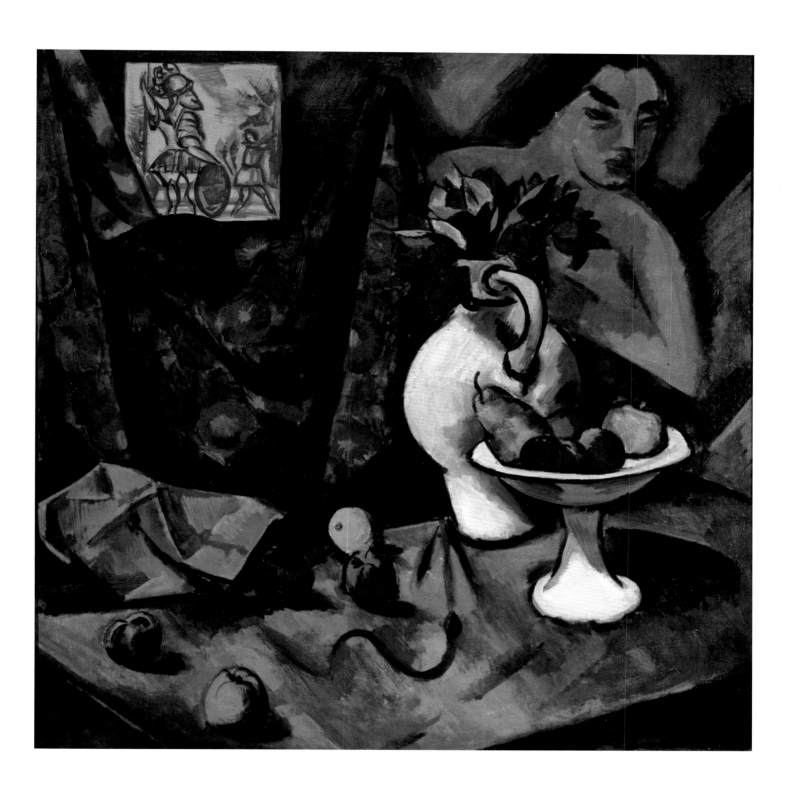

Max Pechstein
Still Life with Nude, Tile, and Fruit, 1913
plate 125 | cat. 176

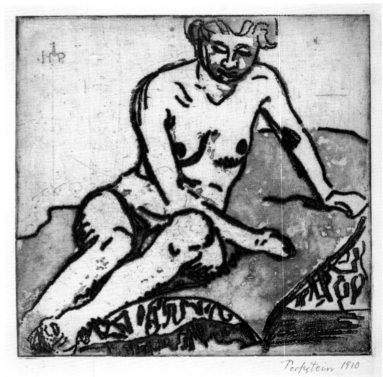

Max Pechstein
Our Lady, 1907
plate 126 | cat. 168

Max Pechstein
Woman on a Sofa, 1908
plate 127 | cat. 169

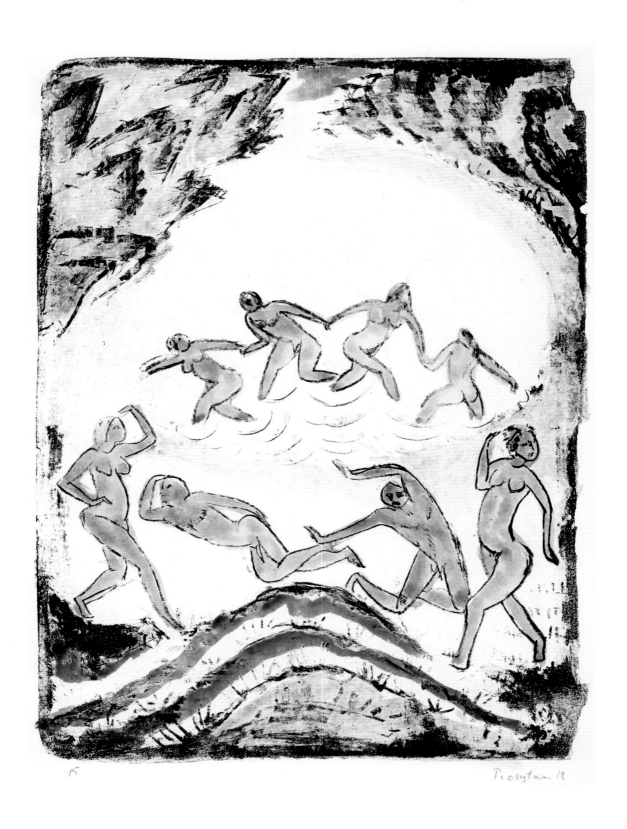

15

Peчstein 12

Max Pechstein
Dancers and Bathers at a Forest Pond, 1912
plate 128 | cat. 174

Max Pechstein
Beach at Nidden, 1911
plate 129 | cat. 173

Max Pechstein
Bathers, 1911
plate 130 | cat. 172

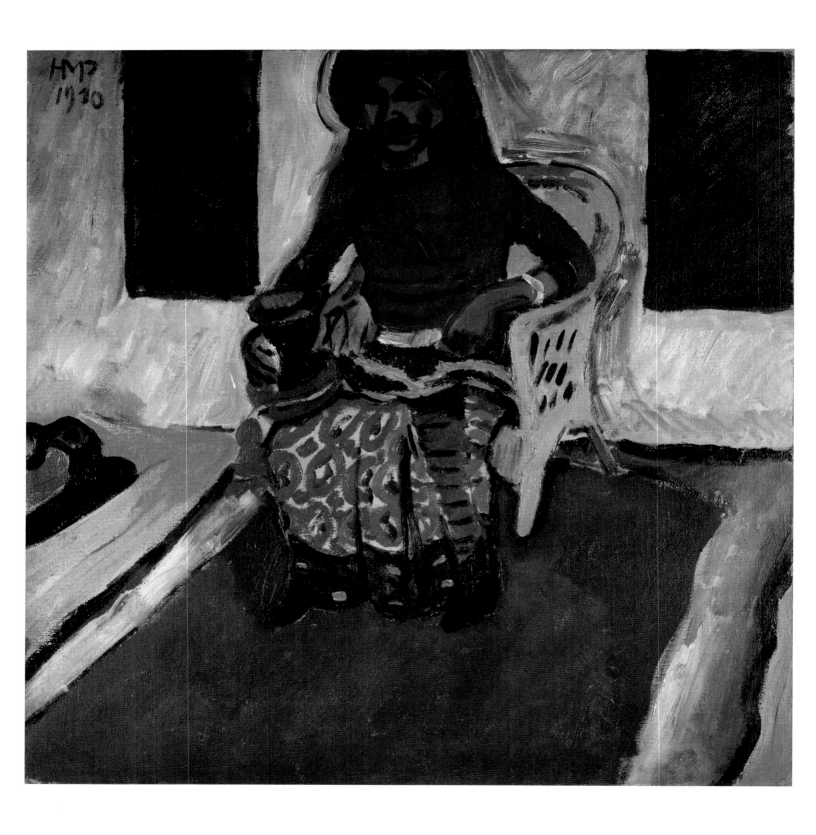

212

Max Pechstein
The Big Indian, 1910
plate 131 | cat. 171

Max Pechstein
Young Girl, 1908
plate 132 | cat. 170

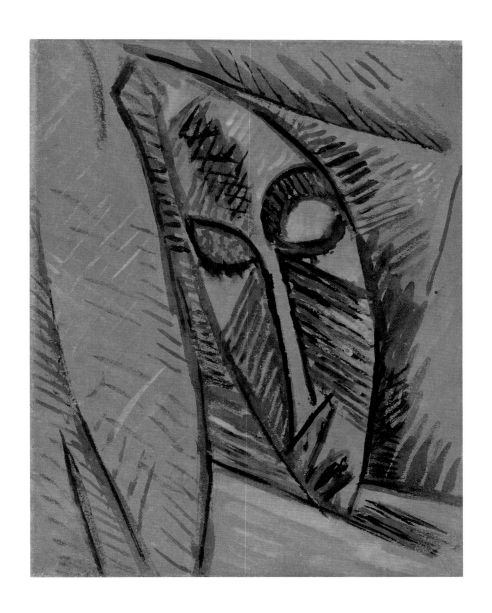

Pablo Picasso
Study for the Head of "Nude with Drapery," 1907
plate 133 | cat. 177

Christian Rohlfs
Birch Forest, 1907
plate 134 | cat. 178

Christian Rohlfs
Nude, 1911
plate 135 | cat. 179

Henri Rousseau
Malakoff, the Telegraph Poles, 1908
plate 136 | cat. 183

Henri Rousseau
The Wedding, 1904–5
plate 137 | cat. 181

Théo van Rysselberghe
Beach at Low Tide, Ambleteuse, Evening, 1900
plate 138 | cat. 184

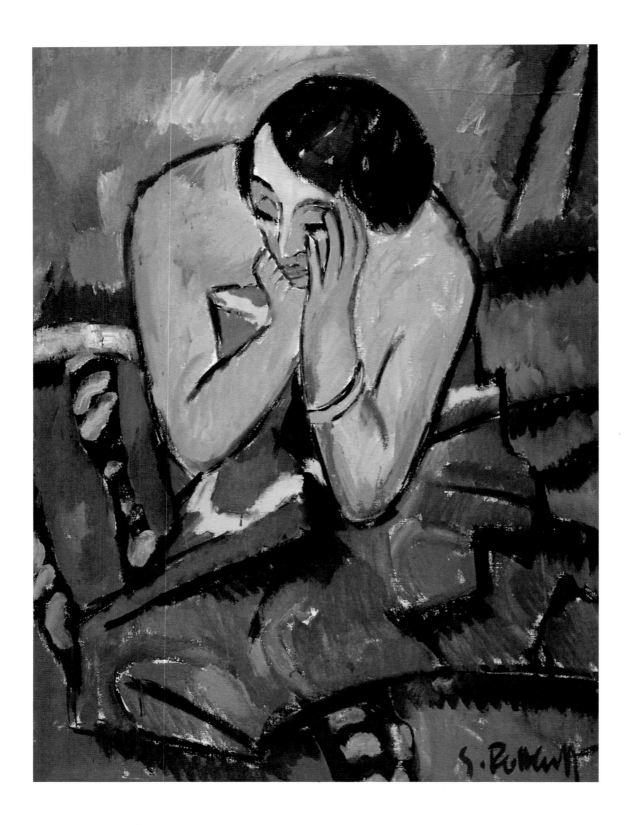

Karl Schmidt-Rottluff
Reflective Woman, 1912
plate 139 | cat. 188

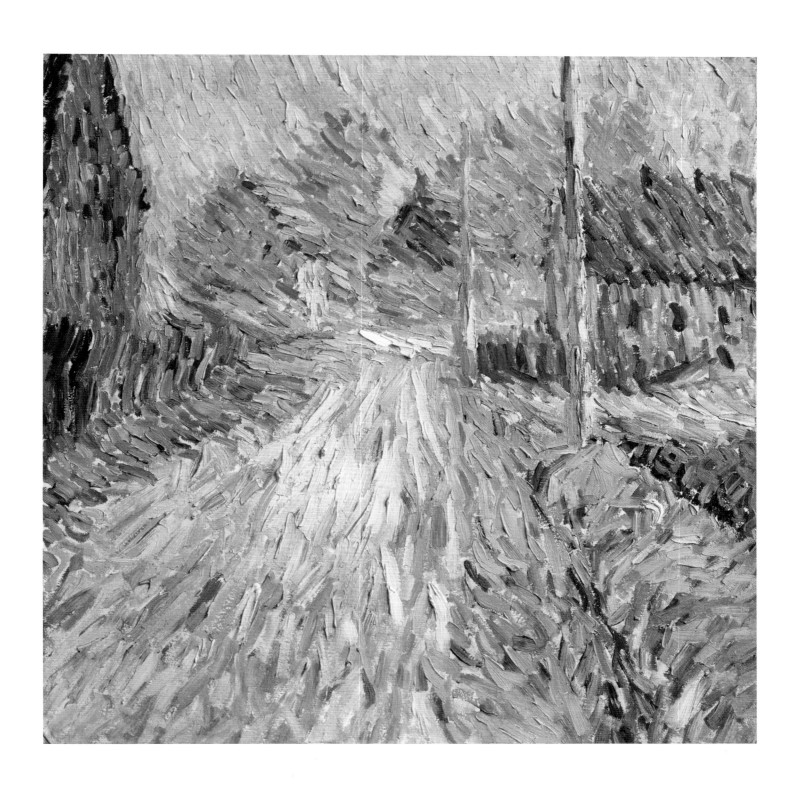

Karl Schmidt-Rottluff
Gartenstrasse Early in the Morning, c. 1906
plate 140 | cat. 185

Karl Schmidt-Rottluff
The Broken Dike, 1910
plate 141 | cat. 186

Paul Signac
Application of Mr. Charles Henry's Chromatic Circle, 1888
plate 142 | cat. 190

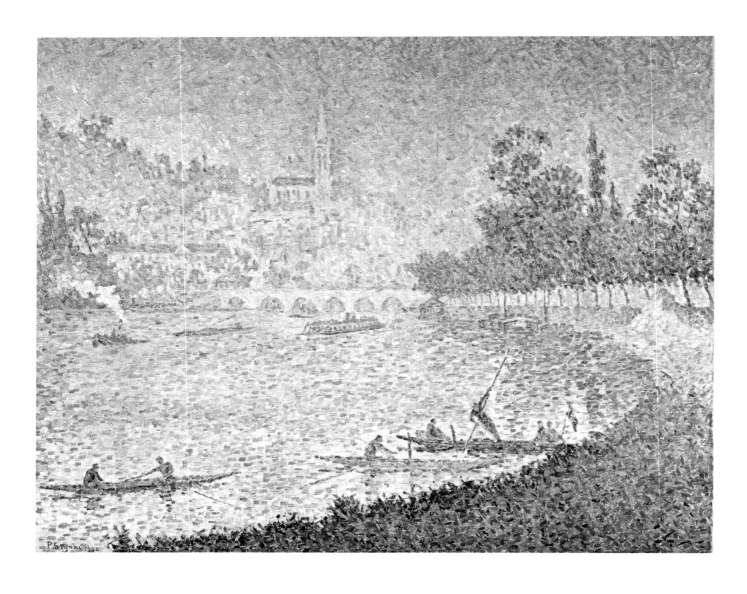

Paul Signac
Saint-Cloud, 1900
plate 143 | cat. 192

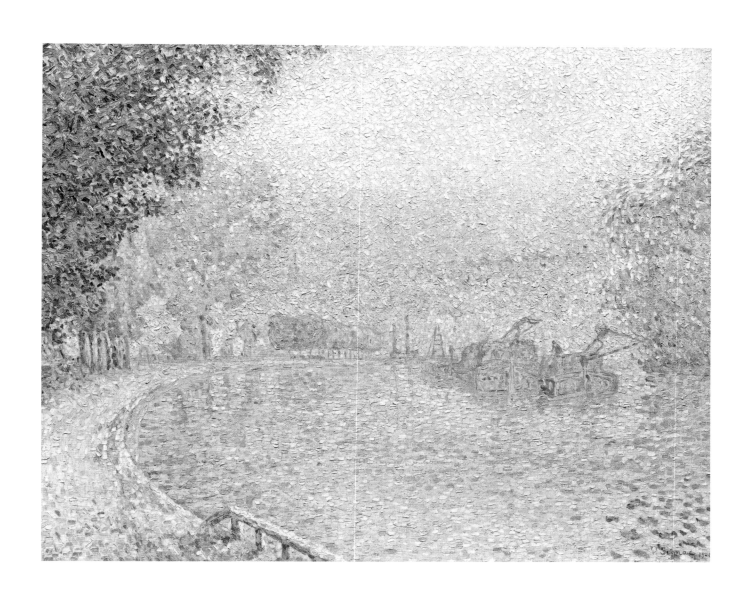

Paul Signac
Samois, the Bank, Morning, 1901
plate 144 | cat. 193

Félix Vallotton
Laziness, 1896
plate 145 | cat. 196

top:
Louis Valtat
Women, No. 5, 1903–5
plate 146 | cat. 201

bottom:
Louis Valtat
Women, No. 1, 1903–5
plate 147 | cat. 198

Maurice de Vlaminck
Houses and Trees, 1907–8
plate 148 | cat. 205

Maurice de Vlaminck
The Seine and Le Pecq, 1906
plate 149 | cat. 204

Maurice de Vlaminck
The Farmer, 1905
plate 150 | cat. 202

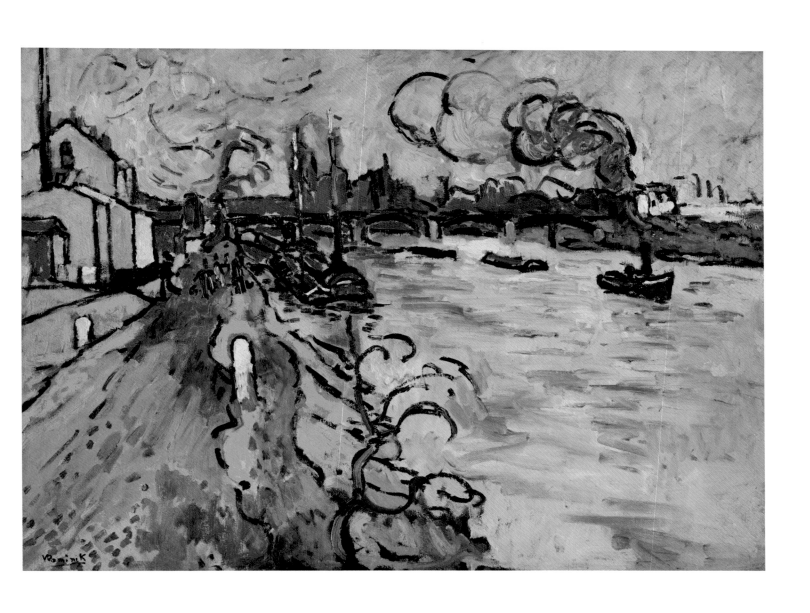

Maurice de Vlaminck
The Seine at Le Pecq, 1905
plate 151 | cat. 203

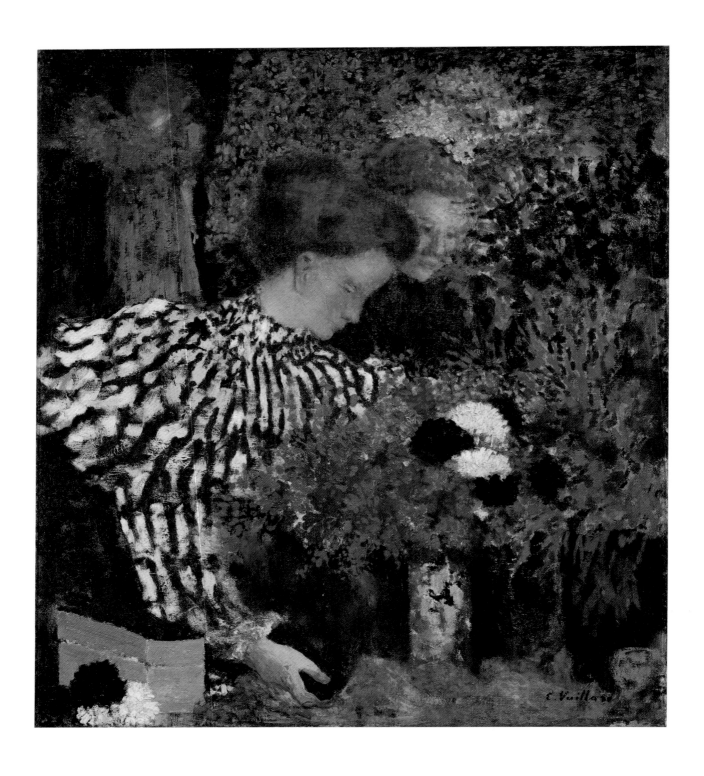

Edouard Vuillard
Woman in a Striped Dress, 1895
plate 152 | cat. 206

Edouard Vuillard
A Walk in the Vineyard, c. 1897–99
plate 153 | cat. 207

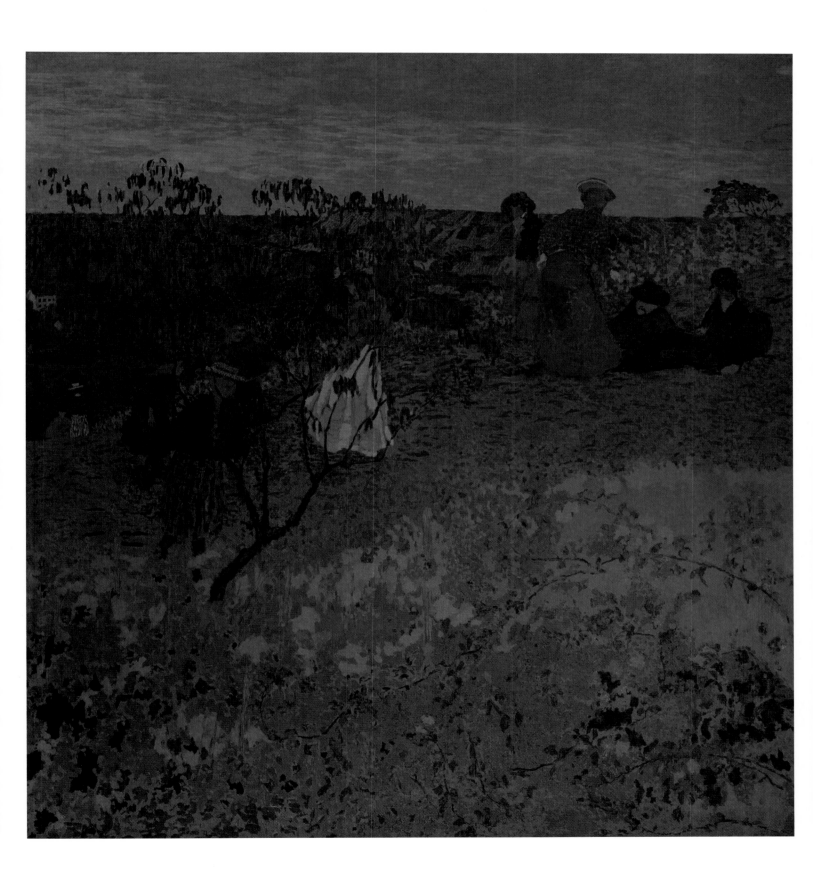

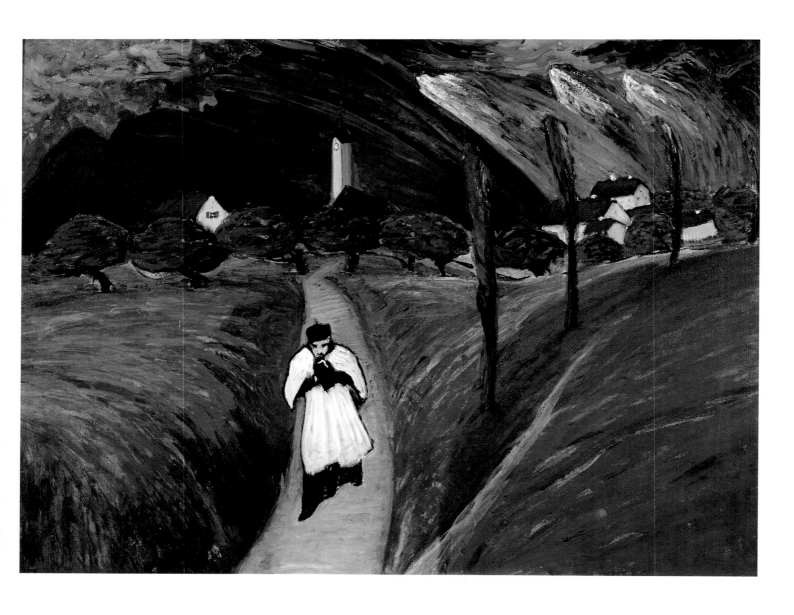

Marianne Werefkin
Corpus Christi, 1911
plate 154 | cat. 209

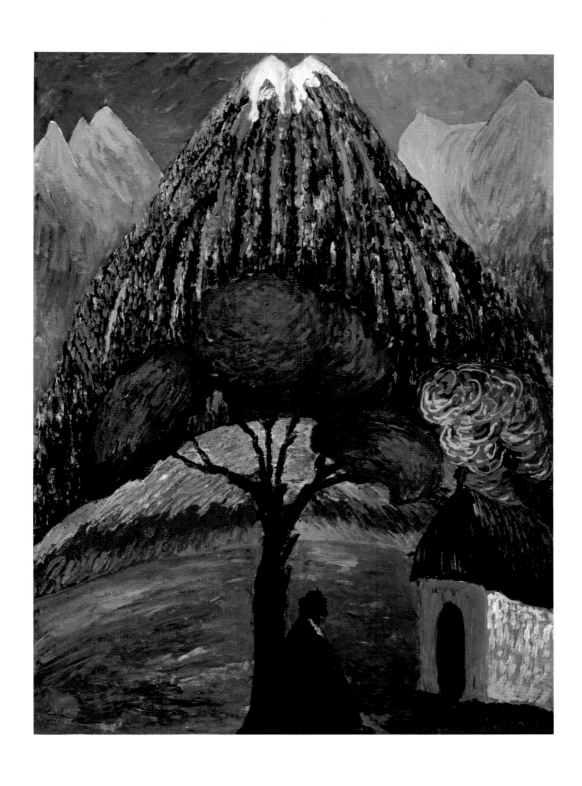

Marianne Werefkin
The Red Tree, 1910
plate 155 | cat. 208

MAGDALENA M. MOELLER

The Brücke
and the Fauves

THE FAUVES and the Brücke artists developed similar stylistic features in their art, albeit during different periods. Although the Fauves can be described more as a loose alliance and not a concrete artists' association like the Brücke with a definable date for its founding and a program, both groups were nevertheless homogeneous in a sense, with comparable goals shared by the individual artists. Both wanted to grasp the world in a subjective way with a previously unknown freedom with respect to reality. That is to say, both groups of artists turned their backs on official, academic painting and broke with the past in order to create something different and new. They sought an expression of reality that was more independent, in terms of both form and color.

The initial points of orientation were the same for the Fauves and the Brücke artists: Impressionism, Pointillism, the Nabis, Van Gogh, and Gauguin, whereas Jugendstil was also crucial for the Brücke. Fauvism and Expressionism took up innovations from the second half of the nineteenth century. Impressionism was esteemed by the Fauves because it had liberated art from the constraints of the academy. But they wanted more: they did not want to break up objects in light, but rather to create pictures that reflected their own emotions. They strove for emotional sensitivity, for expressing inner feelings. Moreover, they had to free themselves of common conventions for both color and form. They created a world from a personal perspective. The Fauves painted in order to express something, not to depict something. That was their revolutionary approach.

From March 15 to March 31, 1901, the first large exhibition of Van Gogh's work, including seventy-one paintings, was held in Paris at the Galerie Bernheim-Jeune, organized by Julien Leclercq.[1] For Henri Matisse and his friends, this retrospective was a revelation, even though Matisse had seen works by Van Gogh as early as 1896. This time, however, the encounter came at the right time. Not only Van Gogh's colors but, above all, the vitality of his painting, the dynamic quality of expression, and the rhythm of the planes were crucial stimuli.

Equally significant for the Fauves in developing their style was Seurat's Pointillism, whose theories were disseminated widely in Paul Signac's 1899 book *D'Eugène Delacroix au néo-impressionnisme* (From Eugène Delacroix to Neo-Impressionism). The Fauves relaxed Seurat's rigid system and combined it with the intensity of Van Gogh's visual language. Their work from 1904 to 1906 shows them coming to terms with Seurat and

Pointillism. In the summer of 1904 Matisse visited Signac in Saint Tropez; the following summer, which Matisse and Derain spent in Collioure, a small fishing village at the base of the Pyrenees, was of decisive significance. The works they produced there reveal their newfound freedom in their approach to style. Color and color chords become dynamic space and light. Traditional perspective was abandoned. This stay in Collioure can be considered the true birth of Fauvism. In 1929, as Matisse put it in his frequently quoted observation: "Fauvism overthrew the tyranny of Divisionism. One cannot live in a house that is too well kept, a house tended by country aunts. One has to go off into the jungle."[2] He now abandoned entirely the forced Neo-Impressionist painting style that resulted from his encounter with Signac.

It should not be forgotten that Paul Gauguin's work was another source of inspiration for the refinement of the Fauvist style. Ambroise Vollard held a Gauguin exhibition at his gallery in Paris as early as 1903. The first Salon d'Automne, also held that year and at which Matisse also exhibited, presented a memorial exhibition to Gauguin, who had died in May. It was the first opportunity to get a comprehensive picture of Gauguin's work. In 1906 another Gauguin retrospective was held at the Salon d'Automne, in which his sculptures were exhibited for the first time. Gauguin, who had been recognized by contemporaries as a pioneer of modernism, revealed in his works the possibilities of the use of planar elements and the significance of the line and the arabesque in parallel with color to intensify expression. This reduction of existing reality to planes and lines—that is, capturing it as a totality without taking details into account—was Gauguin's message.

The same year in which the Fauves had their breakthrough and a *succès de scandale*—thirty-nine of their works were exhibited at the 1905 Salon d'Automne, an event that led critic Louis Vauxcelles to coin the term *Fauves* ("wild beasts")—four architecture students in Dresden formed the artists' group the Brücke. It was founded on June 7, 1905, by Ernst Ludwig Kirchner, Fritz Bleyl, Erich Heckel, and Karl Schmidt. Kirchner and Bleyl had recently completed their studies and received their degrees; Heckel and Schmidt—who called himself Schmidt-Rottluff, after his place of birth—quit their studies shortly thereafter to work exclusively as freelance artists like the other two.

With the uncontrolled passion of beginning unburdened by academia, the Brücke responded to artists and artistic styles that were modern and contrasted

with official painting. "It was clear to us what we had to get away from; where we would arrive, however, was much less certain" was one characteristic statement by Heckel.[3] Kirchner, too, spoke of a "lack of tradition," of rejecting every rule of classical art. Initially, the works of the young Brücke artists reflected a juxtaposition of Jugendstil, Symbolism, and Japonisme. From the outset, however, a vitalistic style and desire for expression, as well as a new attitude toward life characterized by the idea of a new beginning, were all crucial to them. This is the context in which the Brücke program was formulated, and which was distributed as a handbill printed from a woodcut carved by Kirchner in 1906: "With faith in development, in a new generation of both artists and appreciators of art, we appeal to all young people. And as young people, who will be responsible for the future, we want to create freedom to move and live vis-à-vis older, well-established forces. Everyone who renders in a direct and undistorted way that which compels him to create is one of us." Here is a will that is independent of style, but also an outsider's view that no longer conforms to the general conception of art—a Nietzschean protest against the hollowness and hypocrisy of bourgeois culture. They saw themselves as overcoming the art of the Wilhelmine era. Freed from academic rules, the Brücke artists regarded the "direct and undistorted" urge to create as the most important artistic impulse.

The Brücke sought like-minded artists in order to become more effective. In February 1906 Emil Nolde joined the group, at the suggestion of Schmidt-Rottluff. That same year Max Pechstein and Swiss painter Cuno Amiet, who was influenced by Van Gogh, also joined. Pechstein later said of his membership: "Happily we discovered complete harmony in the urge for liberation, in art that plunged forward unhampered by convention."[4] In 1907 Finnish artist Akseli Gallen-Kallela briefly became a member,[5] and in 1908 Kees van Dongen, whom Pechstein had met in Paris, joined for a time.

In their early phase the Brücke artists had a number of opportunities to see modern art, especially French art, and to supplement this information in crucial ways from a variety of current art journals. At the time Dresden was one of Germany's leading artistic centers and a venue for important traveling exhibitions, including the Sächsischer Kunstverein (Saxon Art Society), which showed contemporary art, as well as Galerie Arnold, which specialized in modern French artists (among others), and Galerie Richter, which also presented the latest art movements.

Moreover, Berlin, the capital of the empire, was within easy reach.

From October 28 to November 11, 1905, Galerie Arnold brought a traveling exhibition with fifty paintings by Van Gogh to Dresden. It was the first opportunity for the Brücke artists to see originals by the Dutch painter. As had happened four years earlier with the Fauves, this encounter with the work of Van Gogh was a revelation for the Brücke. As the architect and teacher Fritz Schumacher later wrote, his former students "went wild."[6] Tossing Jugendstil and Japonisme overboard, they switched to an intense expression that from now on would be characteristic of their painting in particular but is also found in their drawings, watercolors, and prints. Like the Fauves, the Brücke artists had to pass through Van Gogh to find themselves. Subjective emotion now became their visual subject matter. Exterior and interior worlds fused into a synthesis. Van Gogh offered these young artists the vitalistic form of expression for which they had instinctively been searching. They produced paintings such as Heckel's *Seated Child* and *Marshland*[7] as well as significant drawings such as *Landscape at Dangast* (plate 64). Such works can only be described as decidedly bold. Heckel squeezed the oil paint directly onto the canvas from the tube and then worked it with the brush. Colors and forms swirl over the painting. Kirchner, Schmidt-Rottluff, and Pechstein worked in similar ways. Kirchner's *Girl on a Divan* offers a good example, as do the woodcuts *Reclining Girl with Headache* or *Slaughterhouse Track in Winter*.[8] In 1906 Schmidt-Rottluff and Nolde painted together on the Baltic Sea island of Alsen and further intensified their style based on Van Gogh. Even Pechstein, who had come from the academy, made *Elias Cemetery in Dresden* as if he had only been waiting to finally paint without restraint.[9] All the members of the Brücke created profoundly stimulating visual messages. Until 1908 Van Gogh's influence remained crucial, accompanied by Neo-Impressionist tendencies after 1906. Later they began to move away from impasto painting toward more generous, more planar forms— another parallel to the evolution of the Fauves. Color retained its expressive brilliance.

In November 1906 an exhibition of French artists conceived by the Paris-based German art historian Rudolf Adelbert Meyer for Galerie Druet was presented at the Galerie Arnold, after it had been shown at the art societies of Munich and Frankfurt am Main and before traveling to the Württembergischer Kunstverein Stuttgart. The sixteen-page catalog, which included a

list of the paintings shown, was published by Druet. The publicity strategy for the exhibition was well planned. The exhibition in Dresden included about fifty works by sixteen artists. The focus was on Neo- and Post-Impressionism, with works by Émile Bernard, Henri Edmond Cross, Maurice Denis, Théo Van Rysselberghe, Georges Seurat, Paul Signac, Paul Gauguin, Emile Schuffenecker, and Van Gogh. Works by the artists considered Fauves were also shown: four paintings each by Charles Camoin, Matisse, Henri Manguin, and Louis Valtat; three by Jean Puy; and five drawings by Matisse. It can certainly be assumed that the Brücke not only were aware of the exhibition

Stream,[12] although it appears as an anomaly in the evolution of his style, which was dominated by Van Gogh's influence until 1908–9. There are a number of ink drawings and watercolors by Fritz Bleyl that represent the most intense use of the pointillist technique among the Brücke artists.

In autumn 1908 there was another opportunity to see works by the Fauves in Dresden. Galerie Richter showed some sixty works by French artists from September 1 to September 13. This exhibition took place at the same time of the annual Brücke exhibition in the same gallery. According to newspaper reports, the following artists were among those represented:

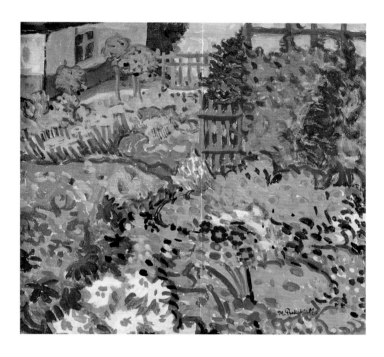

in advance but also saw it, presumably with great curiosity. It is not known whether Fauvism was present in its purest form or whether the works presented were rather of a Neo-Impressionist direction, in keeping with the concept of the exhibition. It is, however, a fact that a pointillist technique was adopted by the Brücke artists from this point onward. Kirchner combined it with Van Gogh's impasto technique as, for example, in paintings such as *Portrait of a Man* (*Hans Frisch*) (1907) or *Portrait of a Woman in White* (1908),[10] while Pechstein painted *Flower Garden*.[11] The technique was used most consistently by Schmidt-Rottluff and Fritz Bleyl. In 1906 Schmidt-Rottluff painted *On Pleisse*

Charles Guérin, Pierre Girieud, André Derain, Othon Friesz, Albert Marquet, Jean Puy, Ker-Xavier Roussel, Paul Signac, Francis Jourdain, Kees van Dongen, Maurice de Vlaminck, Jean Metzinger, and Pablo Picasso. Matisse was not mentioned. The descriptions are not sufficient to enable us to identify the works on exhibit. Kirchner, who had organized the Brücke exhibition, could study the French works in detail. As of September Heckel and Schmidt-Rottluff were still in Dangast, a village on the North Sea, and therefore could not have seen the exhibition. Nevertheless, the show marked the beginning of a stylistic transformation for the Brücke and provided a crucial impetus for their self-discovery as artists.

Max Pechstein
Flower Garden, 1907
Oil and tempera on cardboard
14 3/16 × 14 3/4 in. (36 × 37.5 cm)
Private collection

The style that ultimately resulted, and which is characteristic of the group's first great creative phase, is very close to Fauvism. Over the course of 1908 the Brücke had already begun to move away from an impasto style and achieve more generously conceived forms. The problem of form moved increasingly to the fore, and the color, which was still determined by emotions, had an expressive effect. Their brushstrokes, which until now had been short, transform into bands of color and formations of planes. That means their intricateness transformed into a pictorial arrangement that was more planar in structure. The Brücke thus found itself in a phase of development in the autumn of 1908 that made them receptive to Fauvism.

Even prior to this exhibition in Dresden, the Brücke artists would have had an opportunity to see modern French artists at the exhibitions of the Berlin Secession. Paintings by Jean Puy and Louis Valtat were shown there in the spring of 1907. And at the fourteenth Secession exhibition, which was dedicated to graphic arts, Matisse was represented by eight drawings. Because Kirchner, Pechstein, and Schmidt-Rottluff had intermittently taken part in the "Black-and-White" exhibitions of graphic art at the Berlin Secession since 1906, they may have seen these works.

Pechstein was the first Brücke artist to come into direct contact with art by the Fauves prior to the exhibition at Galerie Richter. He lived in Paris from December 9, 1907, until the end of July 1908. After returning to Germany, he moved to Berlin in August 1908. In Paris Pechstein was confronted with Van Gogh's work again in January 1908. At Galerie Bernheim-Jeune he saw what was then the largest exhibition of that artist's work ever, with more than a hundred works. Gradually, however, he discovered other stylistic movements as well. "There are always capital exhibitions here, and one can make one's observations there," he wrote from Paris.[13] The details of what he saw are unknown, as are the personal contacts he established. We can only make assumptions based on his stylistic development. It is highly probable that he saw works by the Fauves. Judi Freeman claims that he visited Manguin in his studio;[14] in 1947 Pechstein himself reported that he met Derain at the Salon des Indépendants.[15] Derain's art must have impressed him, since the hatched style of Pechstein's ink drawings from Paris is highly reminiscent of Derain. It is reasonable to assume, if only because of their common language, that he met Hans Purrmann and the artists at the Café du Dôme, which was a kind of gathering spot for German artists in Paris. Purrmann was the focus of it, with his contacts to Matisse and the artists of the Bateau-Lavoir in Montmartre.

Another German who tried to introduce his compatriots to French modernism was the artist, collector, and art dealer Wilhelm Uhde. At this time he was a particularly strong advocate of the Fauves, collecting works by Derain, Raoul Dufy, Georges Braque, and Friesz, among others; he also showed works by these artists in the small gallery he had set up in a rear courtyard in the rue de la Grande-Chaumière in 1907. Uhde was an important contact for the Dômiers, the group of artists and writers around the Café du Dôme, and perhaps also for Pechstein. Through the Café du Dôme and Uhde, Pechstein may also have met Kees van Dongen, whose stylistic influence on Pechstein's work is not inconsiderable. There was only one public presentation of Van Dongen's works during Pechstein's stay in Paris: six of his paintings were shown at the Salon des Indépendants in 1908.

It is no longer possible to determine whether the initiative to invite Van Dongen to join the Brücke came from Pechstein or from Kirchner, Heckel, or Schmidt-Rottluff. In any case, in November–December 1908, when Pechstein was already back in Berlin, Galerie Bernheim-Jeune held a retrospective of Van Dongen's work. In the spring of 1908, and hence still prior to the Brücke exhibition at Galerie Richter, Van Dongen was represented by two paintings at the fifteenth exhibition of the Berlin Secession. Perhaps he had come to the attention of the Brücke artists on that occasion. He joined the Brücke in October 1908. Several of his works also demonstrate that Kirchner, too, responded more strongly to this artist's style.

In Paris, Pechstein produced mainly drawings and only a few paintings. *Bridge with Small Steamer* and *Young Girls* can be shown to be from this period.[16] The former still features Van Gogh's whirling vortex of colors, subdivided into clearly articulated, contoured planar structures, a design method that testifies to Derain's influence. By contrast, in *Young Girls* the style is calmer and the effect of the composition is based on a sensitive contrast of the girl's bright clothes and the greenish-blue surroundings. After returning from Paris, Pechstein painted *Young Girl* (plate 132), a picture whose perspective can be called Fauvist.[17] The forms are defined by contours and filled with loose, dablike brushstrokes, and entire sections of the canvas are left blank. The portrait, with its decoratively curving form, has a legerity and lightheartedness that seems entirely French and represented new territory of the Brücke style.

The exhibition at Richter in Dresden offered a great deal that Pechstein must have already seen in Paris. Nevertheless, the exhibition appears to have released something in him, since his subsequent development was enormous. On the one hand, the exhibition confirmed the rightness of the path he had taken; on the other, it encouraged him to try bolder approaches. Pechstein spent the summer of 1909 in Nidden (now Nida, Lithuania) on the Curonian Spit. That January he and Kirchner had also seen the Matisse exhibition at Galerie Cassirer in Berlin, which presumably provided further inspiration as well. All these influences were then assimilated in Nidden, resulting in a colorful style that could be called Pre-Fauvism. Pechstein was where the Fauves had been in 1905. But he developed rapidly, and by the end of the year he had abandoned his hatched style and moved on to planar, large-scale color compositions such as *Seated Man*.

The prerequisites for the mature style that characterized both 1910 and 1911 were now in place. Again and again we find paintings that recall Van Dongen. In addition to a flattering palette and a gentle emphasis on contours, a sensuous component is suggested. With his agreeable style, which brought him early success, Van Dongen's manner of expression was distinct from that of the other Fauves. The themes of figure, nude, and dance dominated his work. Pechstein's painting *Dancer* recalls Van Dongen in the sensuous, erotic movement of its seemingly boneless figure.[18] The gouache *Reclining Woman*, the drawing with watercolor *Reclining Nude with Cat*, and the painting *Female Singer in Red* are very close to the art of the Fauves in terms of conception and brushwork.[19] Pechstein simplified the forms, which are now derived from the figures and objects themselves. He arranges them in planes, surrounded by stabilizing contours. The foreground and background are pulled together into a plane. The pictorial space is constructed by means of color, simple and unmixed. The harmony of pure tones also expresses light. Pechstein elevated the simplification of all means to the principle of his new will to art, along with a harmonious balance of the composition. His intentions come very close to those of Matisse. In the latter's "Notes d'un peintre," first published in German translation in the journal *Kunst und Künstler* in May 1909, Matisse explained his goals:

What I am after, above all, is expression… Expression, for me, does not reside in passion bursting from a human face or manifested by violent movement. The entire arrangement of my picture is expressive: the place occupied by the figures, the empty spaces around them, the proportions, all of that has its share. Composition is the art of arranging in a decorative manner the diverse elements at the painter's command to express his feelings. In a picture every part will be visible and will play its appointed role, whether it be principal or secondary. Everything that is not useful in the picture is, it follows, harmful. A work of art must be harmonious in its entirety: any superfluous detail would replace some other essential detail in the mind of the spectator.[20]

The paintings from 1910 produced on the foundation of the expressive possibilities he had worked out in 1909 represent a point of culmination in Pechstein's oeuvre. In *Yellow and Black Leotard*, *Indian Man and Woman*, and *The Yellow Mask*, for example, his color and form achieve a freedom and intensity of expression that were previously unknown.[21] In 1911, before Pechstein's style shifted toward Cubism, he painted *Early Morning*, a last reminiscence of Fauvism.[22] In the gentle lines and the blue color of the nudes, which inevitably recalls Matisse's *Blue Nude* (*Memory of Biskra*) of 1907 (p. 175), Pechstein was looking back once more at his Fauve phase.

Ernst Ludwig Kirchner
Large Girl Reclining in the Forest, 1909
Charcoal
35 7/16 × 26 3/4 in. (90 × 68 cm)
Brücke-Museum, Berlin

Like Pechstein, Kirchner quickly overcame the nervous intricateness of his pictorial composition and found a new language. In the view of Donald E. Gordon, Kirchner's encounter with the work of Matisse provided the crucial impetus. Prints and drawings by Matisse were presented at the winter exhibition of the Berlin Secession in 1908–9, in which Kirchner also participated. At nearly the same time there was an exhibition at Cassirer's that was Matisse's first solo exhibition in Germany and featured primarily works from his most recent creative phase. It included about thirty paintings, thirty drawings, lithographs, and woodcuts, and ten bronze sculptures. Matisse had come to Berlin with Hans Purrmann to help install the exhibition. Because the paintings were so thoroughly rejected by the critics, Cassirer had them removed after Matisse had departed. Kirchner, who was in Berlin on January 12 (as evidenced by his postcard to Heckel), appears to have seen the exhibitions while the paintings were still up, since Gordon relates various works by Kirchner to paintings and sculptures in the exhibition.[23] For example, he compares Kirchner's lithograph *Dodo Playing with Her Fingers* (plate 85)[24] to *Blue Nude* (p. 175) and points to the violent torsions of the body, which are even more striking in Kirchner's painting *Girl under Japanese Umbrella*,[25] which Gordon also connects to *Reclining Nude I.*[26]

Kirchner was not, however, an artist satisfied with mimesis or adaptation. His concern was using what he saw as a creative impetus for his own artistic style. That does not preclude first seeking out and studying what he saw and then coming to his own pictorial solutions. This approach was, in fact, typical of him and can be observed repeatedly in his oeuvre—for example, in his reception of the art of the South Pacific and his discovery of Indian paintings in the Ajanta Caves. Kirchner's 1909 drawing *Female Dancer Bending Backward*, for example, is a study of a detail from Van Dongen's 1908 painting *La Valse chaloupée*, a kind of modified copy of the female figure in order to study the course of movement of the lines. Even Matisse believed an artist could develop a strong artistic personality only by grappling with the work of others. Kirchner was familiar with the use and effect of the decorative line from his earlier Jugendstil phase. He was a fantastic draftsman, and hence it is understandable that he responded with particular intensity to Matisse's drawings, with their sparse, innovative style of formal economy. He must have been fascinated most of all by the energy of the line in the work of both Matisse and Van Dongen, where it is the lines and contours that produce the tension.

This new, more powerful energy now began to pulse through Kirchner's drawings as well, mostly nudes or figures. The creative impetus deformed the bodies in favor of the overall harmony of the pictorial structure. Kirchner's handling of the expression and form was masterly. The series of large-format pastel and charcoal drawings of 1909 and 1910—which include *Two Nude Girls*[27] and *Large Girl Reclining in the Forest*—reveal particularly well how rapidly Kirchner developed his own means of expression and emancipated himself from his precursors. In the colored drawings he produced over the course of 1909, Kirchner applied his contours in

Ernst Ludwig Kirchner
Wrestlers in the Circus, 1909
Oil on canvas
31 ¹¹/₁₆ × 37 in. (80.5 × 94 cm)
The Cleveland Museum of Art,
Contemporary Collection
of the Cleveland Museum of Art
and Bequest of William R. Valentiner

black to clarify even more the composition and to emphasize the two-dimensional.

The new planar style inspired by the Fauves, with its simplified drawing and emphasis on the line and on pure color, is thus first tangible in the work of Pechstein and Kirchner. Heckel and Schmidt-Rottluff responded to it only later. This precise situation was also reflected in the Brücke's annual exhibition in 1909, which was held again at Galerie Richter from June 15 to June 29. Among other works, Kirchner showed the paintings *Landscape in Spring* and *Flowering Trees*, which feature a new quickness of expression, and the powerfully colorful painting *Two Girls with Masks*.[28] This loosely painted, rhythmic composition was well received by critics in Dresden. Critic Paul Fechter wrote:

> Kirchner has sent the best work of the entire exhibition, *The Masks*. The principles of the group here become evident in purest form: the wish for a picture based upon nature, but only as material for a (more or less consciously) simplified and constructed synthesis. While avoiding any kind of "naturalism," the synthesis depicts the essentials of the impression with the most forceful of means. More vigorously than his other works, Kirchner's picture shows this tendency most clearly.[29]

In Fechter's view, Heckel and Schmidt-Rottluff remained stuck in their old traditions—that is, under Van Gogh's influence.

Other Fauve-influenced major works of 1909 include the aforementioned *Girl under Japanese Umbrella* and paintings such as *Reclining Nude in Front of Mirror* (plate 80), *Japanese Theater*, *Wrestlers in the Circus*, and *Wine Bar*.[30] These works combine energetic, curved lines with planes full of pure color. They feature a unique wealth of means, a fluid liveliness, and a cheerful harmony as well as a lightness and joie de vivre that characterize Kirchner's work from this point forward. *Reclining Blue Nude with Straw Hat* is one of a series of nudes from 1909 painted loosely with thinned paint.[31] The pure shades are distributed among the planes with a lightly applied brush. The linear framing he preferred as recently as the summer of 1909 has been broken down, so that the brushstrokes can expand, unlimited and unhampered, to benefit the expressivity of the message. The unrealistic blue of the nude also heightens the expressivity. In his search for expression, Kirchner abandons existing reality, going beyond Matisse in his tendency to expressivity. In his "Notes d'un peintre," which Kirchner certainly knew, Matisse wrote of his goal of an "art of balance, of purity and serenity, devoid of troubling or depressing subject matter."[32] But Kirchner wanted to express excitement and emotion. His art continued to develop in that direction. In comparison to Pechstein, who clung to the decorative, Kirchner intensified the expressive and adopted the uncontested leading role in the emergence of Expressionism.

After he produced the works in 1909 that would number among the high points of his entire

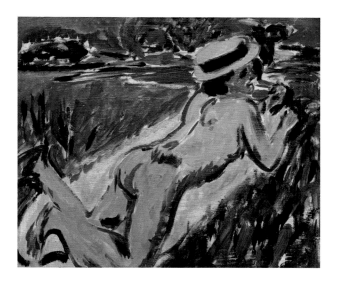

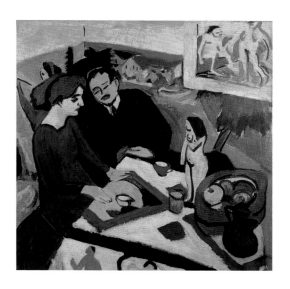

Ernst Ludwig Kirchner
Reclining Blue Nude with Straw Hat, 1909
Oil on canvas
26¾ x 28⅜ in. (68 x 72 cm)
Private collection

Ernst Ludwig Kirchner
Erich Heckel and Dodo in the Studio, 1910
Oil on canvas
47¼ × 47¼ in. (120 × 120 cm)
Private collection

oeuvre, in 1910 Kirchner discovered non-European art, which led to a more angular formal idiom and stricter structures in his compositions. And there was an exhibition of Gauguin's works at Galerie Arnold in Dresden for which Kirchner designed a poster (p. 77) based on a painting by Gauguin (p. 72). Kirchner was again emphasizing planarity more—that is, the clear division of the canvas into zones of color. Works such as *Artist—Marcella*, produced in Moritzburg that summer (plate 81), *Erich Heckel and Dodo in the Studio* (p. 245), and *Fränzi at Breakfast* all reveal a more solid style with planes of brilliant color.[33] The landscapes of 1910 also have this colorful, planar, and compact character. Examples include his *Bridge at the Priessnitz Estuary* and *Müggelsee, near Berlin, with Blooming Chestnut Trees*.[34] We should also mention his *Houses with Flags*,[35] a motif often found in the work of the Fauves, such as Dufy and Marquet. It cannot be said with certainty whether this motif was inspired by them, but it is reasonable to suppose.

One major work by Kirchner from 1911 is *Half-Length Nude with Hat*, one of German Expressionism's most erotic paintings.[36] It was the result of the synthesis of his stylistic experiments of the previous two years, although the new plasticity can be attributed to his coming to terms with the Ajanta style. Here Kirchner achieved an absolute masterpiece before his art took a different direction following his move to Berlin in the autumn

of 1911. The motif of a nude with a large hat is frequently found in the work of the Fauves, especially that of Van Dongen. But Kirchner produced a painting that is even more refined and empathetic, touching his viewers more deeply and addressing them more instinctively.

As noted above, Heckel and Schmidt-Rottluff did not see the exhibition of French works at Galerie Richter in 1908. But they certainly knew Fauvist works from illustrations in current art journals. Heckel, who worked very closely with Kirchner during their Dresden years, would have been familiar with Kirchner's most recent works and intentions, at least, and they surely discussed them as well. During his trip to Italy from February to June 1909, Heckel slowly moved away from the lively style of Van Gogh. He achieved greater simplicity and intensification of form. The tendency to larger structures and compositional units immanent to the painting led to a relaxing of expression. Rhythmically tectonic or rhythmically planar structures—in the painting *Houses near Rome*, for example—altered Heckel's mode of expression.[37] Above all, in Italy he discovered the stylistic possibilities of omission, of the effect of blank spaces within the composition. One major work from his stay in Italy is *Young Man and Girl*; it demonstrates Heckel's new visual idiom in a concentrated form.[38] Working with Kirchner at the Moritzburg Ponds in the summer of 1909 led to a style adapted to his colleague. In 1910, like Kirchner, he began

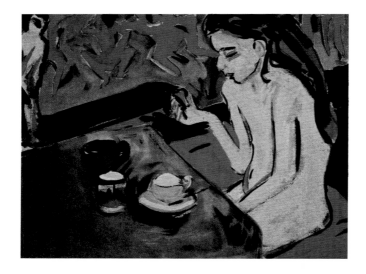

Ernst Ludwig Kirchner
Fränzi at Breakfast, 1909–10
Oil on canvas
20½ × 26⅜ in. (52 × 67 cm)
Private collection

246

working with planes filled uniformly with color and clear contour lines, as clearly evident from the paintings *Girl with Doll* (plate 62)[39] or *Studio Scene*.

Karl Schmidt-Rottluff is a special case among the Brücke artists. He joined the Brücke largely for the company and continued to work in seclusion on his own. From April to October 1909 he was in Dangast, which he and Heckel had begun visiting in 1907. Much like Heckel in Italy, he began to derive his own visual idiom from his reception of Van Gogh. He adapted the latter's lively brushwork to his own desire to express himself. In Dangast in 1909, he produced watercolors almost exclusively. He produced his compositions with long, lively brushstrokes full of lightness and transparency. The forms become increasingly sparse with no loss of dynamics. All the parts of the depiction are pulled together into a plane; everything vibrates. The blank areas that allow the paper to show through become a part of the composition, as they do in Heckel. In September Heckel traveled to Dangast, and Schmidt-Rottluff learned in detail about stylistic innovations, but he appears to have been unimpressed by them at first. In 1910 Schmidt-Rottluff applied a watercolor style to painting. He applied the oil paint only after thinning it. The colors are powerful and brilliant; the forms clearly defined and yet still full of energy, that is, full of expressivity. Gestural brushstrokes are often pulled together into planar structures, as the painting *Entrance* demonstrates.[40]

In 1910 his tendency to simplify the composition and to work with planar zones intensifies, as seen in paintings such as *The Broken Dike* (plate 141), *Red Gable*, and *Self-Portrait with Monocle*.[41] In 1911 the planes relax even more, and he produces works such as *Landscape with Fields*.[42] Schmidt-Rottluff took this painting with planes of color to the limits of abstraction. That is especially true of his works produced in Norway in 1911, as in *Oppedal*. Individual color fields are assembled into a pattern to produce a landscape. Schmidt-Rottluff's works feature not only powerful colors but also a monumentality of expression that is unique to him and is not found in the work of any of the other Brücke artists. Thereafter Schmidt-Rottluff increasingly reduced form to the essential while retaining brilliant shades of color. In 1913 he was in Nidden again, where he produced a number of paintings with fishing boats whose forms and colors reveal parallels to Dufy's paintings from around 1907, such as *Boats at Martigues*. It is impossible to say whether this was coincidence or whether Schmidt-Rottluff had seen such works.

There was undoubtedly a close relationship artistically between works by the Brücke artists from 1908–9 to 1911 and the Fauves. And it has been documented that the Brücke artists were familiar with Fauvist art. For various reasons, however, they denied such knowledge. First, they wanted to give the impression that their art had evolved autonomously and without

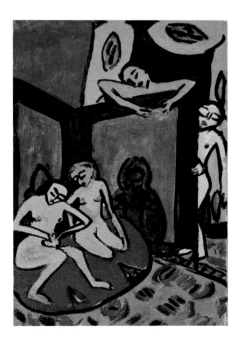

Erich Heckel
Studio Scene, 1910
27 9/16 × 18 7/8 in. (70 × 48 cm)
Staatliche Gemäldesammlungen,
Galerie Neue Meister, Dresden

Karl Schmidt-Rottluff
Oppedal (Hardanger Fjord), 1911
Oil on canvas
30 1/8 × 33 1/4 in. (76.5 × 84.5 cm)
Staatsgalerie Stuttgart

the existence of French models. That is why Kirchner predated his drawings and pastels of 1909 in particular, in which his work is closest to that of Matisse. But another major reason for this was a desire not to be known as *Französlinge* (Francophiles). In 1911 an anthology titled *Ein Protest deutscher Künstler* (Protest of German Artists), edited by painter Carl Vinnen, was published in reaction to the purchase of a painting by Van Gogh for the Kunsthalle Bremen and more generally as a protest against the "great invasion of French art that has been in progress in so-called progressive art circles in Germany over the past few years."[43] The protest was joined by 119 German artists, publishing their commentaries in that volume and speaking out against the growing presence of French art. In "Chronik der Brücke" (Chronicle of the Brücke), which Kirchner wrote in 1913, Matisse and the Fauves go unmentioned as sources of inspiration. Instead, he mentioned Lucas Cranach the Elder, Hans Sebald Beham, and other medieval German masters as well as "negro sculpture" and "Oceanic beam carvings."[44] At the end of the text Kirchner wrote: "Uninfluenced by contemporary movements of Cubism, Futurism, etc., [the Brücke] fights for a human culture, the soil of all real art."[45] As late as 1958 Heckel's statements on the reception of Fauvism were cautious; in an interview with Roman Norbert Ketterer, he said: "We saw more the contrasts, more the palette, which had something ingratiating about it and did not have the scale of colors that seemed desirable to us. We rejected the ingratiating or salon-like taste that still clung to academicism, which was undoubtedly still present in the work of others' painting at the time. That was refined painting, but the refined was not our goal."[46] Kirchner would certainly have given a similar response; after all, he had quickly intensified his reception of Matisse into the expressive. Nevertheless, the Brücke artists were enthusiastic about Matisse at the time, and, in his role as the manager of the Brücke, Heckel tried through Cuno Amiet to get Matisse to join the group.[47]

Without a doubt, the Brücke artists greatly admired the Fauves for the quality of their work. But the question arises whether the development of the Brücke artists would have followed the same path if they had not known works by the Fauves. This should be answered in the affirmative, not the negative. The goal of the Brücke was to create art based on intention and emotion that depicted inner emotion and feelings "in a direct and undistorted way." Powerful colors and simplified form or drawing were sufficient means to achieve that. That is why the Brücke artists responded so powerfully to Van Gogh, Nolde, and Amiet. The shift toward powerful forms of expression, to pure color, was already in the air. The development occurred sooner in France than in Germany, but the points of departure—namely, Van Gogh, Neo-Impressionism, and Gauguin—were the same. In both places, artists had to grapple with these things in order to make progress; the evolutionary steps corresponded.

The artists of the Brücke are usually lumped in with Expressionism, without recognizing that there were two stages of Brücke art. As they each relocated from Dresden to Berlin, their style changed radically, in terms of both motifs and color and form. The colorful and cheerful qualities that initially dominated now disappeared. The Berlin years saw the emergence of the form of expression that is described, more or less universally in art historical surveys, as *Expressionism* perse and that is considered synonymous with German Expressionism. Descriptions like these are the rule: "distortion and exaggeration bordering on the hysterical, a shattering of traditional forms" or "critical and emphatic approach to the world."[48] The artists have been described as "uneasy, neurotic—Kirchner took drugs—and obsessed with moral, religious, and sexual problems. The spirit of German Romanticism lived again."[49] The list of such quotations could be extended at will. But such descriptions do not apply at all to the first phase of Expressionism, that is, the Dresden period. As we have seen, the art of the Brücke in the early years tended to be sunny and carefree, with themes and motifs that were almost facile: female nudes in the studio or a bathtub, scenes of bathing outdoors, landscapes, still lifes. It was a life-affirming, unencumbered art, a German pendant to Fauvism. It was an art that radiated life and lightheartedness. The Brücke artists achieved a quality in their works that is in no way inferior to Fauvism, even if expressivity is emphasized more, and it is also of international stature. If one wishes to define this stylistic phase adequately and underscore its relationship to Fauvism, "Fauve Expressionism" is the only proper term.

Translated by Steven Lindberg

ENDNOTES

References to catalogues raisonnés are from the following sources: Wolf Dieter Dube and Annemarie Dube-Heynig, *Ernst Ludwig Kirchner: Das graphische Werk* (Munich: Prestel, 1967); Donald E. Gordon, *Ernst Ludwig Kirchner: Mit einem kritischen Katalog sämtlicher Gemälde* (Munich: Prestel, 1968); Aya Soika, *Max Pechstein: Das Werkverzeichnis der Ölgemälde*, vol. 1 (Munich: Hirmer, 2011); and Paul Vogt, *Erich Heckel* (Recklinghausen: Bongers, 1965).

1. On this exhibition and those mentioned later, see Donald E. Gordon, *Modern Art Exhibitions, 1900–1916*, 2 vols. (Munich: Prestel, 1974).

2. Quoted in Pierre Schneider, *Matisse*, trans. Michael Taylor and Bridget Strevens Romer (New York: Rizzoli, 1984), 203.

3. Quoted in Hans Kinkel, "Erich Heckel—75 Jahre alt: Aus einem Gespräch mit Erich Heckel," in *Das Kunstwerk* 12, no. 3 (1958–59): 24ff.

4. Max Pechstein, *Erinnerungen* (Stuttgart: Deutsche Verlags-Anstalt, 1993), 23.

5. On this, see also Magdalena M. Moeller, "Gallen-Kallela, affinités allemandes," in *Akseli Gallen-Kallela: Une passion finlandaise*, exh. cat. (Paris: Musée d'Orsay; Ostfildern: Hatje Cantz, 2012), 162–72.

6. Fritz Schumacher, *Stufen des Lebens: Erinnerungen eines Baumeisters* (Stuttgart: Deutsche Verlags-Anstalt, 1935), 283.

7. Vogt, nos. 1906/1 and 1907/9.

8. Gordon, no. 20; Dube, nos. H 82 and H 73.

9. Soika, no. 1906/2.

10. Gordon, nos. 33 and 39.

11. Soika, no. 1907/2.

12. *Am Pleissebach* (On Pleisse Stream), today in the Brücke Museum, Berlin.

13. Quoted in Aya Soika, "'Um die guten Franzosen kennen zu lernen, muss man nach Deutschland gehen!': Max Pechstein und die französische Moderne," in *Deutscher Expressionismus 1905–1913: Brücke-Museum Berlin; 150 Meisterwerke*, exh. cat. (Groningen: Groninger Museum; Munich: Hirmer, 2009), 47.

14. Judi Freeman, "Meditation on Fauve Painting," in Freeman, *Fauves*, exh. cat. (Sydney: The Art Gallery of New South Wales, 1995), 26.

15. See Soika, "'Um die guten Franzosen,'" 48.

16. Soika, nos. 1908/1 and 1908/2.

17. Soika, no. 1908/6.

18. Soika, no. 1910/50.

19. *Die Liegende* (Reclining Woman), 1909, gouache, 38 × 49 cm, private collection; *Liegender weiblicher Akt mit Katze* (Reclining Nude with Cat), today in the Brücke Museum, Berlin; Soika, no. 1910/49.

20. Henri Matisse, "Notes of a Painter," in *Matisse on Art*, ed. and trans. Jack Flam, rev. ed. (Berkeley: University of California Press, 1995), 37–43, esp. 37–38.

21. Soika, nos. 1910/31, 1910/53, and 1910/75.

22. Soika, no. 1910/38.

23. Donald E. Gordon, "Kirchner in Dresden," *The Art Bulletin* 48 (1966): 335–66.

24. Dube, no. L 104.

25. Gordon, no. 57.

26. *Liegender Akt I* (Reclining Nude I), COLLECTION OR CAT RAISONNE NO. TK

27. *Zwei nackte Mädchen* (Two Nude Girls), today in the Brücke Museum, Berlin.

28. Gordon, nos. 62, 61, and 76.

29. Quoted in Gordon, "Kirchner in Dresden," 349.

30. *Liegender Akt vor Spiegel* (Reclining Nude in Front of Mirror), today in the Brücke Museum, Berlin; Gordon, nos. 56, 69, 70, and 71.

31. Gordon, no. 87.

32. Matisse, "Notes of a Painter," 42.

33. Gordon, nos. 744v and 105.

34. Gordon, nos. 117 and 138.

35. *Beflaggte Häuser* (Houses with Flags), Gordon, no. 129.

36. Gordon, no. 180.

37. Vogt, no. 1909/26.

38. Vogt, no. 1909/5.

39. Vogt, no. 1910/16.

40. *Einfahrt* (Entrance), 1910, private collection.

41. *Roter Giebel* (Red Gable), Brücke Museum, and *Selbstbildnis mit Einglas* (Self-Portrait with Monocle), Staatliche Museen zu Berlin, Nationalgalerie.

42. *Landschaft mit Feldern* (Landscape with Fields), Wilhelm Lehmbruck Museum, Duisburg.

43. Carl Vinnen, "Quousque tandem," in *Ein Protest deutscher Künstler* (Jena: Eugen Diederichs, 1911), 3, trans. in Timothy O. Benson and Éva Forgács, eds., *Between Worlds: A Sourcebook of Central European Avant-Gardes, 1910–1930* (Los Angeles: Los Angeles County Museum of Art; Cambridge, MA: MIT Press, 2002), 50–51.

44. Ernst Ludwig Kirchner, "Chronik der Brücke," trans. Peter Selz, in *Theories of Modern Art: A Source Book by Artists and Critics*, ed. Herschel B. Chipp (Berkeley: University of California Press, 1968), 174–78, esp. 175.

45. Ibid., 178.

46. "Erich Heckel" (1958), in Roman Norbert Ketterer, *Dialoge, Bildende Kunst, Kunsthandel* (Stuttgart: Beiser, 1988), 54.

47. Letter from Erich Heckel to Cuno Amiet, Archiv Brücke-Museum Berlin.

48. Kristian Sotriffer, *Expressionism and Fauvism*, trans. Richard Rickett (New York: McGraw-Hill, 1972), 5.

49. Jean-Paul Crespelle, *The Fauves*, trans. Anita Brookner (Greenwich, CT: New York Graphic Society, 1973), 304.

KATHERINE KUENZLI

Expanding the Boundaries of Modern Art:

The Blaue Reiter, Parisian Modernism, and Henri Rousseau

IN THE EARLY TWENTIETH CENTURY, German artists, collectors, and museum curators looked to Paris as the center of modern art. Paintings by Edouard Manet, Paul Cézanne, Paul Gauguin, Vincent van Gogh, and Henri Matisse entered German collections often years before they found comparable recognition in France.[1] Excluded from this pantheon of internationally acclaimed Parisian painters was Henri Rousseau, a retired customs official and self-taught painter who regularly exhibited at the Salon des Indépendants in Paris from 1886 until his death in 1910.[2] Yet his work mattered for German Expressionism, particularly its Munich variant, the Blaue Reiter. A heterogeneous group of artists—foremost among them Franz Marc, Wassily Kandinsky, and August Macke—the Blaue Reiter made history in 1911 and 1912 with its first exhibition and the publication of an almanac titled *Der Blaue Reiter* that prophesied a new, more spiritual direction in modern art.[3] *Der Blaue Reiter* featured no fewer than seven reproductions of Rousseau's paintings. By comparison, only one of Gauguin's works was represented, along with two by Matisse, three by Cézanne, and one by Van Gogh. Marc underlined Rousseau's importance by painting aportrait in homage to the artist that he prominently displayed at the Blaue Reiter's first exhibition.

In foregrounding the work of Rousseau, Blaue Reiter artists altered an emerging canon of modern art forged by critic Julius Meier-Graefe and museum curator Hugo von Tschudi. In their respective publications and acquisitions beginning in the 1890s, Meier-Graefe and Tschudi defined a modern aesthetic centered on Parisian Impressionism, which they celebrated as the apogee of a painterly tradition. Meier-Graefe's three-volume *Entwickelungsgeschichte der modernen Kunst* (Developmental History of Modern Art, 1904) and Tschudi's painting purchases, first as curator at Berlin's National Gallery and subsequently at Munich's Neue Pinakothek, established the parameters of a modern aesthetic that was defined by the work of artists from Manet to Van Gogh.[4] By introducing Impressionist aesthetics into Germany, both men sought to change the course of German art away from allegorical and mythological subjects toward a concentration on optical sensation and the material properties of the medium, including line, color, and surface. They presented a modern aesthetic as the result of a gradual evolution that originated in Byzantine mosaics and culminated in Parisian Impressionism. Dedicating the Blaue Reiter almanac to the recently deceased Tschudi, Marc acknowledged Tschudi's and Meier-Graefe's con-

tributions as "spiritual gifts" that would elevate a culture mired in materialist preoccupations.[5]

Despite this formal acknowledgment, the almanac signaled the waning of Meier-Graefe's and Tschudi's influence. Tschudi's illness and death coincided with Meier-Graefe's shift from contemporary art criticism to historical writing. His later publications, including significantly revised editions of his *Entwickelungsgeschichte* that appeared beginning in 1908, take on a decidedly retrospective, even ruminative character.[6] By contrast, Blaue Reiter artists defined a new era of avant-garde art in which Parisian painting continued to play a role, but in ways that significantly departed from Meier-Graefe's and Tschudi's aesthetics and painterly narrative. Contributors to the almanac,

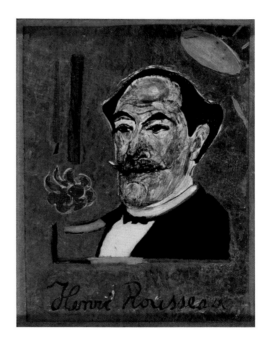

especially Marc and Kandinsky, focused less on modern art's formal qualities and more on underlying spiritual affinities that they believed united artworks from all cultures and historical ages. Parisian painting appears in the almanac alongside art and artifacts from Germany, Russia, Benin, Egypt, Easter Island, Mexico, Japan, and China. Moving away from Meier-Graefe's and Tschudi's focus on optical sensation, Marc and Kandinsky foregrounded the importance of ideas, which they detached from their formal expression.

Despite the geographical range of the almanac's images, modern art continued to be centered on Paris,

Franz Marc
Portrait of Henri Rousseau, 1911
Verre églomisé picture backed with silver foil
6 × 4 ½ in. (15.3 × 11.4 cm)
Städtische Galerie im Lenbachhaus, Munich

251

Paul Cézanne
The Four Seasons: Autumn, 1859–62
Oil on canvas
123½ × 41⅓ in. (314 × 105 cm)
Musée du Petit Palais, Paris, France

Paul Cézanne
The Four Seasons: Winter, 1859–62
Oil on canvas
123½ × 41⅓ in. (314 × 105 cm)
Musée du Petit Palais, Paris, France

but the reception of Parisian art significantly shifted with the Blaue Reiter in ways that shed light on the group's theoretical and practical contributions to avant-garde practice. To be sure, the almanac featured painters and paintings that had been essential to Meier-Graefe's and Tschudi's narrative: Cézanne, Van Gogh, and Gauguin. However, the terms of their admiration changed from an emphasis on sensation and the formal properties of the medium to a prioritization of interior, spiritual content. For instance, Kandinsky and Marc chose to reproduce two of Cézanne's four decorative panels from *The Four Seasons*, whose invented subject matter and formal naiveté set them apart from the artist's closely observed and highly resolved still lifes painted as of the

Graefe's and Tschudi's aesthetic. Marc and especially Kandinsky put forward a very different, even revolutionary understanding of Parisian painting in their contributions to the almanac. Marc radically dissociated form and content, and Kandinsky furthered this point by arguing for the equivalence of realist and abstract painterly languages. He invoked Rousseau's painting as exemplifying how a literal attention to objective appearances could convey elevated spiritual content. These ideas sparked a debate within the Blaue Reiter over the nature of the new spiritual art. Macke remained faithful to Meier-Graefe, insisting in his contribution to the almanac that modern art originates in individual sensation, an idea that he associated

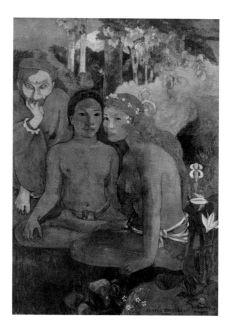

late 1870s, which had garnered Meier-Graefe's and Tschudi's admiration (plate 9). Furthermore, Kandinsky and Marc bypassed Gauguin's decorative paintings with their rich, saturated colors and seductive surfaces in favor of the artist's crude wooden relief, *Mysterious Water*, whose archaism they compared to an Etruscan carving. Marc and Kandinsky also redefined the nature and significance of Parisian art by including Robert Delaunay's *Saint-Séverin No. 1* (p. 254), a painting of a Gothic church whose energetic and austere upward-pointing arches spoke to Marc's and Kandinsky's spiritual interests.[7]

Nevertheless, the inclusion of Rousseau's painting marked the boldest departure from Meier-

with Van Gogh's painting. Parisian modernism provided the grounds for the Blaue Reiter's debates over the new spiritual art, because it, more than any other tradition, had been associated with the physicality of sensation and the material properties of the medium. Rather than rejecting the Parisian achievement, Blaue Reiter artists redefined it in new and important ways that furthered their spiritual objectives.

The End of an Evolution

Meier-Graefe and Tschudi both embraced notions of stylistic evolution, but the progression that they each

Paul Gauguin
Barbarian Tales, 1902
Oil on canvas
51¾ × 35⅝ in. (131.5 × 90.5 cm)
Museum Folkwang, Essen

Paul Gauguin
Mysterious Water, 1884
Carved and painted oak
32⅛ × 24⁷⁄₁₆ × 2 in. (81.5 × 62 × 5 cm)
Ny Carlsberg Glyptotek, Copenhagen

outlined did not include the Blaue Reiter. While the Munich group read and learned from Meier-Graefe's text, the interest was never reciprocated. For his part, Tschudi morally supported Marc's and Kandinsky's plans for an almanac and exhibition, but he never explicitly allied himself with their theories and methods.[8] Kandinsky's and Marc's emphasis on the spiritual in art did not accord with Meier-Graefe's and Tschudi's painterly commitments. In their publications from the 1890s and 1900s, they drew upon an emerging field of color theory and experimental psychology defined by the work of Michel-Eugène Chevreul, Charles Henry, Wilhelm Wundt, and Theodor Lipps. Believing that

arrangements of line and color had emotional properties, Meier-Graefe and Tschudi articulated an approach to composition according to which sensation was transposed into expressive patterns that conveyed elemental emotional content.

They combined an interest in experimental science with French Symbolist art theories, particularly those of Maurice Denis, who sought to reconcile Impressionism with spirituality by defining art as the "sanctification of nature." In his influential theories from the 1890s, Denis elevated the material properties of the medium over content. "A painting," he famously insisted, "before being a nude woman, a battle horse,

or some such anecdote, is above all a flat surface covered with colors assembled in a certain order."[9] Meier-Graefe followed Denis in his emphasis on sensation and the decorative, referring to paintings by Cézanne, Van Gogh, and Georges Seurat as painted tapestries and fresco fragments.[10]

While Marc's and Kandinsky's trips to Paris in 1906 and 1907 had been framed by Denis's theories and Meier-Graefe's writings, by 1911 they began to doubt whether any necessary connection existed between form and content. Marc and Kandinsky dismissed form as relative and contingent and proposed a very different definition of spiritual art that they associated above all with Rousseau's painting. In "Deutsche und französische Kunst" (German and French Art, 1911), Marc redefined Impressionism's importance not in terms of its "decorative" or optical qualities but in terms of its "interiority."[11] He confirmed the spiritual, rather than painterly, significance of the new painting in an essay included in *Der Blaue Reiter*, in which he insisted that it was impossible to conceive of the new spiritual art as resulting from "a formal development and new interpretation of Impressionism."[12] Marc's prioritization of interiority over exterior form laid the groundwork for an appreciation of Rousseau's painting. For his part, Kandinsky associated Rousseau's work with interiority in a letter to Marc: "What a wonderful human being that Rousseau was, and naturally in communication with the hereafter! What depth lies in his paintings!"[13] Marc responded with enthusiasm and immediately set about creating a rendition of Rousseau's self-portrait in homage to the artist.

The source of Kandinsky's and Marc's "revelation" was not Rousseau's paintings, which Kandinsky had seen but not understood in Paris in 1907, but rather the first monograph on Rousseau, published by Wilhelm Uhde in 1911. Uhde was a German critic and gallery owner in Paris who was briefly married to Sonia Terk before her union with Robert Delaunay in 1910. Upon reading Uhde's book, Kandinsky perceived connections between Rousseau's art and the essay that he was currently drafting for the almanac, "On the Question of Form." In this treatise, Kandinsky revised developing accounts of modern art as resulting from a single, formal evolution and introduced the idea of modern art as an opposition between two tendencies that he named "the great realism" and "the great abstraction." These thoughts prompted him to critically revise Uhde's account of Rousseau's art.

Robert Delaunay
Saint-Séverin No. 1, 1909
Oil on canvas
46 ¹⁄₁₆ × 32 ¹¹⁄₁₆ in. (117 × 83 cm)
Private collection, Basel

Like Meier-Graefe and Tschudi, Uhde sought to bridge the divide between German and French art, but his aesthetic interests lay more in Cubism and Expressionism than in Impressionism. Uhde studied art history in Germany and Italy before moving to Paris in 1904. By 1911, he had established a career as an art dealer and collector whose Parisian gallery sold works by Pablo Picasso, Georges Braque, and André Derain. He also actively supported Expressionism through his participation in the Sonderbund. Although Uhde devoted more than half of the book to Rousseau's life and person, the collector claimed that Rousseau's works transcended the artist's personal circumstances. By emphasizing the paintings' formal qualities above

creatures. Perspectival space and narrative coherence in Rousseau's painting give way to decorative arrangement.

The Dream, according to Uhde, revealed the artist as a visionary painter. He underlined how Rousseau made his personal vision the basis of a tableau in which nature was subjected and ordered according to principles of balance.[14] Emphasizing how Rousseau was sometimes terrified by his own powers of imagination, he related how the artist, "while painting his canvases, was so astonished by his proper visions that, anguished and oppressed, he had to open a window to catch his breath."[15] According to Uhde, the trauma of inspiration was followed by a second,

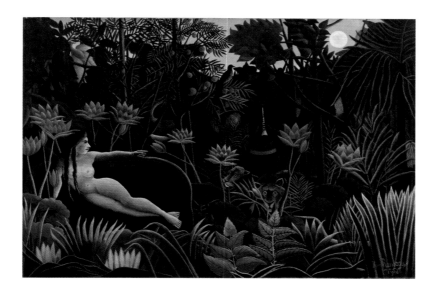

all else, he underlined how the artist willfully condensed and simplified nature in order to arrive at style.

While Uhde touched upon all aspects of the artist's career, he was particularly attracted to his jungle landscapes, *The Dream* in particular, which had drawn a great deal of attention when it was exhibited at the 1910 Salon des Indépendants. Measuring two meters high by nearly three meters across, *The Dream* presents a densely woven wall of vegetation from which female figures and animals emerge. The work offers a striking combination of literal description and poetic suggestion. A pale female nude lounges on a red divan amid oversized lotus blossoms. Partially hidden in the vegetation's dense patterning stands a dark woman who plays a flute surrounded by exotic

calmer moment in which Rousseau simplified nature and made it the basis of stylized arrangement. Uhde juxtaposed the spirituality and wholeness of Rousseau's painting with the conceptually limited practice of naturalism, including both Impressionism and realism as arts based in the description and elaboration of physical objects and sensations. Casting about for a stylistic label that could account for Rousseau's mastery of color and composition as well as his ability to go beyond naturalistic appearances, Uhde arrived at "classicism."[16]

Uhde insisted on the sophisticated and visionary nature of Rousseau's art at the same time as he underscored his outsider status. He juxtaposed the lush exoticism of the artist's jungle landscapes to the

Henri Rousseau
The Dream, 1910
Oil on canvas
80½ × 117½ in. (204.5 × 298.5 cm)
The Museum of Modern Art, New York,
gift of Nelson A. Rockefeller, 1954

profound ordinariness of his life in Plaisance, a modest neighborhood inhabited by artisans and shopkeepers on the southern outskirts of Paris. Drawing upon his firsthand experience of the artist's life, the critic described in some detail the pleasant banality of Rousseau's existence that stood in stark contrast to the rich exoticism of his canvases.[17] Rousseau's appeal lay not only in his visionary painting, Uhde proposed, but also in the simplicity of his person.[18] Although Uhde disputed the stylistic label of "primitive," he attributed to Rousseau some of the same psychological qualities of emotionality and naiveté that were then associated with unschooled artists. His account of Rousseau's painting thus failed to resolve the contradiction between imaginative sophistication and naive imitation that plagued the Parisian reception of the artist.

The Great Realism and the Great Abstraction

While Uhde's text, Kandinsky wrote, was "nice, warmly written and illuminates the figure of the artist," he found the portions on painting decidedly weaker and promised to "ameliorate" Uhde's account.[19] The result was an interpretation of Rousseau's painting that proved foundational to Kandinsky and Marc's definition of spiritual art. Kandinsky agreed with Uhde's passionate defense of Rousseau, but he found the references to "classicism" and "style" irrelevant; he joined Marc in rejecting these terms as outmoded concepts that depended more on external appearances than on the inner realm of the spirit. And while Kandinsky and Marc admired what was then termed "primitive" art (a stylistic category that included children's drawings, African carvings, and European folk and medieval art), they rejected the aesthetic and cultural hierarchies upon which notions of the "primitive" were founded. By interspersing reproductions of modern painting with those of European folk art, Egyptian shadow puppets, and popular devotional images, the almanac's editors played with distinctions between high and low art, "civilized" and "primitive" expression in order to underscore the unimportance of these cultural categories and formal distinctions.

All seven reproductions of Rousseau's works in *Der Blaue Reiter* appear alongside the text of Kandinsky's "On the Question of Form," in which he rejected matters of technical ability and style in order to focus on the "inner spirit." Unlike Uhde, Kandinsky ignored the material circumstances of Rousseau's life

in Paris and the half-comical, half-serious nature of his person in order to focus on purely artistic and metaphysical matters. Uhde's biographical emphasis was well suited to his book's monograph format, whereas Kandinsky's essay addressed theoretical questions that overlapped with, but were not limited to, Rousseau's canvases. Kandinsky's broader intellectual framework allowed him to sidestep matters of biography and place of origin in favor of more abstract questions related to the content of art and the modes of its expression.

Amending Impressionist definitions of art based on optical sensation that had been pivotal for Meier-Graefe and Tschudi, Kandinsky proposed a platonic view of art's origin, according to which "the spirit" inhabits a soul, and then more souls, in which it produces an "inner urge" (*innerlichen Drang*) or "inner necessity" (*innere Notwendigkeit*).[20] In a move to dematerialize or spiritualize artistic creation, Kandinsky insisted that inner necessity takes the form of sounds (*Klänge*) rather than sensations. He distinguished between "inner impulses," which he defined as universal, and the material form of their expression, which he perceived as variable and contingent. Whereas Meier-Graefe had defined a single modern aesthetic, Kandinsky admitted a plurality of forms and styles as equally valid. It makes no difference whether a form is harmonious or disharmonious, refined or crude, he reasoned, so long as it communicates a work's spiritual core. The only recommendation that Kandinsky made concerning form is that it be as pared down as possible so as to reveal an artwork's inner content.

In an effort to identify new parameters for art making without providing specific formal recommendations, Kandinsky conceived of art as vacillating between two poles that he termed "the great realism" and "the great abstraction." Artists might tend toward one pole or the other, he claimed, but all great art consists of a balance between these two modes of expression.[21] The equilibrium between realism and abstraction had been lost in the nineteenth century, Kandinsky regretted, and part of his purpose in writing was to recover art's spiritual dimension. Far from dismissing naturalism and realism, as Uhde had done in his account of Rousseau, Kandinsky redefined realism as a synthesis of matter and spirit, nature and imagination. "The emergent great realism," he explained, "is an effort to banish external artistic elements from painting and to embody the content of the work in a simple ('inartistic') representation of the simple, solid object." This paring down of a composition to its simplest components,

256

he claimed, was the surest way to release "the inner sound" (*Klänge*) stemming from the soul of the artist.[22]

Kandinsky designated Rousseau as the father of the great realism. His selection of Rousseau's paintings in the almanac focused exclusively on the artist's portraits and suburban landscapes because these, unlike his imaginary jungles, had a firmer grounding in the material world. Referring to Rousseau's *Self-Portrait of the Artist with a Lamp,* Kandinsky observed how "in rendering the shell of an object simply and completely, one has already separated the object from its practical meaning and peeled forth its interior sounds."[23] As with the figure of the artist, the oil lamp and flame are rendered matter-of-factly and without embellishment. Throughout the composition, form

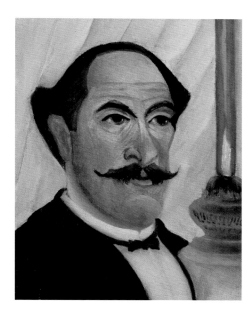

is compressed and space flattened so as to lend the portrait an iconic appearance.

Whereas Uhde had emphasized Rousseau's technical bravura and polished execution, Kandinsky and Marc celebrated the directness and even crudeness of Rousseau's compositions. Upon receiving Kandinsky's copy of Uhde's book, Marc created his own version of Rousseau's *Self-Portrait* in homage to the artist. He worked from the black-and-white reproduction of Rousseau's painting that appeared in Uhde's book, but the result is rougher than its model. Marc's technique also differed from Rousseau's original: he painted a mirror image replica in *verre églomisé* (painted glass backed with silver foil), a technique used in medieval and Renaissance Italy

for reliquaries and portable altars. Marc also took liberties with Rousseau's composition, replacing the oil lamp with a flower and placing a halo in the upper right corner of the composition. Intending his painting as a memorial to the artist, Marc exhibited it in a "corner of remembrance" devoted to Rousseau at the Blaue Reiter's first exhibition, at Galerie Thannhauser in Munich.[24] Rousseau appears in Marc's composition as a saint rather than an artist. No paintbrush or palette is represented, and all signs of technical mastery are absent. Orange, yellow, red, and green colors in Marc's composition are garish, and the foil bubbles and creases against the glass in an amateurish fashion. In this composition, Marc associates a disregard for external appearances with elevated spiritual content.

The complement of the great realism is the great abstraction, according to Kandinsky. This second idiom consists of the attempt to reduce, but not entirely eliminate, the objective component of painting in order to express inner necessity through "'incorporeal' forms."[25] Exactly what he meant by "incorporeal" forms is left unstated. However, it is clear that Kandinsky conceived of abstract paintings in terms of sound. He de-emphasized formal components (lines, surfaces, brushstrokes) in favor of a work's "inner sound," which he equated with its life.[26] While Kandinsky did not explicitly mention any examples of abstract painting in his essay, he implied his own compositions. Attentive readers could find examples of abstract art in the almanac's reproductions of his works, including *Lyrical, Study for Composition IV,* and *Composition V,* all of which represent varying stages of abstraction. *Composition V,* for example, is loosely based on the theme of the Last Judgment. Veiled imagery exists in the composition, including a walled city on a hilltop, angels, a boat, and trumpets.[27] Kandinsky simplified and dematerialized imagery; for instance, a few parallel lines indicate angels; a patch of red color and a few black lines suggest a trumpet. In its free-floating, gestural lines and abstract color, *Composition V* could not appear more different than Rousseau's self-portrait. Despite the surface dissimilarity between these two canvases, Kandinsky asserted that they ultimately lead to the same end, the uncovering of the "internal spirit": "The greatest external difference becomes the greatest internal equality."[28]

Kandinsky not only identified Rousseau as the fountainhead of "the great realism," he also drew distinctions between mental concept and form that provide a framework for understanding the coexistence of

Henri Rousseau
Self-Portrait of the Artist with a Lamp, 1903
Oil on canvas
9 × 7½ in. (23 × 19 cm)
Musée Picasso, Paris, from the personal
collection of Pablo Picasso

craftsmanlike precision and dreamlike suggestion in Rousseau's canvases. Parisian critics, Uhde included, looked to Rousseau's personality and lack of education to explain his work's seeming incongruities and inconsistencies. However, Kandinsky provided a theoretical framework for approaching the duality of Rousseau's achievement by introducing an important tension between a concept and its formal expression. He thus broke with a Romantic tradition asserting "correspondences" between ideas and forms that Tschudi and Meier-Graefe had inherited. By conceiving of form as contingent, Kandinsky also undermined the assumptions underpinning nineteenth-century scientific investigations into the psychology of perception undertaken by Charles Henry in France and Wilhelm Wundt and Theodor Lipps in Germany that had informed Meier-Graefe's and Tschudi's aesthetic. Kandinsky further broke new ground by asserting the relative and even arbitrary relationship between a purposeful idea and its visual expression in ways that intersect with developments in twentieth-century linguistics.[29] Taking the example of a letter of the alphabet, Kandinsky observed that its function is fixed and purposeful as a given sound that constitutes part of a word. He then identified a secondary property of letters as arrangements of lines on a surface. The conceptual and formal parts of a letter do not necessarily relate to each other, according to Kandinsky. For instance, he observed that even though the shape of lines that make up the word *traurig* (sad) may have a silly feel, the practical (conceptual) function of the word is still to connote sadness. He concluded from this example that every word or sign consists of two independent and sometimes opposing properties.[30] Although Kandinsky drew his example from language, he insisted on the applicability of these laws to music and the visual arts.

Kandinsky's views on language help explain his fascination with the seeming contradictions in Rousseau's canvases between the calculated and the whimsical, the rational and the bizarre. Following the terms of his linguistic analysis, one could construe the purposeful, conceptual element of Rousseau's compositions as their representational function. Upon initiating a composition, Rousseau set out to record the external appearance of his chosen model, whether a neighbor, a popular illustration, or a local landscape. The second, formal component of Rousseau's canvases is their combination of colors and lines on the surface of the canvas. In its sheer physicality, this second, abstract element allowed for the exploitation of line and color as

independent, expressive languages. Rather than a product of Rousseau's ignorance, the tension between concept and its formal expression could be taken to undermine the certainties of form and representation. Ultimately, Kandinsky wanted to move beyond conventional language-based logic in favor of primordial, prelinguistic modes of expression that he associated with "inner necessity" and music and that he saw intimated in Rousseau's canvases.

The disconnect between mental concept and its formal expression is exemplified in Rousseau's *Poultry Yard,* a painting that Kandinsky cherished. Obtaining it at the end of 1911, he exhibited it adjacent to Marc's homage to Rousseau at the Blaue Reiter's first exhibition in Munich. The work reappeared in 1912 in an advertising prospectus for the almanac.[31] In its

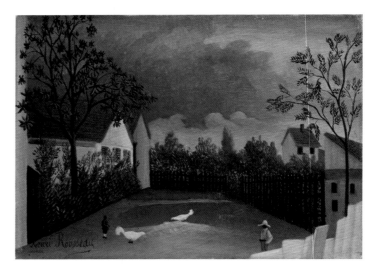

scale and subject matter, the work is much more modest than *The Dream,* which Uhde elevated as Rousseau's greatest achievement. Kandinsky's choice underlines the different framework in which he sought to insert the artist. With its seemingly banal subject matter, *Poultry Yard* signals Kandinsky's determination to overturn existing aesthetic conventions and to redefine realism as a viable mode of modern expression. The painting displays a studious attention to the humble details of everyday life on the outskirts of Paris. Rousseau's attentiveness to material reality and painterly composition coexists with incongruous elements, subtle distortions, and omissions that lend the scene an otherworldly appearance. Scale is distorted so that the chickens

Henri Rousseau
The Poultry Yard, 1896–98
Oil on canvas
9 ½ × 13 in. (24.6 × 32.9 cm)
Musée National d'Art Moderne,
Centre Georges Pompidou, Paris

Gauguin, or Van Gogh, whose works continued to matter in new and fascinating ways, Rousseau's painting signaled the advent of a new, more spiritual and universal art. Kandinsky and Marc thus revised Uhde's association of Rousseau's art with a French classical tradition, just as they undermined Meier-Graefe's and Tschudi's attempt to define a single, modern aesthetic. Rousseau's national origin, his position in a particular geographic location and cultural moment, play no role in the

Blaue Reiter's appreciation of the artist. In aligning Rousseau's work with the great abstraction and the great realism, Kandinsky sought to correct what he saw to be the empiricist bias in modern art practice, theory, and criticism. It was in this context that Blaue Reiter artists presented Rousseau as the most significant painter, whose work enabled them to expand the geographical and conceptual boundaries of modern art.

ENDNOTES

1. Andrea Pophanken and Felix Billeter, eds., *Die Moderne und ihre Sammler: Französische Kunst in deutschem Privatbesitz vom Kaiserreich zur Weimarer Republik* (Berlin: Akademie Verlag, 2001).

2. Cathrin Klingsöhr-Leroy, ed., *Der große Widerspruch: Franz Marc zwischen Delaunay und Rousseau*, exh. cat. (Berlin: Deutscher Kunstverlag, 2009).

3. Hans Christoph von Tavel, ed., *Der Blaue Reiter*, exh. cat. (Bern: Kunstmuseum Bern, 1986); Brigitte Salmen, ed., *Der Almanach "Der Blaue Reiter": Bilder und Bildwerke in Originalen*, exh. cat. (Murnau: Schloßmuseum Murnau, 1998); Christine Hopfengart, ed., *Der Blaue Reiter*, exh. cat. (Bremen: Kunsthalle Bremen, 2000); Wassily Kandinsky and Franz Marc, eds., *Der Blaue Reiter* (Munich: Piper, 1912; facsimile edition Munich: Prestel, 2008), published in English as *The Blaue Reiter Almanac*, ed. Klaus Lankheit, trans. Henning Falkenstein (New York: Viking, 1974).

4. Barbara Paul, *Hugo von Tschudi und die moderne französische Kunst im Deutschen Kaiserreich* (Mainz: Philipp von Zabern, 1993); Johann Georg Prinz von Hohenzollern and Peter-Klaus Schuster, eds., *Manet bis Van Gogh: Hugo von Tschudi und der Kampf um die Moderne*, exh. cat. (Munich: Prestel, 1996); Kenworth Moffett, *Meier-Graefe as Art Critic* (Munich: Prestel, 1973); Catherine Krahmer, "Meier-Graefes Weg zur Kunst," *Hofmannsthal. Jahrbuch zur europäischen Moderne* 4, ed. Gerhard Neumann, Ursula Renner, Günter Schnitzler, and Gotthard Wunberg (Freiburg: Rombach, 1996), 168–226.

5. Franz Marc, "Spiritual Treasures," in Lankheit, *Blaue Reiter Almanac*, 55–60; "Geistige Güter," in Kandinsky and Marc, *Der Blaue Reiter*, 1–4.

6. Grischka Petri, "The English Edition of Julius Meier-Graefe's *Entwicklungsgeschichte der modernen Kunst*," *Visual Culture in Britain* 6, no. 2 (2005): 171–88; Jenny Anger, "Courbet, the Decorative, and the Canon: Rewriting and Rereading Meier-Graefe's *Modern Art*," in *Partisan Canons*, ed. Anna Brzyski (Durham, NC: Duke University Press, 2007), 15–77.

7. On Delaunay's importance to the Blaue Reiter, see Erwin von Busse,

"Robert Delaunay's Methods of Composition," in Lankheit, *Blaue Reiter Almanac*, 119–23; "Die Kompositionsmittel bei Robert Delaunay," in Kandinsky and Marc, *Der Blaue Reiter*, 48–52. Also see Robert Delaunay, *Du Cubisme à l'art abstrait, Documents inédits*, ed. Pierre Francastel (Paris: S.E.V.P.E.N., 1957); Johannes Langner, "Kubismus, Futurismus, Orphismus: Macke und die internationale Avantgarde, 1911 bis 1914," in *August Macke: Gemälde, Aquarelle, Zeichnungen*, ed. Ernst-Gerhard Güse, exh. cat. (Munich: Bruckmann, 1986), 75–88; Susanne Meyer-Büser, ed., *Marc, Macke, und Delaunay: Die Schönheit einer zerbrechenden Welt, 1910–1914*, exh. cat. (Hannover: Sprengel Museum, 2009); and Cathrin Klingsöhr-Leroy, *Der große Widerspruch*. Note that Delaunay was one of Rousseau's primary supporters in Paris and owned a substantial number of his paintings. After Rousseau's death, he helped introduce Rousseau's work to artists in Germany, among them Marc and Kandinsky.

8. Moffett, *Meier-Graefe as Art Critic*, 107–13; Paul, *Hugo von Tschudi*, 327–33.

9. Maurice Denis, "Définition du néo-traditionnisme," in *Le ciel et l'Arcadie*, ed. Jean-Paul Bouillon (Paris: Hermann, 1993), 5, 62. On Denis's theories and their relationship to a modernist aesthetic, see Katherine Kuenzli, *The Nabis and Intimate Modernism: Painting and the Decorative at the Fin-de-Siècle* (Surrey, UK, and Burlington, VT: Ashgate, 2010). Translations are my own unless otherwise indicated.

10. Julius Meier-Graefe, *Entwickelungsgeschichte der modernen Kunst: Vergleichende Betrachtung der bildenden Künste, als Beitrag zu einer neuen Aesthetik*, 3 vols. (Stuttgart: J. Hofmann, 1904), 1:123, 128–30, 169, 179, 225–33.

11. Franz Marc, "Deutsche und französische Kunst," in *Im Kampf um die Kunst: Die Antwort auf den "Protest deutscher Künstler"* (Munich: R. Piper, 1911), 75–78, reprinted in Franz Marc, *Schriften*, ed. Klaus Lankheit (Cologne: DuMont, 1978), 129–31.

12. Franz Marc, "The 'Savages' of Germany," in Lankheit, *Blaue Reiter Almanac*, 64; "Die 'Wilden' Deutschlands," in Kandinsky and Marc, *Der Blaue Reiter*, 7.

13. Kandinsky to Marc, October 29, 1911, reprinted in *Wassily Kandinsky,*

Franz Marc: Briefwechsel, ed. Klaus Lankheit (Munich: R. Piper, 1983), 68.

14. Wilhelm Uhde, *Henri Rousseau* (Paris: Figuière, 1911), 42–44.

15. Ibid., 43.

16. Ibid., 35–36.

17. Ibid., 9.

18. Ibid., 56–57.

19. Kandinsky to Marc, October 29, 1911, in Lankheit, *Kandinsky, Marc*, 68.

20. Kandinsky, "On the Question of Form," in Lankheit, *Blaue Reiter Almanac*, 147 and 153; "Über die Formfrage," in Kandinsky and Marc, *Der Blaue Reiter*, 74 and 78.

21. Ibid., 158; 82.

22. Ibid., 161; 83.

23. Ibid., 178; 94.

24. Götz Adriani, *Henri Rousseau*, exh. cat. (New Haven and London: Yale University Press, 2001), 145–47.

25. Kandinsky, "On the Question of Form," in Lankheit, *Blaue Reiter Almanac*, 164; "Über die Formfrage," in Kandinsky and Marc, *Der Blaue Reiter*, 84.

26. Ibid., 165; 84.

27. Rose-Carol Washton Long, *Kandinsky: The Development of an Abstract Style* (Oxford: Clarendon Press, 1980), 113–16.

28. Kandinsky, "On the Question of Form," in Lankheit, *Blaue Reiter Almanac*, 165; "Über die Formfrage," in Kandinsky and Marc, *Der Blaue Reiter*, 84–85.

29. Kandinsky's complex relationship to modern linguistics, especially the ideas of Ferdinand de Saussure and Edmund Husserl, is a large topic that cannot be developed here. The topic is broached in Leah Dickerman, "Vasily Kandinsky: Without Words," in *Inventing Abstraction, 1910–1925*, ed. Leah Dickerman (New York: Museum of Modern Art, 2013), 50–53; Leah Dickerman, "Bauhaus Fundaments," in *Bauhaus, 1919–1933: Workshops for Modernity* (New York: Museum of Modern Art, 2009).

30. Kandinsky, "On the Question of Form," in Lankheit, *Blaue Reiter Almanac*, 165–67; "Über die Formfrage," in Kandinsky and Marc, *Der Blaue Reiter*, 85–86.

31. Kandinsky obtained the painting from Robert Delaunay, who owned an important number of Rousseau's paintings. See Adriani, *Rousseau*, 126–30.

32. Macke to Marc, early December 1910, in *August Macke, Franz Marc:*

Briefwechsel, ed. Wolfgang Macke (Cologne: M. DuMont, 1964), 25–27.

33. August Macke, "Masks," in Lankheit, *Blaue Reiter Almanac*, 85; "Die Masken," in Kandinsky and Marc, *Der Blaue Reiter*, 22.

34. Macke to Marc, January 22, 1912, in *August Macke, Franz Marc: Briefwechsel*, 96–97.

35. Meier-Graefe, *Entwickelungsgeschichte*, vols. 1 and 2.

36. Julius Meier-Graefe, "Beiträge zu einer modernen Ästhetik IV," *Die Insel* 1, no. 2 (November 1899): 199–200; Meier-Graefe, *Entwickelungsgeschichte*, 2: 703–51.

37. Julius Meier-Graefe, "Beiträge zu einer modernen Ästhetik: Eine Völkerwanderung," *Die Insel* 2, no. 5 (February 1900): 226–27.

38. Hugo von Tschudi, "Kunst und Publikum," in *Gesammelte Schriften zur neueren Kunst*, ed. E. Schwedeler-Meyer (Munich: Bruckmann, 1912), 66–67.

39. See Franz Marc, "The 'Savages' of Germany." Marc also reveals his nationalist ambitions in "Deutsche und französische Kunst" and even more so in "Im Fegefeuer des Krieges," in Marc, *Schriften*, 158–62.

40. Kandinsky, "On the Question of Form," in Lankheit, *Blaue Reiter Almanac*, 153; "Über die Formfrage," in Kandinsky and Marc, *Der Blaue Reiter*, 77–78.

SHERWIN SIMMONS

"A Byway for Sure": Cubism's Reception and Impact on the Brücke, 1910–14

IN DECEMBER 1911 a humorist writing for the weekly magazine *Lustige Blätter* composed a piece of doggerel titled "The Cubists," the first stanza of which read:

> This is a new direction,
> Ideally Parisian
> This is an artistic school,
> That paints three-dimensionally.[1]

The crude poem ended by ridiculing the "*Kubik*" idiot who would buy such art. Thus, Cubism's arrival was signaled to the broad public in Germany a little more than a year after the first such works had been shown by the Neue Künstlervereinigung München (New Artists Association of Munich, or NKVM) at their second exhibition at the Moderne Galerie Heinrich Thannhauser.[2]

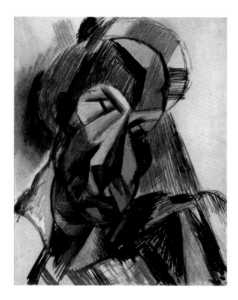

These paintings traveled to Paul Cassirer's gallery in Berlin, where Hans Rosenhagen responded by writing that he would have remained silent about such works "if they could not serve as a horrible example for young German artists."[3] This was reprinted in Carl Vinnen's *Ein Protest deutscher Künstler* (Protest of German Artists), his 1911 diatribe against French art's deleterious influence on modern German art.[4]

French humor magazines later reversed this nationalist disparagement of Cubism, suggesting that the style was in fact a corruption of French taste by German art dealers.[5] While an obvious exaggeration, the assertion drew on the fact that the exhibition of

Braque's paintings—which Louis Vauxcelles described as being composed of *bizarre cubiques*—had been held in the gallery of Daniel-Henry Kahnweiler. A son of German financiers, Kahnweiler became interested in new art in Paris after meeting Wilhelm Uhde, a German collector who began to acquire such works in 1904. He opened his small gallery on rue Vignon in spring 1907, stocking it with works by Fauvist painters. Shortly thereafter, Uhde encouraged Kahnweiler to visit Picasso to see *Les Demoiselles d'Avignon*, marking the beginning of their lifelong relationship. Kahnweiler held four exhibitions during 1908, the last one being that at which Braque's "cubist" paintings were shown. This was, however, Kahnweiler's final public exhibition. Instead, he envisioned a new commercial strategy in which he would not only discourage the artists he represented from taking part in large public exhibitions in Paris, but he would also refrain from holding his own exhibitions; rather, he would simply show his stock to the collectors who came to him. To build his clientele, he circulated photographs and carefully cultivated relationships with dealers, collectors, and artists outside France, particularly in Germany, where he also lent works to important exhibitions.[6] This is how Cubist works came to be included in the NKVM and subsequent exhibitions, which helped create a French perception of strong German involvement with Cubism and produced significant impact on German art and criticism.

Exhibitions and Critical Response

Public awareness of Cubism first arose in France in early 1911 as a result of the presence of Cubist works at the Salon des Indépendants. Lyonel Feininger described the sensation they created: "In the spring I had gone to Paris and found the world agog with Cubism—a thing I had never heard even mentioned before."[7] The German art world gradually became more aware of the work of Braque and Picasso as Alfred Flechtheim, a collector from Düsseldorf who frequented the circle at the Café du Dôme in Paris, facilitated major loans from Uhde, Kahnweiler, and his own collection to the Berlin Secession and Sonderbund exhibitions in spring 1912.[8] *Woman in a Black Hat* (p. 264), shown at the Secession, evidenced the intensely plastic treatment of the figure that Picasso had developed in Spain over the summer of 1909 at Horta de Ebro (Horta de Sant Joan).[9] Curt Glaser gave the most extended critical response, expressing thanks that Picasso's most recent work had now been shown in Berlin and linking it to Cézanne's late paintings,

Pablo Picasso
Head of a Woman, 1909
Gouache, watercolor, and black and ochre chalks, manipulated with stump and wet brush, on cream laid paper
24 5/8 × 18 7/8 in. (62.5 × 48 cm)
Art Institute of Chicago, Edward E. Ayer Endowment Fund in memory of Charles L. Hutchinson

but opining that it "is a byway for sure, and we don't believe that all of painting will one day come around to this path."[10]

At the Sonderbund exhibition in Cologne, sixteen works by Picasso were shown in their own room, eight of which surveyed Cubism's development.[11] Works by Braque and Derain were shown in another room, and these works gave rise to more informed and varied criticism. Hermann von Wedderkop published an exhibition guidebook, in which he quoted extensively from an unpublished essay about Picasso by M. R. Schönlank:

> Therefore the first demand was a new angle of view. Picasso achieved this knowledge about the optical values of a thing by a new cubic relationship to them. He no longer contented himself with the illusionistic, still fortuitous form of modeling; rather he sought the plain cube by dismantling each object into angular surfaces. Then he assembled it from as many different viewpoints, which in nature do not need to be visible at the same time, as he considers necessary for the correct expression of the whole. His cubic quality is therefore a construction of as many surfaces of the object as is demanded for the most intense expressive force of the total vision.[12]

For many critics, however, such paintings were "puzzles" and "head-breakers." Julius Meier-Graefe wrote that "the Cubists are worse academicians than all artists like Carolus-Duran together."[13] His essay shocked the young German artists who had been so stimulated by his writings about French Post-Impressionism, for he said that they had understood nothing about Gauguin, Van Gogh, and Cézanne, forgetting "everything that does not lie on the surface and what is ultimately so important for the surface is like the current under the water's surface. They are surface artists in every way, too flat as people."[14]

While surface decoration was a negative concept to Meier-Graefe, it had been identified as a positive feature of early Expressionism by M. R. Schönlank, its most astute initial critic. Max Raphael (Schönlank being an early pseudonym) began to write about the new art after meeting Max Pechstein in 1910. Raphael wrote that the artist's imagination about color was given total freedom in the new painting, resulting in works with two or three large areas of color: "Artistic power expresses itself in the rhythm in which the areas stand in relation to each other and in which the bodies are arranged

upon them, and then in the coordination of colors, which must have a particular ring, because one must see in large surfaces. One wants a form, but not the natural; rather, the subjective-decorative."[15] Raphael's article about the third exhibition of the Neue Secession cited a passage from Matisse's "Notes d'un peintre" (1908) to emphasize that the new art sought to actively create a primitive and clear synthesis that expressed the essence (not the changing appearances) of reality, fixing it in a unity of form and color.[16] Other essays used the term *Expressionism* to describe the new art, and that was the title of a book manuscript that Raphael proposed in May 1911 to Reinhard Piper for publication.[17]

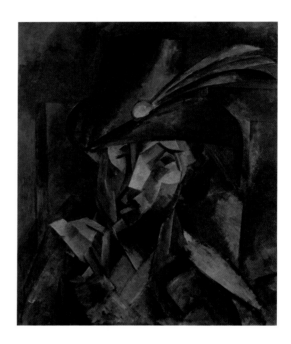

Raphael's critical thinking was altered, however, by a process that began with his seeing Picasso's *Still Life with Inkwell*, a painting from winter 1910–11 that was on display in the window of Kahnweiler's gallery by spring 1911. Raphael later recounted how he tried unsuccessfully to purchase the work that had captivated him, but also how the interaction with Kahnweiler led to a series of visits to Picasso's studio and discussions about his work.[18] He also recalled the powerful impact of the gallery of Picasso's work at the Sonderbund exhibition, terming it the moment when two generations divided. Raphael's altered views first appeared in a response to Walther Heymann's discussion with

Pablo Picasso
Woman in a Black Hat, 1909–10
Oil on canvas
28 ¾ × 23 ⅝ in. (73 × 60 cm)
Toledo Museum of Art

Pechstein about Picasso. Raphael objected to Picasso being called a Cubist, saying that Cubists were ignorant followers of Picasso, who was a "creator of a new world."[19] He argued that cubic form was the product not of intellect, as Pechstein had suggested, but of a determination to give a more independent, richer shape to experience, concentrate "individual sensation by a ruling law," and avoid any "arbitrariness, accident, or caprice."[20]

By the time his book was published in 1913, Raphael had little positive to say about the flat, decorative painting of Matisse and the German Expressionists. He compared Matisse's use of color surfaces with Cézanne's, arguing that, lacking Cézanne's tension between surface and the three-dimensionality of experienced space and things, Matisse's color surfaces were not true pictorial forms but abstract decoration without the tension inherent in life.[21] The Expressionists, he wrote, had begun with gifts, though had not understood that that deformation of nature could not be "arbitrarily undertaken on subjective grounds," but must find the "law of absolute creation." "Today's grave," he wrote, "is the decorative *panneau*, the poster, complete emptiness."[22]

The way Picasso had opened Raphael's eyes to the importance of the tensions of plastic space and form was echoed in Carl Einstein's criticism.[23] Einstein had read extensively in contemporary art history and had also begun to visit Paris, where he joined the Café du Dôme circle and became aware of Picasso. In his first article that mentioned Picasso, in 1912, he argued that Picasso built on Cézanne's use of the plane in plastic modeling and sought "the plastically decisive points, which he doesn't interpret as colored qualities, but rather as stereometric spatial figures. He subordinates all of these to each other and brings them into a system that shows us how much plastic expression resides in a visual experience."[24] Picasso's focus on plastic values left, Einstein wrote, "our wallpaper synthesizers and participants standing in little groups and shaking their heads."[25] In the foreword to the first exhibition catalogue of Otto Feldmann's Neue Galerie in Berlin, Einstein claimed that Picasso's Cubism not only saved painting from the ornamental surface style but also, through its plastic qualities, opened viewers' eyes to similar qualities in African, Egyptian, Gothic, and Baroque sculpture.[26]

Einstein had seen the Picasso retrospective at Thannhauser's Moderne Galerie in February 1913, in which 114 works from 1901 to 1912 were exhibited, and also knew that Otto Feldmann had shown a slightly reduced number of these works at his Rheinische

Kunstsalon in Cologne in March.[27] Thus, Einstein was happy to ally with Feldmann when he opened a gallery in Berlin and probably had some involvement with the Neue Galerie's second exhibition, in winter 1913, which displayed seventy-six works, mostly of the Cubist period, alongside nineteen examples of African sculpture. The latter element was novel and must have appealed to Einstein, who was already collecting material for his important study of African sculpture that would be published in 1915.[28] Adolf Behne provided, with photographs, the most insightful review of the exhibition, in which he cited the importance of Raphael's book.[29] Behne described the "brutality" of the works of 1907–8 as "expressionistic," but recognized the carefully considered construction of some paintings from this period, writing of *Three Women* (which was on its way to Russian collector Sergei Shchukin after its sale to Kahnweiler by Leo and Gertrude Stein) that it was "a treasure with its masses of fused green, blue, and red enamel on the brown of the ground."[30]

Poet and critic Theodor Däubler provided a much more eccentric and personal response to Cubism.[31] During the new century's first decade, he led a vagabond existence but studied architecture and art closely, particularly in Paris and Italy, while writing an epic poem, *Das Nordlicht* (The Northern Lights).[32] Following its publication in 1910, Däubler's work began to appear in Expressionist journals, including a response to Thannhauser's Picasso exhibition of February 1913. He began his essay by addressing what he termed "cubism in nature," comparing the buildings in Picasso's paintings of Horta de Ebro to the towns that mounted the Sabine Hills east of Rome, both of which appeared, he wrote, "like druse, like special random crystals" that had formed on the larger cubic masses.[33] However, he followed this by saying that Cubism arose from psychology, not nature—that is, from Picasso's turn to African art due to his panic about his previous eclecticism. His study of the simple surfaces of African sculpture revealed that each was "the springboard to new unfoldings of space," eventually developing his insights into "a universally valid system." This new system demanded equally passionate involvement from creator and observer. The forest settings of Picasso's paintings done at the rue des Bois required the observer to "sink" into them, while his later works of musicians, poets, and still lifes evoked

…the peaceful dawning of the soul and things in rhythmical stratifications. Often the depicted

world only in its crystalline self-civility, then suddenly its fateful demonic nature melodically tapping in surprising colors.... Then, however, again symphonic compositions of enigma, inevitable secrecies of a soul, lightly moaning renunciations and, in between, again joyful ideas; everything becoming crystal clear to a hair's breadth, and underscored and at the same time softened by colors.[34]

The crystal became Däubler's image for embodying Picasso's system, one suspects, because *Crystal Bowl*, a mysterious faceted surface from winter 1908–9, was one of the paintings that he saw in the Thannhauser exhibition.[35] However, beyond this, the crystal was his principal metaphor for artistic creation in general, prompting him to characterize Cubism elsewhere as follows: "Things show by themselves their inner geometries. They radiate their own ownership of soul. Consequently, once again, mystical perspective, prelude to a hierarchy. Backflow into the I-Crystal."[36]

Däubler wrote these words as one of "Zarathustra's children," a poet with renewed interest in German Romanticism, who sought to follow Nietzsche in the creation of a mythic worldview that combined Dionysian ecstasy with Apollonian order.[37] The thirty thousand verses of *Das Nordlicht* are a vast paean to the sun, set primarily in the Mediterranean

and the Near East, expressive of a constant longing for the earth "to become a radiant star again." The aurora borealis, he wrote, was the manifestation of that intense desire even in the Far North: "Even in the ice. Especially there, at the poles, where the night is deepest and lasts longest—especially there we find this powerful longing."[38] The crystal, with its three-dimensional order, hard facets, and flickering sparks of light, joined artistic form with passion in a way that, for Däubler, recalled its use by Romantic writers as well as by Expressionist artists.[39]

Artistic Response

Both Raphael and Einstein noted and encouraged Pechstein's shift away from surface decoration. Having viewed several late Cézannes shown by Paul Cassirer in April 1912, Pechstein increased his own paintings' spatial effect, particularly in still lifes that introduced colorfully patterned drapery.[40] When these were shown at the Kunstsalon Fritz Gurlitt in February 1913, Raphael pointed to how they "fulfilled Cézanne's two requirements: a personal sensibility and a personal logic," and contained a feeling for life that distanced his work from "the pure surface and pure color of the formalists."[41] Similarly, regarding works shown in the Berlin Secession in spring 1913, Einstein wrote: "Pechstein shows works that belong to the best in the exhibition. He has freed himself from flat decoration, from the cheaply rhythmical, and

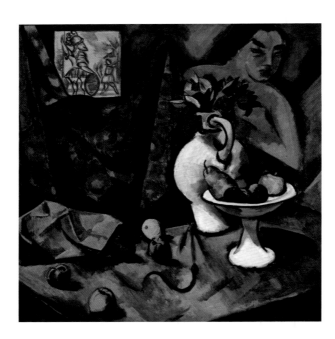

Max Pechstein
Still Life with Nude, Tile, and Fruit, 1913
plate 125 | cat. 176

recognized that to produce strong painting it was a matter above all of a spatial order."[42]

Ernst Ludwig Kirchner's initial encounter with Cubist painting probably came during a trip to Prague in August 1911, which initiated his association with Bohumil Kubišta and helped prepare him for seeing Picasso's and Braque's paintings at the Berlin Secession and Sonderbund exhibitions in 1912.[43] This began to affect the paintings that developed from his stay on Fehmarn island during summer 1912.[44] Curt Glaser recognized Kirchner's response to French art when he wrote about a work exhibited at the Berlin Secession during April and May 1913: "Kirchner speaks most purely in the harbor landscape, reminiscent of Matisse in its strong simplification. However, the pleasant clarity of the French is obvious in comparison. Kirchner still finds it necessary to force things, in order that they fit in his scaffolding of lines and colors."[45]

He compared Kirchner's work to four Matisse paintings in the same exhibition as well as seven Matisses shown at the Kunstsalon Fritz Gurlitt in May 1913.[46] Kirchner's *Burgstaaken Harbor* is dominated by acidic colors, which may have reminded Glaser of Matisse's Moroccan paintings of 1912–13; however, his reference to "scaffolding" is more telling about the painting's new treatment of form and space. *Scaffolding* has become a term used to describe the network of lines and tones that Picasso and Braque began to employ in

1909–10. Braque's *Little Harbor in Normandy* of spring 1909, which was owned by Flechtheim, shows an earlier stage of this development, in which diamond-shaped *taches* cover the surface in the manner of Cézanne, uniting sky, water, boats, and the harbor's structures.[47] If, as has been suggested, this is a representation of Le Havre's harbor done from memory, the image has departed from Impressionism and even from Braque's earlier paintings, for in reality the harbor was busy and huge, composed of multiple basins with interconnecting locks. In the painting, Braque radically shrank the outer harbor, compressing its space by greatly enlarging the lighthouses at the jetties' ends, to a point where it can barely contain the two fishing boats. The ocean liners that would be present are forgotten as Braque's reimagining and the painting's own reality take charge. Fragmented multiple views of the port are enlarged, compressed, and shifted as bowsprits, masts, booms, seawalls, and quays interact within the diagonal grid formed by the *taches*. The result, however, mimics the reality of durational experience, as the boats shift position with the water's rise and fall. Unlike Braque, however, Kirchner retained a much stronger sense of the site as a distinct and working environment. Comparing the painting with his observational sketches shows that he condensed the inner basin's space and synthesized different views of the cargo cutters and harbor's architecture. Although there is little

Ernst Ludwig Kirchner
Burgstaaken Harbor, 1912
Oil on canvas
25 13/16 × 38 1/16 in. (65.5 × 96.7 cm)
Bremen Kunsthalle

Georges Braque
Little Harbor in Normandy, 1909
Oil on canvas
31 7/8 × 31 7/8 in. (81 × 81 cm)
Art Institute of Chicago, Samuel A. Marx
Purchase Fund

267

Cubist scaffolding, to use Glaser's term, other things—such as the granary with its sharply pitched roof, painted or tiled with the letters *M H I S S F*—loom large. Beyond the harbor can be seen the station for the island's rail system and the buildings that line the Staakensweg, the road that runs north to Burg auf Fehmarn, the island's main town.[48]

By contrast, Kirchner's figure paintings during his time on Fehmarn seem more indebted to Picasso than to Braque. Like Picasso's figures of 1907–8, the bodies of Erna and Gerda Schilling bathing amid the boulders below the Staberhuk lighthouse are well-fitted constructions of clearly defined plastic forms, similar to those of African sculpture as defined by Einstein: "Characteristic of Negro sculptures is a pronounced individuation of their component parts.... The parts are aligned, not according to the beholder's point of view, but from within themselves."[49] Only in 1927 did Kirchner acknowledge, to some degree, his relationship with French Cubism, when he noted the ways that Picasso (as in *Woman in a Black Hat*) and he had similarly transformed the representation of the human face by combining profile with *en face* views.[50] It is therefore not surprising that this spatial tension is produced fluidly in one of the pencil sketches Kirchner made in 1913 of a person's face while moving through a Berlin street.

Kirchner referred to "scaffolding" in describing the structure (plate 83) of the street paintings that were based on such sketches, writing: "There are pictures and prints in which a purely linear scaffolding with almost schematic figures nevertheless represents the life of the street in the most vital way."[51] These city paintings extract ideas for representing modern experience from Futurist and Cubist paintings to create works that do not resemble those Italian and French paintings but that are able to convey the feeling of the traffic's velocity, the abrupt changes of direction and varied rhythms of walking in a crowd, as well as the frisson and intimate anonymity of brushing bodies.

Cubism opened different paths for Karl Schmidt-Rottluff, Lyonel Feininger, and Erich Heckel. Feininger probably made Schmidt-Rottluff's acquaintance in late 1911, leading to an invitation, which Feininger declined, to participate in the Brücke's group exhibition at the Kunstsalon Gurlitt in April 1912. This began, however, a lifelong friendship with Schmidt-Rottluff and Heckel. Schmidt-Rottluff likely encountered Cubism around the time he met Feininger, soon after his move in October 1911 from Dresden to Berlin. Its earliest manifestation seems to have been a portrait of a woman reading that was painted in late January 1912. After his arrival, he came into contact with Der Neue Club, a group

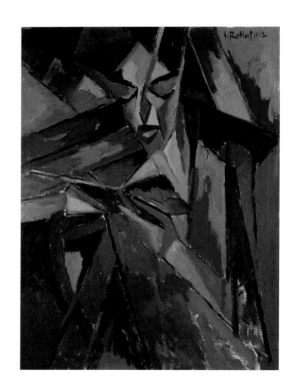

Ernst Ludwig Kirchner
Drawing in Sketchbook 37, 1913
Pencil
8 × 6⅜ in. (20.4 × 16.2 cm)
Kirchner Museum Davos

Karl Schmidt-Rottluff
Reading Woman (Else Lasker-Schüler), 1912
Oil on canvas
40³⁄₁₆ × 29¹⁵⁄₁₆ in. (102 × 76 cm)
Hermann Gerlinger collection
Stiftung Moritzburg, Kunstmuseum
des Landes Sachsen-Anhalt

of Expressionist writers, and designed a new header for the programs of their evenings of public readings, the Neopathetic Cabaret.[52] This increased his involvement with literary figures, as did his friendship that had developed in 1910–11 with writer Richard Dehmel.[53] In 1912, poet and playwright Else Lasker-Schüler announced in *Der Sturm* that Schmidt-Rottluff had asked to paint her portrait, which is likely the previously mentioned work.[54]

The forms and composition of *Reading Woman* are drastically different from a painting of the same title that he had completed the previous year.[55] The young woman in the portrait of 1911 leans back into a cushion as she silently reads a book brought close to her face. All forms are described by flat areas of contrasting colors bound by loosely brushed black lines and areas of exposed canvas. The earlier work's soft, even, decorative surface is replaced by sharply defined, modeled, and angled planes in the later work, in which diagonally positioned arms thrust a blue book forward, forming a vertical triangle that supports the energetic head with downward-focused eyes and open mouth declaiming from the text. Although the portrait of Lasker-Schüler was unfinished when Schmidt-Rottluff left Berlin for Hamburg in mid-January, there is some similarity between *Reading Woman* and the poet's description of her portrait:

Schmidt-Rottluff has painted me sitting in the tent. A mandrill, who recites battle hymns.... Enchanted by my colorful personality, primitive frightfulness, by my dangerousness, but my golden forehead, my golden eyelids watch over my blue poems. My mouth is red like a brambleberry, heaven spruces itself up into a blue dance in my cheek, but my nose waves to the east, a battle flag, and my chin is a spear, a poisonous spear. Thus I sing my song of songs.[56]

The nose and chin projecting down and forward from the brow in *Reading Woman* do resemble a mandrill's elongated muzzle, while the colors suggest the vibrant hues of a dominant male mandrill, the most colorful of all primates.

While Cubism's impact on the work is clear, how it occurred is less so. Schmidt-Rottluff may have seen photographs of works by Braque and Picasso that Kahnweiler sent to Wilhelm Niemeyer, an organizer of the Sonderbund exhibitions, or heard about Niemeyer's visit to Picasso's studio in December 1911. Schmidt-Rottluff had become friends with Niemeyer, the director of the Hamburg School of Applied Arts, during 1911.[57] Finally, he may have seen Picasso's 1909

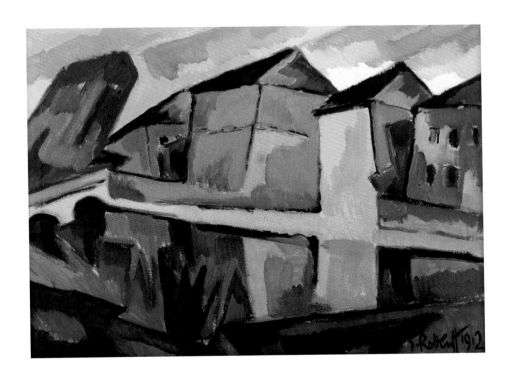

Karl Schmidt-Rottluff
Houses on Canal, 1912
Oil on canvas
29⅛ × 40 3⁄16 in. (74 × 102 cm)
Staatliche Museen zu Berlin,
Neue Nationalgalerie

drawing (p. 263), whose faceting, thrusting torsion and muted radiance suggest a relationship to the Lasker-Schüler portrait.[58] However, it is equally clear that Schmidt-Rottluff followed a path that was distinct from Picasso, as the glowing color—the aspect that Lasker-Schüler had emphasized most in her comments about her portrait—is found in other Cubist-influenced paintings of different genres (such as *Dahlias in Vase*) that he produced in Hamburg between January and March 1912. *Houses on Canal* (p. 269) differs from the landscapes painted at Lofthus, Norway, during the summer of 1911 in a manner similar to the differences between the two *Reading Woman* paintings.[59] The Norwegian landscapes juxtapose areas of color bounded by variously colored lines, many of which are simply glimpses of bare canvas between the color planes. While many diagonal planes are present, in roofs and walls, all hold evenly to the canvas's surface. The forms in *Houses on Canal*, however, are outlined in black and the wall and roof planes have highlights that cause their cubic forms to thrust and shift. Their vectors continue into the sky and are reflected in the water's surface, creating a radiant, multicolored, crystalline world. The ecstatic experience of nature, as suggested in *Houses on Canal*, is a reminder that Schmidt-Rottluff dedicated a woodcut of a monumental female nude, probably executed during this period in Hamburg, to poet Alfred Mombert, a friend of Dehmel;[60] Rosa Schapire later recalled the lines that inspired the print:

> Silvered waters that engulf us, rippling!
> And we sank into the blissful days of creation.
> "Woman, whom do you suggest?" I whispered softly…
> And she smiled the deepest gaze of love.[61]

These were published in *Der himmlische Zecher* (The Celestial Carouser), a 1909 poetry collection in which Mombert sought a "symphonic" linkage of the human, the crystalline, and the cosmic—a multidimensional, dithyrambic unity suggested by the following passage, reminiscent of *Houses on Canal*:

> Close to the crystal panes
> Flooded blue-green
> Looms the iceberg world
> Round about me high and radiant.
> Here in the midst is my dark face:
> Icebergs are its radiant crown.[62]

Schmidt-Rottluff may have influenced Feininger as the latter became, in Carl Einstein's words, "the German Cubist," although he "found his path rather late."[63] A prominent cartoonist, Feininger's determination to become a painter grew stronger in the period between 1905 and 1907. Julia Berg, a twenty-four-year-old artist with whom Feininger began an affair in 1905, encouraged this desire. Having left their spouses, the couple spent an idyllic period sketching together during the spring of 1906 in the villages around Weimar, where Julia was studying. The stone bridge in Oberweimar and the small church in Gelmeroda were among the motifs that captivated them. A commission from the *Chicago Tribune* allowed them to move to Paris, where Feininger joined the circle at the Café du Dôme and split

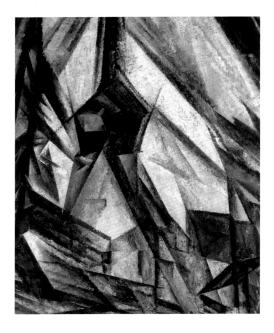

his time between cartoon illustrations and painting. His paintings, which began to be shown in the Berlin Secession after he moved back to Berlin in 1908, developed mostly from his illustrations, using bright, Fauve-inspired colors. These works were criticized for their grotesque distortion of proportion and perspective, but, as Einstein later wrote, these factors opened Feininger to "the self-sufficiency of the picture" he soon found in Cubism.[64] But though Einstein mentioned a "Cubist Head" by Feininger from 1909, this was incorrect, for Feininger came to Cubism more slowly than that. The first true Cubist-inflected qualities in his

Lyonel Feininger
Gelmeroda I, 1913
Oil on canvas
39 9/16 × 31 11/16 in. (100.5 × 80.5 cm)
Private collection

work were seen in 1912 in the tentative faceting of motifs, such as the bridge and church mentioned above, which continued to form a stage for the humorous actions of Biedermeier figures from the age of Romanticism. He developed a restructuring of subject and form during 1913, when he worked again in Weimar from April to September.[65] Writing to an old friend, he stated that his "cubism" differed from that of the French in its concentration of vision, as opposed to the French "chaotic dispersal of form," a process that "degraded into mechanism." He, in contrast, sought a "living form," its "visionary" qualities being better called "prism-ism."[66]

This direction was soon seen in his painting *Bridge I* (plate 35) of the stone bridge that had been built over the Ilm River in 1723. He steepened the bridge's apex and turned its rounded arches into pointed ones. Echoes of these arches rise into the sky, while their reflections unite with the river's rush to create a dynamic interrelationship of human-made forms and natural forces.[67] Feininger also did numerous sketches of the Gelmeroda church, three of which led to more developed Cubist drawings and oil paintings in 1913. *Gelmeroda I* presents the choir and tower from the east, but previous elements of the grotesque, such as the clockface that gazed from the tower's pommel and the mummery of parading figures, have been reduced to small areas of blue and red. The narrow, eight-sided spire dominates the painting, punching through the frame's upper edge, its force sending diagonals radiating through the sky, which echo those of the tower's pommel, the choir's roof, and the evergreen tree on the left edge. The surface becomes a system of strata and facets, leading Däubler to later call Feininger "the clearest maker of crystals," suggesting that while he calculates his paintings, he also has sensitive ears and hears the crystal's powerful rhythm, its "heartbeat, which breathes, grows, lives and loves."[68]

As Feininger explained in a letter to Alfred Kubin, the contemplation of these small churches, such as Gelmeroda, was a spiritual act: "There are church towers in godforsaken holes that are among the most mystical I've ever seen created by so-called cultural beings!"[69] Scholars have noted the continuities with German Romantic thought among Feininger and his peers, as in the fascination with the crystal as artistic symbol and the connections drawn between it and the Gothic, as when Friedrich von Schlegel wrote about Cologne Cathedral: "And if the exterior, with its countless towers and pinnacles, appears at a distance not unlike a forest, the entire structure, if one steps somewhat closer, looks like some magnificent natural crystallization. In a word, in regard to the organic infinitude and inexhaustible wealth of form, it most resembles those wonder-works of art, the works and products of nature itself."[70] An Expressionist paean by Däubler suggests that he was aware of Schlegel's words and the contribution that they had made to the cathedral's completion in the nineteenth century: "Like a glacial mountain, I saw you from Mühlheim, sparkling with a thousand points in August-blue.... I have set foot in Cologne Cathedral. One step and I was removed into a heavenly sphere. Sacred One, you are only accidentally our guest. Cologne glacier, have you flown up from a region of crystalline perfection to

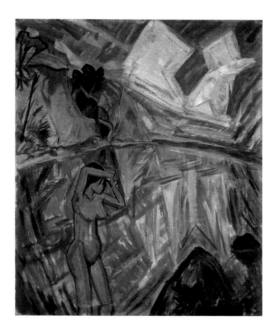

that of humanity?"[71] These feelings and ideas also had contemporary currency in the art theory of Wilhelm Worringer, as well as the architectural fantasy and practice of Paul Scheerbart and Bruno Taut.

Erich Heckel, like Feininger (whom he met in the fall of 1912), was slow to absorb Cubist effects; once present, they were neither obvious nor constant. These effects were first possibly seen in his representations of a wooden bridge over a canal at Caputh, a village southwest of Potsdam, made during the winter and spring of 1912–13.[72] He developed a Cubist-like scaffolding from the tree branches and bridge that are reflected in the

Erich Heckel
Glassy Day, 1913
Oil on canvas
47¼ × 37¹³⁄₁₆ in. (120 × 96 cm)
Bayerische Staatsgemäldesammlungen
Neue Pinakothek, Munich

271

water and form a shallow, diamond-shaped network of lines. This preoccupation with the "constantly moving, prismatic and faceted structure" found in reflections continued in Heckel's works from a summer spent in and near Hamburg, as well as at Osterholz, a site adjacent to the southern coast of the Flensburg Firth.[73] Another Cubist effect is found in certain Osterholz bathing scenes, such as the naked figures that kneel and sit next to boulders. Seeking protection, perhaps, from the chilly wind, they are associated with the mass and endurance of stone, which contrasts with the fugitive effects of light and sky. *Female Nude on the Beach* (plate 60) rises like a slim sculpture, framed by a niche/mandorla developed from the beach's sand and stones. Its angular plasticity and inwardness are related to *Standing Woman*, a wooden sculpture carved at Osterholz and influenced by Gothic

This raises questions about connections between German Romanticism and Heckel's work, particularly the seascapes he made during his military service in Belgium and continuing through the 1920s at Osterholz. It is possible that the influence of German Romanticism grew out of Heckel's friendship, established in 1912, with Walter Kaesbach, a young art historian whom Ludwig Justi had charged with expanding the modern section of Berlin's National Gallery. Heckel and Kaesbach met for reading evenings, in which Romantic texts probably figured, since other friends (such as Ludwig Thormaehlen and Ernst Moritz) were members of the George Circle.[77] Poet Stefan George had resurrected the status of Romantic writer Jean Paul, and was seen around 1910 as the poetic heir of Friedrich Hölderlin, and these were all writers Heckel valued

statues Heckel saw at the Kunstgewerbemuseum in Flensburg.[74] Janina Dahlmanns has related the bather in *Glassy Day* (p. 271) to the sculptures, pointing to the figure's color and woodenness.[75] She has also remarked how, although the blue water is reflected on the bather's brown form, the figure's contrast with the crystalline sky and sea suggests a melancholic separation from nature that is also found in the *Rückenfiguren* of Caspar David Friedrich.[76] This contrast is also at play in the opposing vectors of the brown/blue boulder in the right foreground and the reflections of the white clouds in the water above it.

during the war. Caspar David Friedrich's paintings, of which the National Gallery had a particularly strong collection, may have also become important for Heckel. When Justi published a guide after the war to rehanging nineteenth- and twentieth-century paintings in the Crown Prince's palace, he devoted his longest discussion to Friedrich's *Monastery Graveyard in the Snow,* which opened the book's final chapter, "Expression."[78] Justi's discussion stood in contrast to previous chapters, which were devoted to different approaches to painting, particularly the penultimate chapter, which focused on painting as visual pleasure. Beginning with a discussion

Caspar David Friedrich
Monastery Graveyard in the Snow, 1817–18
(destroyed 1945)
Oil on canvas
47 5/8 × 66 15/16 in. (121 × 170 cm)
Formerly Staatliche Museen zu Berlin,
Nationalgalerie

of Edouard Manet's *Bouquet of Lilacs*, Justi moved through the French painters of the second half of the nineteenth century before turning to the German artists they influenced. He presented Cubism as a logical development of this French tradition, but one that created more enthusiasm among German intellectuals and collectors, who wanted to understand everything, than it did among painters.[79] Justi ended by writing that his final chapter would investigate painting that "leads out of the tranquil rut in which we were deposited by Manet" and into one in which "the expression of inner experience becomes the most essential meaning of artistic creation."[80]

After an exhaustive discussion of the content, form, and color in Friedrich's painting, Justi stressed the tension between the endurance of organic life, as

to painting that he also found in contemporary German painting: "It is a disintegration of self before the eternal secret of nature, which also lives in the desire of our era's young landscapists, comparable not in technique but in creation from inner experience."[82] Justi concluded with a discussion of Heckel's works made during the war, whose inner sound he compared to the works of Friedrich.[83]

Canal in Winter, a painting done over the winter of 1913–14, suggests, however, that Friedrich's influence on Heckel predated the war. While the painting's subject originated in central Berlin, its form echoes words that Heckel wrote to Kaesbach on January 29, 1914: "I was outside in the hoarfrost when it was 17 degrees Fahrenheit in Caputh. The forest a glass structure, no longer burdened by gravity. A ringing clarity. And then the canal with the wooden bridge, completely black,

embodied by the oak grove, and the simultaneously transitory and transcendent qualities of human spiritual culture as manifested in the Gothic ruin and the funerary procession. He summarized: "The rich harmony of the pictorial feeling rests on this double reverberation: the heavy breath of nature in winter and the upward strivings of the heart ascending from the grave to ideas of eternity, which calm and save it."[81] Most important for the topic of this essay, however, is Justi's assertion that in Friedrich's work "it is the soul of the artist, which enters into everything, that lives through and creates the experience of form." This was an approach

white milky ice on the edge, the trees, the branches of which reduced to white crystals, bent down."[84] Ice creeps out from the snow-lined banks that converge toward the horizon, while bare, black trees rise and bow below the crystal-blue sky. No bridge interrupts the rush and fall into the infinite, for the city does not end the vista, only the sky, which continues into its reflection in the water, opening a chasm in which some trees resemble claws or scythes. The landscape has a funereal quality, similar to the solemn content and form of *Monastery Graveyard in the Snow*.

Erich Heckel
Canal in Winter, 1913–14
Oil on canvas
31½ × 27⁹⁄₁₆ in. (80 × 70 cm)
Staatliche Museen zu Berlin,
Nationalgalerie

Conclusion

Each of the artists discussed above was alert to the broad interest in Cubism among German dealers, critics, and collectors during the period immediately prior to World War I. Yet it was to some degree a "byway"—not for the larger field of painting, as Curt Glaser had meant, but for each of them as painters, since they had interests that arose from personal experiences as well as from national traditions of thought and painting. However, they appropriated aspects of Cubism that fit their needs and certainly did not dismiss it as a movement, as indicated by Schmidt-Rottluff's response to Ernst Beyersdorff,

an important patron in Hamburg, who had ridiculed Picasso:

> Now, dear Beyersdorff, your judgment about Picasso! I will not write to you what I think of Picasso, and what he offers me—your characterization prevents me. But don't you believe that it must appear really provincial and even directly comical if a man, who takes seriously the best minds of our age and involves himself intensely with them, is described by you as ripe for the madhouse and as a joker.[85]

ENDNOTES

1. M., "Die Kubisten," *Lustige Blätter* 25, no. 49 (December 6, 1911). Translations are by the author unless otherwise noted.

2. Michael Koch, "Die 'Neue Künstlervereinigung München' und der Kubismus," in Annegret Hoberg and Helmut Friedel, eds., *Der Blaue Reiter und das neue Bild: Von der 'Neuen Künstlervereinigung München' zum 'Blauen Reiter'*, exh. cat. (Munich: Städtische Galerie im Lenbachhaus, 1999), 286–91.

3. Hans Rosenhagen, "Deutsche Wilde," *Der Tag*, February 2, 1911.

4. Carl Vinnen, *Ein Protest deutscher Künstler* (Jena: Diederich, 1911), 65–68.

5. Kenneth E. Silver, *Esprit de Corps: The Art of the Parisian Avant-Garde and the First World War, 1914–1935* (Princeton, NJ: Princeton University Press, 1989), 8–13.

6. Nancy J. Troy, *Couture Culture: A Study in Modern Art and Fashion* (Cambridge, MA: MIT Press, 2003), 57–67.

7. Lyonel Feininger in Berlin/Zehlendorf to Alfred Churchill, March 13, 1913, p. 2, Archives of American Art, http://www.aaa.si.edu/collections/container/viewer/Letters—190602.

8. Ottfried Dascher, *"Es ist was Wahnsinnges mit der Kunst": Alfred Flechtheim; Sammler, Kunsthändler und Verleger* (Wädenswil: Nimbus, 2011).

9. The catalogue also listed "200. Landschaft in Spanien" (Landscape in Spain), so one of the Horta landscapes may have also been on view.

10. Curt Glaser, "Die XXIV. Ausstellung der Berliner Secession," *Die Kunst für alle* 27, no. 18 (June 15, 1912): 418–20.

11. Michael Fitzgerald, "Picasso in Verganenheit und Gegenwart," in Barbara Schaefer, ed., *1912, Mission Moderne: Die Jahrhundertschau des Sonderbundes*, exh. cat. (Cologne: Wallraf-Richartz Museum, 2012), 121–28.

12. H. von Wedderkop, *Sonderbund Ausstellung, 1912: Führer nebst Vorwort* (Bonn: A. Ahn, 1912), as reprinted in Wulf Herzogenrath, ed., *Früher Kölner Kunstausstellungen: Sonderbund 1912, Werkbund 1914, Pressa USSR 1928* (Cologne: Wienand, 1981), 263.

13. Julius Meier-Graefe, "Kunst-Dämmerung," *Frankfurter Zeitung*, June 2, 1912, 1st morning ed., 3.

14. Ibid.

15. M. R. Schönlank, "Der Sonderbund in Düsseldorf," *Nord und Süd* 135, no. 2 (October 1910): 154–57, as reprinted in Max Raphael, *Das schöpferische Auge oder die Geburt des Expressionismus: Die frühen Schriften 1910–1913* (Vienna: Gesellschaft für Kunst und Volksbildung, 1983), 35.

16. M. R. Schönlank, "Die neue Secession," *Nord und Süd* 35, no. 237 (April 1911): 70–73, as reprinted in Raphael, *Das schöpferische Auge*, 57–61.

17. M. R. Schönlank, "Der Expressionismus," *Nord und Süd* 35, no. 438 (1 September 1911), 360–65, and Ron Mannheim, "Max Raphael vor Max Raphael: M. R. Schönlank und die früheste Expressionismustheorie in deutscher Sprache," in Raphael, *Das schöpferische Auge*, 75–81 and 133–35. Piper did not accept the book, which was eventually published in a radically altered version: *Von Monet zu Picasso* (Munich: Delphin, 1913).

18. *Still Life with Inkwell* is in the collection of the Fogg Art Museum, Harvard University. Pierre Daix and Joan Rosselet, eds., *Picasso: The Cubist Years, 1907–1916* (London: Thames and Hudson, 1979), cat. no. 372. Max Raphael, *Aufbruch in die Gegenwart: Begegnungen mit der Kunst und den Künstlern des 20. Jahrhunderts* (Frankfurt am Main: Suhrkamp, 1985), 14–20.

19. M. R. Schönlank, "Lieber Herr Pechstein!" *Pan* 2, no. 25 (May 9, 1912): 738–39, as reprinted in Raphael, *Das schöpferische Auge*, 111.

20. Ibid., 112.

21. Raphael, *Von Monet zu Picasso*, 109–112.

22. Ibid., 106.

23. For discussion of the relationship of Raphael's and Einstein's views, see Werner Drewes, "Max Raphael und Carl Einstein: Konstellationen des Aufbruches in die 'Klassische Moderne' im Zeichen der Zeit," *Etudes germaniques* 53, no. 1 (January–March 1998): 123–37.

24. Carl Einstein, "Anmerkungen zur neueren französischen Malerei," *Neue Blätter* 1, no. 6 (1912): 19–22, as reprinted in Rolf-Peter Baacke, ed.,

Carl Einstein: Werke, vol. 1, *1908–1918* (Berlin: Medusa, 1980), 119.

25. Carl Einstein, "Herbstausstellung am Kurfürstendamm," *Die Aktion* 3 (1913): 1186–89, as reprinted in *Carl Einstein: Werke*, 1:184–87.

26. Carl Einstein, "Vorwort," *Erste Ausstellung der Neuen Galerie*, exh. cat. (Berlin: Neue Galerie, 1913), as reprinted in Carl Einstein, "Zwei Katalogvorworte von 1913/14," *Kritische Berichte* 13, no. 4 (1985), 6–7.

27. Christian Geelhaar, *Picasso: Wegbereiter und Forderer seines Aufstiegs, 1899–1939* (Zürich: Palladion Verlag, 1993), 55–57; and John Richardson, "Picasso und Deutschland vor 1914," *Kunst des 20. Jahrhunderts: 20 Jahre Wittrock Kunsthandel*, exh. cat. (Düsseldorf: Wolfgang Wittrock Kunsthandel, 1994), 10–30.

28. Carl Einstein, *Negerplastik* (Leipzig: Weissen Bücher, 1915). For information about his contacts with collectors and scholars of African art, see Heike M. Neumeister, "Notes on the 'Ethnographic Turn' of the European Avant-Garde: Reading Carl Einstein's *Negerplastik*" (1915) and Vladimir Markov's *Iskusstvo Negov* (1919), *Acta Historiae Artium* 49, no. 1 (2008): 172–85.

29. Adolf Behne, "Pablo Picasso: Zur Ausstellung in der 'Neuen Galerie' Berlin." *Zeit im Bild* 12, no. 2 (8 January 1914).

30. Ibid.

31. Friedhelm Kemp, ed., *Theodor Däubler: Im Kampf um die moderne Kunst und andere Schriften* (Darmstadt: Luchterhand, 1988), 12–13; and Dieter Werner, ed., *Theodor Däubler—Biographie und Werk: Die Vorträge des Dresdener Däubler-Symposions 1992* (Mainz: Gardez! Verlag, 1996).

32. Theodor Däubler, *Das Nordlicht, Florentiner Ausgabe* (Munich and Leipzig: Georg Müller, 1910).

33. Theodor Däubler, "Picasso," *Die Aktion* 5, nos. 33–34 (21 August 1915): 409. The essay was published previously in *Die neue Kunst* 1, no. 3 (March 1914), 231–41; and subsequently in *Der neue Standpunkt* (Leipzig: Insel, 1919): 145–63.

34. Ibid.

35. It was listed in the catalogue as "no. 45 *Kristallschale*." The painting (Daix, cat. no. 320), which is now in

the Staatsgalerie Moderner Kunst, Munich, actually depicts a china bowl that imitates a wicker basket.

36. Theodor Däubler, "Expressionismus," *Die neue Rundschau* 27, no. 2 (1916), 1133.

37. For the neo-Romantic turn, see Raymond Furness, *Zarathustra's Children: A Study of a Lost Generation of German Writers* (Rochester, NY: Camden House, 2000), 6–11 and 152–72.

38. Theodor Däubler, *Das Nordlicht, Genfer Ausgabe* (Leipzig: Insel, 1921–22), 1:11.

39. Henrik Leschonski, *Der Kristall als expressionistisches Symbol: Studien zur symbolik des Kristallinen in Lyrik, Kunst und Architektur des Expressionismus (1910–1925)* (Frankfurt am Main: Peter Lang, 2008).

40. One of the paintings shown by Cassirer was *Still Life with Faience Jug and Fruit*, c. 1900 (Oskar Reinhart Collection, Winterthur), which contains the colorfully patterned drapery that Cézanne introduced in the 1890s.

41. M. R. Schönlank, "Max Pechstein," *Pan* 3, no. 21 (21 February 1913): 492–95, as reprinted in Raphael, *Das schöpferische Auge*, 115–16 and 118.

42. Carl Einstein, "Ausstellung der Sezession in Berlin," *Der Merkur* 4 (1913), 658–59, as reprinted in *Carl Einstein: Werke*, 1:190.

43. Eleanor Moseman, "At the Intersection: Kirchner, Kubista, and Modern Morality," *Art Bulletin* 93, no. 1 (March 2011): 79.

44. I discuss Cubism's impact on Kirchner further in "Hands on the Table: Ernst Ludwig Kirchner and the Expressionist Still Life" (forthcoming in *Art History*).

45. Curt Glaser, "Die XXVI. Ausstellung der Berliner Secession," *Kunst für alle* 28 (July 15, 1913): 462.

46. Five works were destined for Sergei Shchukin's collection, with a triptych going to Ivan Morosov. See "Berliner Ausstellungen," *Kunstchronik* 24 (16 May 1913): 480–91.

47. Dascher, *Alfred Flechtheim*, 419. *Harbor in Normandy* was published in *Umělecký měsíčník* 1, no. 9 (1912): 264–66; another Braque harbor scene (Museum of Fine Arts, Houston) was shown at the fourth exhibition of *Skulpina* in Prague

during spring 1913, and a third Braque harbor painting (National Gallery of Art, Washington, DC) was probably exhibited in the 22nd exhibition of the Berlin Secession as "no. 38 *Der Mastbaum*" in spring 1911.

48. His painting of the town (Donald E. Gordon, *Ernst Ludwig Kirchner* [Cambridge, MA: Harvard University Press, 1968], cat. no. 242), which is in the Städel Museum in Frankfurt am Main, owes much to one of Braque's paintings of La Roche Guyon, which is in the Moderne Museet in Stockholm, to which Flechtheim had access. Dr. Paul Mahlberg, ed., *Beiträge zur Kunst des XIX. Jahrhunderts und unserer Zeit* (Düsseldorf: Ernst Ohle, 1913), 93.

49. *Two Bathers on the Shore with Boat* (Zwei badende Frauen am Strand mit Barke) (Gordon 257), Osthaus Museum, Haagen. Einstein, *Negerplastik*, XIV, as reprinted in *Carl Einstein: Werke*, 1:252.

50. See the entry for 15 April 1927 in Lothar Grisbach, ed., *E. L. Kirchners Davoser Tagebuch* (Cologne: M. Dumont Schauberg, 1968), 142–43.

51. This sentence is also from "Das Werk" in his diary. Grisebach, *E. L. Kirchners*, 86.

52. The new header is found on the programs for December 16, 1911, and April 3, 1912.

53. Gerhard Wietek, *Karl Schmidt-Rottluff in Hamburg und Schleswig-Holstein* (Neumünster: Karl Wachholtz, 1984), 22.

54. Else Lasker-Schüler, "Briefe nach Norwegen," *Der Sturm*, no. 93 (January 1912): 744. Also see Hermann Gerlinger, "Schmidt-Rottluff und 'Der Prinz von Theben,'" in Gunther Thiem and Armin Zweite, eds., *Karl Schmidt-Rottluff: Retrospektive*, exh. cat. (Bremen: Kunsthalle Bremen, 1989), 49–52.

55. Karl Schmidt-Rottluff, *Reading Woman* (Die Lesende), oil on canvas, 76.5 × 84.5 cm, private collection. Thiem and Zweite, plate 30, cat. no. 83.

56. Else Lasker-Schüler, "Brief nach Norwegen," *Der Sturm*, no. 94 (January 1912): 752. The next issue (no. 95) contained a full-page reproduction of a drawing by Schmidt-Rottluff titled *The Prince of Thebes*, which lacked the faceted forms but showed an arm holding a pen thrusting from the chin of Lasker-Schüler's profile.

57. Gerhard Wietek, *Schmidt-Rottluff: Oldenburger Jahre 1907–1912* (Oldenburg: Philipp von Zabern, 1995), 75–77.

58. It had been shown at Paul Cassirer's gallery in early 1911 and was acquired by Charlotte and Paul Mendelssohn Bartholdy for their collection in Berlin.

59. Magdalena M. Moeller, "Schmidt-Rottluff am Hardangerfjord: Zur Entwicklung seiner Landschaftsmalerei," in Magdalena M. Moeller, ed., *Neue Forschungen und Berichte*, Brücke-Archiv 23 (Munich: Hirmer, 2008), 142–50.

60. For Mombert's place in literature, see Furness, 49–73. For the print, see Rosa Schapire, *Karl Schmidt-Rottluff: Das graphische Werk bis 1923* (Berlin: Euphorion, 1924), cat. no. 77.

61. Alfred Mombert, *Der himmlische Zecher* (Berlin: Schuster & Loeffler, 1909), 40. The lines are mentioned in the discussion of woodcut no. 76 in Schapire, 23. One should also note that it is likely Mombert and Otto Müller who are represented in woodcuts nos. 101 and 102, the prints by Schmidt-Rottluff that appear on p. 6 of *Chronik KG Brücke 1913*, exh. cat. (Bern: Kunsthalle Bern, 1948).

62. Mombert, 28. For Schmidt-Rottluff's interest in subsequent crystalline architecture, see his "Ideal Project. Construction of a Mountain City," in Adolf Behne, ed., *Ja! Stimmen des Arbeitsrates für Kunst in Berlin* (Charlottenburg: Photographische Gesellschaft, 1919).

63. Carl Einstein, *Die Kunst des 20. Jahrhunderts* (Berlin: Propyläen Verlag, 1926), 139.

64. Ibid., 140.

65. Martin Faass, *Feininger im Weimarer Land*, exh. cat. (Apolda, Germany: Kunsthaus Apolda Avantgarde, 1999).

66. Feininger to Churchill, pp. 2–3 and 8.

67. Feininger certainly saw Picasso's *Pont Neuf* (private collection; Daix, cat. no. 401) at the Berlin Secession in spring 1912 and while there has been no mention of his visiting the Sonderbund exhibition, one suspects that he did, where he would have seen André Derain's *The Old Bridge* of 1910 (National Gallery of Art, Washington, DC), which was no. 243 in the catalogue.

68. Theodor Däubler, "Lyonel Feininger," *Das Junge Deutschland* 2, no. 10 (1919): 272–73.

69. Lyonel Feininger in Berlin to Alfred Kubin, June 15, 1913, in Ulrich Luckhardt, *Lyonel Feininger* (Munich: Prestel, 1989), 33.

70. Friedrich von Schlegel, "Briefe aus einer Reise durch die Niederlande, Rheingegenden, die Schweiz, und einen Teil von Frankreich," in *Ansichten und Ideen von der christlichen Kunst* (Munich: Ferdinand Schöningh, 1959), 178–79. For the crystal in German Romanticism, see Leschonski, in particular, as well as Ingrid Wernecke, ed., *Lyonel Feininger und die Romantik*, exh. cat. (Quedlinburg: Lyonel-Feininger-Galerie, 1991), and Ingrid Wernecke and Roland März, eds., *Kristall: Metapher der Kunst; Geist und Natur von der Romantik zur Moderne*, exh. cat. (Quedlinburg: Lyonel-Feininger-Galerie, 1997).

71. Theodor Däubler, "Simultanität," *Die weißen Blätter* 3, no. 1 (January–March 1916): 111–12.

72. Erich Heckel, *Canal near Caputh*, 1913, private collection. Magdalena M. Moeller, ed., *Erich Heckel: Aufbruch und Tradition; Eine Retrospektive*, exh. cat. (Berlin: Brücke Museum, 2010), cat. no. 61.

73. Janina Dahlmanns, "'Hoch immer der Himmel über der weit in die Tiefe fliehenden Fläche des Meeres': Die Ostsee und die Stilentwicklung Erich Heckels," in Magdalena M. Moeller and Ulrich Schulte-Wülwer, eds., *Erich Heckel an der Ostsee*, exh. cat. (Berlin, Brücke Museum, 2006), 27.

74. Oliver Kornhoff, "Hölzerne Menschen in der Sommerfrische: Erich Heckels bildhauerische Arbeit an der

Ostsee," in Moeller and Schulte-Wülwer, *Heckel an der Ostsee*, 47–54.

75. Dahlmanns, "Die Ostsee und die Stilentwicklung Erich Heckels," 28.

76. Dahlmanns, "Erich Heckel—Ein Romantiker der Moderne," in Moeller, *Heckel: Aufbruch und Tradition*, 18–19.

77. Thormaehlen, who was trained as both a sculptor and art historian, also worked under Justi at the National Gallery. Kaesbach became commander of a group of nurses that included Heckel in Belgium during World War I. Andreas Gabelmann, "Im Brennpunkt der Moderne—Walter Kaesbach und die Expressionisten," in Christoph Bauer and Barbara Stark, eds., *Walter Kaesbach—Mentor der Moderne*, exh. cat. (Singen: Städtisches Kunstmuseum; Konstanz: Städtische Wessenberg-Galerie, 2008), 9–24.

78. The painting, which was one of the largest that Friedrich created, was a recent gift in 1912 from Paul Freiherr von Merling. Ludwig Justi, *Deutsche Malkunst im neunzehnten Jahrhundert: Ein Führer durch die Nationalgalerie* (Berlin: Bard, 1920), 339–56.

79. Ibid., 277.

80. Ibid., 338. There is a degree of anti-French rhetoric in this position. German intellectuals and collectors were perhaps the most astute in understanding the theory and emotion behind Cubist (i.e., Braque and Picasso) painting and its quality, which would eventually bring a huge windfall to the collectors who invested in it. Painters, on the other hand, were more rooted in their own national tradition of painting, the rhetoric about which had been amplified by World War I and which Justi was perpetuating in showing why the new art of "Expression" was linked to German tradition and should represent the New Germany (the Weimar Republic) in the modern section of the National Gallery.

81. Ibid., 353.

82. Ibid., 356 and 361.

83. Kaesbach was instrumental in acquiring the four works for the National Gallery. Ibid., 396–402.

84. Erich Heckel to Walter Kaesbach, January 29, 1914, as excerpted in Leopold Reidemeister, ed., *Erich Heckel: Gemälde, Aquarelle und Zeichnungen aus dem Nachlaß des Künstlers*, exh. cat. (Berlin: Brücke Museum, 1976), 8.

85. Karl Schmidt-Rottluff to Ernst Beyersdorff, November 15, 1912, as excerpted in Gunther Thiem, "Karl Schmidt-Rottluff: 1912—Experiment Kubismus," *Städel-Jahrbuch* 13 (1991): 245.

Checklist of the Exhibition

Frauke Josenhans

Works are presented chronologically by artist. For dimensions, height precedes width. Venues for each object are indicated at the end of each entry as follows: Zürich (Kunsthaus Zürich); Los Angeles (Los Angeles County Museum of Art); Montreal (Montreal Museum of Fine Arts).

When relevant and possible, we have included exhibition, provenance, and publication history through 1918. Exhibitions are limited primarily to those occurring in France and Germany. Many Neo-Impressionist and Fauvist works were shown in Germany before World War I, but since exhibition catalogues or brochures, if extant, often list only general titles (e.g., "Landscape" or "Still Life"), it is frequently difficult to say whether a specific work was shown in Germany or France during this period. Provenance lists the owner, the place, and the date of acquisition (as available).

The checklist is complete as of November 25, 2013.

Cuno Amiet
Swiss, 1868–1961

Mother and Child in the Garden (Mutter und Kind im Garten), c. 1903
Oil on canvas
27 11/16 × 24 3/4 in. (70.4 × 62.8 cm)
Kunstmuseum Basel, Bequest Philipp Trüdinger 1950
[Zürich, Los Angeles, Montreal]
plate 1 | cat. 1

Portrait of the Violinist Emil Wittwer-Gelpke (Bildnis des Geigers Emil Wittwer-Gelpke), 1905
Oil on canvas
23 13/16 × 24 5/8 in. (60.5 × 62.5 cm)
Kunstmuseum Basel, Birmann-Fond 1975
Exhibition: Brücke group show, Lampenfabrik Seifert, Dresden, 1906
[Zürich, Los Angeles, Montreal]
plate 2 | cat. 2

Paul Baum
German, 1859–1932

View of Sluis (Ansicht von Sluis), 1906
Oil on canvas
27 15/16 × 34 5/8 in. (71 × 88 cm)
Galerie Neue Meister, Staatliche Kunstsammlungen Dresden
Exhibition: probably Twentieth Berlin Secession, 1910, no. 4
[Montreal]
cat. 3

Pierre Bonnard
French, 1867–1947

The Mirror in the Green Room (La Glace de la chambre verte), 1908
Oil on paper
19 3/4 × 25 3/4 in. (50.2 × 65.4 cm)
Indianapolis Museum of Art, James E. Roberts Fund
Exhibition: probably Salon d'Automne, Paris, 1908, no. 184
Provenance: Galerie Bernheim-Jeune, Paris (purchased from Bonnard), 1908; Harry Kessler (purchased from Bernheim-Jeune), Weimar and Berlin, 1909
[Los Angeles, Montreal]
plate 3 | cat. 4

Georges Braque
French, 1882–1963

Landscape at L'Estaque (Paysage à l'Estaque), 1906
Oil on canvas
23 5/8 × 31 7/8 in. (60 × 81 cm)
Merzbacher Kunststiftung
Provenance: Galerie Armand Drouant, Paris
[Zürich]
plate 4 | cat. 5

Landscape at La Ciotat (Paysage de La Ciotat), 1907
Oil on canvas
14 15/16 × 18 1/8 in. (38 × 46 cm)
K20 Kunstsammlung Nordrhein Westfalen
Provenance: René Ludin, Paris; Galerie Wilhelm Grosshennig, Düsseldorf
[Los Angeles, Montreal]
plate 5 | cat. 6

Violin and Palette (Violon et palette), 1909
Oil on canvas
36 1/8 × 16 7/8 in. (91.7 × 42.8 cm)
Solomon R. Guggenheim Museum, New York
Exhibition: Sonderbund, Cologne, 1912, no. 231
Provenance: Galerie Kahnweiler, Paris; Wilhelm Uhde, Paris, 1910; Edwin Suermondt, probably Aachen, c. 1910 (until 1923)
[Los Angeles, Montreal]
plate 7 | cat. 7

Woman with Mandolin (Femme à la mandoline), 1910
Oil on canvas
31 11/16 × 21 1/4 in. (80.5 × 54 cm)
Museo Thyssen-Bornemisza, Madrid
Provenance: Galerie Kahnweiler, Paris (until 1921)
[Los Angeles]
plate 6 | cat. 8

Paul Cézanne
French, 1839–1906

The Temptation of St. Anthony (La Tentation de saint Antoine), 1877
Oil on canvas
18 1/2 × 22 1/16 in. (47 × 56 cm)
Paris, Musée d'Orsay
Exhibition: Salon d'Automne, Cézanne Retrospective, Paris, 1907, no. 3
Provenance: Arsène Alexandre, Paris; Galerie G. Petit, Paris, 1903 (sale at); Eugène Blot, Paris
Publication: J. Meier-Graefe, *Impressionisten* (Munich, 1907), 189; Meier-Graefe, *Paul Cézanne* (Munich, 1910, 1913), p. 21
[Montreal]
plate 13 | cat. 9

Apples and Biscuits (Pommes et biscuits), 1879–80
Oil on canvas
17 11/16 × 21 5/8 in. (45 × 55 cm)
Musée de l'Orangerie, Paris
Exhibitions: Museum of Fine Arts, Budapest, *Collection M. de Nemes*, 1911; Städtische Kunsthalle, Düsseldorf, *Sammlung Marczell von Nemes, Budapest*, 1912, no. 114
Provenance: Ambroise Vollard, Paris; Marczell de Nemes, Budapest; Galerie Manzi-Joyant, Paris, 1913; Baron Maurice de Herzog, Budapest (sold to); Durand-Ruel, Paris
[Los Angeles, Montreal]
plate 9 | cat. 10

Three Bathers (Trois Baigneuses), 1879–82
Oil on canvas
21 5/8 × 20 1/2 in. (55 × 52 cm)
Petit Palais, musée des Beaux-Arts de la Ville de Paris
Exhibitions: Salon d'Automne, Paris, 1904, no. 28; Galerie Bernheim-Jeune, Paris, 1910, no. 27
Provenance: Ambroise Vollard, Paris; Henri Matisse, Paris and Nice, 1899
[Los Angeles, Montreal]
plate 14 | cat. 11

Bathers in Front of a Tent (Baigneuses devant une tente), 1883–85
Oil on canvas
25 × 31 7/8 in. (63.5 × 81 cm)
Staatsgalerie Stuttgart
Exhibition: Salon d'Automne, Paris, 1904
Provenance: Ambroise Vollard, Paris; Moderne Galerie Thannhauser, Munich
Publication: J. Meier-Graefe, *Paul Cézanne* (Munich: 1910, 1913), p. 29; W. Hausenstein, *Der nackte Mensch in der Kunst aller Zeiten und Völker* (Munich: Piper, 1913), fig. 151
[Zürich]
cat. 12

Still Life with Apples and Pears (Grosses pommes), c. 1891–92
Oil on canvas
17 5/8 × 23 1/8 in. (44.8 × 58.7 cm)
The Metropolitan Museum of Art, New York, Bequest of Stephen C. Clark, 1960
Exhibition: Galerie Paul and Bruno Cassirer, Berlin, 1900, no. 12
Provenance: Ambroise Vollard, Paris (bought from the artist), 1899; Emil Heilbut, Berlin (bought from Vollard), 1900; Bruno and Paul Cassirer, Berlin, 1900; Paul Cassirer, Berlin, 1901; Lucie Ceconi (ex-wife of Paul Cassirer), Berlin, 1902; Josse and Gaston Bernheim-Jeune, Paris (sold to), 1912
[Zürich, Los Angeles, Montreal]
plate 10 | cat. 13

Still Life with Apples (Nature morte avec pommes), 1893–94
Oil on canvas
25 3/4 × 32 1/8 in. (65.4 × 81.6 cm)
The J. Paul Getty Museum, Los Angeles
Exhibitions: Pavillon Manes, Prague, *Tableaux modernes*, 1907, no. 55 [?]; Sonderbund, Cologne, 1912, no. 129
Provenance: Ambroise Vollard Paris; Paul Cassirer, Berlin
[Los Angeles]
plate 8 | cat. 14

Boy with a Straw Hat (L'Enfant au chapeau de paille), 1896
Oil on canvas
27 1/8 × 22 7/8 in. (68.9 × 58.1 cm)
Los Angeles County Museum of Art, Mr. and Mrs. George Gard De Sylva Collection
Exhibitions: Moderne Galerie Thannhauser, Munich, 1912, no. 7 [?]; *Französische Kunst des XIX. und XX. Jahrhunderts*, Kunsthaus, Zürich, 1917, no. 17
Provenance: Ambroise Vollard, Paris
[Zürich, Los Angeles, Montreal]
plate 11 | cat. 15

Peasant in a Blue Smock (Paysan
en blouse bleue), c. 1896–97
Oil on canvas
32 1/16 × 25 1/2 in. (81.4 × 64.8 cm)
Kimbell Art Museum, Fort Worth, Texas
Exhibitions: probably Galerie Vollard,
Paris, 1898, no. 14; Galerie Cassirer,
Berlin, 1912, no. 8; Sonderbund, Cologne,
1912, no. 146; *G. F. Reber Collection*,
Galerie Cassirer, Berlin, 1913, no. 28;
G. F. Reber Collection, Mathildenhöhe,
Darmstadt, 1913, no. 13; *Französische
Malerei des 19. Jahrhunderts*, Galerie
Arnold, Dresden, 1914, no. 14
Provenance: Ambroise Vollard, Paris,
by 1906; Auguste Pellerin, Paris; Galerie
Bernheim-Jeune, Paris, 1911; Ambroise
Vollard, Paris, 1911; Paul Cassirer, Berlin,
1912; Gottlieb Friedrich Reber, Lausanne,
1913
[Los Angeles, Montreal]
plate 12 | cat. 16

Henri-Edmond Cross
French, 1856–1910

The Pine (Le Pin), 1905–6
Oil on canvas
12 5/8 × 15 15/16 in. (32 × 40.5 cm)
Kunsthaus Zürich, gift Ottilie
W. Roederstein
Provenance: C. Cherfils, Paris; Galerie
Bernheim-Jeune, Paris, 1907
[Zürich]
cat. 17

Bather (Baigneur [Le Lesteur]), 1906
Oil on canvas
36 1/4 × 28 3/8 in. (92 × 72 cm)
Collection des Musées d'art et d'histoire
de la Ville de Genève, 1954-0035
Exhibition: Galerie Bernheim-Jeune,
Paris, 1910, no. 14
Provenance: Harry Kessler (by commis-
sion from the artist), Weimar and Berlin,
c. 1906
[Los Angeles, Montreal]
plate 15 | cat. 18

Robert Delaunay
French, 1885–1941

Saint-Séverin No. 2, 1909
Oil on canvas
39 1/8 × 29 1/8 in. (99.4 × 74 cm)
Minneapolis Institute of Arts
Exhibitions: Salon des Indépendants,
Paris, 1910; *Blaue Reiter* exhibition,
Berlin and subsequent venues, 1912
Provenance: Herbert von Garvens-
Garvensburg, Hanover
[Zürich, Los Angeles]
plate 16 | cat. 19

Red Eiffel Tower (La Tour rouge), 1911–12
Oil on canvas
49 1/4 × 35 3/8 in. (125 × 90.3 cm)
Solomon R. Guggenheim Museum,
New York. Solomon R. Guggenheim
Museum Founding Collection
Exhibition: Galerie Sturm, Berlin, 1913,
no. 17
[Los Angeles, Montreal]
plate 17 | cat. 20

Three-Part Windows (Fenêtres en trois
parties), 1912
Oil on canvas
13 7/8 × 36 1/8 in. (35.2 × 91.8 cm)
Philadelphia Museum of Art,
A. E. Gallatin Collection, 1952
Exhibition: *Robert Delaunay*, Galerie
Sturm, Berlin, 1913, no. 4
[Los Angeles, Montreal]
plate 19 | cat. 21

Windows on the City (*First Part, First
Simultaneous Contrasts*) (Les Fenêtres
sur la ville [1re partie, 1ers contrastes
simultanés]), 1912
Oil on canvas
20 7/8 × 81 1/2 in. (53 × 207 cm)
Museum Folkwang, Essen
[Zürich]
plate 18 | cat. 22

André Derain
French, 1880–1954

Boats in Chatou (Barques à Chatou),
1904–5
Oil on canvas
15 × 21 5/8 in. (38 × 55 cm)
Private collection, USA
[Los Angeles, Montreal]
plate 20 | cat. 23

Boats in the Port of Collioure (Bâteaux
dans le port de Collioure), 1905
Oil on canvas
28 3/8 × 35 13/16 in. (72 × 91 cm)
Merzbacher Kunststiftung
Provenance: Ambroise Vollard, Paris
[Zürich]
plate 23 | cat. 24

*Landscape by the Sea: The Côte d'Azur near
Agay* (Paysage au bord de la mer: La Côte
d'Azur près d'Agay), 1905
Oil on canvas
21 1/2 × 25 9/16 in. (54.6 × 65 cm)
National Gallery of Canada, Ottawa,
purchased 1952
[Montreal]
plate 22 | cat. 25

Landscape at Cassis (Paysage à Cassis),
1908
Oil on canvas
24 × 20 in. (61 × 50.8 cm)
New Orleans Museum of Art
Exhibition: Second NKVM Exhibition,
Galerie Thannhauser, Munich, 1910
[Los Angeles]
plate 21 | cat. 26

Kees van Dongen
Dutch, active France, 1877–1968

Woman with a Flowered Hat (Femme
au chapeau fleuri), c. 1905
Oil on board
18 1/3 × 14 3/4 in. (47.5 × 37.5 cm)
Private European collection
Exhibition: probably *Kees van Dongen*,
Galerie Kahnweiler, Paris, 1908
Provenance: Galerie Kahnweiler, Paris
(by 1908)
[Zürich, Los Angeles]
cat. 27

Nude Girl (Fille nue), c. 1907
Oil on canvas
39 3/8 × 31 7/8 in. (100 × 81 cm)
Von der Heydt Museum Wuppertal
[Zürich]
plate 25 | cat. 28

Modjesko, Soprano Singer (Modjesko,
chanteur soprano), 1908
Oil on canvas
39 3/8 × 32 in. (100 × 81.3 cm)
The Museum of Modern Art, New York,
gift of Mr. and Mrs. Peter A. Rübel, 1955
192.1955
Exhibitions: Galerie Bernheim-Jeune,
Paris, 1907–8; Galerie Bernheim-Jeune,
Paris, 1908
[Zürich, Los Angeles, Montreal]
plate 27 | cat. 29

Girlfriends (Amies), c. 1908
Oil on canvas
39 3/8 × 31 7/8 in. (100 × 81 cm)
Kunsthaus Zürich, gift of Mr. and
Mrs. René Lang
Provenance: Armand Hammer,
New York
[Zürich, Los Angeles, Montreal]
plate 26 | cat. 30

The Purple Garter (La Jarretière violette),
c. 1910
Oil on canvas
38 3/8 × 14 11/16 in. (97.5 × 37.3 cm)
Collection Art Gallery of Ontario,
Toronto, gift of Rose and Charles
Tabachnick, 1997
[Montreal]
plate 24 | cat. 31

Raoul Dufy
French, 1877–1953

The Little Palm Tree (Le Petit Palmier),
1905
Oil on canvas
47 5/8 × 33 7/16 in. (91.5 × 79 cm)
Carmen Thyssen-Bornemisza Collection,
on deposit at Museo Thyssen-
Bornemisza, Madrid
[Los Angeles, Montreal]
plate 29 | cat. 32

Jeanne in the Flowers (Jeanne dans
les fleurs), 1907
Oil on canvas
35 5/8 × 30 1/2 in. (90.5 × 77.5 cm)
Le Havre, Musée d'art moderne
André Malraux
[Montreal]
plate 28 | cat. 33

The Aperitif (L'Apéritif), 1908
Oil on canvas
23 1/4 × 28 9/16 in. (59 × 72.5 cm)
Musée d'Art moderne de la Ville de Paris
[Zürich]
plate 33 | cat. 34

Green Trees at L'Estaque (Les Arbres
verts à l'Estaque), 1908
Oil on canvas
31 1/2 × 25 1/2 in. (80 × 64.8 cm)
Levy Bequest Purchase, McMaster
Museum of Art, McMaster University,
Hamilton, Ontario
[Los Angeles, Montreal]
plate 32 | cat. 35

Dance (La Danse), c. 1910
Woodcut
Image: 12 3/8 × 12 1/2 in. (31.4 × 31.8 cm)
National Gallery of Art, Washington,
DC, Rosenwald Collection, 1950
[Los Angeles]
plate 31 | cat. 36

Fishing (La Pêche), c. 1910
Woodcut
Image: 12 5/8 × 15 3/4 in. (32.1 × 40 cm)
National Gallery of Art, Washington,
DC, Rosenwald Collection, 1950
[Los Angeles]
cat. 37

Fishing (La Pêche), c. 1910
Woodcut
Image: 12 1/2 × 15 13/16 in. (31.8 × 40.2 cm)
Collection of the Mendel Art Gallery,
acquired 1971
[Montreal]
cat. 38

Hunt (La Chasse), c. 1910
Woodcut
Image: 8 1/4 × 25 1/4 in. (21 × 64.1 cm)
National Gallery of Art, Washington,
DC, Rosenwald Collection, 1950
[Los Angeles]
cat. 39

Hunt (La Chasse), c. 1910
Woodcut
Image: 8 1/4 × 25 3/16 in. (21 × 64 cm)
Collection of the Mendel Art Gallery,
acquired 1971
[Montreal]
cat. 40

Love (L'Amour), c. 1910
Woodcut
Image: 12 1/4 × 12 3/8 in. (31.1 × 31.4 cm)
National Gallery of Art, Washington,
DC, Rosenwald Collection, 1950
[Los Angeles]
plate 30 | cat. 41

Dance (La Danse), c. 1912
Woodcut
Image: 12 3/8 × 12 1/2 in. (31.4 × 31.8 cm)
Collection of the Mendel Art Gallery,
acquired 1971
[Montreal]
cat. 42

Love (L'Amour), c. 1912
Woodcut
Image: 12 1/16 × 12 5/16 in. (30.7 × 31.2 cm)
Collection of the Mendel Art Gallery,
acquired 1971
[Montreal]
cat. 43

Adolf Erbslöh
German, 1881–1947

The Red Skirt (Der rote Rock), 1910
Oil on cardboard
45 1/4 × 33 11/16 in. (115 × 85.5 cm)
Kunst und Museumsverein Wuppertal
Exhibition: Second NKVM Exhibition,
Galerie Thannhauser, Munich, 1910,
no. 36
[Zürich, Los Angeles, Montreal]
plate 34 | cat. 44

Lyonel Feininger
American, active Germany,
1871–1956

The White Man, 1907
Oil on canvas
26¾ × 21 in. (68 × 53 cm)
Carmen Thyssen-Bornemisza Collection
on deposit at Museo Thyssen-
Bornemisza, Madrid
[Montreal]
cat. 45

Bridge O (Brücke O), 1912
Oil on canvas
35¾ × 43½ in. (90.8 × 110.5 cm)
Private collection
[Zürich]
cat. 46

Bridge I (Brücke I), 1913
Oil on canvas
39½ × 47½ in. (100.3 × 120.7 cm)
Mildred Lane Kemper Art Museum,
University purchase, Bixby Fund,
1950
Provenance: Hans Adolph Heiman;
possibly Hans Adolph Hermann
[Los Angeles, Montreal]
plate 35 | cat. 47

Sleeping Woman—Julia (Die Schläferin—
Julia), 1913
Oil on canvas
31½ × 39½ in. (80 × 100.3 cm)
The Robert and Mary M. Looker Family
Trust Collection
Exhibition: *Lyonel Feininger*, Neue Kunst
Hans Goltz, Munich, 1913, no. 2
[Los Angeles, Montreal]
plate 36 | cat. 48

Othon Friesz
French, 1879–1949

The Canal at Anvers (Le Canal d'Anvers),
1906
Oil on canvas
32¹/₁₆ × 23³/₁₆ in. (81.5 × 60.5 cm)
Levy Bequest Purchase, McMaster
Museum of Art, McMaster University,
Hamilton, Ontario
[Los Angeles, Montreal]
plate 37 | cat. 49

Cruiser Decorated with Flags in Anvers
(Croiseur pavoisé à Anvers), 1906
Oil on canvas
23⅝ × 28¾ in. (60 × 72 cm)
Private collection
[Montreal]
cat. 50

Landscape (*The Eagle's Beak, La Ciotat*)
(Paysage [Le Bec de l'Aigle, La Ciotat]),
1907
Oil on canvas
25⅜ × 32 in. (64.5 × 81.3 cm)
San Francisco Museum of Modern Art,
Bequest of Marian W. Sinton
[Zürich, Los Angeles, Montreal]
plate 38 | cat. 51

Paul Gauguin
French, 1848–1903

Swineherd (Le Gardien de porcs), 1888
Oil on canvas
28¾ × 36⅝ in. (73 × 93 cm)
Los Angeles County Museum of Art,
gift of Lucille Ellis Simon and family
in honor of the museum's twenty-fifth
anniversary
Exhibition: Salon d'Automne, Paris,
1906, no. 24
Provenance: Gustave Fayet, Igny
(France)
[Zürich, Los Angeles, Montreal]
plate 44 | cat. 52

The Yellow Haystacks (Les Meules Jaunes
[La Moisson Blonde]), 1889
Oil on canvas
28¾ × 36⁷/₁₆ in. (73 × 92.5 cm)
Paris, Musée d'Orsay, gift of Mme Huc
de Monfreid, 1951
Exhibition: Salon d'Automne, Paris,
1906, no. 182
Provenance: Collection Georges-Daniel
de Monfreid
[Montreal]
plate 39 | cat. 53

Haystacks in Brittany (Les Meules /
Le Champ de pommes de terre), 1890
Oil on canvas
29¼ × 36⅞ in. (74.3 × 93.6 cm)
National Gallery of Art, Washington,
DC, gift of the W. Averell Harriman
Foundation in memory of Marie
N. Harriman
Exhibitions: *Paul Gauguin*,
Grossherzogliches Museum, Weimar,
1905, no. 2; Salon d'Automne, Paris,
1906, no. 16
Provenance: Probably Gauguin sale,
Hôtel des Ventes, Paris, 1895;
Ambroise Vollard, Paris, 1895; Gustave
Fayet, Igny (France), 1900
[Zürich, Los Angeles, Montreal]
plate 45 | cat. 54

The House of Pan-Du (La Maison
du Pan-Du), 1890
Oil on canvas
19⅞ × 24 in. (50.3 × 61.1 cm)
Private collection, Canada
Provenance: Georges Bernheim, Paris
[Los Angeles, Montreal]
plate 40 | cat. 55

Portrait of the Artist's Mother (La Mère
de l'artiste), c. 1890
Oil on canvas
16⅛ × 13 in. (41 × 33 cm)
Staatsgalerie Stuttgart
Exhibitions: Salon d'Automne, Paris,
1906, no. 94; Sonderbund, Cologne,
1912, no. 160a; Salon d'Automne, Paris,
1912, no. 119
Provenance: Bernhard Koehler (purchase),
Berlin, 1912
Publications: Paul Gauguin, *Noa Noa*
(Paris, 1901); *Kunst und Künstler* 6 (1908),
p. 161
[Zürich]
p. 72 | cat. 56

Still Life with Flowers and Idol (Nature
morte aux fleurs et à l'idole), 1892
Oil on canvas
15¹⁵/₁₆ × 12⅝ in. (40.5 × 32 cm)
Kunsthaus Zürich, gift of Walter
Haefner
Publication: P. Mahlberg, *Beiträge zur
Kunst des XIX. Jahrhunderts und unserer
Zeit* (Düsseldorf: Ohle, 1913)
[Zürich]
cat. 57

At Play in Fresh Water / Women at the River
(Auti Te Pape), 1893–94
Woodcut, printed in black, orange-
brown, and yellow on simili Japan paper
9¹³/₁₆ × 15¹¹/₁₆ in. (25 × 39.8 cm)
Private collection, courtesy Galleri K,
Oslo
Publication: Paul Gauguin, *Noa Noa*
(Paris, 1901)
[Zürich]
cat. 58

At Play in Fresh Water / Women at the River
(Auti Te Pape), 1893–94
Woodcut printed in color on wove paper
8⅛ × 14⅛ in. (20.6 × 35.9 cm)
The Metropolitan Museum of Art,
New York, Harris Brisbane Dick Fund,
1936
Publication: Paul Gauguin, *Noa Noa*
(Paris, 1901)
[Los Angeles, Montreal]
plate 41 | cat. 59

The Creation of the Universe (L'Univers
est crée), 1893–94
Woodcut, printed in red, black, and
orange on simili Japan paper
9¹³/₁₆ × 15¹¹/₁₆ in. (25 × 39.8 cm)
Private collection, courtesy Galleri K,
Oslo
Publication: Paul Gauguin, *Noa Noa*
(Paris, 1901)
[Zürich, Los Angeles, Montreal]
plate 47 | cat. 60

Magnificent Land (Nave Nave Fenua),
1893–94
Woodcut, printed in black, light yellow,
red (opaque), and orange on simili Japan
paper
15¹¹/₁₆ × 9¹³/₁₆ in. (39.9 × 25 cm)
Private collection, courtesy Galleri K,
Oslo
Publication: Paul Gauguin, *Noa Noa*
(Paris, 1901)
[Zürich, Los Angeles, Montreal]
plate 48 | cat. 61

The Gods (Te Atua), 1893–94
Woodcut, printed in black over orange-
brown on simili Japan paper
9⅝ × 15¹¹/₁₆ in. (24.5 × 39.8 cm)
Private collection, courtesy Galleri K,
Oslo
Publication: Paul Gauguin, *Noa Noa*
(Paris, 1901)
[Zürich, Los Angeles, Montreal]
plate 46 | cat. 62

Human Misery (Misères humaines),
1898–1900
Woodcut
Sheet: 8½ × 11⅝ in. (21.6 × 29.5 cm)
Los Angeles County Museum of Art,
Graphic Arts Council Fund in memory
of Dorothy Burstein
[Los Angeles, Montreal]
plate 42 | cat. 63

Polynesian Woman with Children (Femme
et deux enfants), 1901
Oil on canvas
38¼ × 29³/₁₆ in. (97.1 × 74.2 cm)
Art Institute of Chicago, Helen Birch
Bartlett Memorial Collection
Exhibition: *La Collection Vollard*,
Galerie Arnold, Dresden, 1910
Provenance: Ambroise Vollard, Paris;
Ernst Arnold, Galerie Arnold, Dresden,
1911
[Los Angeles, Montreal]
plate 43 | cat. 64

Vincent van Gogh
Dutch, active France, 1853–1890

Mallows (Roses trémières), 1886
Oil on canvas
35¹³/₁₆ × 19⅞ in. (91 × 50.5 cm)
Kunsthaus Zürich
Exhibitions: Galerie Bernheim-Jeune,
Paris, 1901, no. 8; Galerie Cassirer,
Berlin, 1904, no. 32; Salon des Artistes
Indépendants, Paris, 1905, no. 4;
Sonderbund, Cologne, 1912, no. 69;
Galerie Cassirer, Berlin, 1913, no. 32
Provenance: Eugène Blot, Paris; Eugène
Druet, Paris; Galerie Bernheim-Jeune,
Paris; Adolph Rothermundt, Dresden,
1909; Georg Caspari, Munich
[Zürich]
cat. 65

Restaurant of the Siren at Asnières
(Le Restaurant de la Sirène à Asnières),
1887
Oil on canvas
21¼ × 25¹³/₁₆ in. (54 × 65.5 cm)
Paris, Musée d'Orsay, bequest of Joseph
Reinach, 1921
Exhibitions: *Ausstellung der
Holländischen Secession*, Wiesbaden,
1903, no. 9; Berlin, Galerie Cassirer,
1905, no. 24; *Internationale
Kunstausstellung*, Kunsthalle, Mannheim,
1907, no. 1083; W. Zimmermann,
Munich, 1908, no. 10
Provenance: Theo van Gogh; Johanna
van Gogh-Bonger; Vincent Willem
van Gogh; Amédée Schuffenecker, Paris,
1906; Joseph Reinach, Paris (until 1921)
[Zürich, Los Angeles, Montreal]
plate 56 | cat. 66

Arles: View from the Wheat Fields (Arles: Vue des champs de blé), 1888
Reed and quill pens and brown ink
12¹⁵⁄₁₆ × 9½ in. (31.2 × 24.1 cm)
The J. Paul Getty Museum, Los Angeles
Exhibitions: Fourteenth Berlin Secession, 1907, no. 123; Galerie Cassirer, Berlin, 1914, no. 87a
Provenance: Paul Cassirer, Berlin, 1907; Gustav Engelbrecht, Hamburg
[Los Angeles]
plate 55 | cat. 67

The Bridge at Langlois (Le Pont de Langlois), 1888
Brown ink over traces of black chalk
9⅝ × 12⁹⁄₁₆ in. (24.4 × 31.9 cm)
Los Angeles County Museum of Art, George Gard De Sylva Collection
Provenance: Johanna van Gogh-Bonger, Amsterdam; Paul Cassirer, Berlin, 1911; Tilla Durieux-Cassirer, Berlin
Exhibitions: Nineteenth Berlin Secession, 1909, no. 208; Galerie Cassirer, Berlin, 1910, no. 64; Galerie Cassirer, Berlin, 1914, no. 72
[Montreal]
plate 54 | cat. 68

Pollard Willows at Sunset (Saules au coucher du soleil), 1888
Oil on canvas mounted on cardboard
12⁷⁄₁₆ × 13½ in. (31.6 × 34.3 cm)
Kröller-Müller Museum, Otterlo, The Netherlands
Exhibitions: Galerie Bernheim-Jeune, Paris, 1908, no. 50; Moderne Kunsthandlung, Munich, 1908, no. 44; Galerie Richter, Dresden, 1908, no. 44; Kunstverein, Frankfurt, 1908, no. 48; Galerie Cassirer, Berlin, 1908; Sonderbund, Cologne, 1912, no. 34
Provenance: Willemina van Gogh; Cornelis Marinus van Gogh, Amsterdam, 1909; A. G. and Helene Kröller-Müller, The Hague, 1910
[Los Angeles, Montreal]
plate 50 | cat. 69

The Road to Tarascon (La Route pour Tarascon), 1888
Pencil, pen, reed pen, and ink
10³⁄₁₆ × 13¾ in. (25.8 × 35 cm)
Kunsthaus Zürich, Grafische Sammlung
Exhibition: Nineteenth Berlin Secession, 1909, no. 207
[Zürich]
plate 53 | cat. 70

The Sower: Outskirts of Arles in Background (Le Semeur), 1888
Oil on canvas
13¾ × 16 in. (34.9 × 40.6 cm)
The Armand Hammer Collection, gift of Dr. Armand Hammer, Hammer Museum, Los Angeles
Exhibitions: Vollard, Paris, 1896; Galerie Commeter, Hamburg, 1911; Galerie Cassirer, Berlin, 1914, no. 42
Provenance: Theo van Gogh; Johanna van Gogh-Bonger; Vincent Willem van Gogh
[Montreal]
plate 52 | cat. 71

The Poplars at Saint-Rémy (Les peupliers sur la colline), 1889
Oil on fabric
24¼ × 18 in. (61.6 × 45.7 cm)
The Cleveland Museum of Art, bequest of Leonard C. Hanna, Jr.
Exhibitions: Galerie Cassirer, Berlin, 1901; *Ausstellung der Holländischen Secession*, Wiesbaden, 1903; Sonderbund, Cologne, 1912, no. 40; Galerie Cassirer, Berlin, 1914
Provenance: Theo van Gogh; Johanna van Gogh-Bonger; Vincent Willem van Gogh; Willem Steenhoff, Amsterdam, 1905; Alfred Flechtheim, Düsseldorf, 1910; Max Siller, Barmen, c. 1914; Moderne Galerie Thannhauser, Munich, c. 1918
[Los Angeles]
plate 57 | cat. 72

Self-Portrait with Bandaged Ear and Pipe (L'homme à la pipe), 1889
Oil on canvas
19½ × 17⅜ in. (49.5 × 44.2 cm)
Private collection
Exhibitions: Galerie Bernheim-Jeune, Paris, 1901, no. 3; Third Berlin Secession, 1901, no. 64; Salon des Indépendants, Paris, 1905, no. 15; Galerie Druet, Paris, 1908, no. 13; Galerie Druet, Paris, 1909, no. 13
Provenance: Henri Laget, Arles; Ambroise Vollard, Paris; Emile Schuffenecker, Paris; Gustave Fayet, Igny (France), 1902
[Zürich]
cat. 73

Wheatfield with Reaper (Champ de blé avec moissonneur / La moisson), 1889
Oil on canvas
23⁷⁄₁₆ × 28⁹⁄₁₆ in. (59.5 × 72.5 cm)
Museum Folkwang, Essen
Exhibitions: Galerie Cassirer, Berlin, 1901; Museum Folkwang, Hagen, 1912, no. 138
Provenance: Theo van Gogh; Johanna van Gogh-Bonger; Vincent Willem van Gogh; Paul Cassirer, Berlin, 1902; Karl Ernst Osthaus, Hagen, 1902
[Los Angeles]
plate 49 | cat. 74

Portrait of Doctor Gachet, 1890
Etching on laid paper
Image: 7³⁄₁₆ × 5¹⁵⁄₁₆ in. (18.2 × 15.1 cm); sheet: 12⅛ × 9⅝ in. (30.8 × 24.4 cm)
National Gallery of Canada, Ottawa, purchased 1966
Exhibitions: Sonderbund, Cologne, 1912, no. 125; Galerie Flechtheim, Düsseldorf, 1913
Provenance: Alfred Flechtheim, Düsseldorf
Publication: J. Meier-Graefe, *Van Gogh* (Munich: Piper, 1910), pp. 72–73
[Montreal]
cat. 75

Thatched Sandstone Cottages at Chaponval (Chaumières à Chaponval), 1890
Oil on canvas
25⁹⁄₁₆ × 31⅞ in. (65 × 81 cm)
Kunsthaus Zürich
Exhibitions: Galerie Cassirer, Hamburg, 1905, no. 23; Galerie Arnold, Dresden, 1905, no. 20; Galerie Cassirer, Berlin, 1905; Galerie Bernheim-Jeune, Paris, 1908, no. 92; Galerie Cassirer, Berlin, 1908, no. 23; Künstlerhaus, Zürich, 1908, no. 82
Provenance: Theo van Gogh; Johanna van Gogh-Bonger; Vincent Willem van Gogh; Cornelis Marinus van Gogh, The Hague, 1908; Hans Schuler, Zürich, 1908
[Zürich]
plate 51 | cat. 76

Two Women Digging in Field with Snow (Deux femmes creusant dans un champ enneigé), 1890
Oil on paper on canvas
19⁷⁄₁₆ × 25³⁄₁₆ in. (49.3 × 64 cm)
Emil Bührle Stiftung
Exhibitions: Galerie Bernheim-Jeune, Paris, 1908, no. 89; Sonderbund, Cologne, 1912, no. 44
Provenance: Theo van Gogh; Johanna van Gogh-Bonger; Vincent Willem van Gogh; Galerie Bernheim-Jeune, Paris, 1907; Bernhard Koehler, Berlin, 1912
[Zürich]
p. 57 | cat. 77

**Erich Heckel
German, 1883–1970**

The Elbe at Dresden (Die Elbe bei Dresden), 1905
Oil on cardboard
20¹⁄₁₆ × 27⁹⁄₁₆ in. (51 × 70 cm)
Museum Folkwang, Essen
[Zürich, Los Angeles, Montreal]
plate 63 | cat. 78

Fear (Angst), 1907
Plate 7 of the portfolio *Die Ballade vom Zuchthaus zu Reading* (The Ballad of Reading Gaol), poem by Oscar Wilde
Woodcut on handmade paper
Image: 8 × 5⅞ in. (20.3 × 14.9 cm)
Los Angeles County Museum of Art, Robert Gore Rifkind Center for German Expressionist Studies
[Zürich, Los Angeles, Montreal]
plate 66 | cat. 79

The Prisoner (Der Gefangene), 1907
Plate 3 of the portfolio *Die Ballade vom Zuchthaus zu Reading* (The Ballad of Reading Gaol), poem by Oscar Wilde
Woodcut on handmade paper
Image: 7⅞ × 5⅞ in. (20 × 14.9 cm)
Los Angeles County Museum of Art, Robert Gore Rifkind Center for German Expressionist Studies
[Zürich, Los Angeles, Montreal]
plate 67 | cat. 80

The Prison Guard (Der Wärter), 1907
Plate 5 of the portfolio *Die Ballade vom Zuchthaus zu Reading* (The Ballad of Reading Gaol), poem by Oscar Wilde
Woodcut on handmade paper
Image: 8¼ × 5⅞ in. (21 × 14.9 cm)
Los Angeles County Museum of Art, Robert Gore Rifkind Center for German Expressionist Studies
[Zürich, Los Angeles, Montreal]
plate 65 | cat. 81

Landscape at Dangast (Dangaster Landschaft), 1907
Colored chalk
11¹⁵⁄₁₆ × 17⅞ in. (30.3 × 44.3 cm)
Brücke Museum, Berlin
[Zürich, Los Angeles, Montreal]
plate 64 | cat. 82

Woman on the Bed (Frau auf dem Bett), 1908
Lithograph on greenish heavy laid paper
Image: 13 × 7³⁄₁₆ in. (33 × 18.3 cm)
Los Angeles County Museum of Art, purchased with funds provided by the Robert Gore Rifkind Foundation, Beverly Hills, CA
[Zürich, Los Angeles, Montreal]
plate 68 | cat. 83

Sand Diggers on the Tiber (Sandgräber am Tiber), 1909
Oil on canvas
38 × 32½ in. (96.5 × 82.6 cm)
Los Angeles County Museum of Art, gift of Dr. and Mrs. Nathan Alpers
Exhibition: Brücke exhibition, Galerie Arnold, Dresden, 1910, no. 3
[Los Angeles, Montreal]
plate 59 | cat. 84

Group on Holiday / Group Outdoors (Gruppe im Freien), c. 1909
Oil on canvas
31⅞ × 37 in. (81 × 94 cm)
Merzbacher Kunststiftung
[Zürich]
plate 58 | cat. 85

Girl with Doll (Mädchen mit Puppe), 1910
Oil on canvas
25⁹⁄₁₆ × 27⁹⁄₁₆ in. (65 × 70 cm)
Sabarsky Collection, courtesy Neue Galerie New York
[Zürich, Los Angeles, Montreal]
plate 62 | cat. 86

Scene in the Woods (Szene im Wald), 1910
Plate 2 of the portfolio *Die Brücke VI* (1911)
Lithograph on heavy wove paper
Image: 11 × 13¾ in. (27.9 × 34.9 cm)
Los Angeles County Museum of Art, Robert Gore Rifkind Center for German Expressionist Studies
[Zürich, Los Angeles, Montreal]
plate 61 | cat. 87

The Swing (Die Schaukel), 1912
Black chalk, oil paint on pale gray paper
18⅜ × 14¹⁵⁄₁₆ in. (46.6 × 38 cm)
Staatsgalerie Stuttgart
[Zürich]
cat. 88

Female Nude on the Beach (Akt am Strand), 1913
Woodcut
Sheet: 26⅛ × 19⅞ in. (66.4 × 50.5 cm)
Los Angeles County Museum of Art, purchased with funds provided by the Robert Gore Rifkind Foundation, Beverly Hills, CA
[Los Angeles, Montreal]
plate 60 | cat. 89

Alexei Jawlensky
Russian, active Germany,
1864–1941

Portrait of Marie Castel, 1906
Oil on canvas
20¹³⁄₁₆ × 19⅜ in. (58.8 × 49.2 cm)
Flint Institute of Arts
[Montreal]
cat. 90

Girl with Peonies (Mädchen mit Pfingstrosen), 1909
Oil on board
39¾ × 29½ in. (101 × 75 cm)
Kunst- und Museumsverein Wuppertal
Exhibitions: First NKVM Exhibition, Galerie Thannhauser, Munich, 1909, no. 33; Sonderbund, Düsseldorf, 1910, no. 99
Provenance: Kunstverein Barmen
[Zürich]
plate 71 | cat. 91

Red Blossom (Rote Blüte), 1910
Oil on cardboard
26½ × 19½ in. (67.3 × 49.5 cm)
The San Diego Museum of Art, bequest of Earle W. Grant
[Los Angeles, Montreal]
plate 70 | cat. 92

Lady in a Yellow Straw Hat (Dame mit gelbem Strohhut), c. 1910
Oil on canvas
34¹⁄₁₆ × 28¹⁵⁄₁₆ in. (86.5 × 73.5 cm)
Merzbacher Kunststiftung
[Zürich]
cat. 93

Landscape (Landschaft), c. 1911
Oil on brown paper laid down on cardboard
21¼ × 19¹¹⁄₁₆ in. (54 × 50 cm)
Stedelijk Museum, Amsterdam
Provenance: Artist's studio; Jos. H. Gosschalk, Wassenaar
[Zürich, Los Angeles, Montreal]
plate 69 | cat. 94

Fairy Princess with a Fan (Märchenprinzessin mit Fächer), 1912
Oil on cardboard
25¹³⁄₁₆ × 21¼ in. (65.5 × 54 cm)
Museum Ludwig, Cologne
Provenance: Galerie Aenne Abels, Cologne; Günther and Carola Peill Collection, Cologne
[Zürich, Los Angeles]
plate 72 | cat. 95

Girl with Purple Blouse (Mädchen mit violetter Bluse), 1912
Oil on paper laid down on canvas
20⅞ × 18⅞ in. (53 × 48 cm)
Private collection, Cologne
[Montreal]
plate 73 | cat. 96

Italian (*Breton Peasant*) (Italiener [Bretonischer Bauer]), 1912
Oil on board
20½ × 18⅞ in. (52 × 48 cm)
Private collection, Cologne
Exhibition: *A Futuristák és Expressionisták Kiállitásának*, Nemzeti Szalon, Budapest, 1913, no. 56
[Montreal]
cat. 97

Reclining Female Nude (Liegender Akt), c. 1920
Offset lithograph printed in black, brown, purple, green, and blue on wove paper
Image: 11⅜ × 15⅞ in. (28.9 × 40.3 cm), irregular
Los Angeles County Museum of Art, Robert Gore Rifkind Center for German Expressionist Studies, gift of Michael and Sherry Kramer
[Los Angeles, Montreal]
cat. 98

Wassily Kandinsky
Russian, active Germany and
France, 1866–1944

Murnau, Burggrabenstrasse 1, 1908
Oil on paper mounted on Masonite
19⅞ × 25 in. (50.5 × 63.5 cm)
Dallas Museum of Art, Dallas Art Association Purchase
Provenance: Gabriele Münter
[Los Angeles, Montreal]
plate 77 | cat. 99

Murnau, Kohlgruberstrasse, 1908
Oil on cardboard
28⅛ × 38⅜ in. (71.5 × 97.5 cm)
Merzbacher Kunststiftung
Exhibitions: Eighteenth Berlin Secession, 1909; Salon d'Automne, Paris, 1909, no. 834
Provenance: Private collection, Germany
[Zürich]
plate 76 | cat. 100

Arabian Cemetery (Arabischer Friedhof), 1909
Oil on cardboard
28⅛ × 38⁹⁄₁₆ in. (71.5 × 98 cm)
Hamburger Kunsthalle
Exhibitions: Atelier Exhibition, Munich, 1909; NKVM exhibition, Kunstsalon Louis Bock, Hamburg, 1910; Kandinsky collective exhibition, Galerie Sturm, Berlin, 1912
[Los Angeles, Montreal]
plate 78 | cat. 101

Section of Composition II (Fragment zu Komposition II), 1910
Oil on cardboard
22⁷⁄₁₆ × 18¹¹⁄₁₆ in. (57 × 47.5 cm)
Merzbacher Kunststiftung
Exhibition: Moderner Bund, Kunsthaus, Zürich, 1912, no. 73
[Zürich]
plate 74 | cat. 102

Sketch I for Painting with White Border (Entwurf zu Bild mit weissen Rand), 1913
Oil on canvas
39⅜ × 30¹³⁄₁₆ in. (100 × 78.3 cm)
Phillips Collection, gift from the estate of Katherine S. Dreier
Exhibitions: *Third Modern Art Circle exhibition*, Stedelijk Museum, Amsterdam, 1913; Galerie Sturm, Berlin, 1916, no. 2
[Zürich, Los Angeles]
plate 75 | cat. 103

Ernst Ludwig Kirchner
German, 1880–1938

Park Lake, Dresden (Parksee, Dresden), 1906
Oil on canvas
23⅝ × 30¹¹⁄₁₆ in. (60 × 78 cm)
Galerie Neue Meister, Staatliche Kunstsammlungen Dresden
[Montreal]
cat. 104

Still Life with Pitcher and Flowers (Stillleben mit Krug und Blumen), 1907
Proof before edition in the portfolio *Die Brücke III* (1908)
Woodcut printed in yellow, gray green, and rose on heavy wove paper
Image: 8 × 6⅝ in. (20.3 × 16.8 cm)
Los Angeles County Museum of Art, Robert Gore Rifkind Center for German Expressionist Studies
[Zürich, Los Angeles, Montreal]
plate 89 | cat. 105

Love Scene (Liebesszene), 1908
Lithograph printed in olive green, orange, and yellow on heavy japan paper
Image: 15⅝ × 13 in. (39.7 × 33 cm)
Los Angeles County Museum of Art, Robert Gore Rifkind Center for German Expressionist Studies
[Los Angeles, Montreal]
plate 90 | cat. 106

Dodo at the Table (*Interior with Dodo*) (Dodo am Tisch [Interieur mit Dodo]), 1909
Oil on canvas
47⁷⁄₁₆ × 35⁷⁄₁₆ in. (120.5 × 90 cm)
Kirchner Museum Davos, Rosemarie Ketterer Stiftung
[Zürich, Los Angeles]
plate 96 | cat. 107

Dodo Playing with Her Fingers (Fingerspielende Dodo), 1909
Lithograph
Image: 13 × 15¾ in. (33 × 40 cm)
Milwaukee Art Museum, Marcia and Granvil Specks Collection
[Los Angeles, Montreal]
plate 85 | cat. 108

Dodo with a Japanese Umbrella (Dodo mit japanischem Schirm), 1909
Color lithograph
15¼ × 12¹³⁄₁₆ in. (38.8 × 32.5 cm)
Hamburger Kunsthalle, private collection
[Zürich]
cat. 109

The Dreaming Woman (Träumende), 1909
Lithograph on wove paper
Image: 15⅛ × 13 in. (38.4 × 33 cm), irregular
Los Angeles County Museum of Art, purchased with funds provided by the Robert Gore Rifkind Foundation, Beverly Hills, CA
[Zürich, Los Angeles, Montreal]
plate 91 | cat. 110

Dance Hall Bellevue (previously known as *Houses in Dresden*) (Dresdner Gebäude), 1909–10
Oil on canvas
22¹⁄₁₆ × 35⁷⁄₁₆ in. (56 × 90 cm)
National Gallery of Art, Washington, DC, Ruth and Jacob Kainen Collection, gift in honor of the 50th anniversary of the National Gallery of Art
Provenance: artist; artist's estate
[Zürich, Los Angeles, Montreal]
plate 79 | cat. 111

Reclining Nude in Front of Mirror (Liegender Akt vor Spiegel), 1909–10
Oil on canvas
32¹³⁄₁₆ × 37⅝ in. (83.3 × 95.5 cm)
Brücke Museum, Berlin
[Zürich, Los Angeles, Montreal]
plate 80 | cat. 112

Artist—Marcella (Artistin—Marcella), 1910
Oil on canvas
39¾ × 29¹⁵⁄₁₆ in. (101 × 76 cm)
Brücke Museum, Berlin
Exhibition: Brücke exhibition, Galerie Arnold, Dresden, 1910, cat. no. 27
[Zürich, Montreal]
plate 81 | cat. 113

Poster for Gauguin Exhibition at Galerie Arnold, Dresden (Plakat für die Ausstellung Gauguin in der Galerie Arnold, Dresden), 1910
Woodcut
33⁷⁄₁₆ × 23¼ in. (85 × 59 cm)
Kupferstich-Kabinett, Staatliche Kunstsammlungen Dresden
[Zürich]
cat. 114

Three Bathers at the Moritzburg Lakes (Drei Badende an den Moritzburger Seen), 1910
Plate 3 of the portfolio *Die Brücke V* (1910)
Drypoint on heavy wove paper
Image: 7 × 8¹⁄₁₆ in. (17.8 × 20.5 cm)
Los Angeles County Museum of Art, Robert Gore Rifkind Center for German Expressionist Studies
[Zürich, Los Angeles, Montreal]
plate 92 | cat. 115

Woman in a Green Blouse (Frau in grüner Bluse), 1910
Oil on canvas
31⅝ × 27⅝ in. (80.3 × 70.2 cm)
Saint Louis Art Museum
Provenance: Ida Fischer, Frankfurt am Main, 1913 (purchase from the artist)
[Los Angeles, Montreal]
plate 88 | cat. 116

Two Women (Zwei Frauen) (verso),
c. 1910
Nude in Bath (Nacktes Mädchen im Bad)
(recto)
Pen and ink and colored crayon on
paper
14 5/16 × 18 1/8 in. (36.3 × 46 cm)
The San Diego Museum of Art, gift from
the Estate of Vance E. Kondon and
Liesbeth Giesberger
[Los Angeles, Montreal]
plate 86 | cat. 117

Dodo with a Feather Hat (Dodo mit
Federhut), 1911
Oil on canvas
31 1/2 × 27 1/8 in. (80 × 68.9 cm)
Milwaukee Art Museum, gift
of Mrs. Harry Lynde Bradley
[Los Angeles, Montreal]
plate 95 | cat. 118

Otto and Maschka Mueller in the Studio
(Otto und Maschka Mueller im Atelier),
1911
Oil on canvas
28 1/2 × 24 in. (72.4 × 60.9 cm)
Virginia Museum of Fine Arts,
the Ludwig and Rosy Fischer Collection,
gift of the estate of Anne R. Fischer
[Los Angeles, Montreal]
plate 87 | cat. 119

Seated Woman with Wood Sculpture
(Sitzende Frau mit Holzplastik), 1912
Oil on canvas
38 1/2 × 38 1/2 in. (98 × 98 cm)
Virginia Museum of Fine Arts,
Adolph D. and Wilkins C. Williams
Fund Purchase
Exhibition: *Die Neue Malerei*, Galerie
Arnold, Dresden, 1914, no. 85
[Los Angeles, Montreal]
plate 82 | cat. 120

Still Life with Jug and African Bowl
(Stillleben mit Krug und afrikanischer
Schale), 1912
Oil on canvas
47 5/8 × 35 13/16 (121 × 91)
Los Angeles County Museum of Art,
gift of Richard Smooke, Michael Smooke,
and Barry Smooke in honor of their
parents, Marion and Nathan Smooke
[Los Angeles, Montreal]
plate 84 | cat. 121

Woman Tying Her Shoe (Frau, Schuh
zuknöpfend), 1912
Woodcut on wove paper
25 1/16 × 17 5/8 in. (63.7 × 44.7 cm)
Collection Art Gallery of Ontario,
Toronto, gift of Vivian and David
Campbell, 1998
[Montreal]
cat. 122

Nude Combing Her Hair (Sich käm-
mender Akt), 1913
Oil on canvas
49 3/16 × 35 7/16 in. (125 × 90 cm)
Brücke Museum, Berlin
[Zürich]
plate 94 | cat. 123

Street, Berlin (Straße, Berlin), 1913
Oil on canvas
47 1/2 × 35 7/8 in. (120.6 × 91.1 cm)
The Museum of Modern Art, New York,
purchase, 1939
[Zürich, Los Angeles, Montreal]
plate 83 | cat. 124

Portrait of Gewecke (Porträt Gewecke),
1914
Oil on canvas
25 3/4 × 18 1/2 in. (65.4 × 46.9 cm)
Virginia Museum of Fine Arts,
the Ludwig and Rosy Fischer Collection,
gift of the estate of Anne R. Fischer
[Los Angeles, Montreal]
plate 93 | cat. 125

Paul Klee
Swiss, active Germany 1879–1940

The Castle (Das Schloss), 1913
Charcoal, pen and watercolor
4 1/8 × 7 1/2 in. (10.5 × 19 cm)
Private collection
Exhibition: First German Autumn Salon,
Galerie Sturm, Berlin, 1913,
no. 204
[Montreal]
cat. 126

Landscape in a Rainy Mood (Kleine
Landschaft in Regenstimmung), 1913
Watercolor on paper on cardboard
7 7/8 × 4 3/4 in. (20 × 12 cm)
Zentrum Paul Klee, Bern, gift Livia Klee
[Zürich]
plate 98 | cat. 127

Soaring Vision of a Town (Hochstrebende
Stadtvision), 1915
Watercolor on paper on cardboard
8 1/2 in. × 6 1/2 in. (21.5 × 16.5 cm)
Centre Pompidou, Paris, Musée national
d'art moderne / Centre de création indus-
trielle, Don de M. Heinz Berggruen, 1972
Provenance: Galerie Hans Goltz,
Munich
[Zürich]
plate 99 | cat. 128

Untitled (*Spatial Architecture, Tunisia*)
(Raumarchitektur, Tunis), 1915
Watercolor with white gouache
6 7/16 × 8 1/8 in. (16.3 × 20.7 cm)
Levy Bequest Purchase, McMaster
Museum of Art, McMaster University,
Hamilton, Ontario
Exhibition: *Klee und Albert Bloch*,
Galerie Sturm, Berlin, 1916, no. 33
Provenance: Herwarth Walden
(purchased from the artist)
[Los Angeles, Montreal]
plate 97 | cat. 129

With the Four Riders (Mit den vier
Reitern), 1915
5 11/16 × 4 3/4 in. (14.5 × 12 cm)
Watercolor and pen
Private collection
Provenance: Karl Ernst Osthaus,
Essen and Hagen
[Montreal]
cat. 130

Maximilien Luce
French, 1858–1941

The Pile Drivers/The Pavers (Les Batteurs
de pieux), 1902–3
Oil on canvas
60 1/4 × 76 3/4 in. (153 × 195 cm)
Paris, Musée d'Orsay, gift of Frédéric
Luce, son of the artist, 1948
Exhibitions: Salon des Indépandants,
Paris, 1903; Eleventh Berlin Secession,
1906; Exhibition Luce, Paris, 1907
[Zürich, Los Angeles, Montreal]
plate 100 | cat. 131

August Macke
German, 1887–1914

Nude (Akt), c. 1910
Charcoal on thick brownish wove paper
24 15/16 × 19 in. (63.3 × 48.3 cm)
Los Angeles County Museum of Art,
Robert Gore Rifkind Center for German
Expressionist Studies
Provenance: Elizabeth Macke
[Los Angeles, Montreal]
plate 101 | cat. 132

Vegetable Fields (Gemüsefelder), 1911
Oil on canvas
18 1/2 × 25 3/16 in. (47 × 64 cm)
Kunstmuseum Bonn
Provenance: Michael Hennes,
Bonn, 1913
[Zürich]
cat. 133

Landscape with Cows and Camel
(Landschaft mit Kühen und Kamel),
1914
Oil on canvas
18 1/2 × 21 1/4 in. (47 × 54 cm)
Kunsthaus Zürich
[Zürich, Los Angeles]
plate 102 | cat. 134

*Landscape with Cows, Sailing Boat,
and Figures* (Landschaft mit Kühen,
Segelboot und eingemalten Figuren),
1914
Oil on canvas
20 1/4 × 20 1/4 in. (51.4 × 51.4 cm)
Saint Louis Museum of Art, bequest
of Morton D. May
Provenance: Macke estate
[Los Angeles, Montreal]
cat. 135

Henri Manguin
French, 1874–1949

The Mistral (Le Mistral), 1905
Oil on canvas
19 11/16 × 24 in. (50 × 61 cm)
Kunsthaus Zürich, Legat Dr. Hans
Schuler, 1920
Provenance: Henri Manguin;
Paul Vallotton, Lausanne, 1909
[Zürich, Los Angeles, Montreal]
plate 103 | cat. 136

Fruits and Bowl (Fruits et moustiers),
1907
Oil on canvas
28 3/4 × 23 5/8 in. (73 × 60 cm)
Toulouse, Musée des Augustins
Provenance: Mme Henri Manguin,
Saint-Tropez; Mme Odette
Manguin-Redon
[Montreal]
cat. 137

Franz Marc
German, 1890–1916

Sketch, Nude on Vermilion (Aktbild
auf Zinnober, Skizze), 1909–10
Oil on canvas
31 5/16 × 23 5/8 in. (79.5 × 60 cm)
University of Iowa Museum of Art,
gift of Owen and Leone Elliott
Provenance: Maria Marc, Ried
[Los Angeles, Montreal]
plate 104 | cat. 138

Stony Path (Mountains/Landscape)
(Steiniger Weg [Gebirge/Landschaft]),
1911 (repainted 1912)
Oil on canvas
51 1/2 × 39 3/4 in. (130.8 × 101 cm)
San Francisco Museum of Modern Art,
gift of the Women's Board and Friends
of the Museum
Exhibitions: *Der Blaue Reiter*, Galerie
Thannhauser, Munich, 1911–12, no. 32;
Galerie Sturm, Berlin, 1912, no. 94;
Galerie Thannhauser, Munich, 1913;
Kunstverein, Jena, 1913; *Franz Marc*,
Galerie Sturm, Berlin, 1913; Kunstsalon
Bock, Hamburg, 1913; *Franz Marc.
Gedächtnis-Ausstellung*, Neue Secession,
Munich, 1916, no. 106; *Expressionisten,
Futuristen, Kubisten*, Galerie Sturm,
Berlin, 1916, no. 46; *Franz Marc. Gedächtnis-
Ausstellung*, Galerie Sturm, Berlin, 1916,
no. 13; *Franz Marc. Gedächtnis-Ausstellung*,
Nassauischer Kunstverein, Neues
Museum, Wiesbaden, 1917, no. 37
Provenance: Dr. Hans Gerson, Hamburg
(acquired between 1913 and 1916)
[Zürich, Los Angeles, Montreal]
plate 106 | cat. 139

Mountain Goats (Bergziegen), 1913
Oil on canvas
29 1/8 × 23 1/4 in. (74 × 59 cm)
Private collection
Exhibition: Galerie Arnold, Breslau,
1914
[Zürich]
cat. 140

Stables (Stallungen), 1913
Oil on canvas
29 × 62 in. (73.6 × 157.5 cm)
The Solomon R. Guggenheim Museum,
New York, Solomon R. Guggenheim
Museum Founding Collection
Exhibition: *Die Neue Malerei*, Galerie
Arnold, Dresden, 1914, no. 98
Provenance: Maria Marc, Ried
[Los Angeles, Montreal]
plate 105 | cat. 141

Colored Flowers, 1913–14
Tempera over graphite
8 × 6⅜ in. (20.3 × 16.2 cm)
The San Diego Museum of Art, gift
of Mr. and Mrs. Norton S. Walbridge
[Los Angeles, Montreal]
cat. 142

Albert Marquet
French, 1875–1947

The Beach at Sainte-Adresse (La Plage
de Sainte-Adresse), 1906
Oil on canvas
25⅜ × 31½ in. (64.5 × 80 cm)
Private collection
Exhibition: Moscow, *La Toison d'Or*,
1909, no. 83
[Montreal]
cat. 143

Le Havre, Sailboat at the Dock (Le Havre,
voilier à quai), 1906
Oil on canvas
13 × 16⅛ in. (33 × 41 cm)
Kunsthaus Zürich, Bequest Dr. Hans
Schuler, 1920
[Zürich]
cat. 144

*Sunny Street in Ciboure, near Saint-
Jean-de-Luz* (Rue ensoleillée à Ciboure,
près de Saint-Jean-de-Luz), 1907
Oil on canvas
13 × 16 in. (33 × 40.6 cm)
Collection: A. K. Prakash
[Montreal]
plate 107 | cat. 145

Henri Matisse
French, 1869–1964

Still Life with Oranges II (Nature morte
aux oranges II), c. 1899
Oil on canvas
18¹/₁₆ × 21⅞ in. (45.9 × 55.6 cm)
Mildred Lane Kemper Art Museum,
gift of Mr. and Mrs. Sydney M.
Shoenberg, Jr., 1962
Provenance: Eugène Boch, Monthyon
(France) (until 1941)
[Los Angeles, Montreal]
plate 111 | cat. 146

Nude Study in Blue (Académie bleue),
c. 1899–1900
Oil on canvas
28¾ × 21⅜ in. (73 × 54.3 cm)
Tate: Bequeathed by C. Frank Stoop,
1933
Provenance: Paris, La Peau de l'Ours
collectors association (c. 1904);
Galerie Bernheim-Jeune, Paris, March 2,
1914 (purchased through Drouot);
Kurt Vollmoeller, Basel, March 17, 1914
(purchased for Vollmoeller by Hans
Purrmann)
[Zürich, Los Angeles, Montreal]
plate 118 | cat. 147

Studio Interior (Intérieur d'atelier),
c. 1903–4
Oil on canvas
21⅝ × 18⅛ in. (55 × 46 cm)
Tate: Bequeathed by Lord Amulree,
1984
Exhibitions: Galerie Vollard, Paris,
1904, no. 2; Salon d'Automne, Paris,
1904, no. 614
Provenance: Eugène Blot, Paris
[Zürich, Los Angeles, Montreal]
plate 108 | cat. 148

Interior at Collioure (*The Siesta*) (Intérieur
à Collioure [La Sieste]), 1905
Oil on canvas
23⅝ × 28¾ in. (60 × 73 cm)
Merzbacher Kunststiftung
Exhibitions: *Henri Matisse*, Galerie Druet,
Paris, 1906, no. 4; Sonderbund, Cologne,
1912, no. 260
Provenance: Galerie Druet, Paris
[Zürich]
plate 109 | cat. 149

Open Window, Collioure (La Fenêtre
ouverte, Collioure), 1905
Oil on canvas
21¾ × 18⅛ in. (55.3 × 46 cm)
National Gallery of Art, Washington,
DC, collection of Mr. and Mrs. John
Hay Whitney
Exhibitions: Salon d'Automne, Paris,
1905, no. 715; *Henri Matisse*, Galerie
Druet, Paris, 1906, no. 41; Cercle de l'art
moderne, Le Havre, 1906
Provenance: Galerie Druet, Paris;
Collection Pieter van de Velde, Le Havre,
1906
[Los Angeles]
plate 110 | cat. 150

Margot, 1906
Oil on canvas
31⅞ × 25⁹/₁₆ in. (81 × 65 cm)
Kunsthaus Zürich
Provenance: Leo Stein, Paris; Oskar
Moll, Breslau (Wrocław), 1914
(through Galerie Bernheim-Jeune)
[Zürich]
cat. 151

Nude with Black Hair in Profile
(Nu accroupi, mains aux sein), 1906
Lithograph on japan paper
Image: 15⁹/₁₆ × 8⁷/₁₆ in. (39.5 × 21.4 cm)
Los Angeles County Museum of Art,
Dr. Dorothea Moore Bequest
[Los Angeles, Montreal]
plate 113 | cat. 152

Red Rugs (*Still Life with a Red Rug*)
(Les tapis rouges [Nature morte au tapis
rouge]), 1906
Oil on canvas
35¹/₁₆ × 45⅞ in. (89 × 116.5 cm)
Musée de Grenoble
Exhibitions: Galerie Cassirer, Berlin,
1907; Galerie Bernheim-Jeune, Paris,
1910, no. 49
Provenance: Galerie Druet, Paris, 1906;
Collection Gustave Fayet, Paris, 1906;
Galerie Bernheim-Jeune, Paris, 1907;
Collection Marcel Sembat, Paris, 1908
[Zürich]
plate 112 | cat. 153

Seated Nude (Petit Bois noir), 1906
Woodcut
18⅛ × 11⁷/₁₆ in. (46 × 29 cm)
Baltimore Museum of Art
Exhibitions: *Henri Matisse*, Galerie Druet,
Paris, 1906; Salon des Indépendants,
Paris, 1907
[Los Angeles, Montreal]
plate 116 | cat. 154

Seated Nude (Petit Bois clair), 1906
Woodcut
18⅛ × 11⁷/₁₆ in. (46 × 29 cm)
Centre Pompidou, Paris, Musée national
d'art moderne / Centre de création indus-
trielle, gift of Mme Marie Matisse in 1985
Exhibitions: Galerie Druet, Paris, 1906;
Salon des Indépendants, Paris, 1907
[Zürich]
cat. 155

Seated Nude Asleep (Le Grand Bois), 1906
Woodcut
22⅝ × 18⅛ in. (57.5 × 46 cm)
Paris, Institut national d'histoire de l'art
Exhibitions: *Henri Matisse*, Galerie Druet,
Paris, 1906; Salon des Indépendants,
Paris, 1907
[Zürich]
cat. 156

Seated Nude (Petit Bois clair), 1906
Woodcut
18⅛ × 11⁷/₁₆ in. (46 × 29 cm)
Baltimore Museum of Art
Exhibitions: *Henri Matisse*, Galerie Druet,
Paris, 1906; Salon des Indépendants,
Paris, 1907
[Los Angeles, Montreal]
plate 115 | cat. 157

Seated Nude (Petit Bois noir), 1906
Woodcut
18³/₁₆ × 11¼ in. (46.2 × 28.5 cm)
Centre Pompidou, Paris, Musée national
d'art moderne / Centre de création indus-
trielle, gift of Mme Marie Matisse in 1985
Exhibitions: *Henri Matisse*, Galerie Druet,
Paris, 1906; Salon des Indépendants,
Paris, 1907
[Zürich]
cat. 158

Seated Nude Asleep (Le Grand Bois), 1906
Woodcut
22⅝ × 15¾ in. (57.5 × 40 cm)
Baltimore Museum of Art
Exhibitions: *Henri Matisse*, Galerie Druet,
Paris, 1906; Salon des Indépendants,
Paris, 1907
[Los Angeles, Montreal]
plate 114 | cat. 159

Barbizon, 1908
Oil on canvas
28¾ × 23⅝ in. (73 × 60 cm)
Kunsthaus Zürich, acquired with
a contribution of the Holenia Trust
in memory of Joseph H. Hirshhorn
Provenance: Family of Henri Matisse
[Zürich]
cat. 160

Pink Nude (*Seated Nude*) (Nu rose
[Nu assis]), 1909
Oil on canvas
13³/₁₆ × 16⅛ in. (33.5 × 41 cm)
Musée de Grenoble
Exhibition: Galerie Bernheim-Jeune,
Paris, 1910, no. 63
Provenance: Artist's workshop; Marcel
Sembat, Paris, 1909 (from the artist)
Publication: M. Sembat, "Henri Matisse,"
Les Cahiers d'aujourd'hui 4 (April 1913),
pp. 190–91
[Los Angeles, Montreal]
plate 117 | cat. 161

Paula Modersohn-Becker
German, 1876–1907

Girl with Flower Vases (Mädchen mit
Blumenvasen), c. 1907
Oil on canvas
35¹/₁₆ × 43 in. (89 × 109 cm)
Von der Heydt-Museum Wuppertal
[Zürich, Los Angeles, Montreal]
plate 119 | cat. 162

Gabriele Münter
German, 1877–1962

Aurelie, 1906
Woodcut printed in black, orange, pink,
and beige on japan paper
7³/₁₆ × 6⁹/₁₆ in. (18.2 × 16.7 cm)
Los Angeles County Museum of Art,
Robert Gore Rifkind Center for German
Expressionist Studies
[Los Angeles, Montreal]
cat. 163

Wooden Doll (Holzpuppe), 1909
Oil on canvas board
14¹¹/₁₆ × 20⅛ in. (37.3 × 51.1 cm)
The San Diego Museum of Art,
gift from the Estate of Vance E.
Kondon and Liesbeth Giesberger
[Los Angeles, Montreal]
plate 120 | cat. 164

Emil Nolde
German, 1867–1956

The White Tree Trunks (Die weissen
Stämme), 1908
Oil on canvas
26⁹/₁₆ × 30½ in. (67.5 × 77.5 cm)
Brücke Museum, Berlin
[Montreal]
plate 123 | cat. 165

Ship in Dock (Schiff im Dock), 1910
Oil on canvas
22¹/₁₆ × 27⁹/₁₆ in. (56 × 70 cm)
Hamburger Kunsthalle, gift
of Dr. Michael Otto
Exhibitions: Galerie Commeter,
Hamburg, 1911; Münster Kunstverein
1912; Der Neue Kunstsalon, Munich,
1912, no. 6
[Los Angeles, Montreal]
plate 122 | cat. 166

Blue Sea (Blaues Meer), c. 1914
Oil on canvas
22 × 27½ in. (55.8 × 69.8 cm)
Virginia Museum of Fine Arts,
the Ludwig and Rosy Fischer Collection,
gift of the estate of Anne R. Fischer
Provenance: Ludwig Fischer,
Frankfurt am Main
[Los Angeles, Montreal]
plate 121 | cat. 167

Max Pechstein
German, 1881–1955

Our Lady (Unsere Frau), 1907
Plate 3 of the portfolio *Die Brücke III*
(1908)
Woodcut printed in dark green on
heavy wove paper
Image: 9 × 4⅞ in. (22.9 × 12.4 cm)
Los Angeles County Museum of Art,
Robert Gore Rifkind Center for German
Expressionist Studies
[Zürich, Los Angeles, Montreal]
plate 126 | cat. 168

Woman on a Sofa (Frau auf dem Sofa),
1908
Etching and aquatint on heavy wove
paper
Image: 7⅞ × 7⅞ in. (20 × 20 cm)
Los Angeles County Museum of Art,
Robert Gore Rifkind Center for German
Expressionist Studies
[Zürich, Los Angeles, Montreal]
plate 127 | cat. 169

Young Girl (Junges Mädchen), 1908
Oil on canvas
25³⁄₁₆ × 19⅞ in. (65.5 × 50.5 cm)
Staatliche Museen zu Berlin,
Nationalgalerie. Acquired by the federal
state of Berlin
Provenance: Galerie Gurlitt, Berlin
[Zürich, Los Angeles, Montreal]
plate 132 | cat. 170

The Big Indian (Der grosse Inder), 1910
Oil on canvas
35¼ × 35¼ in. (89.5 × 89.5 cm)
Saint Louis Art Museum
Exhibitions: *Ausstellung des deutschen
Künstlerbundes*, Darmstadt, 1910, no. 181;
Jena/Kiel, 1911
[Los Angeles, Montreal]
plate 131 | cat. 171

Bathers (Badende) (recto), 1911
Seated Girl in the Forest (Sitzendes
Mädchen im Wald) (verso), 1910
Oil on canvas
27¾ × 31¾ in. (70.5 × 80.6 cm)
Virginia Museum of Fine Arts,
the Ludwig and Rosy Fischer Collection,
gift of the estate of Anne R. Fischer
Exhibitions: Bromberg (now Bydgoszcz,
Poland), 1912; *Die Neue Kunst*,
Frankfurter Kunstverein, 1917, no. 91
Provenance: Galerie Ludwig Schames,
Frankfurt am Main; Ludwig and Rosy
Fischer, Frankfurt am Main, 1917
[Los Angeles, Montreal]
plate 130 | cat. 172

Beach at Nidden (Strand bei Nidden), 1911
Oil on canvas
19½ × 28½ in. (49.5 × 72.4 cm)
Los Angeles County Museum of Art,
gift of Mr. and Mrs. John C. Best
Provenance: Galerie Gurlitt, Berlin
[Los Angeles, Montreal]
plate 129 | cat. 173

Dancers and Bathers at a Forest Pond
(Tanzende und Badende am Waldteich),
1912
Plate 2 of the portfolio *Die Brücke VII*
(1912)
Lithograph with blue and green water-
color on heavy wove paper
Image: 17¹⁄₁₆ × 12¹³⁄₁₆ in. (43.3 × 32.5 cm)
Los Angeles County Museum of Art,
Robert Gore Rifkind Center for German
Expressionist Studies
[Los Angeles, Montreal]
plate 128 | cat. 174

Magdalena: Still Life with Nude
(Magdalena: Stillleben mit Akt), 1912
Verso: *Palau Landscape / Summer Day*
(Sommertag), c. 1911
Oil on canvas
36 × 35⅞ in. (91.4 × 91.1 cm)
The San Diego Museum of Art, gift from
the Estate of Vance E. Kondon and
Liesbeth Giesberger
Exhibition: *Max Pechstein*, Kunstsalon
Fritz Gurlitt, Berlin, 1913, no. 3, 9, or 31
Provenance: Dr. Karl Lilienfeld, Leipzig/
Berlin/New York, 1917
[Los Angeles, Montreal]
plate 124 | cat. 175

Still Life with Nude, Tile, and Fruit
(Stillleben mit Akt, Kachel und
Früchten), 1913
Verso: *Curonian Forest Landscape*
(Kurische Waldlandschaft), 1912
Oil on canvas
39 × 38¾ in. (99 × 98.5 cm)
Collection Alfred and Ingrid Lenz
Harrison, Wayzata, Minnesota
Exhibition: *Deutscher Künstlerbund*,
Kunsthalle Mannheim, 1913, no. 267
Provenance: Private collection,
Stuttgart, 1914–16
[Zürich, Los Angeles, Montreal]
plate 125 | cat. 176

Pablo Picasso
Spanish, active France, 1881–1973

Study for the Head of "Nude with Drapery,"
1907
Watercolor and gouache on brown paper
Sheet: 12³⁄₁₆ × 9⅝ in. (31 × 24.5 cm)
Museo Thyssen-Bornemisza, Madrid
Provenance: probably Leo and Gertrude
Stein, Paris, 1907
[Los Angeles]
plate 133 | cat. 177

Christian Rohlfs
German, 1849–1938

Birch Forest (Birkenwald), 1907
Oil on canvas
43⁵⁄₁₆ × 29½ in. (110 × 75 cm)
Museum Folkwang, Essen
Provenance: Karl Ernst Osthaus for
the Museum Folkwang, Hagen, 1912
[Zürich, Los Angeles, Montreal]
plate 134 | cat. 178

Nude, 1911
Oil on canvas
23¾ × 20⅛ in. (60.3 × 51.1 cm)
The San Diego Museum of Art,
gift from the Estate of Vance E.
Kondon and Liesbeth Giesberger
[Los Angeles, Montreal]
plate 135 | cat. 179

Henri Rousseau
French, 1844–1910

The Walk in the Forest (La Promenade
dans la forêt), c. 1886
Oil on canvas
27⁹⁄₁₆ × 23¹³⁄₁₆ in. (70 × 60.5cm)
Kunsthaus Zürich
Exhibition: *Henri Rousseau*, Galerie
Bernheim-Jeune, Paris, 1912, no. 6
Provenance: Wilhelm Uhde, Paris, 1910
Publication: Wilhelm Uhde, *Henri
Rousseau* (Paris: 1911), p. 7.
[Zürich]
cat. 180

The Wedding (La Noce), 1904–5
Oil on canvas
64³⁄₁₆ × 44⅞ in. (163 × 114 cm)
Musée de l'Orangerie, Paris
Exhibitions: Salon des Indépendants,
Paris, 1905, no. 3589; Salon des
Indépendants, Paris, 1911, no. 1
Provenance: Serge Jastrebzoff, Paris
Publications: Wilhelm Uhde, *Henri
Rousseau* (Paris, 1911), p. 8; *Blaue
Reiter Almanach* (Munich: 1912), p. 95
[Los Angeles, Montreal]
plate 137 | cat. 181

Portrait of Monsieur X (*Pierre Loti*),
c. 1906
Oil on canvas
27⁹⁄₁₆ × 23¹³⁄₁₆ in. (70 × 60.5 cm)
Kunsthaus Zürich
Provenance: Georges Courteline, Paris,
c. 1906; Paul Rosenberg, Paris, 1913;
Paul and Lotte Mendelssohn-Bartholdy,
Berlin, 1914
Publication: Wilhelm Uhde, *Henri
Rousseau*, German ed. (Düsseldorf, 1914)
[Zürich]
cat. 182

Malakoff, the Telegraph Poles (Malakoff,
les poteaux télégraphiques), 1908
Oil on canvas
18⅛ × 21⅝ in. (46 × 55 cm)
Private collection, courtesy Pieter Coray
Exhibitions: *Henri Rousseau*, rue
Notre-Dame-des-Champs, Paris, 1908;
Der Blaue Reiter, Galerie Thannhauser,
Munich, 1911–12, no. 2?
Provenance: Wilhelm Uhde
Publications: Wilhelm Uhde, *Henri
Rousseau* (Paris, 1911), p. 25; *Blaue Reiter
Almanach* (Munich, 1912), p. 83
[Zürich, Los Angeles]
plate 136 | cat. 183

Théo van Rysselberghe
Belgian, 1862–1926

Beach at Low Tide, Ambleteuse, Evening
(Plage à marée basse à Ambleteuse,
le soir), 1900
Oil on canvas
20¾ × 25¼ in. (52.7 × 64.1 cm)
Portland Art Museum, gift of Laura
and Roger Meier
Exhibitions: *La Libre Esthétique*,
Brussels, 1901, cat. 471; *Deutsche und
französische Impressionisten und
Neo-impressionisten*, Weimar, 1903;
Galerie Druet, Paris, 1905; Galerie
Emile Richter, Dresden, 1908
[Los Angeles, Montreal]
plate 138 | cat. 184

Karl Schmidt-Rottluff
German, 1884–1976

Gartenstrasse Early in the Morning
(Gartenstraße frühmorgens), c. 1906
Oil on board
28⅛ × 27¹⁵⁄₁₆ in. (71.5 × 71 cm)
Kunstsammlungen Chemnitz, Inv.
No. L 108, loan from a private collection
[Zürich, Los Angeles, Montreal]
plate 140 | cat. 185

The Broken Dike (Deichdurchbruch), 1910
Oil on canvas
29¹⁵⁄₁₆ × 33¹⁄₁₆ in. (76 × 84 cm)
Brücke Museum, Berlin
Exhibition: Brücke exhibition, Galerie
Arnold, Dresden, 1910, no. 70
[Zürich]
plate 141 | cat. 186

Seated Female Nude (Sitzender
Frauenakt), 1911
Colored chalk on paper
16¾ × 12⅝ in. (42.5 × 32 cm)
Staatsgalerie Stuttgart
[Zürich]
cat. 187

Reflective Woman (Sinnende Frau), 1912
Oil on canvas
40³⁄₁₆ × 29¹⁵⁄₁₆ in. (102 × 76 cm)
Brücke Museum, Berlin
[Zürich, Los Angeles, Montreal]
plate 139 | cat. 188

Paul Signac
French, 1863–1935

Comblat-le-Château: The Poplar (Comblat-
le-Château. Le Peuplier), 1887
Oil on canvas
18⅛ × 25⁹⁄₁₆ in. (46 × 65 cm)
Kunsthaus Zürich, collection Johanna
and Walter L. Wolf
Provenance: the artist
[Zürich]
cat. 189

*Application of Mr. Charles Henry's
Chromatic Circle* (Application du Cercle
chromatique de M. Charles Henry), 1888
Color lithograph
6⅜ × 7¼ in. (16.2 × 18.4 cm)
Los Angeles County Museum of Art,
Prints and Drawings Deaccession Fund
[Zürich, Los Angeles, Montreal]
plate 142 | cat. 190

Saint-Tropez: Evening Sun (Saint-Tropez:
Soleil du soir), 1894
Watercolor over traces of graphite
10 ⅝ × 8 ¼ in. (27 × 21 cm)
Los Angeles County Museum of Art,
Mr. and Mrs. William Preston Harrison
Collection
[Los Angeles]
cat. 191

Saint-Cloud, 1900
Oil on canvas
25 ⁹⁄₁₆ × 31 ¹⁵⁄₁₆ in. (65 × 81.2 cm)
Museum Folkwang, Essen
Exhibition: Berlin, 1901
Provenance: artist's studio; Folkwang
Museum, Hagen, 1901 (through Galerie
Keller and Reiner)
[Zürich, Los Angeles, Montreal]
plate 143 | cat. 192

Samois, the Bank, Morning (Samois.
La Berge. Matin), 1901
Oil on canvas
25 ¹³⁄₁₆ × 31 ¹⁵⁄₁₆ in. (65.6 × 81.2 cm)
Private collection, Canada
Exhibitions: *Deutsche und Französische
Neo-Impressionisten*, Galerie Cassirer,
Berlin, 1902; Galerie Cassirer, Hamburg,
1903; *Deutsche und französische
Impressionisten und Neo-Impressionisten*,
Weimar, 1905, no. 80
Provenance: Galerie Cassirer, Berlin;
Karl Bett, Berlin
[Los Angeles, Montreal]
plate 144 | cat. 193

Georg Tappert
German, 1880–1957

Betty, 1911
Oil on canvas
44 ¾ × 24 ⅝ in. (113.7 × 62.6 cm)
The San Diego Museum of Art,
gift from the Estate of Vance E. Kondon
and Liesbeth Giesberger
[Los Angeles, Montreal]
cat. 194

Félix Vallotton
Swiss, 1865–1925

Laziness (La paresse), 1896
Woodcut
Sheet: 9 ¹⁵⁄₁₆ × 12 ¹³⁄₁₆ in. (25.3 × 32.5 cm)
Graphische Sammlung ETH Zürich
[Zürich]
cat. 195

Laziness (La paresse), 1896
Woodcut
Sheet: 9 ¹³⁄₁₆ × 12 ⅝ in. (25 × 32.1 cm)
National Gallery of Art, Washington,
DC, gift of Frank and Jeannette Eyerly,
1986
[Los Angeles]
plate 145 | cat. 196

Laziness (La paresse), 1896
Woodcut
Sheet: 9 ⅞ × 12 ¹³⁄₁₆ in. (25.1 × 32.5 cm)
Montreal Museum of Fine Arts
[Montreal]
cat. 197

Louis Valtat
French, 1869–1952

Women, No. 1 (Les Femmes, No. 1),
1903–5
Woodcut in red-brown and yellow
6 ¹¹⁄₁₆ × 7 ½ in. (17 × 19 cm)
Baltimore Museum of Art, Nelson
and Juanita Greif Gutman Fund
[Los Angeles, Montreal]
plate 147 | cat. 198

Women, No. 2 (Les Femmes, No. 2),
1903–5
Woodcut in light green and gray
7 ½ × 6 ¹¹⁄₁₆ in. (19 × 17 cm)
Baltimore Museum of Art, Nelson
and Juanita Greif Gutman Fund
[Los Angeles, Montreal]
cat. 199

Women, No. 4 (Les Femmes, No. 4),
1903–5
Woodcut in red and light blue
6 ⁵⁄₁₆ × 7 ¹⁄₁₆ in. (16 × 18 cm)
Baltimore Museum of Art, Nelson
and Juanita Greif Gutman Fund
[Los Angeles, Montreal]
cat. 200

Women, No. 5 (Les Femmes, No. 5),
1903–5
Woodcut in dark blue and red
6 ⅞ × 7 ⁵⁄₁₆ in. (17.5 × 18.5 cm)
Baltimore Museum of Art, Nelson
and Juanita Greif Gutman Fund
[Los Angeles, Montreal]
plate 146 | cat. 201

Maurice de Vlaminck
French, 1876–1958

The Farmer (Le Cultivateur), 1905
Oil on canvas
18 ⁵⁄₁₆ × 21 ⅞ in. (46.5 × 55.5 cm)
Private collection, Canada
[Los Angeles, Montreal]
plate 150 | cat. 202

The Seine at Le Pecq (La Seine au Pecq),
1905
Oil on canvas
33 ⅞ × 74 in. (86 × 188 cm)
Merzbacher Kunststiftung
Provenance: Ambroise Vollard, Paris
[Zürich]
plate 151 | cat. 203

The Seine and Le Pecq (La Seine
et Le Pecq), 1906
Oil on canvas
13 ¾ × 16 ⅛ in. (35 × 41 cm)
Kunsthaus Zürich, collection Johanna
and Walter L. Wolf
[Los Angeles, Montreal]
plate 149 | cat. 204

Houses and Trees (Maisons et arbres),
1907–8
Oil on canvas
28 ¾ × 23 ⅝ in. (73 × 60 cm)
Kunsthaus Zürich, collection Johanna
and Walter L. Wolf
Provenance: Ambroise Vollard, Paris
[Zürich, Los Angeles]
plate 148 | cat. 205

Edouard Vuillard
French, 1868–1940

Woman in a Striped Dress (Le corsage
rayé), 1895
Oil on canvas
25 ⅞ × 23 ⅛ in. (65.7 × 58.7 cm)
National Gallery of Art, Washington,
DC, collection of Mr. and Mrs. Paul
Mellon
Exhibitions: Maison de l'Art Nouveau
Paris, 1895–96 (winter), no. 210;
Ninth Berlin Secession,
Ausstellungshaus am Kurfürstendamm,
1906, no. 296.1; Munich Secession,
Gebäude am Königsplatz, 1911, no. 202.
Provenance: Thaddée Natanson,
Paris, 1895 (by commission); M. Escher,
1908 (purchase)
[Zürich, Los Angeles, Montreal]
plate 152 | cat. 206

A Walk in the Vineyard (Promenade),
c. 1897–99
Oil on canvas
102 ½ × 98 in. (260.4 × 248.9 cm)
Los Angeles County Museum of Art,
gift of Hans de Schulthess
Exhibition: Jubilee Exhibition, Folkwang
Museum, Hagen, 1912
Provenance: Jack Aghion; Jos Hessel,
1892; Galerie Bernheim-Jeune;
Henry van de Velde, 1908 (purchase
for Karl Ernst Osthaus); Karl Ernst
Osthaus, Villa Hohenhof, Hagen
[Los Angeles]
plate 153 | cat. 207

Marianne Werefkin
Russian, active Germany
and Switzerland, 1860–1938

The Red Tree (Der rote Baum), 1910
Tempera on paper on cardboard
29 ¾ × 22 ¼ in. (75.5 × 56.5 cm)
Ascona, Marianne Werefkin Foundation,
Museo comunale d'arte moderna
[Zürich]
plate 155 | cat. 208

Corpus Christi, 1911
Tempera on paper on cardboard
20 ⅞ × 28 ⅛ in. (53 × 71.5 cm)
Ascona, Marianne Werefkin Foundation,
Museo comunale d'arte moderna
[Zürich, Los Angeles, Montreal]
plate 154 | cat. 209

Selected Bibliography

Frauke Josenhans

Primary Literature

Apollinaire, Guillaume. "Die moderne Malerei." Translated by Jean-Jacques. *Der Sturm* 3, no. 148/149 (February 1913): 272.

———. *Les peintres cubistes: Méditations esthétiques*. Paris: E. Figuière, 1913.

Bahr, Hermann. *Expressionismus*. Munich: Delphin-Verlag, 1916.

Baudelaire, Charles. *Le peintre de la vie moderne*. Paris, 1863.

Beckmann, Max. *Leben in Berlin: Tagebuch 1908–1909*. Edited by Hans Kinkel. Munich: R. Piper, 1983.

Clutton-Brock, Arthur. "The Post-Impressionists." *The Burlington Magazine* 18 (January 1911): 2016–19.

Coellen, Ludwig. *Die neue Malerei: Der Impressionismus, Van Gogh und Cézanne, die Romantik der neuen Malerei, Hodler, Gauguin und Matisse, Picasso und der Kubismus, die Expressionisten*. Munich: E. W. Bonsels, 1912.

Delaunay, Robert. "Ueber das Licht." Translated by Paul Klee. *Der Sturm* 3, no. 144/145 (January 1913): 255–56.

Einstein, Carl. *Werke*. Vol. 1, *1908–1918*. Edited by Rolf-Peter Baacke with Jens Kwasny. Berlin: Medusa, 1980.

Fechter, Paul. *Der Expressionismus*. Munich: R. Piper, 1914.

Gleizes, Albert, and Jean Metzinger. *Du cubisme*. Paris: E. Figuière, 1912.

Gogh, Vincent van. *Briefe*. Berlin: Bruno Cassirer, 1906.

Hausenstein, Wilhelm. *Der nackte Mensch in der Kunst aller Zeiten und Völker*. Munich: Piper, 1913.

Herrmann, Curt. *Der Kampf um den Stil: Probleme der modernen Malerei*. Berlin: E. Reiss, 1911.

Im Kampf um die Kunst: Die Antwort auf den "Protest deutscher Künstler." Munich: R. Piper, 1911.

Kahnweiler, Daniel Henry. *Der Weg zum Kubismus*. Munich: Delphin-Verlag, 1920.

Kandinsky, Wassily. *Klänge*. Munich: R. Piper, 1913.

Kandinsky, Wassily, and Franz Marc. *Der Blaue Reiter*. Munich: Piper, 1912. Translated by Henning Falkenstein, with the assistance of Manug Terzian and Gertrude Hinderlie, as *The Blaue Reiter Almanac*, edited by Klaus Lankheit (New York: Viking, 1974).

———. *Briefwechsel: Mit Briefen von und an Gabriele Münter und Maria Marc*. Edited by Klaus Lankheit. Munich: R. Piper, 1983.

Kessler, Harry. *Der deutsche Künstlerbund*. Berlin: Bruno Cassirer, 1904.

———. *Gesammelte Schriften in drei Bänden*. Vol. 2, *Künstler und Nationen: Aufsätze und Reden 1899–1933*. Edited by Cornelia Blasberg and Gerhard Schuster. Frankfurt am Main: Fischer Tashenbuch Verlag, 1988.

———. *Impressionisten: Die Begründer der modernen Malerei in ihren Hauptwerken*. Munich: F. Bruckmann, 1908.

———. *Journey to the Abyss: The Diaries of Count Harry Kessler, 1880–1918*. Edited and translated by Laird M. Easton. New York: Alfred A. Knopf, 2011.

———. *Tagebuch eines Weltmannes*. Edited by Gerhard Schuster and Margot Pehle. Marbach am Neckar: Deutsche Schillergesellschaft, 1988.

———. *Über den Kunstwert des Neo-Impressionismus: Eine Erwiderung von Harry Graf Kessler*. Berlin: von Holten, 1903.

Mahlberg, Paul, comp. *Beiträge zur Kunst des XIX. Jahrhunderts und unserer Zeit*. Düsseldorf: Ohle, 1913. Published by Galerie Alfred Flechtheim on the occasion of their opening.

Matisse, Henri. "Notes d'un peintre." *La Grande Revue* 2, no. 24 (December 25, 1908): 731–45. Published in German as "Notizen eines Malers." *Kunst und Künstler* 7, no. 8 (May 1909): 335–47. Translated in Herschel B. Chipp et al., *Theories of Modern Art* (Berkeley: University of California Press, 1968).

Meier-Graefe, Julius. *Cézanne und sein Kreis*. Munich: R. Piper, 1918.

———. *Edouard Manet*. Munich: R. Piper, 1912.

———. *Entwickelungsgeschichte der modernen Kunst*. 3 vols. Stuttgart: Verlag J. Hoffmann, 1904. Translated by Florence Simmonds and George W. Chrystal as *Modern Art: Being a Contribution to a New System of Aesthetics*, 2 vols. (New York: G. P. Putnam's Sons; London: William Heinemann, 1908).

———. *Der Fall Böcklin und die Lehre von den Einheiten*. Stuttgart: Julius Hoffmann, 1905.

———. *Impressionisten: Guys, Manet, Van Gogh, Pissarro, Cézanne*. Munich: R. Piper, 1907.

———. *Kunst ist nicht für Kunstgeschichte da: Briefe und Dokumente*. Edited by Catherine Krahmer. Göttingen: Wallstein Verlag, 2001.

———. *Manet und sein Kreis*. Berlin: Julius Bard, 1902.

———. *Der moderne Impressionismus*. Berlin: Julius Bard, 1903.

———. *Paul Cézanne*. 3rd ed. Munich: Piper, 1910.

———. *Tagebuch 1903–1917 und weitere Dokumente*. Edited by Catherine Krahmer. Göttingen: Wallstein, 2009.

———. *Vincent van Gogh*. Munich: R. Piper, 1910. Translated by John Holroyd Reece as *Vincent van Gogh: A Biographical Study*, 2 vols. (London: Medici Society, 1922).

Moderne Kunst: Plastik, Malerei, Graphik. Edited by Kurt Freyer. Hagen: Museum Folkwang, 1912.

Morice, Charles. "À qui la couronne." *Le Temps*. February 22, 1910.

Nolde, Emil. *Mein Leben*. Cologne: DuMont, 1976.

———, et al. *Emil und Ada Nolde, Karl Ernst und Gertrud Osthaus: Briefwechsel*. Edited by Herta Hesse-Frielinghaus. Bonn: Bouvier, 1985.

Raphael, Max. *Das schöpferische Auge; oder, Die Geburt des Expressionismus: Die frühen Schriften 1910–1913*. Edited by Patrick Healy. Vienna: Gesellschaft für Kunst und Volksbildung, 1993.

———. *Aufbruch in die Gegenwart: Begegnungen mit der Kunst und den Künstlern des 20. Jahrhunderts*. Edited by Hans-Jürgen Heinrichs. Expanded edition. Frankfurt am Main: Suhrkamp, 1989.

———. *Von Monet zu Picasso: Grundzüge einer Ästhetik und Entwicklung der modernen Malerei*. Edited by Klaus Binder. Frankfurt am Main: Suhrkamp, 1989.

Rotonchamp, Jean de. *Paul Gauguin, 1848–1903*. Paris: E. Druet, 1906. Printed in Weimar.

Scheffler, Karl. *Der Deutsche und seine Kunst: Eine notgedrungene Streitschrift*. Munich: R. Piper, 1907.

Sembat, Marcel. "Henri Matisse." *Les Cahiers d'aujourd'hui* 4 (April 1913): 185–94.

Signac, Paul. "Neoimpressionismus." *Pan* 4 (1898): 55–62.

———. *D'Eugène Delacroix au néo-impressionnisme*. Paris: Éditions de la Revue Blanche, 1899. Translated by Sophie Herrmann as *Von Eugen Delacroix zum Neo-Impressionismus* (Krefeld: Rheinische Verlagsanstalt, 1903).

Tschudi, Hugo von. *Gesammelte Schriften zur neueren Kunst*. Edited by E. Schwedeler-Meyer. Munich: F. Bruckmann, 1912.

Uhde, Wilhelm. *Henri Rousseau*. Paris: E. Figuière, 1911. German translation published by Ohle (Düsseldorf) in 1914.

Vinnen, Carl. *Ein Protest deutscher Künstler*. Jena: Diederich, 1911.

Walden, Herwarth. *Einblick in die Kunst: Expressionismus, Futurismus, Kubismus*. Berlin: Sturm-Verlag, 1917.

———. *Expressionismus, die Kunstwende*. Berlin: Sturm-Verlag, 1918.

Worringer, Wilhelm. *Abstraktion und Einfühlung*. Munich: R. Piper, 1908.

Exhibition Catalogues before 1914 (arranged chronologically)

Deutsche Jahrhundertausstellung: Ausstellung deutscher Kunst aus der Zeit von 1775–1875 in der Königlichen Nationalgalerie; Berlin 1906. 2 vols. Munich: F. Bruckmann, 1906.

Ausstellung des Sonderbundes Westdeutscher Kunstfreunde und Künstler, Düsseldorf, 1910. Düsseldorf: Aug. Bagel, 1910.

K. G. *"Brücke": Katalog zur Ausstellung in der Galerie Ernst Arnold in Dresden*. Dresden, 1910.

Neue Künstlervereinigung München E.V. II. Ausstellung. Munich: F. Bruckmann, 1910.

Die erste Ausstellung der Redaktion der Blaue Reiter. Wassily Kandinsky and Franz Marc. Munich: Galerie Thannhauser; Munich: F. Bruckmann, 1911.

Ausstellung von Künstlergruppe Brücke im Kunstsalon Fritz Gurlitt, Berlin, W. Potsdamerstr. 113, Villa 2. N.p., 1912.

Die zweite Ausstellung der Redaktion der Blaue Reiter: Schwarz-weiss. Munich: H. Golz Kunsthandlung, 1912.

Paul Cassirer, XV. Jahrgang, 1912–1913, Oktober–November, Erste Ausstellung. Berlin, 1912.

Sonderbund Ausstellung, 1912: Führer nebst Vorwort. Harro von Wedderkop. Bonn: A. Ahn, 1912.

Ausstellung Pablo Picasso: Moderne Galerie Heinrich Thannhauser, Februar 1913. Munich: Galerie Thannhauser, 1913.

Erste Ausstellung der Neuen Galerie. Foreword by Carl Einstein. Berlin, 1913.

Erster Deutscher Herbstsalon. Herwarth Walden. Berlin: Der Sturm, 1913.

Henri Matisse: Kunstsalon Fritz Gurlitt. Berlin: Kunstsalon, 1914.

Secondary Literature

Anger, Jenny. *Paul Klee and the Decorative in Modern Art.* Cambridge: Cambridge University Press, 2004.

Augustine, Dolores L. *Patricians and Parvenus: Wealth and High Society in Wilhelmine Germany.* Oxford: Berg Publishers, 1994.

Barr, Alfred H. *Matisse: His Art and His Public.* New York: Museum of Modern Art, 1951.

Behr, Shulamith, David Fanning, and Douglas Jarman, eds. *Expressionism Reassessed.* Manchester: Manchester University Press, 1993.

Belting, Hans. *Die Deutschen und ihre Kunst: Ein schwieriges Erbe.* Munich: C. H. Beck, 1992. Translated by Scott Yeager as *The Germans and Their Art: A Troublesome Relationship* (New Haven, CT: Yale University Press, 1998).

Benson, Timothy O., and Éva Forgács, eds. *Between Worlds: A Sourcebook of Central European Avant-Gardes, 1910–1930.* Los Angeles: Los Angeles County Museum of Art; Cambridge, MA: MIT Press, 2002.

Berger, Renate, and Anja Herrmann, eds. *Paris, Paris! Paula Modersohn-Becker und die Künstlerinnen um 1900.* Stuttgart: W. Kohlhammer Verlag, 2009.

Boorman, Helen. "Rethinking the Expressionist Era: Wilhelmine Cultural Debates and Prussian Elements in German Expressionism." *The Oxford Art Journal* 9, no. 2 (1986): 3–15.

Bradley, William S. *Emil Nolde and German Expressionism: A Prophet in His Own Land.* Ann Arbor: UMI Research Press, 1986.

Bridgwater, Patrick. *The Expressionist Generation and Van Gogh.* Hull: Hull University, 1987.

Brühl, Georg. *Die Cassirers: Streiter für den Impressionismus.* Leipzig: Edition Leipzig, 1991.

———. *Herwarth Walden und "Der Sturm."* Cologne: Dumont, 1983.

Cachin, Françoise. *Signac: Catalogue raisonné de l'oeuvre peint.* Paris: Gallimard, 2000.

Coppel, Stephen. "The Fauve Woodcut." *Print Quarterly* 16, no. 1 (March 1999): 3–33.

Crespelle, Jean-Paul. *Fauves und Expressionisten.* Munich: Bruckmann, 1963.

Dascher, Ottfried. *"Es ist was Wahnsinniges mit der Kunst": Alfred Flechtheim; Sammler, Kunsthändler und Verleger.* Wädenswil: Nimbus, 2011.

Delaunay, Robert. *Du cubisme à l'art abstrait.* Edited by Pierre Francastel with a catalogue by Guy Habasque. Paris: S.E.V.P.E.N., 1957.

Doede, Werner. *Die Berliner Secession: Berlin als Zentrum der deutschen Kunst von der Jahrhundertwende bis zum Ersten Weltkrieg.* Frankfurt am Main: Propyläen-Verlag, 1977.

Dube, Wolf Dieter, and Annemarie Dube-Heynig. *E. L. Kirchner: Das graphische Werk.* 2 vols. Munich: Prestel, 1967.

Duthuit, Claude, and Marguerite Duthuit-Matisse. *Henri Matisse: Catalogue raisonné de l'oeuvre gravé.* 2 vols. Paris: Claude Duthuit, 1983.

Easton, Laird M. *The Red Count: The Life and Times of Harry Kessler.* Berkeley: University of California Press, 2002.

Echte, Bernhard, and Walter Feilchenfeldt. *Kunstsalon Bruno & Paul Cassirer: Die Ausstellungen 1898–1901; "Das Beste aus aller Welt zeigen."* Wädenswil: Nimbus, Kunst und Bücher, 2011.

Espagne, Michael, and Michael Werner, eds. *Transferts: Les relations interculturelles dans l'espace franco-allemand (XVIIIe–XIXe siècle).* Paris: Éditions Recherche sur les civilisations, 1988.

Ewers-Schultz, Martina. *Die französischen Grundlagen des "rheinischen Expressionismus" 1905 bis 1914: Stellenwert und Bedeutung der französischen Kunst in Deutschland und ihre Rezeption in den Werken der Bonner Ausstellungsgemeinschaft von 1913.* Münster: Lit Verlag, 1996.

Fäthke, Bernd. *Jawlensky und seine Weggefährten in neuem Licht.* Munich: Hirmer, 2004.

Fehr, Michael, and Joachim Fischer. *Briefe an Karl Ernst Osthaus.* Berlin: Kulturstiftung der Länder; Hagen: Karl Ernst Osthaus-Museum, 2000.

Feilchenfeldt, Rahel E., and Markus Brandis. *Paul Cassirer Verlag, Berlin 1898–1933: Eine kommentierte Bibliographie; Bruno und Paul Cassirer Verlag 1898–1901; Paul Cassirer Verlag 1908–1933.* Munich: K. G. Saur, 2002.

Feilchenfeldt, Walter. *"By Appointment Only": Schriften zu Kunst und Kunsthandel; Cézanne und Van Gogh.* Wädenswil: Nimbus, 2005. Translated as *By Appointment Only: Cézanne, Van Gogh and Some Secrets of Art Dealing; Essays and Lectures* (London: Thames and Hudson, 2006).

———. *Vincent van Gogh: Die Gemälde 1886–1890; Händler, Sammler, Ausstellungen; Die frühen Provenienzen.* Wädenswil: Nimbus, 2009.

———. *Vincent van Gogh & Paul Cassirer, Berlin: The Reception of Van Gogh in Germany from 1901 to 1914.* Zwolle: Waanders, 1988.

Feist, Günter, ed. *Kunst und Künstler: Aus 32 Jahrgängen einer deutschen Kunstzeitschrift.* Mainz: Kupferberg, 1971.

Fineberg, Jonathan David. *Kandinsky in Paris, 1906–1907.* Ann Arbor: UMI Research Press, 1984.

Fleckner, Uwe, and Thomas Gaehtgens, eds. *Prenez garde à la peinture! Kunstkritik in Frankreich 1900–1945.* Berlin: Akademie, 1999.

Fleckner, Uwe, Thomas Gaehtgens, Martin Schieder, and Michael F. Zimmermann, eds. *Jenseits der Grenzen: Französische und deutsche Kunst vom Ancien Régime bis zur Gegenwart; Thomas W. Gaehtgens zum 60. Geburtstag.* 3 vols. Cologne: DuMont, 2000.

Forster-Hahn, Françoise, ed. *Imagining Modern German Culture, 1889–1910.* Washington, DC: National Gallery of Art, 1996.

Fulda, Bernhard, and Aya Soika. *Max Pechstein: The Rise and Fall of Expressionism.* Boston: De Gruyter, 2012.

Gaehtgens, Thomas W. "Les rapports de l'histoire de l'art et de l'art contemporain en Allemagne à l'époque de Wölfflin et de Meier-Graefe." *Revue de l'art* 88 (1990): 31–38.

———, ed. *Künstlerischer Austausch = Artistic exchange: Akten des XXVIII. Internationalen Kongresses für Kunstgeschichte, Berlin, 15.–20. Juli 1992.* Berlin: Akademie Verlag, 1993.

Gautherie-Kampka, Annette. *Les Allemands du Dôme: La colonie allemande de Montparnasse dans les années 1903–1914.* Bern: Peter Lang, 1995.

Gebhardt, Volker. *Das Deutsche in der deutschen Kunst.* Cologne: DuMont, 2004.

Geelhaar, Christian. *Picasso: Wegbereiter und Förderer seines Aufstiegs 1899–1939.* Zürich: Palladion Verlag, 1993.

Gordon, Donald E. *Ernst Ludwig Kirchner: Mit einem kritischen Katalog sämtlicher Gemälde.* Munich: Prestel, 1968.

———. *Expressionism: Art and Idea.* New Haven, CT: Yale University Press, 1987.

———. *Modern Art Exhibitions, 1900–1916.* 2 vols. Munich: Prestel, 1974.

———. "On the Origin of the Word 'Expressionism.'" *Journal of the Warburg and Courtauld Institutes* 29 (1966): 368–85.

Grohmann, Will. *E. L. Kirchner.* Stuttgart: W. Kohlhammer, 1958.

Hackstein, Ariane. *Die Karl Ernst Osthaus Rezeption.* Weimar: VDG, 1996.

Hahl-Fontaine, Jelena. *Kandinsky.* New York: Rizzoli, 1993.

Hesse-Frielinghaus, Herta, et al. *Karl Ernst Osthaus: Leben und Werk.* Recklinghausen: Bongers, 1971.

Hoberg, Annegret, and Isabelle Jansen. *Franz Marc: The Complete Works.* 3 vols. London: Philip Wilson Publishers, 2004.

Hoffmann, Meike. *Leben und Schaffen der Künstlergruppe "Brücke" 1905 bis 1913: Mit einem kommentierten Werkverzeichnis der Geschäfts- und Ausstellungsgrafik.* Berlin: Reimer, 2005.

Holleczek, Andreas, and Andrea Meyer, eds. *Französische Kunst—Deutsche Perspektiven 1870–1945: Quellen und Kommentare zur Kunstkritik.* Berlin: Akademie Verlag, 2004.

Hulsker, Jan. *The New Complete Van Gogh: Paintings, Drawings, Sketches.* Amsterdam: J. M. Meulenhoff; Philadelphia: John Benjamins, 1996.

Illetschko, Georgia. *Kandinsky und Paris: Die Geschichte einer Beziehung.* Munich: Prestel, 1997.

Jansen, Isabelle. *Franz Marc et l'art français du XIXe siècle.* Paris: Éditions de la Maison des sciences de l'homme, 2007.

———. "Paris–Munich 1900–1914: Un dialogue artistique riche et complexe." In *L'expressionnisme: Une construction de l'autre; France et Italie face à l'expressionnisme = L'espressionismo: Una costruzione d'alterità; Francia e Italia di fronte all'espressionismo*, edited by Dominique Jarrassé and Maria Grazia Messina, 37–49. Le Kremlin-Bicêtre: Éd. Esthétiques du Divers, 2012.

Jordan, Jim M. *Paul Klee and Cubism*. Princeton, NJ: Princeton University Press, 1984.

Junge, Henrike. *Avantgarde und Publikum: Zur Rezeption avantgardistischer Kunst in Deutschland 1905–1933*. Cologne: Böhlau, 1992.

Kennert, Christian. *Paul Cassirer und sein Kreis: Ein Berliner Wegbereiter der Moderne*. Frankfurt am Main: Peter Lang, 1996.

Kostka, Alexandre, and Françoise Lucbert, eds. *Distanz und Aneignung: Kunstbeziehungen zwischen Deutschland und Frankreich 1870–1945 = Relations artistiques entre la France et l'Allemagne 1870–1945*. Berlin: Akademie Verlag, 2004.

Krause, Frank, ed. *Frankreich und der deutsche Expressionismus = France and German Expressionism*. Göttingen: V&R Unipress, 2008.

Kropmanns, Peter. "Die deutsche Matisse-Premiere: Vor 90 Jahren—München 1906." *Weltkunst* 66, no. 13 (July 1996): 1519–21.

———. *Gauguin und die Schule von Pont-Aven: Im Deutschland nach der Jahrhundertwende*. Sigmaringen: Thorbecke, 1997.

———. "The Gauguin Exhibition in Weimar in 1905." *The Burlington Magazine* 141, no. 1150 (January 1999): 24–31.

———. "Matisse in Deutschland." PhD diss., Humboldt Universität, 2000.

———. *Matisse en Allemagne: Présence et réceptions méconnues, 1906–1910*. Quimperlé: Editions Mona Kerloff, 2009.

Krüger, Günter. *Das druckgraphische Werk Max Pechsteins*. Tökendorf: R. C. Pechstein-Verlag, 1988.

Kuenzli, Katherine M. *The Nabis and Intimate Modernism: Painting and the Decorative at the Fin-de-Siècle*. Burlington, VT: Ashgate, 2010.

Lasko, Peter. *The Expressionist Roots of Modernism*. Manchester: Manchester University Press, 2003.

Lenman, Robin. *Artists and Society in Germany, 1850–1914*. Manchester: Manchester University Press, 1997.

Leschonski, Henrik. *Der Kristall als expressionistisches Symbol: Studien zur Symbolik des Kristallinen in Lyrik, Kunst und Architektur des Expressionismus (1910–1925)*. Frankfurt am Main: Peter Lang, 2008.

Linnebach, Gabrielle. *La peinture française en Allemagne: Recherches sur les rapports artistiques franco-allemands à la veille de la première guerre mondiale (1905–1914)*. Paris: École du Louvre, 1977.

Luckhardt, Ulrich. *Lyonel Feininger*. Translated by Eileen Martin. Munich: Prestel, 1989.

Luckhardt, Ulrich, and Uwe M. Schneede, eds. *Private Schätze: Über das Sammeln von Kunst in Hamburg bis 1933*. Hamburg: Christians, 2001.

Manguin, Lucile, and Claude Manguin, eds. *Henri Manguin: Catalogue raisonné de l'oeuvre peint*. Neuchâtel: Ides et Calendes, 1980.

Manheim, Ron. "The 'Germanic' Van Gogh: A Case Study of Cultural Annexation." *Simiolus* 19, no. 4 (1989): 277–88.

Moffett, Kenworth. *Meier-Graefe as Art Critic*. Munich: Prestel, 1973.

Mongan, Elizabeth, Eberhard W. Kornfeld, and Harold Joachim. *Paul Gauguin: Catalogue Raisonné of His Prints*. Bern: Galerie Kornfeld, 1988.

Murken-Altrogge, Christa. "Der französische Einfluß im Werk von Paula Modersohn-Becker." *Die Kunst und das schöne Heim* 87, no. 3 (1975): 145–52.

Negendanck, Ruth. *Die Galerie Ernst Arnold (1893–1951): Kunsthandel und Zeitgeschichte*. Weimar: VDG, 1998.

Neumann, Gerhard, and Günter Schnitzler, eds. *Harry Graf Kessler: Ein Wegbereiter der Moderne*. Freiburg im Breisgau: Rombach, 1997.

Novotny, Fritz. *Cézanne*. Vienna: Phaidon, 1937. English translation published by Phaidon in 1948.

Paret, Peter. *The Berlin Secession: Modernism and Its Enemies in Imperial Germany*. Cambridge, MA: Belknap Press of Harvard University Press, 1980.

———. *German Encounters with Modernism, 1840–1945*. New York: Cambridge University Press, 2001.

———. "The Tschudi Affair." *The Journal of Modern History* 53, no. 4 (December 1981): 589–618.

Paul, Barbara. *Hugo von Tschudi und die moderne französische Kunst im Deutschen Kaiserreich*. Mainz: von Zabern, 1993.

Paul Klee Foundation. *Paul Klee: Catalogue Raisonné*. 9 vols. London: Thames and Hudson, 1998–2004.

Pophanken, Andrea, and Felix Billeter, eds. *Die Moderne und ihre Sammler: Französische Kunst in deutschem Privatbesitz vom Kaiserreich zur Weimarer Republik*. Berlin: Akademie Verlag, 2001.

Rewald, John. *The Paintings of Paul Cézanne: A Catalogue Raisonné*. In collaboration with Walter Feilchenfeldt and Jayne Warman. 2 vols. New York: Harry N. Abrams, 1996.

Sanchez, Pierre, ed. *Les expositions de la Galerie Eugène Druet: Répertoire des artistes exposants et liste de leurs oeuvres, 1903–1938*. Dijon: L'Échelle de Jacob, 2009.

Schapiro, Meyer. *Paul Cézanne*. New York: Harry N. Abrams, 1952.

Selz, Peter. *German Expressionist Painting*. 1957. Reprint, Berkeley: University of California Press, 1974.

Silver, Kenneth E. *Esprit de Corps: The Art of the Parisian Avant-Garde and the First World War, 1914–1925*. Princeton, NJ: Princeton University Press, 1989.

Soika, Aya. *Max Pechstein: Das Werkverzeichnis der Ölgemälde*. 2 vols. Munich: Hirmer, 2011.

Teeuwisse, Nicolaas. *Vom Salon zur Secession: Berliner Kunstleben zwischen Tradition und Aufbruch zur Moderne 1871–1900*. Berlin: Deutscher Verlag für Kunstwissenschaft, 1986.

Thiem, Gunther. "Karl Schmidt-Rottluff 1912: Experiment Kubismus." *Städel-Jahrbuch* 13 (1991): 245–56.

Uhde, Wilhelm. *Von Bismarck bis Picasso: Erinnerungen und Bekenntnisse*. Zürich: Verlag Oprecht, 1938. Reprinted with an afterword by Anne-Marie Uhde and an essay by Bernd Roeck. Zürich: Römerhof, 2010.

Vogt, Paul. *Das Museum Folkwang Essen: Die Geschichte einer Sammlung junger Kunst im Ruhrgebiet*. Cologne: DuMont, 1965.

———. *Erich Heckel*. Recklinghausen: Bongers, 1965.

Walther, Ingo F., and Rainer Metzger. *Van Gogh: The Complete Paintings*. Translated by Michael Hulse. Cologne: Taschen, 2006.

Weikop, Christian, ed. *New Perspectives on Brücke Expressionism: Bridging History*. Burlington, VT: Ashgate, 2011.

Werenskiold, Marit. *The Concept of Expressionism: Origin and Metamorphoses*. Oslo: Universitetsforlaget, 1984.

Wiese, Stephan von. *Graphik des Expressionismus*. Stuttgart: Hatje, 1976.

Wildenstein, Daniel. *Gauguin: A Savage in the Making; Catalogue Raisonné of the Paintings (1873–1888)*. 2 vols. Paris: Wildenstein Institute; Milan: Skira, 2002.

Wildenstein, Georges. *Gauguin*. Paris: Beaux-Arts, 1964.

Exhibition Catalogues (arranged chronologically)

Meisterwerke des deutschen Expressionismus. Zürich: Kunsthaus Zürich, 1961.

Le Fauvisme français et les débuts de l'expressionnisme allemand = Der französische Fauvismus und der deutsche Frühexpressionismus. Michel Hoog and Leopold Reidemeister. Munich: Haus der Kunst; Paris: Musée national d'art moderne, 1966.

The "Wild Beasts": Fauvism and Its Affinities. Edited by John Elderfield. New York: Museum of Modern Art, 1976.

Paris-Berlin, 1900–1933: Rapports et contrastes France-Allemagne, 1900–1933. Paris: Centre national d'art et de culture Georges Pompidou, 1978.

Cuno Amiet und die Maler der Brücke. Zürich: Kunsthaus Zürich, 1979.

Post-Impressionism: Cross-Currents in European Painting. Edited by John House and Mary Anne Stevens. London: Royal Academy of Arts, 1979.

Die Tunisreise: Klee, Macke, Moilliet. Edited by Ernst Gerhard-Güse. Münster: Landschaftverband Westfalen-Lippe, Westfälisches Landesmuseum für Kunst und Kulturgeschichte; Stuttgart: G. Hatje, 1982.

Delaunay und Deutschland. Edited by Peter-Klaus Schuster. Munich: Bayerische Staatsgemäldesammlungen/Staatsgalerie Moderner Kunst; Cologne: DuMont Buchverlag, 1985. Exhibition held at the Haus der Kunst, Munich.

Prints by Erich Heckel and Karl Schmidt-Rottluff: A Centenary Celebration. With an essay by Gunther Thiem. Los Angeles: Los Angeles County Museum of Art, 1985.

August Macke: Gemälde, Aquarelle, Zeichnungen. Edited by Ernst-Gerhard Güse. Münster: Westfälisches Landesmuseum für Kunst und Kulturgeschichte; Bonn: Städtisches Kunstmuseum; Munich: Städtische Galerie im Lenbachhaus; Munich: Bruckmann, 1986.

Der Blaue Reiter. Edited by Hans Christoph von Tavel. Bern: Kunstmuseum Bern, 1986.

Expressionisten: Die Avantgarde in Deutschland 1905–1920. Günter Schade and Manfred Ohlsen. Berlin: Staatliche Museen zu Berlin, Nationalgalerie und Kupferstichkabinett; Berlin: Henschelverlag Kunst und Gesellschaft, 1986.

Alfred Flechtheim: Sammler, Kunsthändler, Verleger. Düsseldorf: Kunstmuseum Düsseldorf, 1987.

The Art of Paul Gauguin. Edited by Richard Brettell, et al. Washington, DC: National Gallery of Art, 1988.

Matisse und seine deutschen Schüler: Friedrich Ahlers-Hestermann, Otto Richard Langer, Rudolf Levy, Marg Moll, Oskar Moll, Franz Nölken, Hans Purrmann, Walter Alfred Rosam, William Straube. Edited by Gisela Fiedler-Bender, Heinz Höfchen, and Wolfgang Stolte. Kaiserslautern: Pfalzgalerie, 1988.

Stationen der Moderne: Die bedeutenden Kunstausstellungen des 20. Jahrhunderts in Deutschland. Edited by Michael Bollé and Eva Züchner. Berlin: Berlinische Galerie, Museum für Moderne Kunst, Photographie und Architektur; Berlin: Nicolai, 1988.

Curt Herrmann 1854–1929: Ein Maler der Moderne in Berlin. Edited by Rolf Bothe. Berlin: Berlin-Museum; Berlin: W. Arenhövel, 1989.

The Fauve Landscape. Judi Freeman. Los Angeles: Los Angeles County Museum of Art; New York: Abbeville Press, 1990.

Vincent van Gogh und die Moderne 1890–1914. Edited by Georg-W. Költzsch and Ronald de Leeuw. Essen: Museum Folkwang; Amsterdam: Van Gogh Museum; Freren: Luca, 1990. Published in English as *Vincent van Gogh and the Modern Movement, 1890–1914.*

Gabriele Münter 1877–1962: Retrospektive. Edited by Annegret Hoberg and Helmut Friedel. Munich: Städtische Galerie im Lenbachhaus; Munich: Prestel, 1992.

Henri Matisse: A Retrospective. Edited by John Elderfield. New York: Museum of Modern Art, 1992. Distributed by H. N. Abrams.

Der Gereonsklub 1911–1913: Europas Avantgarde im Rheinland. Concept and texts by Hildegard Rheinhardt and Mario-Andreas von Lüttichau, book and exhibition by Peter Dering. Bonn: Verein August Macke Haus, 1993.

Henri Matisse: 1904–1917. Paris: Centre Georges Pompidou, 1993.

Der frühe Kandinsky: 1900–1910. Edited by Magdalena M. Moeller. Berlin: Brücke-Museum; Tübingen: Kunsthalle Tübingen; Munich: Hirmer, 1994.

Aufbruch zur Farbe: Luministische Malerei in Holland und Deutschland. Edited by Burkhard Leismann. Ahlen: Kunst-Museum Ahlen; Neuss: Clemens-Sels-Museum; Bonn: August Macke Haus; Bönen: DruckVerlag Kettler, 1996.

Café du Dôme: Deutsche Maler in Paris 1903–1914. Annette Gautherie-Kampka. Wilhelmshaven: Kunsthalle Wilhelmshaven; Bremen: Donat, 1996.

Cézanne. Edited by Françoise Cachin. New York: H. N. Abrams in association with the Philadelphia Museum of Art, 1996.

Farben des Lichts: Paul Signac und der Beginn der Moderne von Matisse bis Mondrian. Edited by Erich Franz. Münster: Westfälisches Landesmuseum für Kunst und Kulturgeschichte; Ostfildern: Edition Tertium, 1996.

Manet bis Van Gogh: Hugo von Tschudi und der Kampf um die Moderne. Edited by Johann Georg Prinz von Hohenzollern and Peter-Klaus Schuster. Berlin: Nationalgalerie; Munich: Neue Pinakothek; Munich: Prestel, 1996.

Von der Brücke zum Blauen Reiter: Farbe, Form und Ausdruck in der deutschen Kunst von 1905 bis 1914. Edited by Tayfun Belgin. Dortmund: Museum am Ostwall; Heidelberg: Edition Braus, 1996.

Gauguin und die Schule von Pont-Aven. Edited by Ronald Pickvance. Künzelsau: Museum Würth; Sigmaringen: Thorbecke, 1997.

Paula Modersohn-Becker 1876–1907: Retrospektive. Edited by Helmut Friedel. Munich: Städtische Galerie im Lenbachhaus; Munich: Hirmer, 1997.

Die grosse Inspiration: Deutsche Künstler in der Académie Matisse. Edited by Burkhard Leismann. 3 vols. Ahlen: Kunst-Museum Ahlen, 1997–2004.

Alexej von Jawlensky: Reisen, Freunde, Wandlungen. Edited by Tayfun Belgin. Dortmund: Museum am Ostwall; Heidelberg: Umschau/Braus, 1998.

Der Almanach "Der Blaue Reiter": Bilder und Bildwerke in Originalen. Edited by Brigitte Salmen, Birgit Jooss, and Annette Splieth-Locherer. Murnau: Schloßmuseum, 1998.

Die Explosion der Farbe: Fauvismus und Expressionismus 1905 bis 1911. Edited by Patricia Rochard. Ingelheim: Museum Altes Rathaus; Mainz: Verlag Hermann Schmidt, 1998.

Paul Gauguin: Das verlorene Paradies. Edited by Georg-Wilhelm Költzsch. Essen: Museum Folkwang; Cologne: DuMont, 1998.

Aufstieg und Fall der Moderne. Edited by Rolf Bothe and Thomas Föhl. Weimar: Kunstsammlungen zu Weimar; Berlin: Deutsches Historisches Museum; Ostfildern-Ruit: Hatje Cantz, 1999.

Der Blaue Reiter und das Neue Bild: Von der "Neuen Künstlervereinung München" zum "Blauen Reiter." Edited by Annegret Hoberg and Helmut Friedel. Munich: Städtische Galerie im Lenbachhaus, 1999.

Der Blaue Reiter und seine Künstler. Edited by Magdalena M. Moeller. Berlin: Brücke Museum; Munich: Hirmer Verlag, 1999.

Cuno Amiet: Von Pont-Aven zur "Brücke." Edited by Therese Bhattacharya-Stettler and Toni Stooss. Bern: Kunstmuseum Bern; Milan: Skira, 1999.

Deutschland Frankreich: Dialoge der Kunst im XX. Jahrhundert. Edited by Beate Reifenscheid. Koblenz: Ludwig Museum im Deutschherrenhaus; Bielefeld: Kerber, 1999.

Erich Heckel: Meisterwerke des Expressionismus; Aquarelle und Zeichnungen aus der Sammlung des Brücke-Museums Berlin. Edited by Magdalena M. Moeller. Berlin: Brücke Museum; Munich: Hirmer, 1999.

Le Fauvisme; ou, "L'épreuve du feu": Éruption de la modernité en Europe. Paris, Musée d'art moderne de la ville de Paris; Paris: Paris Musées, 1999.

Feininger im Weimarer Land. Edited by Martin Faass. Apolda: Kunsthaus Apolda Avantgarde; Weimar: VDG, 1999.

Der Blaue Reiter. Edited by Christine Hopfengart. Bremen: Kunsthalle Bremen; Cologne: DuMont, 2000.

Gabriele Münter: Das druckgraphische Werk. Edited by Helmut Friedel. Munich: Städtische Galerie im Lenbachhaus; Munich: Prestel, 2000.

Die Ordnung der Farbe: Paul Klee, August Macke und ihre Malerfreunde. Edited by Volker Adolphs and Josef Helfenstein. Bonn: Kunstmuseum Bonn; Cologne: DuMont, 2000.

Der Sturm: Chagall, Feininger, Jawlensky, Kandinsky, Klee, Kokoschka, Macke, Marc, Schwitters und viele andere im Berlin der zehner Jahre. Edited by Barbara Alms and Wiebke Steinmetz. Delmenhorst: Städtische Galerie Delmenhorst, Haus Coburg; Bremen: Hauschild, 2000.

August Macke und die Moderne in Europa. Edited by Ursula Heiderich and Erich Franz. Münster: Westfälisches Landesmuseum für Kunst und Kulturgeschichte; Bonn: Kunstmuseum Bonn; Ostfildern: Hatje Cantz, 2001.

Beyond the Easel: Decorative Paintings by Bonnard, Vuillard, Denis, and Roussel, 1890–1930. Gloria Groom. Chicago: Art Institute of Chicago; New Haven, CT: Yale University Press, 2001.

Die Brücke in Dresden: 1905–1911. Edited by Birgit Dalbajewa and Ulrich Bischoff. Dresden: Galerie Neue Meister; Cologne: König, 2001.

Ernst Ludwig Kirchner: Gemälde, Zeichnung, Druckgraphik, Neuerwerbungen des Brücke-Museums Berlin seit 1988. Edited by Magdalena M. Moeller. Berlin: Brücke Museum; Cologne: DuMont, 2001.

Expressionismus: Meisterwerke aus dem Von der Heydt-Museum Wuppertal. Sabine Fehlemann. Schleswig: Stiftung Schleswig-Holsteinische Landesmuseen Schloss Gottorf, 2001.

Henri Rousseau: Der Zöllner; Grenzgänger zur Moderne. Götz Adriani. Tübingen: Kunsthalle Tübingen; Cologne: DuMont, 2001. Translated by Scott Kleager and Jenny Marsh as *Henri Rousseau* (New Haven, CT: Yale University Press, 2001).

Schmidt-Rottluff: Ein Maler des 20. Jahrhunderts; Gemälde, Aquarelle und Zeichnungen von 1905 bis 1975. Edited by Magdalena M. Moeller and Tayfun Belgin. Dortmund: Museum am Ostwall; Munich: Hirmer, 2001.

August Macke und die rheinischen Expressionisten: Werke aus dem Kunstmuseum Bonn und anderen Sammlungen. Edited by Magdalena M. Moeller. Berlin: Brücke-Museum; Munich: Hirmer, 2002.

Central European Avant-Gardes: Exchange and Transformation, 1910–1930. Edited by Timothy O. Benson. Los Angeles: Los Angeles County Museum of Art; Cambridge, MA: MIT Press, 2002.

Paris: Capital of the Arts, 1900–1968. Edited by Sarah Wilson and Eric de Chassey. London: Royal Academy of Arts, 2002.

Van Gogh: Fields; The "Field with Poppies" and the Artists' Dispute. Edited by Wulf Herzogenrath and Dorothee Hansen. Bremen: Kunsthalle Bremen; Ostfildern-Ruit: Hatje Cantz, 2002.

Ernst Ludwig Kirchner: The Dresden and Berlin Years. Edited by Jill Lloyd and Magdalena M. Moeller. London: Royal Academy of Arts, 2003.

Max Beckmann. Edited by Sean Rainbird. New York: Museum of Modern Art, 2003.

Die Brücke und die Moderne 1904–1914. Edited by Heinz Spielmann. Hamburg: Bucerius Kunst Forum; Munich: Hirmer, 2004.

Gauguin: Tahiti. George T. M. Shackelford and Claire Frèches-Thory. Paris: Galeries nationales du Grand Palais; Paris: Réunion des musées nationaux; Boston: MFA Publications, 2004.

Brücke und Berlin: 100 Jahre Expressionismus. Edited by Anita Beloubek-Hammer, Magdalena M. Moeller, and Dieter Scholz. Berlin: Neue Nationalgalerie; Berlin: Nicolaische Verlagsbuchhandlung, 2005.

Christian Rohlfs: Die Begegnung mit der Moderne. Edited by Dirk Luckow, Magdalena M. Moeller, and Peter Thurmann. Kiel: Kunsthalle zu Kiel; Berlin: Brücke Museum; Munich: Hirmer, 2005.

Franz Marc: The Retrospective. Edited by Annegret Hoberg and Helmut Friedel. Munich: Städtische Galerie im Lenbachhaus; New York: Prestel, 2005.

Gabriele Münter: The Search for Expression, 1906–1917. Edited by Annegret Hoberg and Shulamith Behr. London: Courtauld Institute Art Gallery in association with Paul Holberton Pub., 2005.

Karl Schmidt-Rottluff: Meisterwerke aus den Kunstsammlungen Chemnitz. Edited by Roland Doschka. Chemnitz: Städtische Kunstsammlungen; Balingen: Stadthalle; Munich: Prestel, 2005.

Le néo-impressionnisme: De Seurat à Paul Klee. Edited by Dominique Lobstein. Paris: Musée d'Orsay; Paris: Réunion des musées nationaux, 2005.

Cézanne to Picasso: Ambroise Vollard, Patron of the Avant-Garde. Edited by Rebecca A. Rabinow, Douglas W. Druick et al. New York: Metropolitan Museum of Art; New Haven, CT: Yale University Press, 2006.

Feast of Color: The Merzbacher-Mayer Collection. Edited by Tobia Bezzola. Zürich: Kunsthaus Zürich; Cologne: DuMont, 2006.

Kandinsky: The Path to Abstraction. Edited by Hartwig Fischer and Sean Rainbird. London: Tate, 2006.

Paula Modersohn-Becker und die Kunst in Paris um 1900: Von Cézanne bis Picasso. Edited by Anne Buschhoff and Wulf Herzogenrath. Bremen: Kunsthalle Bremen; Munich: Hirmer, 2007.

Vincent van Gogh and Expressionism. Edited by Jill Lloyd and Michael Peppiatt. Amsterdam: Van Gogh Museum; New York: Neue Galerie; Ostfildern: Hatje Cantz, 2007.

Emil Nolde. Sylvain Amic. Montpellier: Musée Fabre; Paris: Réunion des musées nationaux, 2008.

Kirchner and the Berlin Street. Deborah Wye. New York: Museum of Modern Art, 2008.

Van Dongen. Edited by Nathalie Bondil and Jean-Michel Bouhours. Montreal: Montreal Museum of Fine Arts; Monaco: Nouveau Musée National de Monaco; Paris: Hazan, 2008.

Brücke: The Birth of Expressionism in Dresden and Berlin, 1905–1913. Edited by Reinhold Heller. New York: Neue Galerie; Ostfildern: Hatje Cantz, 2009.

Der große Widerspruch: Franz Marc zwischen Delaunay und Rousseau. Edited by Cathrin Klingsöhr-Leroy. Kochel am See: Franz-Marc-Museum; Berlin: Deutscher Kunstverlag, 2009.

Marc, Macke und Delaunay: Die Schönheit einer zerbrechenden Welt (1910–1914). Hannover: Sprengel-Museum, 2009. Translated by Simon Pleasance in an accompanying booklet as *Marc, Macke und Delaunay: The Beauty of a Fragile World (1910–1914)*.

Deutscher Expressionismus 1905–1913: Brücke-Museum Berlin; 150 Meisterwerke. Edited by Magdalena M. Moeller and Mariëtta Jansen. Groningen: Groninger Museum; Berlin: Brücke-Museum; Munich: Hirmer Verlag, 2010.

Erich Heckel: Aufbruch und Tradition; Eine Retrospektive. Edited by Magdalena M. Moeller. Schleswig: Stiftung Schleswig-Holsteinische Landesmuseen Schloss Gottorf; Berlin: Brücke Museum; Munich: Hirmer, 2010.

Ernst Ludwig Kirchner: Retrospective. Edited by Felix Krämer. Frankfurt am Main: Städel Museum; Ostfildern: Hatje Cantz, 2010.

Cézanne et Paris. Denis Coutagne. Paris: Musée du Luxembourg; Paris: Éditions de la RMN-Grand Palais, 2011.

German Expressionism: The Graphic Impulse. Edited by Starr Figura. New York: Museum of Modern Art, 2011.

Liebermanns Gegner: Die Neue Secession in Berlin und der Expressionismus. Edited by Anke Daemgen and Uta Kuhl. Berlin: Stiftung Brandenburger Tor; Schleswig: Stiftung Schleswig-Holsteinische Landesmuseen Schloss Gottorf; Cologne: Wienand, 2011.

Lyonel Feininger: At the Edge of the World. Edited by Barbara Haskell. New York: Whitney Museum of American Art; Montreal: Montreal Museum of Fine Arts; New Haven, CT: Yale University Press, 2011.

The Steins Collect: Matisse, Picasso, and the Parisian Avant-Garde. Edited by Janet Bishop, Cécile Debray, and Rebecca Rabinow. San Francisco: San Francisco Museum of Modern Art in association with Yale University Press, 2011.

Die Brücke, 1905–1914: Aux origines de l'expressionnisme. Grenoble: Musée de Grenoble; Quimper: Musée des beaux-arts de Quimper; Paris: Somogy, 2012.

Im Farbenrausch: Munch, Matisse und die Expressionisten. Edited by Mario-Andreas von Lüttichau and Ulrike Hofer. Essen: Museum Folkwang; Göttingen: Steidl, 2012.

Inventing Abstraction, 1910–1925: How a Radical Idea Changed Modern Art. Leah Dickerman. New York: Museum of Modern Art, 2012.

Matisse: In Search of True Painting. Edited by Dorthe Aagesen and Rebecca Rabinow. New York: The Metropolitan Museum of Art, 2012.

1912: Mission moderne; Die Jahrhundertschau des Sonderbundes. Edited by Barbara Schaefer. Cologne: Wallraf-Richartz-Museum & Fondation Corboud; Cologne: Wienand, 2012.

Der Sturm: Zentrum der Avantgarde. 2 vols. Edited by Antje Birthälmer and Gerhard Finckh. Wuppertal: Von der Heydt-Museum, 2012.

De l'Allemagne: De Friedrich à Beckmann. Edited by Sébastien Allard and Danièle Cohn. Paris: Musée du Louvre; Paris: Hazan, 2013.

Collection Catalogues

Alley, Ronald. *Catalogue of the Tate Gallery's Collection of Modern Art, Other Than Works by British Artists*. London: The Tate Gallery in association with Sotheby Parke Bernet, 1981.

Barnett, Vivian Endicott. *Handbook: The Guggenheim Museum Collection, 1900–1980*. New York: The Solomon R. Guggenheim Museum, 1980.

Einblicke: Das 20. Jahrhundert in der Kunstsammlung Nordrhein-Westfalen, Düsseldorf. Ostfildern-Ruit: Hatje Cantz, 2000.

Foundation E. G. Bührle Collection Zürich: Catalogue. Edited by Lukas Gloor and Marco Goldin. Conegliano: Linea d'ombra, 2004.

Gemäldegalerie Dresden, Neue Meister: 19. und 20. Jahrhundert; Bestandskatalog und Verzeichnis der beschlagnahmten, vernichteten und vermissten Gemälde. Edited by Horst Zimmermann and Helga Fuhrmann. Dresden: Staatliche Kunstsammlungen, 1987.

German Expressionist Art: The Ludwig and Rosy Fischer Collection. Essays by Frederick R. Brandt and Eleanor M. Hight. Richmond: Virginia Museum of Fine Arts, 1987.

German Expressionist Prints and Drawings: The Robert Gore Rifkind Center for German Expressionist Studies. Essays by Stephanie Barron, Wolf-Dieter Dube, Alexander Dückers et al. Catalogue by Bruce Davis. 2 vols. Los Angeles: Los Angeles County Museum of Art; Munich: Prestel, 1989.

Hansen, Dorothee, and Henrike Holsing. *Vom Klassizismus zum Kubismus: Bestandskatalog der französischen Malerei in der Kunsthalle Bremen*. Munich: Hirmer, 2011.

Kunsthaus Zürich: Gesamtkatalog der Gemälde und Skulpturen. Christian Klemm et al. Ostfildern: Hatje Cantz, 2007.

Vogt, Paul. *Das Museum Folkwang Essen: Die Geschichte einer Sammlung junger Kunst im Ruhrgebiet*. Cologne: M. DuMont Schauberg, 1965.

Von der Heydt-Museum: Die Gemälde des 19. und 20. Jahrhunderts. Edited by Sabine Fehlemann. Cologne: Wienand, 2003.

Index

Photo Credits

2, 47, 101: Photo: Art Resource, NY. 3, 122, 124: © 2013 Wassily Kandinsky/ Artists Rights Society (ARS), New York/ ADAGP, Paris. Photo © Merzbacher Kunststiftung. 11, 12: © Nachlass des Künstlers/Estate of the artist. Photo © Kunstmuseum Basel, by Martin Bühler. 13: © 2013 Pierre Bonnard Estate/Artists Rights Society (ARS), New York/ADAGP, Paris. Photo courtesy of the Indianapolis Museum of Art. 14: © 2013 Georges Braque Estate/Artists Rights Society (ARS), New York/ADAGP, Paris. Photo © Merzbacher Kunststiftung. 15: © 2013 Georges Braque Estate/Artists Rights Society (ARS), New York/ADAGP, Paris. Photo © Walter Klein. 16: © 2013 Georges Braque Estate/Artists Rights Society (ARS), New York/ADAGP, Paris. Photo: Museo Thyssen-Bornemisza/ Scala/Art Resource, NY. 17: © 2013 Georges Braque Estate/Artists Rights Society (ARS), New York/ADAGP, Paris. Photo: Solomon R. Guggenheim Foundation/Art Resource, NY. 19, 105: Photo courtesy J. Paul Getty Museum, Los Angeles. 20: Photo © RMN-Grand Palais/Art Resource, NY. Photo: Franck Raux. 21: Image copyright © Metropolitan Museum of Art. Photo: Malcolm Varon. Image source: Art Resource, NY. 22, 48, 80 (right), 94 (bottom), 96, 104 (bottom), 161, 184: Photo © 2013 Museum Associates/ LACMA. 23: Photo: Kimbell Art Museum, Fort Worth, Texas/Art Resource, NY. 24, 92, 219: Photo © RMN-Grand Palais/Art Resource, NY. Photo: Hervé Lewandowski. 25: Photo © Bridgeman Art Library. 27: Photo © Musées d'art et d'histoire de la Ville de Genève, by Yves Siza. 28: © Robert Delaunay Estate, Pracusa 2013047. Photo courtesy Minneapolis Institute of Arts. 29: © Robert Delaunay Estate, Pracusa 2013047. Photo © Solomon R. Guggenheim Foundation/Art Resource, NY. 30 (top): © Robert Delaunay Estate, Pracusa 2013047. Photo courtesy Museum Folkwang. 30 (bottom): © Robert Delaunay Estate, Pracusa 2013047. Photo: Philadelphia Museum of Art/Art Resource, NY. 32: © André Derain Estate/Artists Rights Society (ARS), New York/ADAGP, Paris. Photo courtesy private collection. 33: © André Derain Estate/Artists Rights Society (ARS), New York/ADAGP, Paris. Photo © New Orleans Museum of Art. 34: © André Derain Estate/Artists Rights Society (ARS), New York/ ADAGP, Paris. Photo © National Gallery of Canada. 35: © André Derain Estate/ Artists Rights Society (ARS), New York/ ADAGP, Paris. Photo © Merzbacher Kunststiftung. 36: © Kees van Dongen Estate/Artists Rights Society (ARS),

New York/ADAGP, Paris. Photo © Art Gallery of Ontario, photo by Ian Lefebvre. 37: © Kees van Dongen Estate/Artists Rights Society (ARS), New York/ ADAGP, Paris. Photo © Erich Lessing/ Art Resource, NY. 38: © Kees van Dongen Estate/Artists Rights Society (ARS), New York/ADAGP, Paris. Photo © Kunsthaus Zürich. 39: © Kees van Dongen Estate/Artists Rights Society (ARS), New York/ADAGP, Paris. Digital Image © The Museum of Modern Art/Licensed by SCALA / Art Resource, NY. 40: © Raoul Dufy Estate/Artists Rights Society (ARS), New York/ ADAGP, Paris. Photo © Florian Kleinefenn. 41: © Raoul Dufy Estate/ Artists Rights Society (ARS), New York/ ADAGP, Paris. Photo © Museo Thyssen-Bornemisza/Scala/Art Resource, NY. 42, 43: © Raoul Dufy Estate/Artists Rights Society (ARS), New York/ ADAGP, Paris. Image courtesy National Gallery of Art, Washington, DC. 44: © Raoul Dufy Estate/Artists Rights Society (ARS), New York/ADAGP, Paris. Photo courtesy McMaster Museum of Art, by John Tamblyn. 45: © Raoul Dufy Estate/Artists Rights Society (ARS), New York/ADAGP, Paris. Photo © Musée d'Art Moderne/Roger-Viollet. 46, 213: © Max Pechstein Estate/Artists Rights Society (ARS), New York/ VG Bild-Kunst, Bonn. Image: bpk, Berlin/Staatliche Museen zu Berlin/Photo: Roman Maerz/Art Resource, NY. 50 (left): Photo courtesy Nelson Atkins Museum, photo by Jamison Miller. 50 (right), 223: © Karl Schmidt-Rottluff Estate/Artists Rights Society (ARS), New York/VG Bild-Kunst, Bonn. Photo: Kunstsammlungen Chemnitz/Detlef Göschel. 51: © Nolde Stiftung Seebüll, Germany. Photo © Nolde Stiftung Seebüll, Germany. 52: © 2014 Succession H. Matisse/Artists Rights Society (ARS), New York. Photo © State Hermitage Museum/photo by Vladimir Terebenin. 53 (left): © 2013 Max Beckmann Estate/Artists Rights Society (ARS), New York/VG Bild-Kunst, Bonn. 53 (right), 133, 138, 139: © Ernst Ludwig Kirchner, Courtesy Ingeborg & Dr. Wolfgang Henze-Ketterer, Wichtrach/Bern. Photo © 2013 Museum Associates/LACMA. 54, 128, 129: © Ernst Ludwig Kirchner, Courtesy Ingeborg & Dr. Wolfgang Henze-Ketterer, Wichtrach/Bern. Photo © Brücke Museum, Berlin, photographer: Roman März. 56: Photo © Virginia Museum of Fine Arts. Photo: Travis Fullerton. 57: Photo courtesy Foundation E.G. Bührle Collection, Zürich. 58: © 2013 Estate of Pablo Picasso/Artists Rights Society (ARS), New York. Digital Image © The Museum of Modern Art/ Licensed by SCALA/Art Resource,

NY. 62, 70, 200, 253 (left): Photo: Erich Lessing/Art Resource, NY. 63: Photo: bpk, Berlin/Nationalgalerie, Staatliche Museen zu Berlin, Germany/Photo: Klaus Goeken/Art Resource, NY. 66, 68: Photo © Albright-Knox Art Gallery/ Art Resource, NY. 67: Photo courtesy Museum Folkwang. 69: Photo © Klassik Stiftung Weimar. 72 (left): © 2014 Succession H. Matisse/Artists Rights Society (ARS), New York. Photo courtesy Museum Folkwang. 72 (right): Photo courtesy Staatsgalerie Stuttgart. 74: © Ernst Ludwig Kirchner, Courtesy Ingeborg & Dr. Wolfgang Henze-Ketterer, Wichtrach/Bern. Photo © Bayerische Staatsgemäldesammlungen, Munich, Bruno Hartinger, Haydar Koyupinar. 75: Photo © Philadelphia Museum of Art/Art Resource, NY. 77: © Ernst Ludwig Kirchner, Courtesy Ingeborg & Dr. Wolfgang Henze-Ketterer, Wichtrach/Bern. Photo: bpk, Berlin/Kupferstichkabinett, Staatliche Kunstsammlungen, Dresden, Germany/ Photo: Elke Estel/Art Resource, NY. 78: Photo: bpk, Berlin/Kunsthalle Bremen, Germany/Photo: Hermann Buresch/ Art Resource, NY. 79: Photo © Walker Art Center. 80 (left): Photo: bpk, Berlin/Neue Pinakothek, Bayerische Staatsgemäldesammlungen, Munich, Germany/Art Resource, NY. 83: Photo: LWL-Museum für Kunst und Kultur (Westfälisches Landesmuseum)/ Sabine Ahlbrand-Dornseif. 84: © 2014 Succession H. Matisse/Artists Rights Society (ARS), New York. Photo © SMK Foto Statens Museum for Kunst. 87: © 2013 Adolf Erbslöh Estate/ Artists Rights Society (ARS), New York/ ADAGP, Paris. 88: © 2013 Lyonel Feininger Estate/Artists Rights Society (ARS), New York/VG Bild-Kunst, Bonn. Photo © Mildred Lane Kemper Art Museum. 89: © 2013 Lyonel Feininger Estate/Artists Rights Society (ARS), New York/VG Bild-Kunst, Bonn. Photo © Bill Dewey Photography. 90: © 2013 Othon Friesz Estate/Artists Rights Society (ARS), New York/VG Bild-Kunst, Bonn. Photo courtesy McMaster Museum of Art, by John Tamblyn. 91: © 2013 Othon Friesz Estate/Artists Rights Society (ARS), New York/VG Bild-Kunst, Bonn. Photo © San Francisco Museum of Modern Art. 93, 218: Photo courtesy private collection. 94 (top): Image copyright © Metropolitan Museum of Art. Image source: Art Resource, NY. 95, 169 (left): Copyright © Unknown Photographer/Art Institute of Chicago Image. 97, 228: Image courtesy National Gallery of Art, Washington, DC. 98, 99: Photo courtesy Galleri K, Oslo. 100: Photo: bpk, Berlin/ Museum Folkwang/Art Resource, NY. 102, 104 (top), 185: Photo © Kunsthaus

Zürich. 103: Photo © Hammer Museum. 106: Photo © RMN-Grand Palais/Art Resource, NY. Photo: Patrice Schmidt. 107: Photo © Cleveland Museum of Art. 108: © Nachlass Erich Heckel/Artists Rights Society (ARS), New York/VG Bild-Kunst, Bonn. Photo © Merzbacher Kunststiftung. 109, 110, 114, 115: © Nachlass Erich Heckel/Artists Rights Society (ARS), New York/VG Bild-Kunst, Bonn. Photo © 2013 Museum Associates/ LACMA. 111: © Nachlass Erich Heckel/ Artists Rights Society (ARS), New York/ VG Bild-Kunst, Bonn. Photo: Neue Galerie New York/Art Resource, NY. 112: © Nachlass Erich Heckel/Artists Rights Society (ARS), New York/VG BILD-KUNST, Bonn. Photo courtesy Museum Folkwang. 113: © Nachlass Erich Heckel/Artists Rights Society (ARS), New York/VG Bild-Kunst, Bonn. Photo © Brücke-Museum, Berlin, photographer: Roman März. 117: © 2013 Alexej Jawlensky Estate/Artists Rights Society (ARS), New York/VG Bild-Kunst, Bonn. Photo © Collection Stedelijk Museum Amsterdam. 118: © 2013 Alexej Jawlensky Estate/Artists Rights Society (ARS), New York/VG Bild-Kunst, Bonn. Photo © San Diego Museum of Art. 119: © 2013 Alexej Jawlensky Estate/Artists Rights Society (ARS), New York/VG Bild-Kunst, Bonn. Photo: Erich Lessing/Art Resource, NY. 120: © 2013 Alexej Jawlensky Estate/ Artists Rights Society (ARS), New York / VG Bild-Kunst, Bonn. Photo © Rheinisches Bildarchiv Köln, rba_c006789. 121: © 2013 Alexej Jawlensky Estate/Artists Rights Society (ARS), New York/VG Bild-Kunst, Bonn. Photo courtesy private collection. 123: © 2013 Wassily Kandinsky/Artists Rights Society (ARS), New York/ ADAGP, Paris. Photo © The Phillips Collection. 125: © 2013 Wassily Kandinsky/Artists Rights Society (ARS), New York/ADAGP, Paris. Photo © Dallas Museum of Art. 126: © 2013 Wassily Kandinsky/Artists Rights Society (ARS), New York/ADAGP, Paris. Photo: bpk, Berlin/Hamburger Kunsthalle, Hamburg, Germany/Photo: Elke Walford/Art Resource, NY. 127: © Ernst Ludwig Kirchner, Courtesy Ingeborg & Dr. Wolfgang Henze-Ketterer, Wichtrach/Bern. Image courtesy National Gallery of Art, Washington, DC. 130, 140: © Ernst Ludwig Kirchner, Courtesy Ingeborg & Dr. Wolfgang Henze-Ketterer, Wichtrach/Bern. Photo © Virginia Museum of Fine Arts. Photo: Travis Fullerton. 131: © Ernst Ludwig Kirchner, Courtesy Ingeborg & Dr. Wolfgang Henze-Ketterer, Wichtrach/Bern. Digital Image © The Museum of Modern Art/Licensed by SCALA / Art Resource, NY. 134: